Amedeo Modigliani

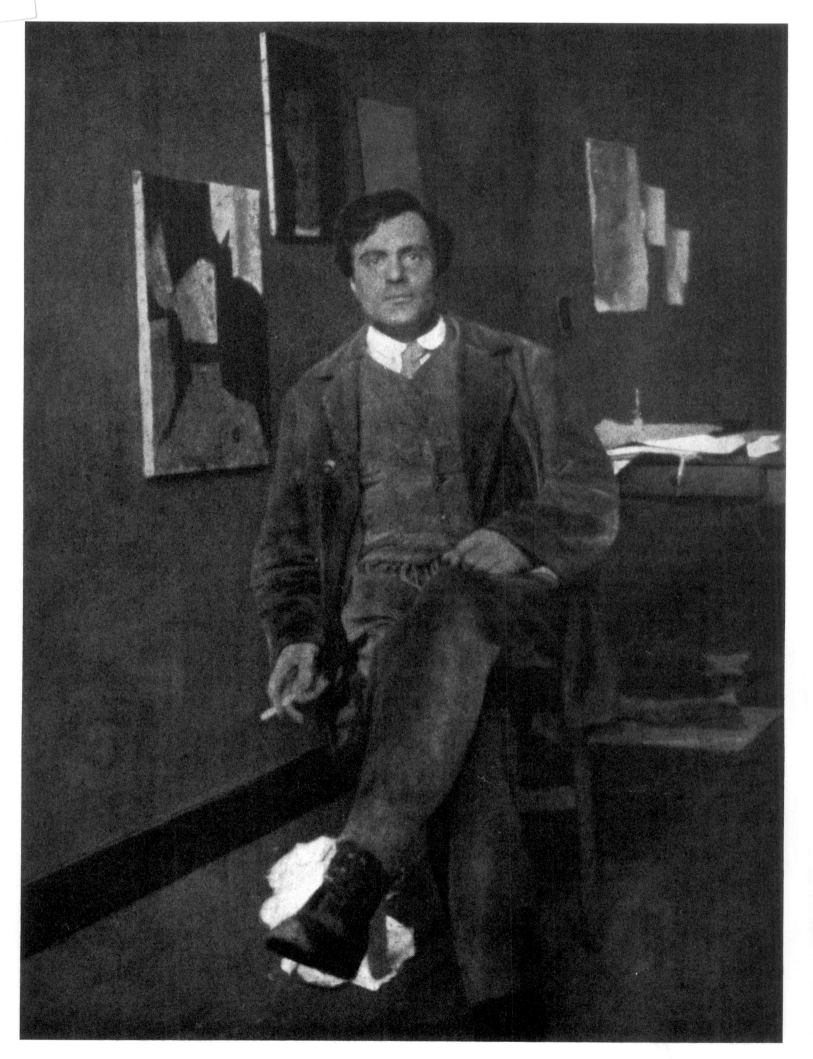

Werner Schmalenbach

Amedeo Modigliani

Paintings · Sculptures
Drawings

Prestel

First published in conjunction with the exhibition
"Amedeo Modigliani. Malerei · Skulpturen · Zeichnungen"
at the Kunstsammlung Nordrhein-Westfalen, Düsseldorf
(19 January – 1st April 1991)
and at the Kunsthaus, Zurich (19 April – 7 July 1991)

Translations from the German by David Britt (essay by
Werner Schmalenbach) and Peter Underwood (documents),
from the French by Caroline Beamish and from the Italian
by Brian Binding

Front cover: *Portrait of Max Jacob*, 1916 (pl. 4)
Back cover: *Self-portrait*, 1919 (pl. 91)
Frontispiece: Amedeo Modigliani in his studio, *c.* 1918

© Prestel-Verlag, Munich 1990

© of works illustrated by the artists, their heirs and assigns,
except in the following cases: Constantin Brancusi, Carlo Carrà,
André Derain, Oskar Kokoschka, Henri Matisse, Pablo Picasso
by VG Bild-Kunst, Bonn, 1990; Ernst Ludwig Kirchner
by Dr. Wolfgang and Ingeborg Henze, Campione d'Italia.

Photographic credits, see page 227

Prestel-Verlag
Mandlstrasse 26, D-8000 Munich 40,
Federal Republic of Germany
Tel: (89) 38 17 09 0; Telefax: (89) 38 17 09 35

Distributed in continental Europe by Prestel-Verlag
Verlegerdienst München GmbH & Co KG,
Gutenbergstrasse 1, D-8031 Gilching,
Federal Republic of Germany
Tel: (8105) 2110; Telefax: (8105) 5520

Distributed in the USA and Canada on behalf of Prestel-Verlag by te Neues
Publishing Company, 15 East 76th Street, New York, NY 10021, USA
Tel: (212) 288 0265; Telefax: (212) 570 2373

Distributed in Japan on behalf of Prestel-Verlag by YOHAN-Western
Publications Distribution Agency, 14-9 Okubo 3-chome, Shinjuku-ku,
J-Tokyo 169 Tel: (3) 208 0181; Telefax: (3) 209 0288

Distributed in the United Kingdom, Ireland and all other countries
on behalf of Prestel-Verlag by Thames & Hudson Limited,
30-40 Bloomsbury Street, London WC1B 3QP, England
Tel: (71) 636 5488; Telefax: (71) 636 4799

Colour separations: Karl Dörfel GmbH, Munich
Typesetting: Fertigsatz GmbH, Munich
Printing: Karl Wenschow-Franzis Druck GmbH, Munich
Binding: R. Oldenbourg, Heimstetten

Printed in Germany

ISBN 3-7913-1077-1 (German edition)
ISBN 3-7913-1095-X (English edition)

Contents

Foreword

This book was inspired by a very special kind of identification with the art of Amedeo Modigliani, for the author acquired three outstanding works by the artist for the musuem of modern art in Düsseldorf, the Kunstsammlung Nordrhein-Westfalen, of which he was the director for 28 years. The first was an oil sketch of a caryatid dating from around 1911 when Modigliani still aspired to become a sculptor. It came to the collection in 1962—the year the museum was founded—almost directly from its previous owner Dr. Paul Alexandre who, by this time well advanced in years, had been Modigliani's doctor in Paris and also his first buyer. The second was acquired in 1965 at the memorable auction of the André Lefèvre collection in Paris. This was one of Modigliani's finest portraits, that of the poet Max Jacob from the year 1916. The third was added much later—in 1985—and was the highly unorthodox portrait of the Mexican painter Diego Rivera from 1914 who, like Max Jacob, was one of Modigliani's closest friends.

It was the presence of these three magnificent works in the collection which inspired the author to study the artist's œuvre in greater depth. This resulted in an exhibition at the Kunstsammlung Nordrhein-Westfalen in Düsseldorf and subsequently at the Kunsthaus Zürich accompanied by a catalogue, the present book.

I would like to thank Dr. Anette Kruszynski for all her help in carrying out this project and in particular for compiling the texts following the plate section which are taken from statements about Modigliani made by his friends and contemporaries.

Thanks are also due to my publishers, Prestel-Verlag, with whom it was yet again a real pleasure to work.

WERNER SCHMALENBACH

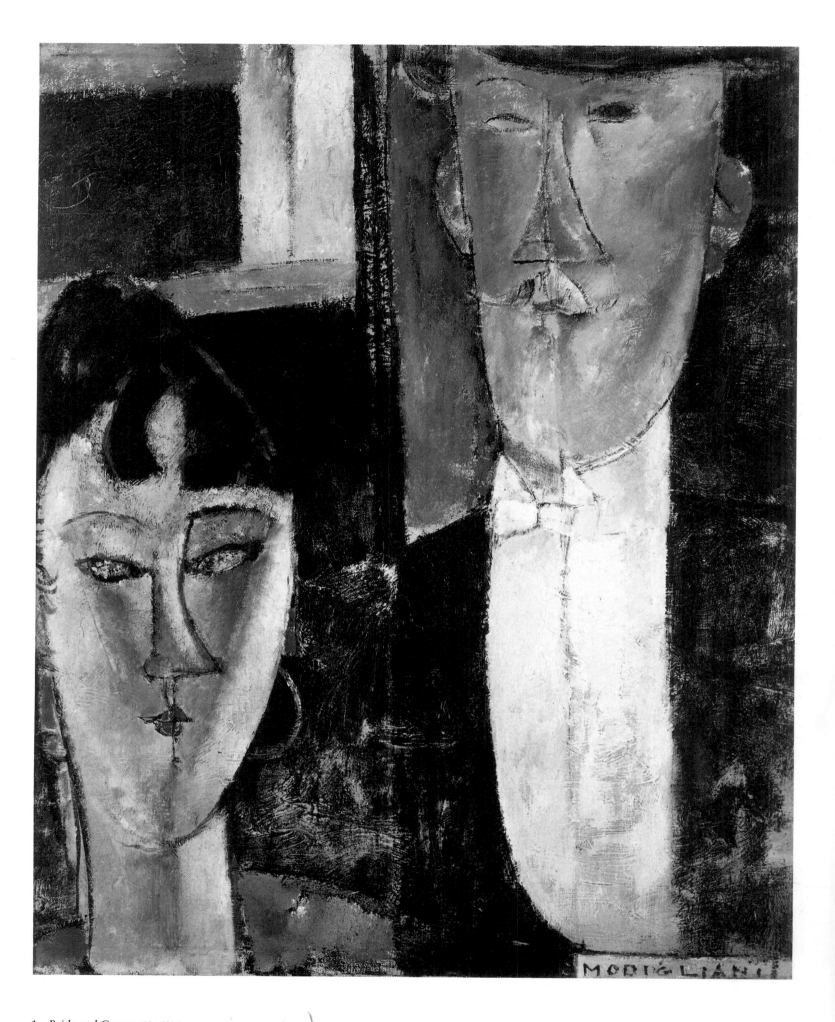

1 Bride and Groom *1915/16*

Preface

To this day, the work of Amedeo Modigliani is still in many ways eclipsed by the legend of his life. Views of his art, of a more or less conventional nature, have been formulated and have gained currency; but the great fascination for many people remains the man himself. This is partly, but not wholly the consequence of a latter-day film based on a romanticized version of his life. It was not long after his death that his own literary friends and contemporaries, some of whom were to survive him by several decades, began to portray his life in a sensationally effective mixture of fact and fiction.

All this has long since been corrected; but even today, the principal image of Modigliani in people's minds is that of a dazzling bohemian figure in pre-1920s Paris. By way of compensation, as it were, for their bourgeois lives, people seem to need a projection of their own unrealized dreams. They love to see—at a distance—a painter who appears to embody all the freedom that is beyond their own grasp, along with such appropriate trappings as women, drugs and alcohol in excess: a man who is radiant and tragic at one and the same time; a life that is lived to the full; a life that lurches towards a fated early death, followed two days later by the suicide of the woman who is carrying the artist's child. All this seems as beautiful and as terrible as stereotypical artistic life is supposed to be. It has very little to do with reality.

True, the triad of women, drugs and alcohol did play a crucial role in Modigliani's life. Even more crucial was his always precarious state of health, after the onset of tuberculosis in his early years in Italy. But how did all this affect his art? The answer is that it did not affect it at all. Artistically, Modigliani's restless life is an irrelevance. Accordingly, anyone who looks in this book for a *chronique scandaleuse* will look in vain. None of the perils that menaced his life is reflected in his art. None of them ever deflected him from his chosen artistic course. His painting is totally free of destructive influences; it is, indeed, an exceptionally controlled art. Everywhere we look there is form, order and a sense of artistic responsibility. It might be said that Modigliani led a double life: on the one hand his erratic existence on the streets of Paris, in cafés, dives and studios; on the other the life that he led with his art. Even where these two lives came into contact thematically, they were lived quite separately.

This is demonstrated by even his swiftest studies, those in which he captured the look of a man or woman at an adjoining café table: they show an unfailing mastery of form. Modigliani's line never wavers. His sketches, the works that by their nature are most exposed to the passing influences of life, are always remarkable for the amazing sureness of their line. This applies in particular to the last years of his life, when he was in a process of rapid physical decline. All of which means there is no need to dwell on his biography.

He was an Italian, and he was a Jew. He was a member of the *Ecole de Paris*, a school of painting that in the early years of this century was made up of numerous major and minor artists from every country under the sun. There was a strong contingent from Eastern Europe, and many of these were Jews. Modigliani knew almost all of them, and some of them were his friends. Artistically, however, he remained a loner—although Paul Cézanne remained his guiding star all his life, and although from a very early stage he was in touch with Pablo Picasso, Constantin Brancusi and a few others.

For all his modernity, Modigliani was a great traditionalist; and yet, of all the artists of the past—and of the Italian Renaissance in particular—whose work he loved so much, there is not one to whom he can be said to have been particularly indebted. If there is a strong classical tendency in his art, this does not mean that his art was backward-looking, nor that he took any part in the varieties of Neo-classicism that were already beginning to emerge in his lifetime. Artistically, he stood at the periphery of the contemporary avant-garde, though he was surrounded by avant-garde artists.

The stature of his art is somewhat obscured by a large number of weak works, such as every strong artist produces, and in Modigliani's case these are largely responsible for the way in which his art is commonly visualized: they are the works in which certain stylistic traits are turned into formulas. From such a view of his work, which dismisses it as all 'swan necks and almond eyes', he needs to be liberated for the sake of those magnificent paintings by him that we possess—the portraits above all. Such is the purpose of this book, which treats Modigliani's art not as a mirror of his life but—in accordance with the artist's own lofty aesthetic ethos—as a body of work quite separate from the life.

The Sculptor: Heads and Caryatids

It seems to have been the dream of Modigliani's life—at least for a period, and possibly at a very early stage, when he was still living in his native Livorno—to become a sculptor. This is contradicted, admittedly, by the fact that in Livorno, in Florence and in Venice he studied not sculpture but painting, but it remains significant that when he was living in Paris, after 1906, his mother addressed her letters to 'Amedeo Modigliani, *scultore*'. It is suggested that he was prevented from realizing his dream by his less than robust state of health, and possibly also by the high cost of materials.

His output of sculptures is small and spans a very narrow thematic and stylistic range. Almost without exception, his sculptures are idol-like heads, carved in stone; there is also one kneeling caryatid, and one standing figure. Although we can assume that some works were destroyed—wooden sculptures in particular, only one of which has survived—the tally of surviving works is a modest twenty-five or so. This body of work is, however, accompanied by numerous drawings, watercolours and gouaches, and by a few oil sketches, on sculptural themes. Many of these studies relate directly to specific sculptural projects, whether realized or not.

Modigliani very rarely dated his works, so their chronology and evolutionary sequence are highly uncertain. It seems that his intensive concern with sculpture began in 1910, and that it was over by 1913 or 1914. At that point, for whatever reason, Modigliani lost interest; and if his work is considered as a whole—sculpture on one hand, painting on the other—it seems very likely that he simply concluded that he was not really a born sculptor. What he was born to do was to paint and to draw.

It has sometimes been said that Modigliani's work as a painter reveals a fundamental leaning towards sculpture, insofar as its only theme is the human individual, isolated from any context that might qualify his or her sheer physical presence. This is not wholly convincing, because his paintings are invariably characterized not only by painterly flesh-tones but by a strongly marked pictorial coherence. True, in his early works there are clear indications of volume, but these indicate a closeness to Cubism rather than to sculpture. It is not true that in the depths of his being Modigliani was a sculptor, prevented by circumstances from pursuing his true vocation. He was a painter in the full sense of the word. Painting was his natural medium, and his few sculptural works—fine though they are—reveal that sculpture was not. That lifelong dream of his was a self-deception, and after a few years he gave it up.

It was around 1911 or 1912 that Modigliani painted an oil sketch of a kneeling or crouching *Caryatid* that has to be seen in the context of his interest in sculpture (pl. 2). By comparison with the rest of his paintings, it has a decidedly sculptural character: it looks rather as the artist might have imagined a stone caryatid to look.

What was it about the caryatid theme that fascinated Modigliani during his period of exclusive concentration on sculpture? It is true that the female human body was a lifelong preoccupation of his; but then, this can hardly be described as the body of a woman. This caryatid is not a nude. It is not a representation of an unclothed woman, although it is a female figure consisting of torso, limbs and head. The figure works primarily in a 'formal' way: its form exhausts its meaning. Under the pretext of carrying an—invisible—burden, the body and its component parts are forced in specific directions, generating a complex rhythm of horizontals, verticals, diagonals and curves. The artist has chosen his theme solely for the sake of this formal structure.

Accordingly, this *Caryatid*—in contradiction of the very definition of the word—does not assume the function of supporting an entablature. There is nothing there to support. The relevant posture is nothing but an attitude. The figure braces her arms (although 'braces' is far too active a word) against the upper edge of the picture; but the load-bearing theme remains an empty gesture, a mere undertone to a preoccupation with something quite different. The motif here is not the act of bearing a load but the rhythm of the parts of the female body, uninfluenced, and certainly uncoerced, by any load whatever. The artist is concerned with clear volumes, and with their rhythmic relationship to each other; he interprets his *Caryatid* entirely 'abstractly', as a strictly formal, totally static figure. Even in his late paintings a strong element of abstraction persists.

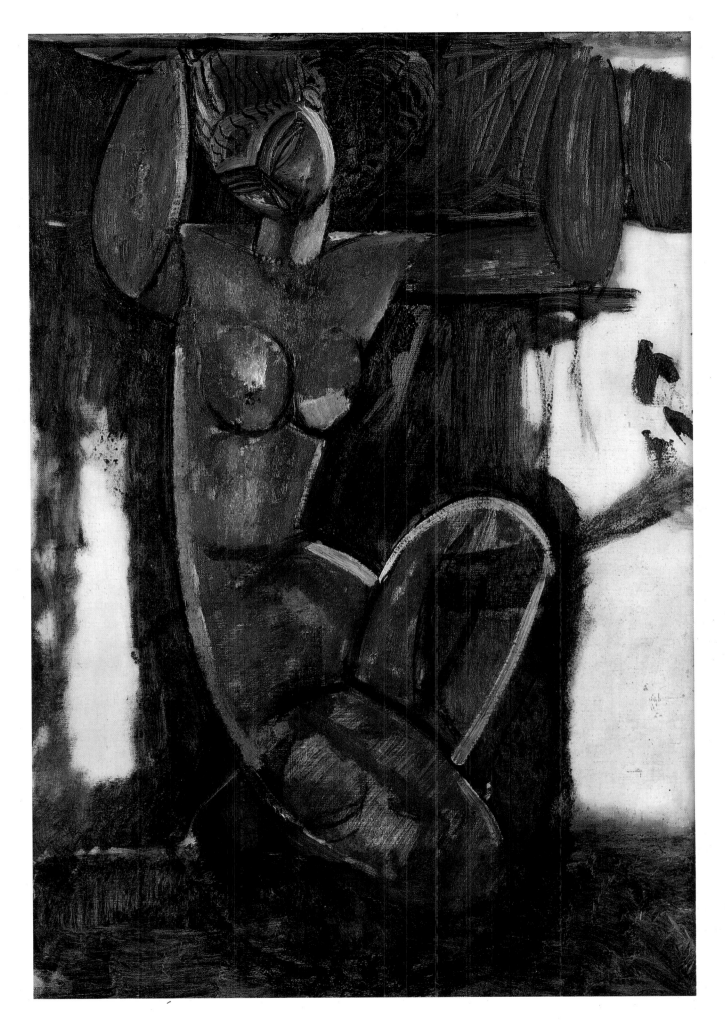

2 Caryatid *1911/12*

Fig. 1 *Caryatid*, 1910/11, charcoal

Fig. 2 *Caryatid*, 1910/11, charcoal

In all this, there is no such thing as an attempt at 'spiritual' expression. The 'spirit' lies in the artistic language itself; and that language, despite a few temperamental, freehand, sketchy brush-strokes, is devoid of expressiveness.

Whenever a painter takes the human body as his subject, he tells us a great deal by what he actually does to it. Modigliani is interested in clearly demarcating the individual solid forms from each other, thereby interrupting the organic flow. The body of his *Caryatid* is composed of a small number of solids separated by strong outlines: the trapezoid of the trunk, with the globes of the breasts; the thighs at right angles; the forearms acting as supports, one of which is perpendicular to the horizontal of the upper arm; and finally, supported by the cylindrical form of the neck and leaning in the opposite direction, the oval of the head—in which, again, the individual parts are precisely demarcated from each other: the narrow, volumetric triangle of the nose and the almond-shaped eyes beneath arched brows. The artist is concerned, above all, to set off form against form, and to give each individual part a high degree of formal autonomy. In many related drawings this becomes even more evident. This scansion of the body does not impair its overall form: all is held together by rhythm, colour and natural proportion.

The same sort of structuring consistently appears in Modigliani's caryatid studies of 1910–12 (figs. 1, 2), whether the figure is kneeling or standing, and whether the technique is pencil, pastel, watercolour or gouache. Occasional 'painterly' additions, often hugging the outer edge of contours, serve to emphasize the figure and to proclaim the ultimate purpose of the work, which is its realization as a sculpture (apart, that is, from those occasional cases where the additions were made much later by another hand). The strong decorative impulse is unmistakable—as is the linear schematization that arises in some of these works, with their near-geometric articulation and the clean divisions between their parts.

At the time when Modigliani painted his oil sketch of a *Caryatid*, the separation of volumes was a central principle in contemporary art. The notion of discontinuity unleashed, among the leading artists of his generation, an unprecedented questioning of the organic continuities of Nature. It was this idea of 'Abstraction' that Wilhelm Worringer contrasted with 'Empathy' in his celebrated book *Abstraktion und Einfühlung*, published in 1908. 'Abstraction', in Worringer's sense of the term, did not at all imply a renunciation of Nature as a whole but a refusal to 'empathize' with its organic essence. In sharp contrast to the 'melodious' linearity of Art Nouveau, art now became decidedly anti-organic. Cubism, above all, dismembered and fragmented everything in order to give full expression to form, as distinct from living Nature. Even the Fauves, who were not very interested in 'form', shattered the continuum of Nature with their 'autonomous' slabs of colour.

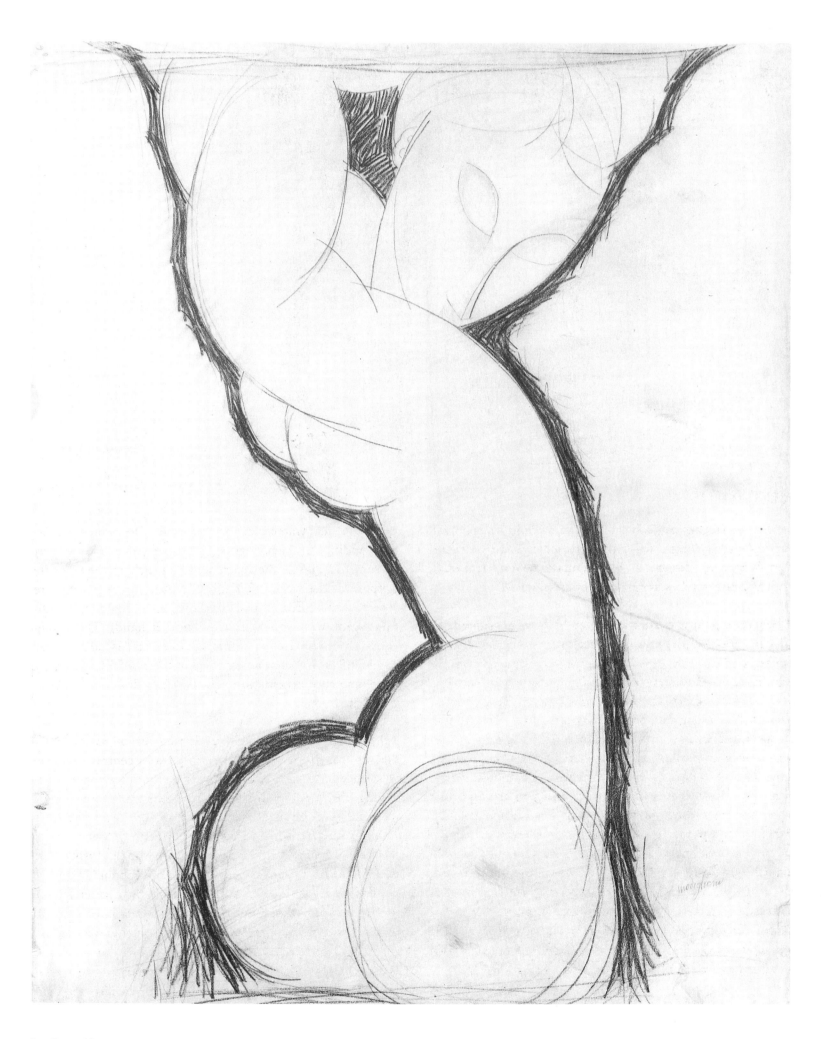

3 Caryatid *1914*

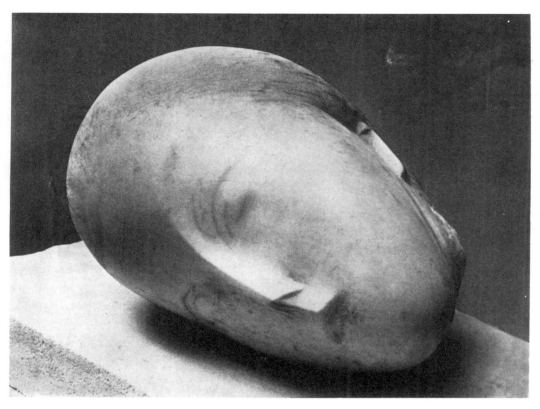

Fig. 3 Constantin Brancusi, *Sleeping Muse*, 1909, marble. Solomon R. Guggenheim Museum, New York

The principle of discontinuity and disjunction was particularly potent in sculpture—not only in that of Picasso, but equally in that of Henri Matisse. The 'logical' consequences of the principle included collage and assemblage, techniques that were practised in the circles in which Modigliani himself moved; not only by the Cubist painters, the true originators of these new procedures, but also by such sculptors as Alexander Archipenko (whom Modigliani did not rate highly) and Henri Laurens.

Modigliani himself never took the decisive step of 'destroying' objects and figures. It was characteristic of him that he always avoided extreme Modernist gestures. There are no assemblages in his work, nor even any collages, which became the dominant trend in Cubist circles from 1912 or 1913, with such momentous consequences for all of twentieth-century painting. Just once, he prominently affixed a newspaper clipping to one of his paintings (pl. 28). His relationship to the various Modernist movements was—to put it paradoxically—one of close detachment. This applied particularly to Cubism, whose influence on Modigliani's early work is visible but should not be exaggerated. He painted portraits of Picasso and of Juan Gris, but he was very little influenced by their art. He was never prepared to 'destroy' a bodily whole for the sake of a totally different conception of pictorial wholeness.

His *Caryatid*, despite her brusquely juxtaposed parts, is a 'whole' figure, not only because of the unified colour scheme but because the proportions of the human body have been respected. In particular, the body is unified by the unbroken curve that leads from the right armpit down to the right knee, and past the fractures in the central parts of the body and at the top of the thighs. Modigliani took no part in what used to be called, wrongly, the Cubist shattering of form. All destructiveness—even where, as in the work of the Cubists, it had a manifestly constructive pictorial function—was profoundly alien to him. The *Caryatid* makes it clear that his intention, despite his almost geometrical reduction of the individual parts, was constructive, even architectural.

It should be said that by 1910 or 1911, when the *Caryatid* was painted, the decomposition (or 'shattering') of objects for the sake of new formal structures was no longer part of the Cubists' programme; their eye was already much more on the autonomous rhythm of the pictorial components, in which the objective motif ended by being almost entirely absorbed. In this sense, Modigliani's approach was not only distanced from theirs but retarded—closer, in fact, to the early Cubism of 1908 than to that of the period around 1910 or 1911. This 'retardation' is a plain fact to anyone aware of the historical dynamics involved, but it has no bearing on any assessment of artistic stature. No artist is under any obligation to keep up with history.

Was Modigliani simply a moderate, a measured Modernist? That is one way to put it, certainly, especially as the whole idea of measure is undoubtedly central to his whole work —remarkably so for an artist whose life showed such an appalling lack of it. Cézanne's historic exhortation to repro-

14

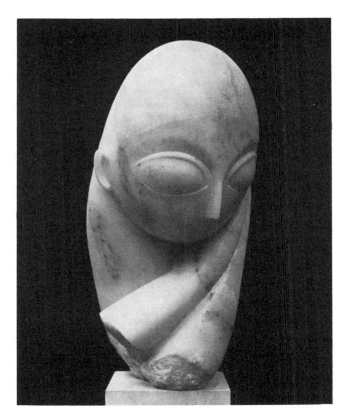

Fig. 4 Constantin Brancusi, *Mademoiselle Pogany*, 1913, marble.
Musée National d'Art Moderne, Centre Georges Pompidou, Paris

duce Nature in accordance with its formal content of 'spheres, cones and cylinders' reached Modigliani around 1908, although he did not draw from it the same logical conclusions as did the Cubists. The Cézanne retrospective at the 1908 Salon des Indépendants came as a revelation to him, as it did to many contemporary artists. His *Caryatid* can hardly be called Cézannesque, but its form is clearly dictated by the 'spheres, cones and cylinders' posited by Cézanne.

This strictly formal, 'architectonic' concern is connected with Modigliani's lifelong desire to give his paintings a tight skin of paint and with it the qualities of solidity, stability and durability. *Caryatid* exemplifies this. It may be regarded as an essential characteristic of his painting that he set out to convey, through composition and through the paint itself, an impression of something constant and enduring, beyond personal 'temperament', beyond any individual need for self-expression, and also beyond the aesthetic precepts of the moment. Beauty, harmony, proportion, euphony are constant features of his art, features that we associate with the idea of the classical.

This deep-seated preoccupation enabled Modigliani to absorb the powerful influence of Cézanne while at the same time distancing himself from any further evolutionary moves, whether made by Picasso or by Matisse. He stood aloof from all kinds of radical innovation, such as defined the image of new art in his day. And yet his art, for all its ties with artistic traditions, and especially with those of his native Italy, was not backward-looking; in its own time it was

entirely 'modern', even though some were already reproaching him for not being progressive enough. Modigliani's art contained no trace of his training in the Italian academies. But it also stayed free of contemporary artistic trends; and this was both its strength and its weakness. It was its strength, as an entirely individual and autonomous art; and its weakness, as an art that opened up no new territory.

One influence that was present, and powerfully so for a time, was that of Brancusi, who was his neighbour in the Cité Falguière just after he moved from Montmartre to Montparnasse in 1908–09. In artistic terms this move represented a decisive break with the past: it was now that he embarked on his 'own' path as an artist, and at the beginning of that path stood not only Cézanne but Brancusi. Modigliani and Brancusi were both engaged in finding an artistic language of their own, and each probably had something to give to the other; but the Romanian sculptor, who was eight years older and had come to Paris two years earlier, was probably more important to Modigliani than Modigliani was to him.

It is noteworthy that, in spite of Modigliani's innate classicizing tendency, it was not Aristide Maillol who influenced him—as he influenced the young German sculptor Wilhelm Lehmbruck, also in Paris at that time, who needed Maillol as a way to free himself from Rodin. Modigliani's contact with the more radical innovator Brancusi meant that he had no need to take the detour by way of Maillol.

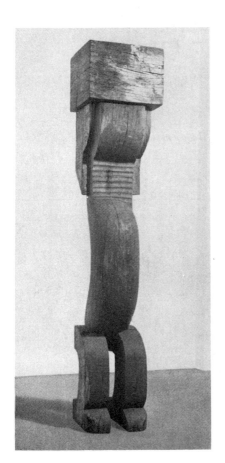

Fig. 5 Constantin Brancusi,
Caryatid, 1915, wood.
Musée National d'Art Moderne,
Centre Georges Pompidou, Paris

Brancusi and Modigliani remained very close for a while. Modigliani made just one portrait of his older friend—not a very convincing one—on the back of one of the two versions of his *Cellist*. Later, when Modigliani gave up sculpture, he and Brancusi became estranged.

In 1909 Brancusi made the prone marble head to which he gave the title *Sleeping Muse* (fig. 3). Its closeness to Modigliani's *Caryatid*, and to a number of his drawings on the same theme, is unmistakable, although, surprisingly, the volumetric articulation is more marked in the painter's work than in that of the sculptor. Brancusi's concern with volumetric detail seems much greater three years later, in *Mademoiselle Pogany* (fig. 4). Thereafter, his interest turned in the direction of absolute form, which became his ideal world. Modigliani was too involved with the human image to be capable of following Brancusi along this more 'Modernist' path. This is evident from a comparison of any sculpture of a head by Modigliani with any by Brancusi, even though these hieratic idols mark the extreme of formal absoluteness in Modigliani's oeuvre. In 1915 Brancusi carved a wooden *Caryatid* of his own (fig. 5). This audacious work goes far beyond Modigliani; surprisingly, its proportions are rather African-looking, far more so than is ever the case in Modigliani, and to a degree that by 1915 was decidedly out of fashion.

The two artists inevitably parted company; indeed, as *Sleeping Muse* shows, they had been on different paths from the very first. Modigliani's art was frankly anthropocentric. The human form was its content and its measure, so exclusively so that in the whole of his output there are just four landscapes and not one single still life—let alone a 'narrative' image or, at the opposite extreme, a gesture towards non-figurative, non-objective, 'absolute' art: the art, represented by Brancusi, to which the immediate future belonged.

Whenever one considers these early Paris years of Modigliani's, the name of Picasso spontaneously comes to mind, not only because he was the central avant-garde figure at that time but because he embodied, as no one else did, the 'Cézanne tradition', while simultaneously taking the decisive steps that led beyond Cézanne. Picasso was central to Modigliani's field of view, even though the latter felt closer, personally, to other artists in his circle. It was clear that Picasso set the standard, both through his commanding stature and through his incomparably innovative action and thought.

In 1907, the year after Modigliani's arrival in Paris, Picasso painted *Les Demoiselles d'Avignon* (fig. 6), the key work in early twentieth-century art. It may be assumed that Modigliani saw it in Picasso's studio, which was close to his own. In the centre of this massive painting stands a woman with her arms linked above her head. She may not be a caryatid, but the figure—especially in Picasso's numerous sketches for the painting—definitely bears comparison with Modigliani's work on the caryatid theme. For Picasso, too, this is a purely formal theme, in which the principle of discontinuity, drastically reduced to a few lines, is even more decisively

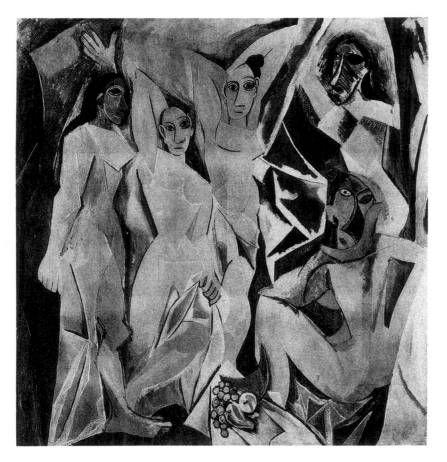

Fig. 6 Pablo Picasso, *Les Demoiselles d'Avignon*, 1907, oil on canvas. The Museum of Modern Art, New York

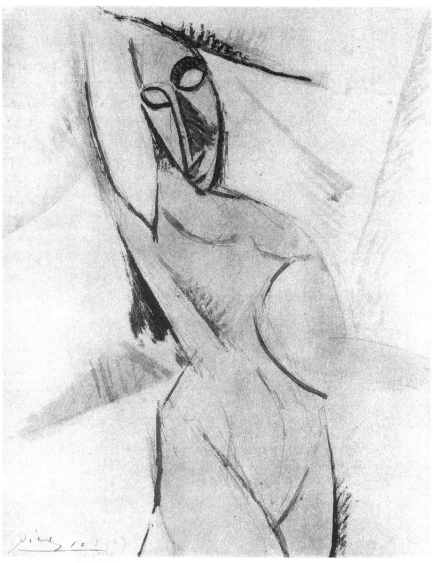

Fig. 7　Pablo Picasso, *Standing Nude*, 1907, watercolour

Fig. 8　*Caryatid*, 1911-14, Graphite pencil, black ink and pale red crayon

applied than it is by Modigliani: the triangle of the torso, the splayed thighs, the rectangle of the folded arms. In the final painting, admittedly, Picasso goes beyond the formal into the expressive. We need not assume that Modigliani saw Picasso's sketches, but the affinity is obvious; and it is anything but accidental, because this way of structuring the human body reveals the destined course of art after 1900: away from organic unity and towards an opposite, near-geometric, non-organic approach to form.

In almost every one of his studies, however hasty, Picasso shows himself to be the more dynamic and expressive artist; Modigliani always remains not only static but often purely decorative. Many of his caryatid drawings foreshadow what later became known as 'Art Deco'. Only rarely does one of Modigliani's drawings betray the 'expressive' influence of Picasso. If one of these works is compared with a Picasso watercolour study dated 1907 (figs. 7, 8), the affinities are as obvious as the differences. The cast of the facial features is surprisingly similar in both artists; but the body in Modigliani, by contrast with that of Picasso, reposes in the harmony

of its curves. Picasso's dynamism, his forward impulse, his crossing of boundaries, is entirely foreign to Modigliani. His ideal of beauty is wholly different, which one might be tempted to ascribe to his Italian origins were it not for the fact that around 1910 Italian art was represented by the Futurists.

The theme of the caryatid has a dignified tradition of its own. In the history of European art and architecture it has close ties with the idea of Classicism, especially as it takes its exemplary form in the caryatid portico of the Erechtheum on the Acropolis in Athens. But the origins of the motif are far older; and to Modigliani, for all his classical bent, the home of the caryatid was in Archaic and—closer to his own heart —in Etruscan art.

The art of other ancient cultures was also important to him, notably that of Africa, which from the mid 1900s onwards became the focus of the aesthetic debate and which, in artistic and intellectual circles, very soon became a dominant fashion. In African art the caryatid theme appears especially in the supporting figures of the stools made by the Luba (fig. 9), in

present-day Zaïre, and also in Cameroon, Nigeria and elsewhere, although less often in the former French colonies, which were the sources most readily accessible to Paris.

Black African art had been 'discovered' a few years before Modigliani's arrival by a number of artists whom he was to know well, including Picasso, Matisse, André Derain and Maurice de Vlaminck, all of whom became passionate collectors. Others who became his friends, including the sculptors Jacques Lipchitz and Jacob Epstein, were collectors of African art, as was the painter Frank Burty Haviland of whom Modigliani painted two portraits (pl. 21). And finally there was Paul Guillaume, the subject of several portraits (pls. 36, 37) and Modigliani's occasional dealer from 1914 onwards, who dealt not only in the work of the leading younger artists but also, with great enthusiasm, in African sculpture.

We know from Lipchitz that Modigliani was a great admirer of the art of Africa and Oceania, but there can be no question of it having had a very strong influence on his work. The direct influence of 'primitive' art on the Parisian artists of those years has in any case tended to be overestimated. They were very deeply impressed, but the impact on their own work remained generalized. Those who were first captivated by this art, the Fauves, reveal next to no influence in their own work. For clear symptoms of a personal confrontation with African art, we must turn to Picasso.

Aside from what was spoken of, in highly general terms, as its 'primitive' quality, African art was perceived (although this was never made explicit) in terms of the principle of separation of volumes, together with the vitality inherent in the material, which was wood: an anti-organic formal principle on one hand, and the organic natural power of the material on the other. The interaction of these two opposing forces generated the extraordinary formal and expressive intensity that was so admired in African sculpture.

Paul Gauguin had failed to perceive this, as can be seen from his own ostensibly 'primitive' woodcarvings; these works, in which he attempted to come closer to the formal ideas of the peoples of Oceania, are strange hybrids of European, Indian and Oceanic elements. Gauguin's horizon, in keeping with the artistic sensibilities of his generation, was bounded by the ancient cultures of Egypt and India. In his paintings he never disrupted the organic unity of the human body. This was done only in the generation that followed him, and it was only in that generation that any real encounter between European art and the art of (mainly) Black Africa, but also East Africa, could take place.

Here, too, Modigliani kept his distance. A comparison immediately shows just how un-African even his caryatid studies are. His figures have none of the vitality, and none of the expressiveness, of the African stool-supporters. Their spirit is a completely different one, as is their wholly un-

Fig. 9 Stool from Zaïre (Luba/Hemba). Museum für Völkerkunde, Frankfurt/Main

Fig. 10 Ernst Ludwig Kirchner, *Fruit Bowl*, 1912, carving. Kirchner-Haus, Davos

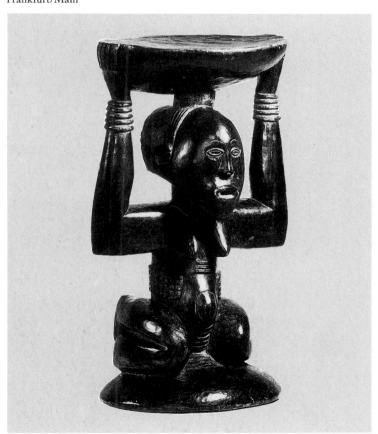

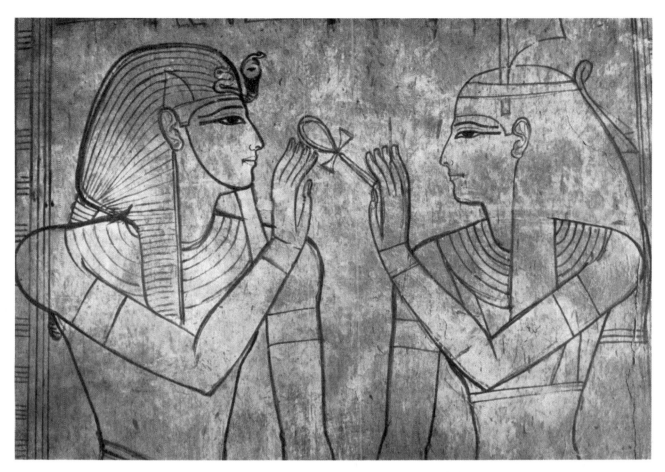

Fig. 11 Sethos I. before Maat, *c*. 1300 BC.
tomb of Sethos I., Thebes, Valley of Kings

Fig. 12 *Female Head in Profile*, 1910/11, charcoal.
The Museum of Modern Art, New York,
The Loan and Lester Avnet Collection

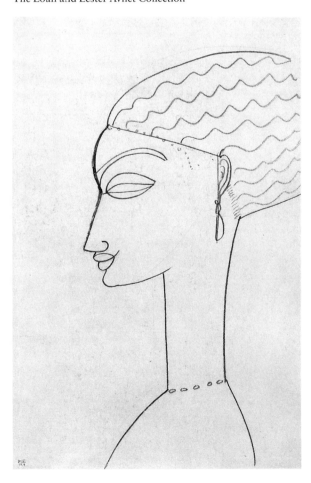

African air of proportion and elegance. Just how much more directly it was possible for an artist of Modigliani's generation to respond to these works is shown by a wooden caryatid figure carved by Ernst Ludwig Kirchner (fig. 10)—even though Kirchner's deliberately crude treatment of his material is based on a misconception of the nature of 'primitive' art, which it seems to attempt to outdo in primitiveness.

Modigliani was more strongly influenced by other artistic worlds: Egypt, India, Archaic Greece, the Etruscans. Here, too, however, direct influences are found only very occasionally, even though these worlds had already been important to some of the artists of the preceding generation, and to Gauguin in particular. Here and there, even so, there is an allusion to Egypt (figs. 11, 12). The Russian poet Anna Akhmatova tells us that Modigliani often used to take her to the Egyptian department of the Louvre; according to her, he dreamed of Egypt and 'all the rest could be disregarded'. Several of his stone idols have the 'Archaic Smile' (fig. 13, pl. 94), found not only in early Greece (fig. 14) but in India and even in the Gothic art of mediaeval Europe. Modigliani was well aware of all this, and the affinities are conscious. He also certainly found stimulus in Cycladic and Cretan art.

All this particularly applies to the stone heads that form the major proportion of his surviving sculpture. It seems that Modigliani visualized these idol-like heads, seven of which he showed at the 1912 Salon d'Automne, as a large 'decora-

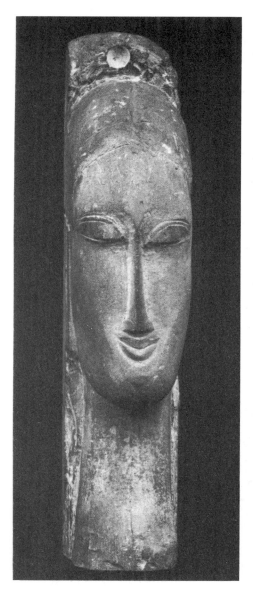

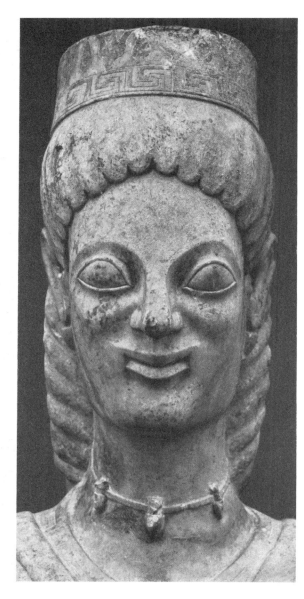

Fig. 13 *Head*, 1911/12 (pl. 94)

Fig. 14 *Head of a Standing Goddess*,
attic, *c.* 580 BC. Antiken-Sammlung, Staatliche
Museen Preussischer Kulturbesitz, Berlin

tive ensemble'. Similarly, as Paul Guillaume and Ossip Zad-
kine both tell us, he seems to have imagined his caryatids as
colonnes de tendresse: pillars in a temple of beauty. Such
quasi-religious ideas are in keeping with the hieratic auster-
ity of the heads, their abandonment of naturalism, and the
remoteness of their expressions. In these works Modigliani,
surely under the influence of Brancusi, carried the ideal of
formal purity far beyond all the abstractness and 'purism' of
his paintings. Here, far more radically than in his paintings,
he was an artist of the twentieth century—not that that
meant anything to him.

His *Heads* are 'formal' to an extreme degree, without
thereby losing their enigmatic character. The most radically
formalized is the splendid *Head* from the Niarchos collection
(pl. 98), with its exaggerated verticality, the utterly dispro-
portionate nose that juts so sharply from the swelling form
of its face, its long chin, and its vestigial forehead. To vary-
ing degrees, most of the *Heads* show the same characteris-
tics. Not only are they strictly frontal in design, but they are
almost invariably left rough on the back, and this in itself
may indicate that the artist did not really think in three-

dimensional terms and was therefore not wholly a sculptor.
In the course of the few years he spent as a sculptor, Modig-
liani's style underwent a transformation. His one and only
Standing Figure—also conceived as a caryatid, faintly re-
miniscent of Cycladic idols (figs. 15, 16) —is still styl-
istically close to the purely formal studies; by contrast, the
figure of a *Kneeling Caryatid* is much more strongly spatial
and voluminous (pl. 100). In this it differs markedly from the
Caryatid in the earlier oil sketch (pl. 2), despite the related
pose. Its individual forms no longer have the same decisive-
ness; all is softer, more rounded, more mobile. The woman's
body detectably bends under the weight of the superincum-
bent slab, though there is no sign of muscular exertion.
These comparatively organic properties make the figure far
removed from the Cubist vision, which still shows its influ-
ence in the oil sketch. On the other hand, the principle of the
discreteness and autonomy of the individual masses is com-
pletely maintained.

This sculpture is accompanied by numerous related studies,
which are also less formalized and less static than their pre-
decessors: more lively, mobile, dynamic (fig. 17). Slender-

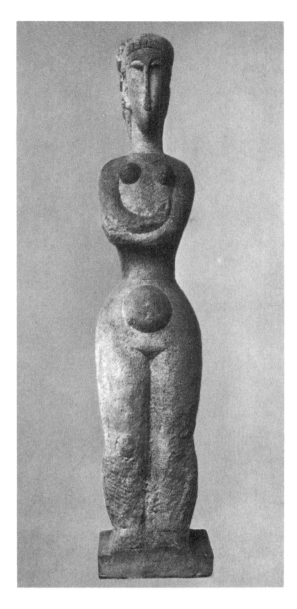

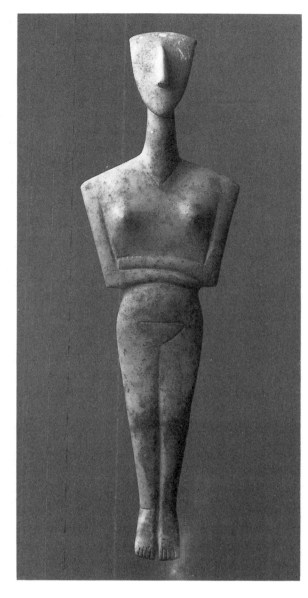

Fig. 15 *Standing Figure*,
c. 1912/13, limestone. Australian
National Gallery, Canberra

Fig. 16 Idol, Greece,
2700-2400 BC, marble.
Cyclades, Naxos,
The Menil Collection, Houston

ness has given way to ampler forms. Everything now seems more organic; but the increased dynamism is based not so much on a natural deployment of forces as on a vigorous jockeying for position on the part of the individual body parts. Sometimes this takes place at the expense of anatomy, in that individual parts are disproportionately emphasized. It is also noticeable how inorganically the oval or round form of the head rests on the shoulders.

The bodies in the earlier studies are so decoratively articulated that they seem to fit effortlessly into the rectangle of the paper, but in the later works the bodies seem not only to fill the picture area to the very edges but to be on the point of bursting out of it. The drooping heads, pressed down by their burden, still recall Brancusi, but even these are now much more freely handled, with less concern for volume in detail and much more solidity of effect overall. This applies even more strongly to the head of the *Kneeling Caryatid* sculpture, which presents itself as an almost amorphous mass (pl. 100). All this is in keeping with the way in which the finely articulated line of the early studies is replaced by a freer, more painterly idiom in the later ones. The choice of

technique is also symptomatic: initially more pencil, later more pastel, watercolour and gouache.

In the context of the sculpture of his time, Modigliani, with his tiny oeuvre, stands very much alone, despite his close link with Brancusi. There is nothing in contemporary sculpture remotely like, for instance, his hieratic *Heads*. Some have wondered whether he ever met Lehmbruck, who was in Paris from 1910 to 1914, the very period in which Modigliani was active as a sculptor. It is entirely likely that the two did meet, in Brancusi's studio or elsewhere, but no record of such a meeting exists. The fact is, however, that the answer to the question would be of no more than biographical interest unless it were to have some artistic relevance; and artistically there is no connection between Modigliani and Lehmbruck. The fact that Lehmbruck's female figures and busts, too, have a certain elegiac air—which would in any case link them rather with Modigliani's later paintings than with his sculptures—is no evidence of a connection.

Lehmbruck was virtually unaffected by anything that was going on in Paris at that time. What mattered to him was an

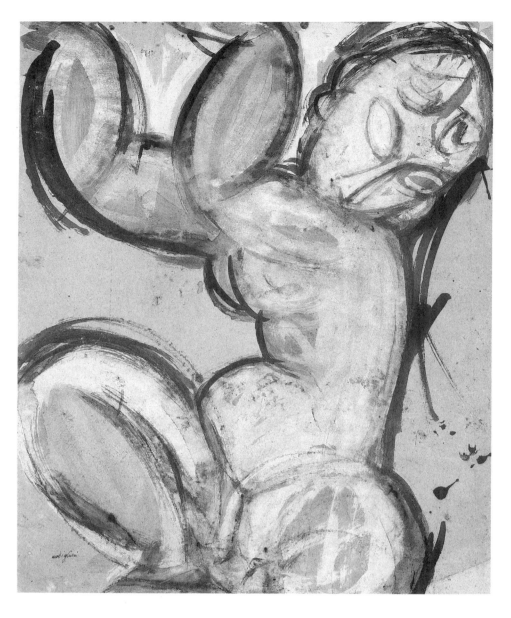

Fig. 17 *Caryatid*, *c*. 1913/14, watercolour

Fig. 18 *Head of a Woman*, *c*. 1914,
red chalk and charcoal. Öffentliche Kunstsammlung,
Kupferstichkabinett, Basle

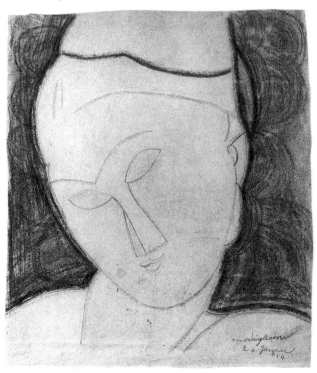

'earlier' situation. To free himself from Rodin he had first to work through his encounter with Maillol; not with Cubism, and least of all with Brancusi. This preoccupation is certainly not to be explained by the fact that Lehmbruck was three years older than Modigliani; he was, after all, exactly the same age as Picasso. The fact is that the central ideas of the period around 1910—those of anti-organic form, of the separation of volumes, and of disassembly and even demolition of the human body—were not Lehmbruck's ideas. Nor did he, as a 'Gothic' German, have anything to learn from African sculpture. Lehmbruck's modernity was a mental, not a formal thing, as the *Fallen Man* of 1915, usually praised as an example of formal audacity, illustrates in every detail.

If Lehmbruck's *Kneeling Woman* of 1911 (fig. 19) is compared with Modigliani's *Standing Figure* (fig. 15), the gulf that separates them becomes apparent: in the Lehmbruck an organic, melodic flow runs through all the forms, with an unmistakable note of 'sentiment'; in the Modigliani there is strict frontality and axiality, firm separation of all the parts, and a total elimination of 'feeling'. The creasing visible in the

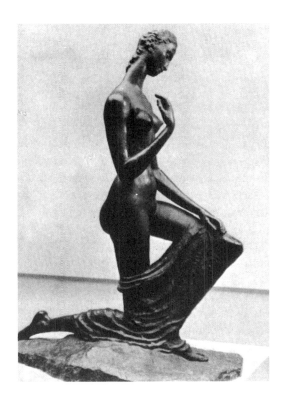

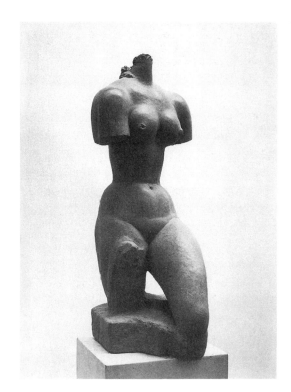

Fig. 19 Wilhelm Lehmbruck,
Kneeling Woman, 1911, Bronze. Wilhelm
Lehmbruck-Museum, Duisburg

Fig. 20 Wilhelm Lehmbruck,
Female Torso, 1913/14, Beton.
Kunstmuseum, Berne

Lehmbruck *Kneeling Woman*, or the naturalism of the hands and feet, liberated from all formal constraint, would be entirely inconceivable in Modigliani. In his standing caryatid, the central vertical axis goes from the steep slope of the nose straight down to the fork; in the Lehmbruck figure, everything follows the relaxed energies of the body. Cretan idols are closer to Modigliani than is Lehmbruck's 'Gothic' naturalism. Lehmbruck came closest to Modigliani's formal thinking in such a work as *Female Torso* (1913–14, fig. 20), with the sharp central fracture that interrupts the romantic flow.

Fig. 21 Wilhelm Lehmbruck, *Head of a Woman* (detail), 1911,
Sienna pencil

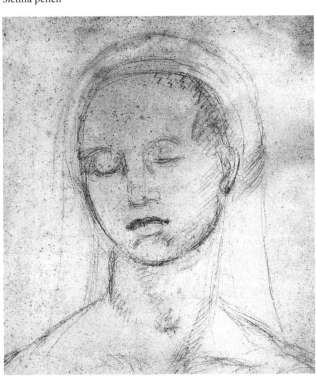

The contrast is particularly evident in the two artists' drawings, whether studies of the nude or of heads. Lehmbruck's lines flow and often model the contours; Modigliani's lines —in the early drawings—are precise outlines without any body-building function (figs. 18, 21). There is no point of contact even in the increasingly modelled forms of Modigliani's somewhat later drawings for sculpture.

In any review of sculpture between 1910 and 1920 Modigliani has a secure place, small though his contribution was in terms of quantity. Without any doubt, he owes this position to the sacred *Heads*. In these, above all, as in the drawings, he tackled sculptural issues analogous to those faced by the other major sculptors of his time, while standing aloof from the experimental aspects of their work. In terms of formal innovation, he lagged far behind Brancusi, Lipchitz, Laurens and Archipenko, just because he clung, as if bound by fate, to the human image.

How his sculpture might have evolved after mid-decade, in parallel to the change in his painting, is impossible to say. It presumably would have become, like the painting, more organic and 'melodious'. Not only Modigliani's art but art in general was in the process of recognizing the importance of the organic whole; the paradigm of this shift was Picasso's reversion to the example of J.A.D. Ingres. The human form once more became 'the measure of all things', and this was what Modigliani wanted; but it was a desire that he could no longer pursue as a sculptor. Just as he had more or less given up painting to concentrate on sculpture, when he turned back to painting in 1914 he gave up sculpture for good—or, as Zadkine put it, 'Gradually, the sculptor in him died.'

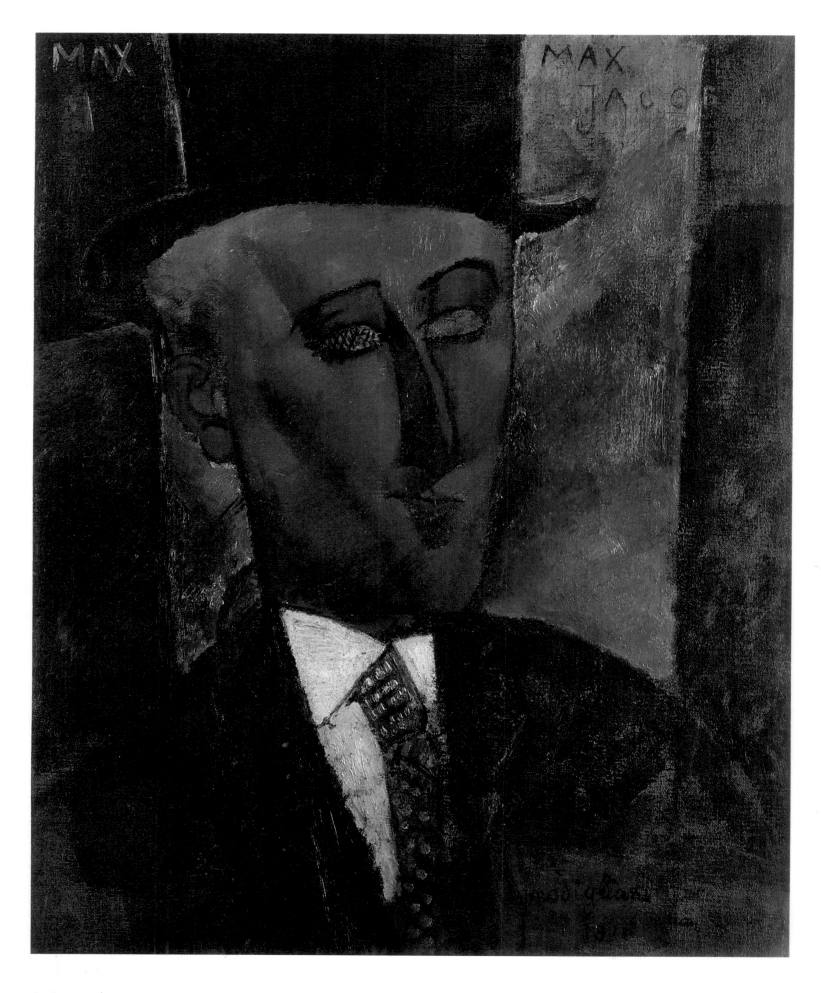

4 Portrait of Max Jacob *1916*

The Portraits

More than anything else, Modigliani was a portrait painter. His portraits exceed in number not only his few sculptures and associated works but also the nudes with which, for many people, his art was to become identified. Nor is the pre-eminence of the portraits only a quantitative one; these are the works with which the artist has earned his place in the history of art.

Almost all the significant encounters of his brief and restless life—and many casual encounters besides—led to portraits, either painted or drawn, and very often dashed off at a café table. Most are of painters, sculptors, poets, writers, art collectors, art dealers; then there are women friends from the same milieu and, towards the end of his life, also simple, ordinary people.

In his portraits, without ever setting out to be so, he was a chronicler of the *vie bohème* of Montparnasse, the district where in his time the artistic life of the French capital was being transformed. He painted so many people from this world that one is almost impelled to ask whom he did not paint. His sitters included many of the foreign artists who so strongly affected the new art in Paris. One whom he never did portray was, remarkably enough, Marc Chagall, with whom he seems to have had an uneasy personal relationship.

Modigliani was part of this *bohème* in a highly personal and indeed an exemplary way. In the eyes of his contemporaries he was—as he has remained—its epitome, though more for his lifestyle than for his art, which betrays none of the instability that characterized his life. His art was never particularly 'modern': its firm base in tradition was always detectable. Even if others were much more innovative, he was incontestably one of the 'new' artists, and thus a member of the very group that he portrayed with such tireless zeal.

It must have been, for Modigliani, an entirely basic need, something like a primary instinct, to take possession of those around him by painting and drawing them, irrespective of their degree of closeness to himself. Not that he had any desire to probe the inner depths of anyone's being. What motivated him was the impulse, rooted in his own nature as an artist, to give human beings new form by transposing them into the pictorial dimension. It may well be asked, indeed, whether his interest in the sitter was not diminished, at least in the early years, by his interest in the picture. The physiognomy was always only one aspect; the other aspect was that of form, colour, painting as such. Several witnesses testify to his profound insight into the people he painted. And yet in most of these works it is dubious, or at least debatable, whether he manifests any concern for the sitter at all. The fact that his portraits emphasize people's distinctive features does not at all imply that he set out to penetrate their characters. His primary interest was in the individual's physiognomy and deportment, and he wanted each portrait to be a stable, tight, autonomously valid image.

As an example we may take one of his finest portraits, that of the poet Max Jacob, who was a close friend. Modigliani painted Jacob twice, first in a top hat, then bald-pated (pl. 4, fig. 22). More importantly, the first portrait is more pictorial, more formally striking, and conveys a more youthful impression overall; the second is more contemplative, frailer, and less emphatically pictorial. The portrait that concerns us here is the one with the top hat, probably painted, like the other, in 1916, at a time when Modigliani's sculptural career already lay a year or two in the past.

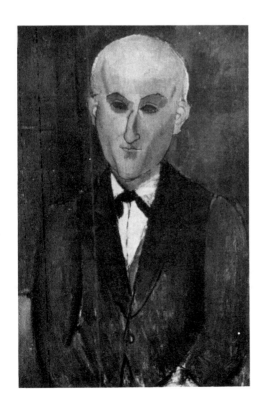

Fig. 22
Portrait of Max Jacob,
1916, oil on canvas.
Cincinnati Art Museum

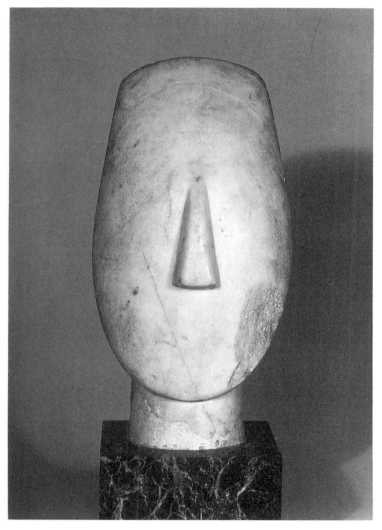

Fig. 23 Head of an Idol, *c.* 2600 BC, marble, found on Amorgos.
Musée du Louvre, Paris

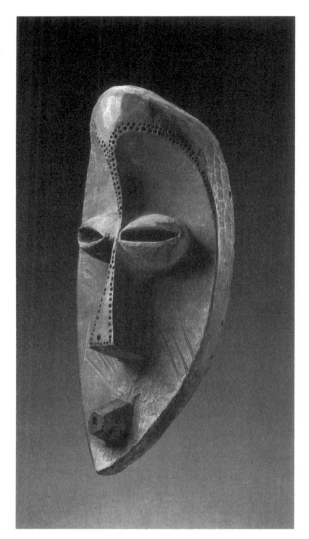

Fig. 24 African mask (Mahongwe), People's
Republic of the Congo

A certain sculptural spirit marks this extraordinary painting. This is most markedly apparent in one detail that here—as often with Modigliani—is given great formal importance: the nose, which looks as if hewn from a plank with an axe. Partly for this conspicuous reason, the work can be classed among the few by this artist in which the influence of African sculpture is a direct and conscious one (fig. 24), although it is also possible to think of works from other cultures—Cycladic figures for instance—in which the nose may well be the only sculptural indication of the face (fig. 23). In any art with a primary interest in unequivocal spatial forms (a definition that would include the art of Brancusi), the nose tends to be endowed with an importance that goes beyond its purely expressive value as compared with the eyes or the mouth. Eyes and mouth are expressive focuses; the nose is essentially a three-dimensional form, and it tends to come into its own in a primarily formal artistic idiom, both as a vertical axis and as a volumetric accent. This is clearly shown by his stone heads, and by the related drawings, because these involve no 'compromise' between form his and likeness.

Here, too, the source is Picasso. The heads in his proto-Cubist works, around 1908, have their structure essentially

defined by the powerfully emphasized three-dimensionality of the nose. We can assume that Modigliani derived essential impulses from this, even though by 1916, when Modigliani was painting his portraits of Jacob, Picasso had long since passed on to other things: he had left Cubism behind him —not only in its early but also in its mature, no longer cubic form—and was on his way to a quite different art.

Another detail that Modigliani may possibly owe to Picasso is the treatment of the eyes: their pupil-less 'blindness' and their asymmetry. In the Max Jacob portrait one eye has been painted shut, while the other is cross-hatched over in green. Many other paintings show the eyes simply as dark areas. Clearly, the artist was seeking to avoid the outward-directed gaze of his interlocutor, and with it all that the eyes can reveal of the essence of a human being. That essence does not seem to have been his concern. This was also a highly effective way of making the painting look inturned, concentrated on itself. In the absence of eye contact, the viewer relates to the painting as such rather than to the person depicted.

This idea, which is so important in Modigliani's early work, must have been familiar to him from its use by Picasso,

26

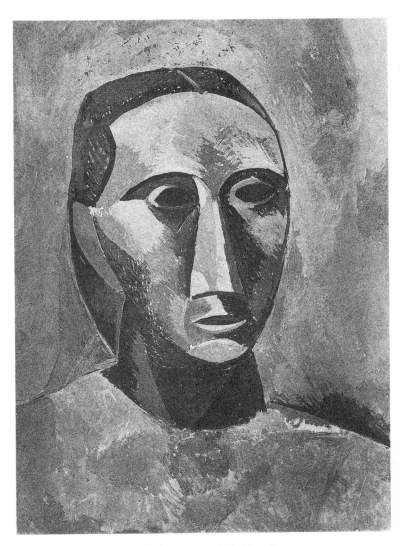

Fig. 25 Pablo Picasso, *Head of a Woman*, 1908, Gouache

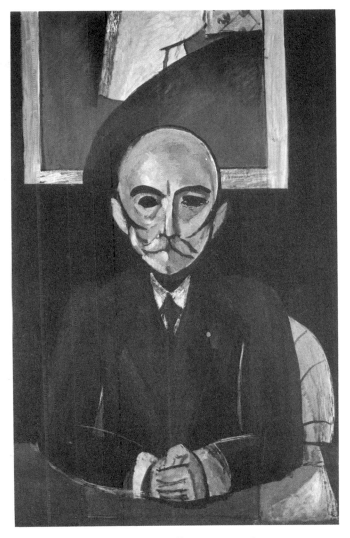

Fig. 26 Henri Matisse, *Auguste Pellerin II*, 1916, oil on canvas.
Musée National d'Art Moderne, Centre Georges Pompidou, Paris

who—again in the period around 1908—frequently (if not quite so consistently as Modigliani) painted the eyes of his subjects 'blind'. The outstanding example in Picasso is the woman in the right-hand background of *Les Demoiselles d'Avignon* (see fig. 6); and in a succession of later works blank eyes serve as an alienation device to enhance the autonomy of the painting (fig. 25). They carry with them a message of depersonalization, which in Modigliani's work then comes into conflict with the individual identity of the portrait.

Modigliani was well aware, of course, that the motif of eyes 'painted shut' also occurs many times in Cézanne. Modigliani's friend Chaim Soutine reports him as having made the following rather obscure statement: 'Cézanne's faces, like the beautiful statues of antiquity, have no gaze. Mine, on the other hand, do gaze. They gaze, even where I have decided not to paint any pupils; but, like the faces of Cézanne, they express nothing but a mute concord with life.' This notion of a 'sightless gaze' may indeed apply to some of Modigliani's portraits, but as a rule his sightless eyes do not 'gaze' at all; this is exemplified by the portrait of Max Jacob, and even by the pencil study for it (fig. 29).

Cézanne's influence in this respect affected not only Picasso and Modigliani but also Matisse, in whose work the same motif appears in such outstanding works as the portraits of his wife (1912), of Yvonne Landsberg (1914) and of Auguste Pellerin (1916, fig. 26). Deep black eyes can be found in many of Ernst Ludwig Kirchner's Dresden and early Berlin paintings. In Italy, Carlo Carrà used similar devices, as for instance in *Composition with Female Figure* of 1915, in which the eyes are treated asymmetrically (fig. 27), or in *The Drunken Gentleman* (1916), whose eye is painted without a pupil (fig. 28).

It was Modigliani who used the device most consistently, and in many of his drawings he simply left the eyes blank. It was one way among many to give the image its due measure of autonomy. For portraiture, which nevertheless remained his lifelong obsession, was a genre that in his lifetime had fallen into a profound and inescapable crisis.

The fact that the artists of Modigliani's generation were more interested in the picture than in the thing depicted was bound to affect the individual portrait most strongly of all. The notion of pictorial autonomy was simply not applicable

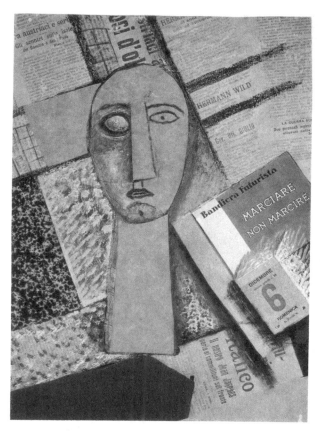

Fig. 27 Carlo Carrà, *Composition with Female Figure*, 1915, Tempera and collage. Pushkin Museum, Moscow

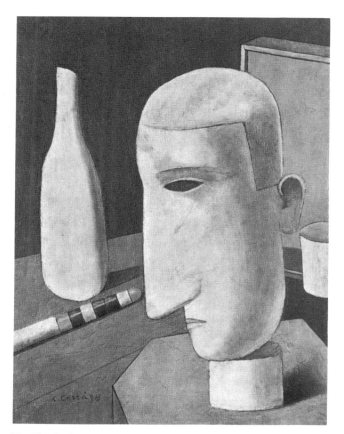

Fig. 28 Carlo Carrà, *The Drunken Gentleman*, 1916, oil on canvas. Collection Frua de Angeli, Milan

to the portrait. And the fact that this newly anachronistic genre was precisely the one that remained central to Modigliani is the strongest sign of the backward-looking nature of his modernity. His response to the dichotomy between painting and portrait-painting was to sacrifice a part of what makes human beings into individuals: the eyes, the gaze. It is only in the works of his later years—a term that serves to remind us how very brief his creative life was—that we more often find the subject looking back at us. This is in keeping with the increasing naturalism of his portraits, though it by no means always works to their advantage.

Eyes and nose are certainly not the only elements that give character to such a work as the portrait of Max Jacob. Formally, its character stems from the decided cast of the face, its sharp triangular shape, beneath the top hat whose black rectangle is cut short by the upper edge of the painting. It stems, also, from the restrained but dense and warm coloration, from whose near-monochrome darkness there emerges a white flash of shirt and collar. The sombre overall harmony reflects the influence of Cubism, although no painting by Picasso or by Braque incorporates so saturated a brown. Cubism is intuitively, not demonstratively, present. If we simplify the movements of the day into excessively linear terms, this work belongs to the 'Cézannesque' strain of Cubism and not to the Fauve strain, with its dynamic use of colour.

Ultimately, it is the sitter himself who gives the painting its individuality: the poet, stylized as a wit, as a Jew and as an

intellectual dandy, with his wry smile and the jaunty set of his hat. It seems that Modigliani—at least when working on the pencil study (fig. 29)—closely followed a photograph that shows the poet in the same pose. In the drawing he is already transposing the photographic original into pictorial terms. And yet it is impossible to speak of reduction to a

Fig. 29 *Portrait of Max Jacob*, 1916, pencil

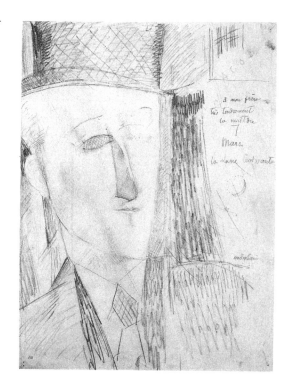

28

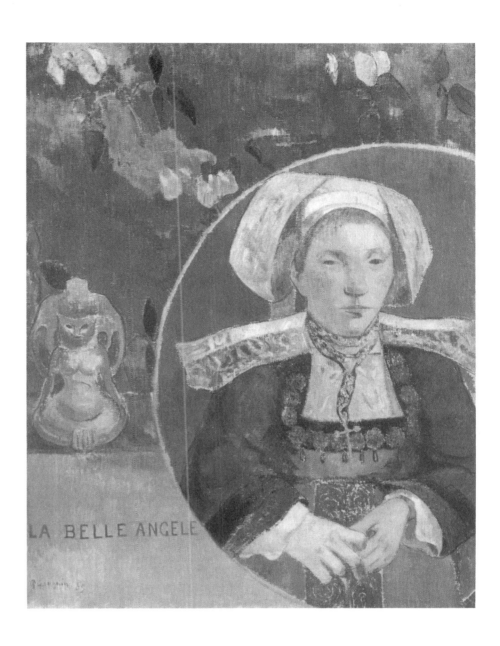

Fig. 30 Paul Gauguin, *La belle Angèle*, 1889,
oil on canvas. Musée d'Orsay, Paris

type; nor do the added emphases simply serve a formal purpose. This is a true portrait, the depiction of an entirely individual person, even though it is stylized, which in this case means reduced to a certain characteristic manner and 'translated' into a highly pronounced pictorial style. For all its artistic distinctiveness —for all its Modigliani quality—the individuality of the painting rests to a great degree on the individuality of the person portrayed.

Here, as in many of his other paintings, Modigliani has set down the sitter's name in capital letters alongside his likeness. It may be that this habit of inscribing paintings is another sign of Cubist influence, as it is in the work of such other contemporary artists as Robert Delaunay and Paul Klee. The incorporation of lettering as a stylistic device also appears in the work of some older artists, including Vincent van Gogh and, especially, Gauguin (fig. 30). In Modigliani it also has overtones of 'popular culture': it recalls the *imagerie populaire*, the woodcuts sold from fairground booths, or the broadsides sold by the street balladeers still common in his native Italy. There were also precedents in so-called 'high

culture': the inscriptions on ancient Egyptian and Mexican paintings and reliefs, those on Greek vase paintings, and much more besides.

Just so long as art was not naturalistic, so long as it remained oblivious of the perspectival illusion of space and continued to treat the picture plane as a plane, the addition of writing came perfectly naturally. It was only with the breakthrough to naturalism, from the early Renaissance onwards, that this habit largely disappeared, and what had once been natural now became unnatural. It was not until naturalism came to be 'transcended' and the picture plane was rediscovered, in the late nineteenth century, that it once more became possible to integrate script into the painting. And so the poster-like inscriptions on Modigliani's early paintings are a sign of his modernity. They are also a deliberately trite device.

As a rule, what he wrote on the painting was the sitter's name. Sometimes, however, he jotted down one or more words, related in meaning to the subject, as with the word *savoir*—'to know', 'knowing', 'knowledge'—that he put on

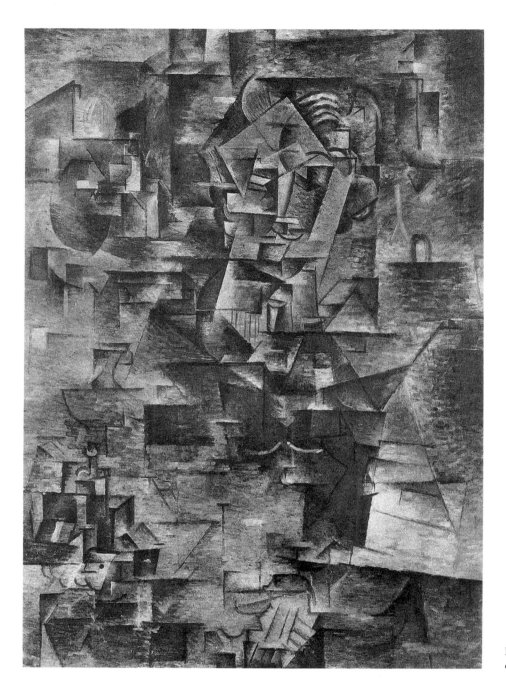

his portrait of Picasso (pl. 20). A number of drawings carry quotations from poems by Dante Alighieri, by Gabriele D'Annunzio, by the Comte de Lautréamont and others, or cryptic quatrains by Nostradamus, whom he seems to have studied. It is by no means unlikely that the impulse to inscribe his paintings came directly from the works of Gauguin. As the German painter Ludwig Meidner tells us, Modigliani saw the Gauguin exhibition at the Salon d'Automne in 1906, shortly after he arrived in Paris, and probably also the one held at the Galerie Ambroise Vollard in 1910. He is known to have had a high regard for Gauguin, though Cézanne remained supreme.

Modigliani's rapprochement with Cubism in 1915 and 1916, so superbly exemplified by the portrait of Max Jacob, took place with great reservations on Modigliani's part con-

cerning not only Cubist practice but above all the real or supposed theoretical implications. The affinity consists in this case, apart from the brownish, not-quite-Cubist coloration, in little more than the volumetric stylization of the face, which distantly recalls Cubism without ever developing into true Cubist faceting. None of the Cubists ever painted a portrait comparable with *Max Jacob*; and in any case, by 1915 or 1916 Cubism had long since taken a turn towards two-dimensionality and colour, thus achieving a high degree of abstraction. Ultimately, the very importance of portraiture to Modigliani illustrates his remoteness from Cubism.

The same remoteness existed in his personal relations with Picasso, for all the camaraderie that there was and despite the high regard he had for the Spaniard's art. It is significant that his portrait of Picasso (pl. 20) looks remarkably imper-

sonal, as if he had chosen not to go too far into the man's personality. There was, however, one close bond between the two painters, in that both counted Max Jacob among their closest friends. Modigliani's portrait of Gris is markedly more individual, and also artistically much more striking (pl. 32). Little is known of any contacts with Braque. Fernand Léger, with whom he had nothing in common artistically, nevertheless walked in his memorable funeral cortege across Paris in January 1920 and attended his burial at Père Lachaise cemetery.

The early portraits—those painted in 1915 and 1916, immediately after the sculpture period—are marked by a considerable degree of structuring applied to the human face. They are simplified and are endowed to a greater or lesser degree with articulation and rhythm, by the formal manipulations to which they are subjected. Often this formal process has taken place in the pencil studies that precede the paintings. Characteristic features are asymmetry and, as we have seen, an emphasis on the nose, whether linear or stereometric; closed or hatched-over eyes; and added lettering. The faces threaten to veer out of control, but the cause is never expressive, always formal, and never prevents the emergence of a characteristic and individual expression. This is exemplified by, among many others, the likenesses of Max Jacob, Paul Guillaume, Moïse Kisling, Juan Gris, Celso Lagar and the young Raymond Radiguet, Jean Cocteau's friend (pls. 4, 32, 36–40).

The outstanding female portrait is that of Modigliani's girlfriend Beatrice Hastings, with the inscription *Madam Pompadour* (pl. 30). This is one of Modigliani's most delightful works, one example (among many) of the extraordinary formal grace that is so enchanting a feature of the portraits of 1915 and 1916. The *Pierrot* (pl. 31), wrongly supposed to be a self-portrait, belongs to this group, as does the double portrait *Bride and Groom* (pl. 1) in the Museum of Modern Art, New York. Another portrait of Beatrice Hastings, now in the Barnes Foundation (pl. 28), reveals—very unusually for Modigliani—a markedly Cubist, or else Futurist, element in the shape of a pasted-on scrap of newspaper; this, however, is not enough to make Modigliani into a *collagiste*.

Modigliani's portraits were painted at a time when it was possible to suppose that the portrait was a genre without a future, and indeed without a present, because photography had taken over its function and because of the underlying and, as it must have seemed, irreversible march of art history. When Modigliani painted his *Max Jacob*, Picasso's portrait of Daniel-Henri Kahnweiler (fig. 31) lay half a decade in the past—a work in which the sitter appears radically fragmented to the brink of unrecognizability, so that the portrait as such is almost entirely deprived of its meaning.

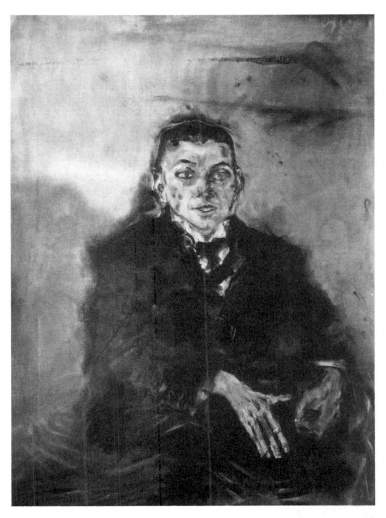

Fig. 32 Oskar Kokoschka, *Portrait of Karl Kraus*, c. 1908, oil on canvas

Picasso's 'destruction' of the portrait had taken place between 1906—the date of the 'intact' portrait of Gertrude Stein—and 1910. Modigliani had witnessed this process at very close quarters without ever letting it disturb his own conception of portraiture. In his deep-seated dislike of theoretical intentions and declarations—which was the reason why he was never able to do justice to Cubism—he kept his distance. Modigliani was never tempted to tamper with the physical and physiognomical integrity of the human individual. The look of that individual was the stimulus that prompted him to draw or to paint, though all his sitters had then to be brought into line with his own idiosyncratic pictorial concerns.

The portrait, of course, was not dead at all. In those years of the birth of Modernism, plenty of artists were painting portraits as before. But this happened largely at the periphery of the new developments. The portrait was one of the prime victims of the historical dynamic, because to a greater extent than other artistic genres it defines itself in terms of its conformity to external reality—to put it simply, in terms of individual likeness. Modigliani was one great exception. The other, far removed from him, was Oskar Kokoschka. In the work of these two polar opposites there are powerful tradi-

Fig. 33 *Head of a Woman with Hat*, *c.* 1907/08, watercolour

tional forces at work: Italian traditions in Modigliani, German traditions—as seen through Austrian eyes—in Kokoschka. Both were 'modern' artists who nevertheless stood aloof from the autonomy of form and colour that was the foundation of Modernism; and that was what enabled both to paint portraits, even at that time.

Whatever freedom Kokoschka may have allowed to the pictorial means 'liberated' by the Modernist age, in his work the primary task, to which all formal considerations must be subordinated, remained the artist's encounter with the theme. And that theme, over and over again, was the person. With greater intensity than Modigliani, Kokoschka set out to grasp the deeper essence of his sitter, to overcome all detachment, to force a way into him as if with a scalpel or, as it has often been said, with X-rays. In his paintings, very unlike those of Modigliani, the psychological interest outweighs the formal interest, even though it would be possible to say that every one of Kokoschka's portraits is also a self-portrait. Neither Cubism nor African art ever touched Kokoschka. True, his portraits invariably present us with an idiosyncratic, rhetorical, pictorial language; but they also confront us with the essence —the assumed inner self—of the person depicted.

Fig. 34 *Nude (Nudo dolente)*, *c.* 1908 (pl. 9)

Fig. 35 Franz von Stuck, *Salome*, 1906, oil on wood

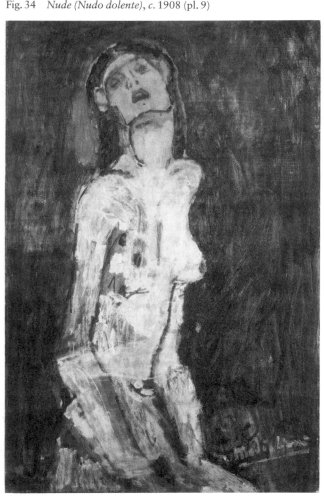

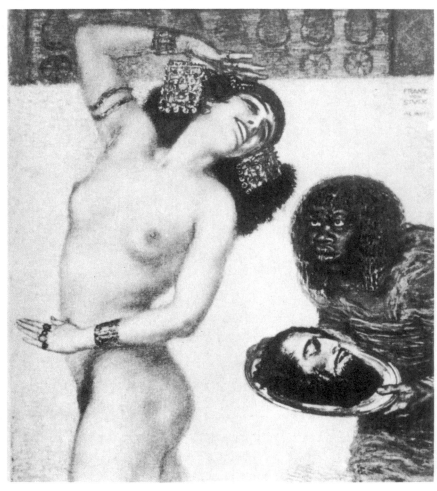

This sort of psychological interest does not arise in Modigliani. His portraits, too, show the individual in all his uniqueness, but they are never character studies of an analytical—a psychoanalytical—kind. What they present is always more physiognomy than psychology. It is possible, as it never is with Kokoschka, to ask whether Modigliani was deeply interested in his sitters at all. His commentators answer the question in the affirmative, but this is probably the result of conventional expectations, because the paintings themselves do very little to confirm it. How little he says about, say, his friend Max Jacob. How little about the essence of his mistress Beatrice Hastings. However skilfully he characterizes those whom he paints, how little he penetrates into them. The depiction always remains very much distanced, even where it reveals highly characteristic features, and even where, as in the portraits of Paul Guillaume, it strongly emphasizes them.

By contrast, how much we learn about Karl Kraus from Kokoschka's 1908 portrait of him (fig. 32): not only the facial features but right down to the nervous hands! One case in which Modigliani does show a comparable interest in the sitter is the powerful portrait of Diego Rivera (pl. 19), where his friend's sheer bulk and turbulent nature seem to burst the bounds of Modigliani's stylistic repertoire, or of such of it as was already in place by 1914. It is as if the painter, with all his ideas of pictorial discipline, had simply capitulated in the face of the Mexican's extraordinary outer and inner presence.

This remained an exception in his work. Where Modigliani's portraits have character, the character is not primarily that of the person depicted. At all events, it is where the painting lacks character that the sitter comes more clearly to the fore, even if only in physiognomical terms; this is exemplified by such portraits as those of Viking Eggeling, Blaise Cendrars and Léon Bakst.

Kokoschka, by carrying his closeness to the sitter to the pitch of fervent identification, placed himself well outside the great French tradition that runs from Manet by way of Cézanne to Picasso and Modigliani. In all lucidity, Modigliani opted for Paris, and thereby for French painting—which at that moment was admittedly largely an Iberian, and thus a Mediterranean, affair. The journey from Livorno to Paris was intrinsically a shorter and an easier one than the journey from Vienna to Paris would have been, although it should not be forgotten that in Venice, very early in his career, Modigliani had come into contact with the work of the Vienna Secession.

When Modigliani arrived in Paris in 1906, the first influence that he underwent was not that of Picasso, nor that of the Fauves, nor even that of Cézanne, whom he had still to discover. What he saw first was the art of Henri de Toulouse-Lautrec. This is clear, in particular, from a number of drawings and watercolours that probably date from 1907 or 1908 (pl. 102), as well as portraits of women that are wholly Art Nouveau, with echoes not only of Lautrec but of Aubrey Beardsley, with whose art Modigliani was familiar from an early age (fig. 33).

Meidner, who knew Modigliani in Paris at that time, records that he admired not only Gauguin but also Lautrec, whose linear style was understandably more of an inspiration to him than was the chromatic and expressive style of van Gogh. But there were other sources of inspiration. One unique nude, not a very large work, probably painted in 1908 (fig. 34, pl. 9), is hard to imagine without the Art Nouveau (or *Jugendstil*) of the German-speaking countries, with which the artist had come into contact in Venice. One is also reminded of such a painter as Franz von Stuck (fig. 35), and—even more strongly—of Edvard Munch, whose *Madonna* of 1893–94 (fig. 36) has a related air.

In those years, between 1908 and 1914, Modigliani was a seeker. A number of portraits were painted, not one of which

Fig. 36 Edvard Munch, *Madonna*, 1893/94, oil on canvas. Munch-Museet, Oslo

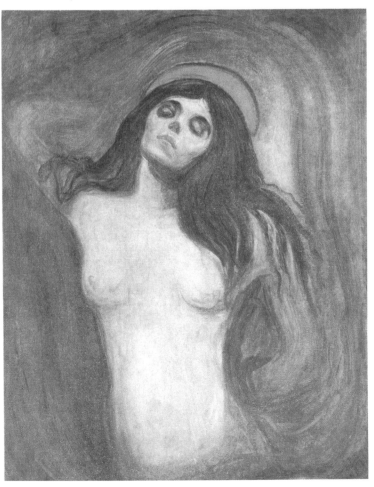

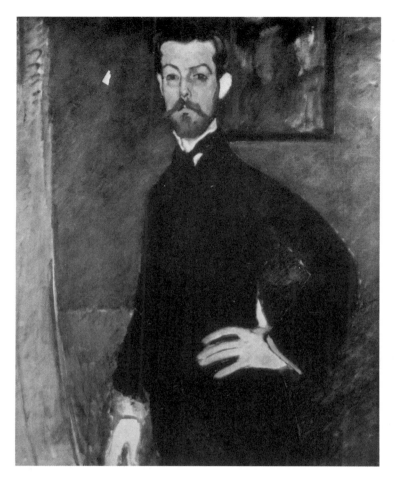

Fig. 37 *Portrait of Paul Alexandre*, 1909, oil on canvas. Private collection

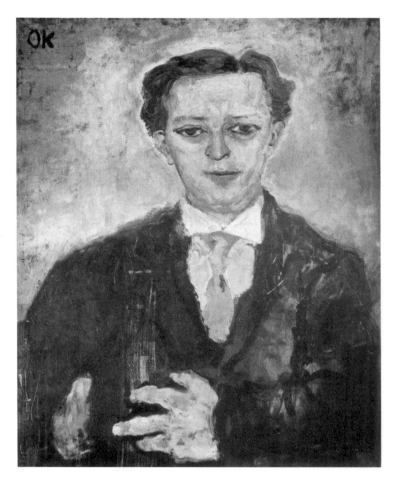

Fig. 38 Oskar Kokoschka, *Trance Player*, c. 1908, oil on canvas.
Musées Royaux des Beaux-Arts, Brussels

could be called a 'real' Modigliani. Only after the pause for sculpture, from 1910 to 1913 or 1914, do we find the first of the series of major portraits that show the artist immediately at the peak of his genius.

Only a year before the break, he painted three portraits of Paul Alexandre (fig. 37), a physician who was his early patron and first collector; a few years later a fourth appeared. The first three are paintings in a conventional portrait pose, without any particular stylistic identity. They do, however, display a thoroughly free use of colour, together with the economical, almost geometrical articulation of the background that reappears so often in later works. Another feature of the later works is already noticeable: the rather casual, summary and shapeless treatment of the hands. In the course of the sequence of Alexandre portraits, the sitter's figure is progressively simplified and brought closer and closer to the viewer; but not even the last of these paintings, with its strongly Cézannesque background features, is entirely 'Modigliani'. The four portraits arouse an impression of cool, almost impersonal detachment.

Whereas Kokoschka—even in his earliest portrait, the almost contemporaneous *Trance Player* (fig. 38)—reveals an intense psychological curiosity, Modigliani is free of any such curiosity from the very start. Even in the last and most

concentrated of the four Guillaume portraits, probably painted in 1913, the painter shows no more interest in the sitter's psyche than before. The result is that the viewer similarly takes no interest in the doctor's personality; we merely learn what he looked like.

The opposite artistic pole to Modigliani—to which we have here attached the name of Kokoschka—appeared to Modigliani himself in the guise of Chaim Soutine. In Soutine he found himself at close quarters with a genuine Expressionist temperament, in the person of one of his most beloved friends. Born in Poland, Soutine moved to Paris, by way of Lithuania, in 1912. Once there, he belonged, as did Modigliani, to the Jewish diaspora that was making so powerful a contribution to art in France. He too was a *'peinture maudit'*, a 'painter under a curse'. Soon after Soutine's arrival the two painters met and became friends, despite their antithetical temperaments. Modigliani, always described by those who knew him as 'aristocratic', became very close to the outwardly 'plebeian' Soutine.

Soutine was far less committed to portrait-painting than his friend, but the few that he did paint reveal him as far more identified with the emotions and sufferings of his subjects. Characteristically, in most of these works his subject is himself (fig. 39); Modigliani, by contrast, has left us just one

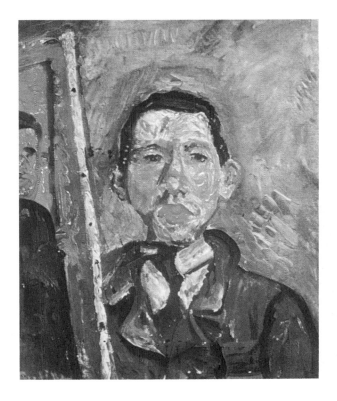

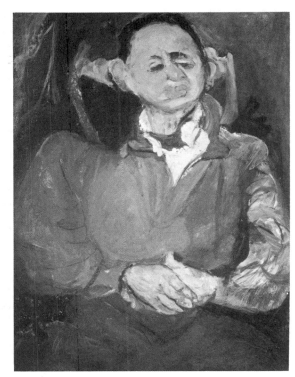

Fig. 39
Chaim Soutine, *Self-portrait*,
1917, oil on canvas.
Henry and Rose Pearlman
Foundation, Inc., New York

Fig. 40
Chaim Soutine, *Portrait of
Oskar Miestchaninoff*,
1923, oil on canvas.
Musée National d'Art
Moderne, Centre Georges
Pompidou, Paris

self-portrait. Soutine's portraits, like all his paintings, are the utterances of a man who seems driven to express an existential truth; they are full of disquiet and of powerful expressive distortion, in utter contrast to Modigliani's lofty formal discipline. Modigliani formalized his people in a totally unexpressive manner, whereas Soutine—like Kokoschka or Meidner—tests every sitter to destruction. In those two friends, Modigliani and Soutine, the two great evolutionary currents of early twentieth-century art meet: the currents that bear the names of Cézanne and van Gogh.

The extreme contrast is particularly interesting in one pair of paintings in which both artists portray the same person, the sculptor Miestchaninoff. Modigliani, economical as ever in his deployment of colour and of form, paints the man in all tranquillity and objectivity (pl. 42). Soutine projects all his own inner unrest on to his subject, although the latter faces him just as quietly and as frontally as he does Modigliani (fig. 40). Quite unlike Kokoschka, however, Soutine does not dissect the sitter's superficial appearance in the interests of psychological enquiry, but as a result of his own haunting obsessions. Something of this can just be detected in one of Modigliani's portraits of Soutine, a work that stands out from most of his portraits by virtue of an unusual degree of human sympathy and perhaps fellow-suffering (pl. 47). Another, larger portrait of Soutine by Modigliani reveals no such inner agitation (pl. 46). It presents the sitter with total detachment; the brushwork betrays nothing of his character.

Modigliani's portraits are always 'likenesses'. They are unequivocally portraits and, contrary to all the artistic precepts of the age, they posses a documentary value. Even a portrait such as that of Max Jacob, for all its formalization and

stylization, is still a likeness—incontestably so, since it is actually based on a photograph. At the same time, however, the sitter's individuality is reduced to the extent that the stylization creates the effect of a mask. This brings African masks to mind, but here there is nothing alien, mysterious or demonic about the mask; it masks nothing. On the contrary, the sitter has sacrificed to the form some of his individuality, his emotions, his affective life, just as the painter, for his part, keeps emotion well away from that form. He looks at his fellow man with great coolness. The warmth of the painting lies solely in its colour. This combination of cool detachment with painterly warmth lends the painting—like many other works by this artist—its own specific 'temperature'. Overheating, *à la* Soutine, cannot arise.

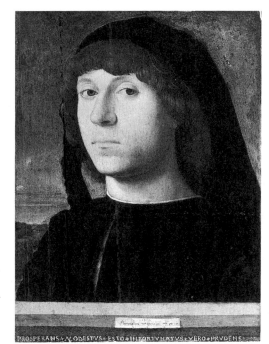

Fig. 41
Antonello da Messina,
Young Man, 1474,
oil on wood. Gemälde-
galerie, Staatliche
Museen Preussischer
Kulturbesitz, Berlin

35

Modigliani's portraits, and indeed his art as a whole, have often been described as very Italian. By this is meant not only such general qualities as measure, organization, balance and harmony, but the presence of concrete allusions to the Italian art of the past: to that of the Early Renaissance in particular, and later increasingly also to that of the High Renaissance and of Mannerism. To specify direct sources is impossible, although it has occasionally been tried, with scant success. We know that Modigliani owned reproductions of Italian Renaissance paintings, and that he pinned them to the walls of the studios that he occupied in rapid succession. As a student he had had many opportunities of studying the old masters in the museums of Florence, Rome and Venice. Among the names that have been cited are those of Duccio, Giotto, Simone Martini, Uccello, Carpaccio, Bellini and Botticelli, and also those of Giorgione, Titian and Pontormo. His friend Gino Severini speaks of Modigliani's 'entirely Tuscan elegance', and Soutine is reported to have said: 'Modigliani: that is the whole soul of Italy.'

The fact that, through all his years in Paris, lines of Italian poetry, and that of Dante above all, were constantly on his lips shows how conscious he was of his origins and how present they remained, both to him and to his friends. However, it is fruitless to try to compare any specific portrait by him with specific portraits by the Italian masters of the Early Renaissance—say Botticelli or, an obvious choice, Antonello da Messina (fig. 41). Beyond the general cool distancing, the strict compositional discipline and the painterly warmth, any idea of direct influence proves immediately elusive. Not much is left beyond an unspecific *italianità*, through which he defines himself in relation to the various contributions that the other painters of the 'School of Paris' brought with them from their places of origin. Modigliani's portraits, especially in the early years, have a vaguely Quattrocento timbre that derives partly from the qualities already named and partly from their concentration on the head at the expense of the spatial context, which causes the sitter to dominate the picture.

It has to be asked whether, alongside the link with the Italian tradition, Modigliani's Jewish origin also finds expression in his art, as it does to an extreme degree in the subject matter of Chagall and in the mind of Soutine. The answer—so far as Jewishness is definable at all—must be in the negative. Modigliani himself was acutely conscious of his Jewish identity. He often spoke of it and reacted with great vehemence to the occasional anti-Semitic remark. Many of his closest artist friends were Jews: Soutine, Kisling, Lipchitz, Zadkine, Epstein, Pinchus Krémègne and, of course, Max Jacob. His own family was long since assimilated and remote from Jewish orthodoxy; but family legends still survived, one of which was that on the maternal side he was descended from Baruch Spinoza.

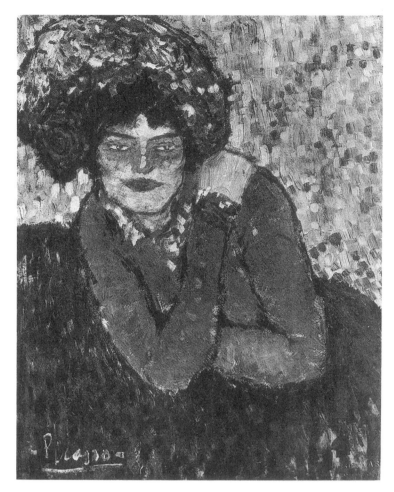

Fig. 42 Pablo Picasso, *Portrait of Corina Romeu*, 1902, oil on canvas

To Modigliani, very unlike the young Chagall, there was nothing sacrilegious in creating likenesses of human beings in defiance of Jewish law, or indeed in making this the sole theme of his work. He was entirely 'emancipated'; but he frequently stressed his Jewish identity, and there are Hebrew inscriptions on some of his drawings. For the rest, however one may choose to define Jewishness, there is no trace of it in his work. The Italian prevails. His is a fundamentally Latin, Italian art. The Jewish identity that was so important to him left no mark on his work—one more sign of the wide gulf that separated his art from his life.

It is tempting to interpret Modigliani's ties with artistic tradition, and his reservations about current movements, as specifically Italian characteristics, but it should be remembered that Italy itself, at exactly the same time, was making its own definitive and radical contribution to Modernism. Paris in 1912 was the scene of the historic Futurist exhibition that caused a sensation among artists. Modigliani had met Umberto Boccioni in Rome in 1901, and again two years later in the life class at the Accademia in Venice, and he was friendly with Gino Severini, who arrived in Paris in the same year as he did. But he would have no part of the Futurist scenario. He had no interest in theses, slogans and manifestos. Everything he stood for, as a person and as a painter, was the absolute negation of the Futurist programme: his

love of the old masters, his attachment to traditional values, his belief in beauty and harmony, and—not least—his habit of painting the nude, a subject execrated by the Futurists. He could never have signed the Futurist call to 'Burn the Louvre!' In 1909, when Severini asked him to sign the Futurist Manifesto, he declined. How could he have glorified the pace of modern life, the big city, the railroad—all that the Futurists praised? Their progress mania was matched by his faith in tradition.

In Italy between 1910 and 1920, the link between modernity and tradition was represented not so much by Modigliani as by Metaphysical Painting (*Pittura metafisica*), a movement that was both more traditional and more innovative than Modigliani; it elevated *italianità* into a programme in itself. Modigliani stood aloof from all this. 'Metaphysical' dreams, and indeed any dreams, were foreign to him as a painter. His whole work was concerned with the physical appearance of the human being, whether as a face or as a nude.

It is remarkable that when Modigliani arrived in Paris in 1906, the Fauves, who were at the peak of their activity, had virtually no influence on him, despite the friendship that soon linked him with André Derain and Maurice Vlaminck. He must have seen the Fauve paintings that were shown alongside Gauguin at that year's Salon d'Automne. The Fauve liberation of colour is something that appeared only peripherally in Modigliani's work, and then only in 1914, immediately after the end of the sculpture phase, when some works combined Fauve and Pointillist elements in a way that was not without analogies in contemporary art. Severini, too, was using Pointillist techniques at this time, less in response to the Fauves than to Robert Delaunay, whose recent colour-light paintings harked back to Georges Seurat.

Modigliani produced just a few paintings that reveal a kind of Fauve-coarsened Pointillism before the true, Cézannesque line in his painting prevailed. The main examples are the two portraits of his painter friend Frank Burty Haviland, assumed to have been painted in 1914 (fig. 44, pl. 21). However, the apparent Fauvism of these works is if anything closer to certain turn-of-the-century Picassos such as the *Portrait of Corina Romeu* (fig. 42); and that work in turn reveals the influence of Lautrec. On the other hand, Pointillism as a decorative structuring element of certain areas returned to Picasso's painting in 1914. Other works by Modigliani with Pointillist-cum-Fauvist features are *Rosa Porprina* (fig. 43), *La Marseillaise* and *Beatrice Hastings Leaning on her Elbow*, all of 1915, and a number of coloured drawings in which the lines are shown as strings of dots. It is not without interest that a number of paintings effected in a completely un-Fauve style have a 'Tachist' underpainting that is invisible on the surface, as if Modigliani had started them off in a Fauve style and then completely changed tack.

Fig. 43 *Rosa Porprina*, 1915, crayon and oil on cardboard, Collection Riccardo Jucker, Milan

Fig. 44 *Portrait of Frank Burty Haviland*, 1914, oil on canvas. Collection Mattioli, Milan

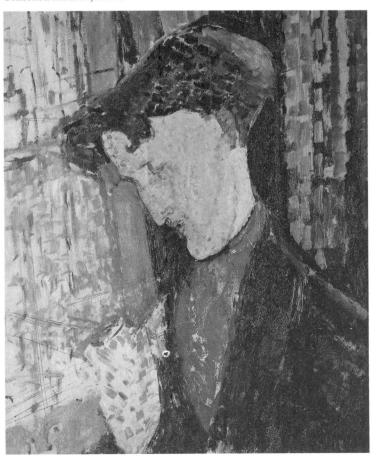

Fig. 45 Paul Cézanne, *Boy in a Red Waistcoat*, 1888-90, oil on canvas. Collection Mr. and Mrs. Paul Mellon, Upperville, VA

There are Fauve echoes, too, in one of the artist's most extraordinary paintings, *Pierrot* (pl. 31), the colouring of which additionally recalls Picasso's Rose Period. Other works that belong to this context are the portrait of Diego Rivera and the accompanying oil sketch (pl. 18, 19), although the finished version in particular, for all the looseness of its handling, can hardly be described as Fauve, because its colours are not bright but dark. They have a blue-black glow that is somewhat reminiscent of Georges Rouault. This powerful portrait was probably painted in 1914, soon after Modigliani's return to painting.

Whereas the significance of Fauvism, for Modigliani, was highly peripheral, and that of Cubism never went very deep, the significance of Cézanne was central. Cézanne was the lodestar of his art. In the same year, 1906, in which the twenty-two-year-old Modigliani arrived in Paris, Cézanne died in Aix-en-Provence. In the following year the Salon d'Automne put on the commemorative exhibition that had so powerful an impact on the younger generation of artists. Modigliani was one of them. We know that he always carried a reproduction of *Boy in a Red Waistcoat* (fig. 45) in his pocket, producing it with a flourish in the course of many an artistic argument.

From 1909 onwards, the influence of Cézanne became increasingly evident, as exemplified by such paintings as *The Beggar, The Engraver Maurice Potin* and above all the two versions of *The Cellist* (fig. 46, pl. 14). There is something Cézannesque in all of these: in their handling (however varied), in their near-monochrome sobriety, in their structural clarity, and in their formal rather than emotional or psychological interest. With *The Cellist*, the principal work in the group, one feels that this is a man who could easily sit down at the same table as Cézanne's *Card-Players* (fig. 47). Even so, the echoes of Cézanne tend to fade as soon as one compares these Modiglianis directly with works by Cézanne: there is in them almost nothing of Cézanne's specific way of handling paint. The relationship with Cézanne is thus associative rather than direct. The traces of his influence on Modigliani's art progressively disappear, only to reappear in a specific area of his late work.

The Cubist—or, to be more precise, the explicitly structural—elements in Modigliani's art gradually receded after 1916. The faces showed fewer and fewer sharp folds, and

Fig. 46 *The Cellist (study)*, 1909, oil on canvas

Fig. 47 Paul Cézanne, *Two Card-Players*, 1892-93, oil on canvas. Private collection

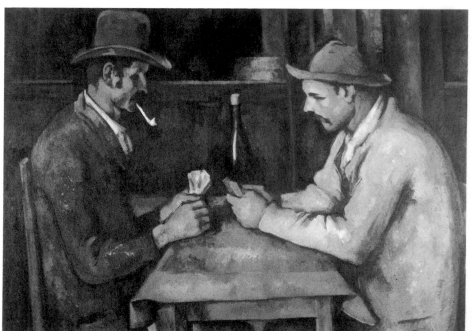

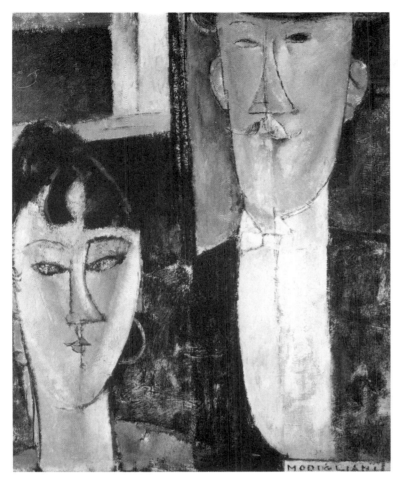

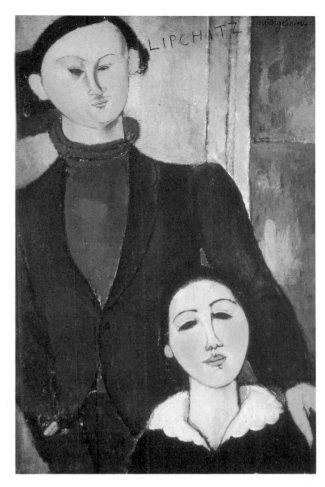

Fig. 48 *Bride and Groom*, 1915 (pl. 1) Fig. 49 *Jacques and Berthe Lipchitz* (pl. 45)

there was less of a tendency to subject them to linear or geometric subdivisions, or to interpret them primarily as formal structures. Gradually, the conspicuous formalism of Modigliani's art gave way to a more relaxed naturalness. The portraits, which now more frequently showed the upper half of the body and the arms, were set free from the formal constraints in which, paradoxically, his formal freedom and self-confidence had hitherto manifested themselves. It was these formal manipulations, transcending the depiction of the person, that had given the portraits of 1915 and 1916 their high aesthetic charm. The change is betrayed, most of all, by the way in which the noses, previously formally accentuated, now progressively lost their significance: the artist no longer placed any particular emphasis on their specific three-dimensional qualities, nor on their function as the axis of the face.

Overall, an increased bodily relaxation was reflected by a reduction in formal tension, even a lessening of the artist's preoccupation with form. Compare, to choose two particularly beautiful examples, the portrait of Beatrice Hastings (1915, pl. 28), at the Barnes Foundation, with that of Hannah Zborowska (1917, pl. 52) in the Museo d'Arte Moderna in Rome: Modigliani's transition from 'harder' formalism to 'softer' naturalism can easily be detected, even though in the later painting he has by no means given up his formal idiosyncrasies. The same is proved by another and equally

magical pair of works, the extravagantly formal *Madam Pompadour* of 1915 (pl. 30) and the *Marie* of 1917−18 (pl. 68). It is thanks to this easily detectable stylistic shift that Modigliani's paintings, which he himself very seldom dated, can be given a rough chronology without great difficulty.

The same shift took place in the drawings that ran alongside his paintings as a constant accompaniment. In these, too, whether or not linked to a specific painting, formalism gradually receded in favour of a free, melodiously linear flow, uninterrupted by hard emphases and capable of great elegance.

The process that took place in Modigliani's art between 1915 and 1917 is exemplified by his two double portraits: *Bride and Groom*, of 1915 (fig. 48, pl. 1), and *Jacques Lipchitz and his Wife*, of 1917 (fig. 49, pl. 45). If we look at the later painting in comparison with the earlier, it is as if the sitters had laid aside their masks; as if—to exaggerate for a moment, without any implied value judgement—as if character puppets had been transformed into human beings. The earlier painting is essentially defined by its formal nature which has, at the same time, a social aspect, in that the idea of a demi-monde is evoked. This idea emerges not only from the clothing but from the typed, rather than individual, characteristics of the two figures. Their individuality is eclipsed by their formal and social posture. The faces, with

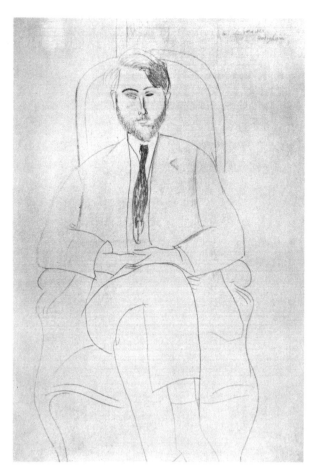

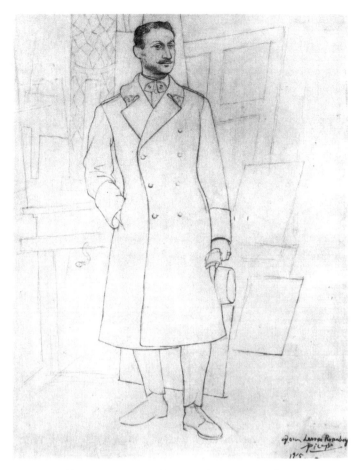

Fig. 50 *Portrait drawing of Leopold Zborowski*, c. 1917, pencil. Museum of Art, Rhode Island School of Design, gift of Miss Edith Wetmore

Fig. 51 Pablo Picasso, *Portrait drawing of Léonce Rosenberg*, 1915, lead pencil

their vertical caesuras, are as if cut in half; the halves of the man's face look slightly out of kilter, from the moustache to the collar and tie. This same 'halving' is continued in the vertical division of the shirtfront. Once again the noses are given a linear emphasis through the imposition of geometrical form and asymmetry.

All these means of formal emphasis, combined with the demi-monde associations, have led some to detect a touch of humour or even of caricature in this work. The same is said of other portraits, including that of Max Jacob (pl. 4) and, especially, that of Jean Cocteau (pl. 33), in which the sitter's snobbish pose does seem overstated. The Paul Guillaume portraits (pls. 36, 37), too, are pointed—even a touch ironic —in their characterization of that cosmopolitan art dealer. But none of these is a caricature. Humour and caricature are beyond the pale of Modigliani's artistic thinking. Not even in his most rapid drawings is there a trace of caricature, although the opportunity was often there. The tendency to accentuate the physiognomy and the pose came naturally to him, especially in the years when the formal emphasis in his work was so strong, but all this reveals no more than an ingrained tendency to overstatement.

Modigliani's 'liberation' from the formalism of 1915 and 1916 is additionally documented by two drawings, between

which, in spite of the short time that separates them, the formal distance could hardly be greater. The pencil *Study of a Seated Man* (pl. 124) seems formalized in a way unusual even for Modigliani. It makes an effective contrast with the portrait drawing of his dealer, Leopold Zborowski, which he did in 1917 (fig. 50). There is nothing geometrical here, nothing Cubist, nothing 'abstract'; no arbitrary consideration of style disrupts the gentle melodic line. But if Cubism is worlds away, Picasso is very near: a transformed Picasso.

It was in 1917 that Picasso travelled to Italy with the Russian Ballet. This journey stood at the beginning of a reversion to the traditions of naturalism, classicism, even academicism, which had been foreshadowed a few years earlier in such works as a portrait drawing of his dealer, Léonce Rosenberg (fig. 51). The great source here was Ingres. In his name, Picasso turned his back on the shift away from the principle of discontinuity that had marked, at the turn of the century, the decisive break between past and present. That principle, which had also had its effects on Modigliani, now lost its dominance.

In his drawings Modigliani now also turned to Ingres and the flowing line, thus coming closer to the Picasso of the same period—although the analogy is less complete when we find that the paintings contain very little sign of *Ingrisme*.

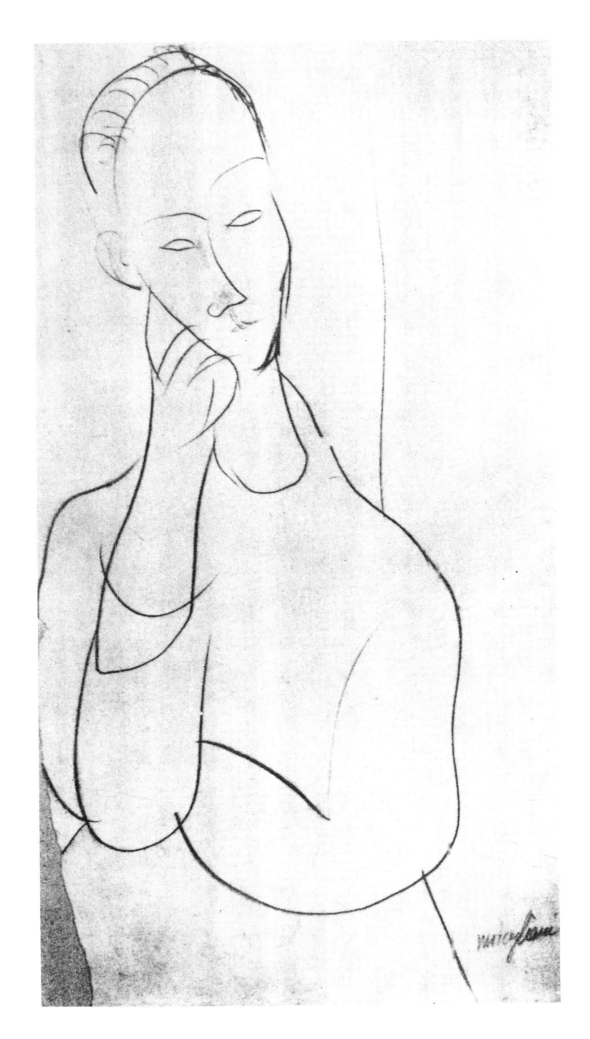

5 Portrait of Lunia Czechowska *1919*

Signs of change are evident, but there is never a decisive break of the kind that Picasso accomplished under the auspices of Ingres. In any direction Modigliani went less far, and so he had less to lose and less to gain by change. Like his art itself, his change of course was far more moderate.

The work now became more naturalistic and more organic; but this was not enough for Modigliani. However marked the rapprochement with Nature, his own stylistic concerns still required expression. The path of formal manipulation of the human image was no longer open to him; if he wanted to modify that image, he had somehow to do so while respecting natural appearances. He achieved this by imposing on the figure a specific physical attitude. His portraits, especially those of women, are often dominated by an S-shaped curve, a flowing, 'melodic' line to which the whole body is made to conform. He elongated his figures and faces. Necks, in particular, grew longer, while heads nodded over to one side. After the quasi-Cubist formalism of previous years, this was a new formalism, whereby the sitters were no longer given an internal structure but extended and stretched as unitary images. The result was often an impression of charm, prettiness, even affectation, that had barely been hinted at in the work of his younger self.

Even so, some early works do anticipate later characteristics —as with the elongated necks in such outstanding works as *Madam Pompadour* (pl. 30) and *Pierrot* (pl. 31), and also in the portrait of Jean Cocteau (pl. 33). Even earlier than these,

between 1909 and 1913, there are portraits of women and standing caryatids with, if not swan necks, at least over-long, pillar-like necks, although they are not at all mannered works. Finally there are the stone busts, some of which show the same feature, although much more formalistically than the late portraits and without their occasional hint of sentimentality.

It appears to be characteristic of this stylistic phenomenon that the portraits of men become fewer than those of women. Images of women were evidently more susceptible to the mannered interpretation than were those of men, which tended to resist the new 'prettiness'. It is certainly no coincidence that at this stage he embarked on the rapid succession of female nudes that culminated in 1917; it is noticeable, however, that those nudes—until the very last ones, painted in 1919—are almost entirely free of the mannered pose. Such women as Jeanne Hébuterne, the mother of Modigliani's daughter, and his close friend Lunia Czechowska, had something of a natural affinity with the new style (pl. 5). During his last two years Modigliani frequently painted both of them, Jeanne in particular, still producing such major paintings as the 1918/19 seated portrait of Jeanne (pl. 78).

Historical associations impose themselves: echoes not only of the fifteenth-century Mannerism of Sandro Botticelli (fig. 52) but of the classic sixteenth- and seventeenth-century Mannerism of Pontormo, Parmigianino and perhaps also El Greco. One work often mentioned in connection with Modig-

Fig. 52 Botticelli, *Birth of Venus* (detail), *c*. 1484-86, Tempera on canvas. Uffizi, Florence

Fig. 53 Parmigianino, *Madonna with the Long Neck* (detail), 1534-40, oil on wood. Uffizi, Florence

Fig. 54 *Girl in Blue*, 1918, oil on canvas

liani's late portraits of women is Parmigianino's *Madonna with the Long Neck* (fig. 53); Pontormo's *St Anne Altarpiece* is equally relevant. Modigliani had a sound knowledge of Italian art, and we must assume that he was well aware of all this, however direct or indirect the actual influence.

Modigliani's 'Mannerism' was, in the years in question, only one aspect of his art. Alongside it there was something quite different, a long way from the female portraits that tend to define the cliché image of Modigliani. It was precisely at this time that Modigliani became the painter of simple, unknown, nameless people. He painted portraits of ordinary men and women: a gardener, an apprentice, a young peas-

ant, a chambermaid, a woman druggist, and occasionally a child—people from a social background other and 'lower' than his own (pls. 65, 67, 68, 76, 82–87). This sprang not from any hankering after social comment but from an intensely 'human' interest. These paintings may seem atypical by comparison with the usual stereotypes of his art, but there are too many of them to be called exceptions. They convey a reticent but forcefully expressed inner sympathy, and they achieve great poignancy, especially in the few portraits of children, such as *Girl in Blue* (fig. 54). It is as if, in order to do justice to these simple people, the painter had renounced all his aesthetic eloquence; as if he were being even more restrained in his use of colour than usual; as if he were

43

Fig. 55 Paul Cézanne, *Madame Cézanne in a Yellow Easychair*, 1893-95, oil on canvas

Fig. 56 *Young Peasant*, c. 1918 (pl. 85)

approaching his sitters quietly, almost shyly. Quite early on, Modigliani chose his sitters from the same simple milieu. Some of these works are closely related to those of later years, even if the artistic method is a different one. For example, that enchanting portrait of a seated girl he called *Little Louise* (1915, pl. 26).

It is in this small group of paintings, which stands out so sharply from the portraits of his male and female friends, that Cézanne makes his reappearance in Modigliani's work, not so much in the manner of painting as in the vision of humanity. A particularly fine example is the *Young Peasant* (fig. 56, pl. 85) from the Tate Gallery in London. The sitter takes his place on the canvas with the same almost still-life-like passivity as the people in Cézanne's paintings, where an intensely human note is struck by this same—as it were—hushed approach on the artist's part (fig. 55). Cézanne's portraits of his wife, and many of his other portraits, have the same intensely moving way of conveying this quality through and in spite of the painter's extreme emotional restraint.

Modigliani's works in this vein include *Seated Young Woman in Blue Blouse, Dark Young Woman Seated in Front of a Bed* (pl. 80), *Seated Woman with Child* (pl. 77); all have the same

quiet tonality, the almost vegetative presence of the sitter, and a human understanding that is more intense because nothing is mannered. Another echo of Cézanne: again and again, in these paintings, heavy hands rest in the sitters' laps, as if to characterize 'working people' in contradistinction to those of his own cultivated milieu, with their narrow faces and delicate hands. Modigliani's late works are often colourful to the point of gaudiness, but these paintings of ordinary people incline toward Cézannesque monochrome. True, the boundary between Modigliani's two pictorial worlds remains fluid, but it is still as if the artist, by way of compensation for his closeness to the world of 'culture', had turned to a more 'natural' world at a time when the stereotypes of his late 'Mannerism' were beginning to be a danger to him.

This may also explain Modigliani's late, and brief, excursion into landscape painting, in which, once more, the remote exemplar was Cézanne, who remained to the end Modigliani's ideal rather than his model or source (fig. 57). Modigliani never tried to imitate Cézanne. The art of his great predecessor served him rather in the capacity of a tuning-fork: something that helped him to define the pitch of his own painting. In the very last of his portraits, that of Mario Varvogli (pl. 79), there is a faint echo of Cézanne's *Boy in a*

Red Waistcoat (fig. 45), of which, as mentioned earlier, he always carried a reproduction in his pocket.

Cézanne's influence is particularly manifest in the four landscapes that Modigliani painted in Nice or at Cagnes-sur-Mer in 1918 (pls. 88, 89); he wrote of them to Zborowski that they were probably still rather novice efforts. Since his youth, when he had painted conventional landscapes under the influence of his teachers Guglielmo Micheli and Giovanni Fattori, he had entirely neglected this whole genre; and, indeed, his painting was essentially urban in nature. Now, however, as the common people began to find their way into his urban scene, he became receptive to the natural world for the first time. On his trip to the Mediterranean he turned to Nature, but in a way far removed from the *Macchiaioli* tradition in which he had been brought up. Cézanne had long since intervened. Now he approached landscape with the same hesitant gentleness as he did the simple people whom he was painting at the same time. It does seem doubtful, however, whether his heart was entirely in his landscape painting. He painted only four—tranquil, still-life-like pictures that show a few houses and a few cypresses or leafless trees, all in highly simplified shapes; perspective, too, is reduced to a minimum.

Modigliani was not alone in painting landscapes in this vein. There are comparable paintings by such painters as Derain (fig. 59) or his own close friend Kisling; and in Italy Giorgio Morandi painted small landscapes of a related kind (fig. 58), which again reveal the authority of Cézanne. Much earlier, around 1908, Picasso and Braque had recognized the strong formal value of leafless trunks and branches.

Fig. 57
Paul Cézanne,
House with Split Walls, 1892-94,
oil on canvas

Two years after Modigliani's 1918 landscapes, Carlo Carrà was to paint his *Pine by the Sea* (fig. 60); with its bare trunk, it is surprisingly reminiscent of Modigliani. It was quite natural that such an art as that of Carrà, with its nostalgic regard for the traditions of Italian painting—and particularly for Giotto, on whom Carrà published a book in 1924—should show points of contact with that of Modigliani. However, Modigliani's homage to tradition never amounted to a total metamorphosis of his art: unlike Carrà, he had never taken any part in the 'progressive', anti-traditional Futurist movement. His position between tradition and Modernism remained the same all through the decade, unaffected by the change that overtook his painting.

Fig. 58 Giorgio Morandi, *Landscape*, 1928, oil on canvas

Fig. 59 André Derain, *Harbour in Provence*, Martigues, 1914, oil on canvas, Hermitage, Leningrad

Fig. 60 Carlo Carrà, *Pine by the Sea*, 1921, oil on canvas

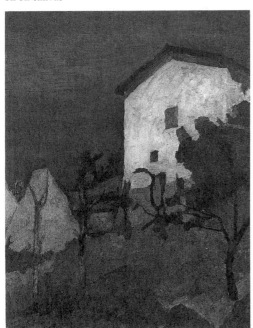

45

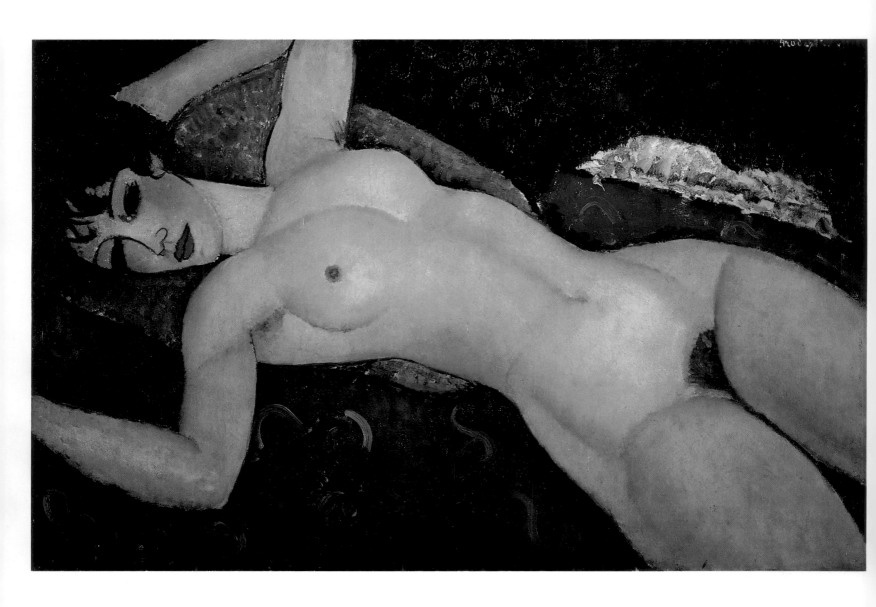

6 Nude *1917*

The Nudes

'We demand, for a period of ten years, the total suppression of the nude in painting.' No one more firmly resisted the Futurists' demand than did Amedec Modigliani; so much so, that for many people the name of Modigliani is almost synonymous with his nudes. And yet these are not particularly numerous; the portraits far outnumber them. There is room for debate, too, as to the accuracy of the view, expressed by some commentators, that the nudes represent Modigliani's major artistic contribution. These works have certainly attracted the lion's share of attention, but this could be for thematic rather than artistic reasons—reasons that have become increasingly irrelevant over the succeeding decades, as society has become more 'permissive'.

The Futurists, for their part, had no moral objections; they disapproved of the female nude because it was the epitome of tradition in painting. Perhaps they never would have condemned it so apodictically if only Modigliani's nudes had already existed around 1910; entirely traditional though these were, they shocked the contemporary public so profoundly on moral grounds that the Futurists might well have considered them entirely in keeping with their own anti-bourgeois élan.

This, again, is a symptom of Modigliani's position between tradition and Modernism. No other painter, in our century or in any other, has painted the female human body as he did. And yet his nudes evoke involuntary associations of Classicism. They are a continuation of a great tradition of European painting, not only thematically but also in the 'spiritual' interpretation of the theme, insofar as they constitute a celebration of beauty, immaculateness and perfection, and thus an idealization of physical Nature—which, in these pictures, dispenses with an idealized visual context and may thus be understood as a contribution to the freeing of sex from moralistic intrusions. The nudes are wholly liberated, even if the artist himself had no thought of making a liberating gesture.

Modigliani's nudes take their place among the historical landmarks of the art of the nude since the Renaissance: works such as the Venuses of Giorgione (fig. 61), Titian and Tintoretto; Francesco Goya's *Maja desnuda*; Ingres' *Grande Odalisque*; Edouard Manet's *Olympia* (figs. 63–65); and also, if you like, certain paintings by Gauguin. It is tempting to draw comparisons between Modigliani's nudes and all of these, but such comparisons are no more meaningful than the effort to relate Modigliani's portraits to historic works of art on the grounds of a vague sense of kinship. Such juxtapositions lead only to one conclusion, a fairly obvious one: that Modigliani's nudes are nudes and nothing but. No mythology, no landscape, no draperies, no social relevance, no coquetry; just bare facts. In a genre that spans the whole of art history, right down to the salon painting of the nineteenth century, and in a vein that might well have seemed exhausted by Modigliani's day, this is a unique achievement. It remains so even though the centre of gravity of Modigliani's art really lies in the portraits, and above all in those of the period between 1914 and 1916, at the end of which the superb sequence of nudes begins.

There was no ideology at work here, neither a Rousseau-esque 'Back to Nature' impulse—such as moved the contemporary Expressionist painters to paint people naked in the freedom of Nature—nor a critique of bourgeois morality. There is no escapism, and no rebellion, in Modigliani's nudes. What singles them out is their self-evidence: the self-evidence of the naked body, from which nothing could be more remote than any idea of cast-off clothing or a cast-off morality. They do not urge us to strive for the freedom that they possess.

Fig. 61 Giorgione, *Reclining Venus*, c. 1508. Gemäldegalerie, Dresden

Perhaps that is why they were considered so immoral: the fact that morality has no part in them, not even in the guise of immorality—flirtatious glances, or the like. Well might the total absence of *pudeur* or sexual shame be considered shameless, and—in this innocent sense—it is not wrong to call them amoral. (There is, even so, a kind of *pudeur* in the fact that the artist never painted his own girlfriends naked but used only 'anonymous' models.) It was surely Modigliani's freedom from shame that incensed the contemporary guardians of morality and led in one case to the closing of an exhibition by the police. Voyeuristic allusions were entirely accepted in painting, and had indeed been part of the mainstream tradition of the nude ever since Titian; in fact, the undressed state was more readily accepted than 'honest' nudity. There was a failure to perceive that it was just because Modigliani's nudes do not engage in erotic games, even with a fan or a mirror, that they were fundamentally 'moral'. They unveiled nothing, because nothing remained veiled, whether by mythology or by anecdote, or even by an 'accidentally' placed scrap of cloth. The moral indignation that these paintings unleashed was the result of their total openness, of their extreme reduction of the woman's body to itself, and of the straightforwardness with which Modigliani related to his subject.

It may well be asked, therefore, just how sensual Modigliani's nudes really are. The story of his indignant outburst on visiting Auguste Renoir at Cagnes, when he seems to have been shocked in all innocence by the latter's praise of the female thigh, is well known. Even to raise the question of the sensuality of his nudes is an answer in itself. Or does 'healthy' eroticism really lie in openness, untrammelled by scraps of clothing or by other accessories of seduction? Does it consist in the way in which the naked body, in each of the paintings, seems almost like a cut-out, presented on its bed like an object?

Again and again, these paintings have ensnared authors into the most astonishing flights of erotic fantasy—which entitles us to reflect that, even if the paintings contain none of all this, they do serve to inspire it. Many an interpreter has been all too willing to be enticed on to the beds of Modigliani's models and to re-enact, in effigy, what he imagines this quintessentially bohemian artist to have enjoyed in real life. But Modigliani's ideal of perfection—of perfect and here almost sterile beauty—lies beyond eroticism. He pursues an entirely aesthetic ideal. Among the names of the notorious erotic artists in the Paris of his time, such as Kees van Dongen, Jules Pascin or Foujita, all of whom he knew, the name of Modigliani has no place.

And so it makes no sense, when looking at Modigliani's nudes, to reflect on the artist's relationships with women: to wonder, for instance, whether he saw women in purely 'animal' terms, as objects of male lust; whether he is making a statement of male superiority or of equality between man and woman. Such questions lead nowhere. If we look at his biography and read of the many women whom he is said to have 'possessed', we learn nothing that does not emerge clearly from the paintings themselves: the utterly self-evident fascination that the female body held for him, and the total absence of any vulgarity.

One thing that is remarkable, in a portraitist as great as Modigliani was, is the very small degree of individuality that he permits to his nude models. On a subliminal level, this too may have fuelled his contemporaries' indignation; it made it possible to conclude that the painter had reduced women to their physicality and their sexuality without respecting their personality, so that they could be seen as available objects and not as responsible individuals—although sexual candour in such individuals would have seemed all the more reprehensible.

It was indeed the body that Modigliani celebrated, not all the human being in all her humanity. At the same time, however, the sensuality involved was partly, if not mostly, that of the painting itself. With Modigliani, the painting always wins. The unprecedented closeness of these nudes, their strong presence, their uninhibited self-presentation, may well be called sensual; but the flesh is almost always depicted in a very unsensual way—so much so that one hardly feels like speaking of 'flesh' in this context at all. The epidermis we see is that of the painting much more than that of the body; indeed, the bodily epidermis seems less sensual than the drapes and backgrounds, with their saturated colour. Not least, the scope for sensuality is limited by the strong outlines: the sensuality of the bodies is unable to unfold freely; there is no fleshly swelling, no bodily pulsation. Even here, where no purely formal interference is permitted, the painting itself has the last word. It can sometimes seem that the artist, for this theme and this theme alone, has renounced the use of his own specific idiom, whether structural or—later —'Mannerist'. He has not changed the shape of the body, but he has outlined it 'unnaturally', trimmed parts off it, fitted it compositionally into the painting, altered its colour, and permitted the colours in which it lies to be more sensual than the body itself.

Everything in Modigliani is seen in close-up; this is a characteristic feature of his art. And it is a paradox. For on the one hand he keeps his distance from the people he depicts, and on the other he closes in on them. Not until his last years do we find many paintings in which almost the whole person is to be seen, together with the interior in which he or she is located. And so, in the paintings of nudes as elsewhere, he

7 Standing Female Nude *c. 1918/19*

Fig. 62 *Nude*, 1916, oil on canvas. National Gallery of Art, Washington

gets close to his women to paint them, and this is emphasized by the fact that some parts of the body, usually the feet and often the hands, remain outside the picture. The spatial context is mostly no more than hinted at and consists of hardly more than a horizontally and vertically structured backdrop. Next to the human form itself we seldom see more than the bedclothes, a cushion, a cloth—all this with very little representational clarity. The whole emphasis lies on the naked body, which is given almost absolute status by virtue of its total isolation within its coloured context.

Direct though all this is, it also signifies detachment. In Modigliani's nudes there is rarely any sign of emotional involvement, and, for this reason as well as for others, it seems symptomatic that he never painted his own girlfriends as nudes.

Modigliani eternalizes what may be called the objective beauty of the female body. This is perfectly exemplified by the radiant nude from the Mattioli collection (pl. 6). In a majestic diagonal, the woman's body extends right across the painting, which is not a very large one; the arms are without hands, and one is cut off by the upper edge of the painting; the legs are cut off above the knees, so that thighs and pelvis seem all the larger, before the body's upward movement leads into the breasts and into the right-angled spread of the arms. The face, with its dark outline, once more expresses both closeness and remoteness. The distancing effect is greatly emphasized by the unpupilled blackness of the eyes. In other nudes Modigliani has painted the pupils, which means that the reclining woman makes contact with the viewer and thus recalls her contact with the painter who observes her: an opportunity for the viewer to give rein to his fantasies. In such paintings, the gaze that emerges from the image means a departure from the 'pure' pictorial dimension—not always to the benefit of the painting.

People tend to form a rather sweeping collective impression of Modigliani's nudes, as if one followed the other without

any great variation. But in fact many of these works speak a language that diverges considerably from the customary image. Thus, the nude in the Museum of Modern Art in New York (pl. 63) is unique in Modigliani's work. The woman's body crosses the entire width of the picture as a narrow, pale, horizontal form, just above the centre. Here, as elsewhere, the body seems like a cut-out, a negative form amid the surrounding colour. The painting draws its life from the contrast between the coolness of the body and the warmth of the coloured materials around it, and from the contrast between the—admittedly non-naturalistic—precision of the reclining figure and the objective imprecision and greater painterly freedom of its environment. The body is reinforced as an objective presence by this contrast; indeed, it becomes an object in itself, like the bowl in a still life. At the same time, the contrast that isolates the body serves to heighten its abstractness: nothing ties it into its context.

The woman, presumably, is asleep, a motif that recurs only in Modigliani's last three nudes, painted in the year before his death (pl. 90). Unusually, the girl's head is shown in profile—a rarity in his portraits as well as in his nudes. In the expression of the sleeping face we sense a trace of human emotion on the artist's part. The face, furthermore, is surprisingly un-Modiglianesque; it is, quite simply, a sleeping face, incorporating none of the devices that this artist usually employs in depicting women's faces.

The formal strength of this painting does not spring from deliberate manipulation but from its overall pictorial conception. One evident piece of manipulation, even so, is the bulky, rounded form of the right arm in its contrast to the slender body; another is the difference in the treatment of the two hands. Here, for all its naturalness, the painting reveals the presence of a formal resolve. The nude reposes in its own natural forms; but here, as everywhere, the artist's formal consciousness remains alert.

The sequence of nudes began to appear only in 1916, at a time when Modigliani's portraits—such as that of Max Jacob (pl. 4)—were still highly formalized. The nudes are entirely free of such formalisms, as if the two genres had demanded quite different languages as a matter of principle. What Modigliani did to faces, he could not or would not do to women's bodies. With their natural bodily presence, the nudes are far removed from the *Caryatid* of 1911–12 (pl. 2), which shows a nude female figure that is just that and no more: a figure, not a woman. Early drawings of the nude, such as a study of 1913 (pl. 109), or even the drawing known by the erroneous title of *Nude with African Statue* (pl. 104), show the application of a 'Cubist', or more precisely an abstractly structured, form of representation to the body. The artist entirely emancipated himself from this in his

paintings of the nude from 1916 onwards, whereas formalist scansion persisted in the portraits for a while longer.

This shift becomes evident if we compare the early, formalized, rhythmic drawings with such a work as the *Seated Female Nude* in the Courtauld Institute Galleries in London (pl. 56), probably one of Modigliani's earliest paintings of the nude. The head, drooping on to the left shoulder with eyes closed, still retains an echo of the earlier formal principles, but the body is entirely left to its own devices; and this means that the dominant principle is not formal tension but natural relaxation. For the rest, the painting differs from Modigliani's 'classic' reclining nudes through its far less consistent perfection, its greater painterly transparency and fluidity, and its more individual approach to the girl. Here, too, it may well be the closed eyes that suggest a degree of emotional involvement not generally found in Modigliani's nudes.

The nude in the National Gallery of Art, in Washington, (fig. 62), again shows in the woman's face a remnant of 'Cubist' articulation from which the body is entirely free. The expressive effect is basically defined by the fact that the woman is looking at the viewer—or, in other words, at the painter. This entails the risk that the viewer will speculate as to the real relationship between artist and model, as tends to happen with such works as Goya's *Maja desnuda*, Ingres' *Grande Odalisque* or Manet's *Olympia* (figs. 63–65), and thus turn the painting into a piece of evidence for some amatory anecdote. This painting does not work that way, firstly because we do not know who the model was, and secondly because she is given very little individuality. Modigliani's legendary life, in which women are said to have played so great a part, finds no reflection even in his nudes.

On the other hand there are some nudes in which a stronger personal commitment is evident, and in which, accordingly, the theme is not so much the perfection of the female body as a certain intimacy. This applies to some seated figures in

Fig. 63 Francisco de Goya, *Maja desnuda*, c. 1800, oil on canvas. Museo del Prado, Madrid

Fig. 64 Edouard Manet, *Olympia*, 1863, oil on canvas. Musée d'Orsay, Paris

particular, such as *Nude with Necklace* or the Donation Masurel nude in the Villeneuve d'Ascq museum (pl. 64). The latter, in particular, seems highly 'personal', and arouses emotion through the gesture with which the woman presses her shift to her body: a human touch quite foreign to the celebration of the female form that we find in the reclining nudes. The late *Red-Haired Young Woman in a Shift* (pl. 59), too, belongs to this special group, in which the artist concerns himself with something other than cold perfection. In these works the vision of womanhood is refracted; they do not constitute an invitation to admire female beauty.

Fig. 65 Jean-Auguste-Dominique Ingres, *Grande Odalisque*, 1814, oil on canvas. Musée du Louvre, Paris

Fig. 66 *Nude*, 1917, oil on canvas

One of the nudes (fig. 66) directly recalls Ingres' *Grande Odalisque* (fig. 65)and looks like a transposition of that famous painting into the universe and the idiom of the twentieth century; this comes as no surprise in the context of 1917, when a new *Ingrisme* was beginning to make itself felt in French painting. However, the relationship is a superficial one; it hardly goes beyond the pose. It remains surprising, even so, that Modigliani, with his supreme mastery of the theme of the nude, seems almost clumsy by comparison with Ingres. This painting has little of the relaxed quality of the *Grande Odalisque*. The comparison goes to show how far from 'natural', and how emphatically pictorial, Modigliani's nudes are, and how they exemplify his position, constantly emphasized throughout his work, as an artist between classical tradition and Modernism.

Modigliani's nudes show little sign of the set of peculiarities, typical of his other work of the same period, that is known by the rather oversimplified term 'swan neck'. It may be that these mannerisms depend on verticality, so that they develop less fully in the horizontal context of a reclining figure. A number of standing and seated nudes do manifest more than usual the stylistic features of Modigliani's later years, together with the associated 'elegiac' tone. So, indeed, do the three very late reclining nudes of 1919 (pl. 90), which have lost the supreme artistic self-confidence of their predecessors. They have much the same subdued colouring as Modigliani's only self-portrait (pl. 91), painted at around the same time. Modigliani's life seems to have found direct artistic expression only as it was drawing to an end.

The female nude makes only sporadic appearances in Modigliani's early work—if, that is, we can talk about the early work of an artist whose entire career was so brief. There is the strongly expressive nude study of 1908 (pl. 9) with its languishing, entirely *fin-de-siècle* pose. Around the same time he painted two related nudes (pl. 12), which demonstrate Cézanne's influence. After this the theme was taken up—in the context of sculpture—by the caryatids, which by their very nature are not naked women but 'figures'. These are the works in which Modigliani reaches his greatest degree of formalism and abstraction.

There is no organic or logical connection between such works and the paintings of the nude from 1916 onwards; this was a clean break. Whereas in the caryatids, and even in the portraits until 1916, the formal aspect dominates, in the nudes the depiction of the woman displaces all formal considerations. Only when posing the question of the sensual nature of these works does one realize that these paintings, too, ultimately possess an intrinsic formal character. Their greater naturalism does not impair their laconic pictorial individuality—as the comparison with Ingres makes plain.

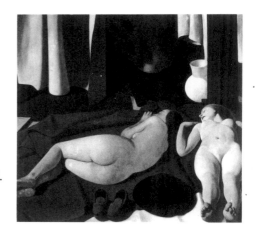

Fig. 67 Felice Casorati, *Midday*, 1922, oil on wood. Civico Museo Revoltella, Galleria d'Arte Moderna, Trieste

A little later, there emerged in European art a school of painting that countered early twentieth-century Modernism by concerning itself not so much with form as with objects and persons. One sign of this was *Ingrisme* in French art. In Italy the talk was of *Verismo*; in Germany of *Neue Sachlichkeit*. This German word, *Sachlichkeit*, roughly translated as 'objectivity' or 'matter-of-factness', is partly an affirmation of the 'object' or 'matter in hand' and partly a claim to possession of a truth inaccessible to mere naturalistic depiction. The 'object' is preserved in its external appearance, and even emphasized, but simultaneously, for the sake of its 'truth', it is reduced to its essence. It is singled out by being isolated from any setting, milieu or atmosphere. Metaphysical Painting had pointed in the same direction, although this was a 'Magic Realism' in which objects were made enigmatic by an emphasis on their sheer physical presence. The Metaphysical incorporates a sublimated form of *Verismo*.

Many of Modigliani's later portraits, restrained in their handling and free of mannerisms, convey a touch of *Verismo* in the sense of an objectivity undisturbed by formal or expressive concerns. But it is in the nudes, above all, that he mostly goes straight to the 'matter in hand' with unprecedented directness, undistracted by formal or emotional considerations and in total isolation from any context. On the other hand, these paintings—as opposed to contemporary *Verismo*—remain saturated with colour and paint, even though the coolness of the bodies themselves sets them apart from the glowing warmth of the surrounding areas, which are far richer in a painterly sense than they are themselves.

Compared with the nudes of a *Verismo* painter such as Francesco Casorati (fig. 67), Modigliani's nudes seem both more radical and more traditional. More radical in their objectivity, and in the absolute status given to the female body; more traditional by virtue of the paint itself, which—for all the hermetic tightness of the painted epidermis—continues to be 'painterly'; more traditional, too, in the solidity that establishes a continuity with the historical tradition of nude painting.

Conclusion

What is the position of Amedeo Modigliani's work in the art of the decade 1910–20, a time in art history that was immensely rich in major artists and in momentous ideas? The criterion is furnished by the other artists themselves. Another criterion might well be the extent of Modigliani's influence on the art of his own lifetime and after, to which the answer has to be that there was no such influence. Whereas Fauvism, Cubism, Futurism and Metaphysical Painting were movements that transformed art, Modigliani transformed nothing. He did not alter the course of art history, if only because his art neither contains nor implies a programme.

Slight as its historical impact was, however, its artistic impact has remained great to this day, and this is the impact that counts, since it rests solely on the individuality of the artist and of his work. This painter stood in the very centre of the artistic life of his time, and must be regarded as one of the most interesting figures active on the Parisian scene, but as an artist he remained on the periphery of his age, notably resistant to the varied artistic temptations to which he was so comprehensively exposed. This independence, which never makes him look merely dated, is undoubtedly part of his greatness.

In 1906 he moved from provincial Italy to the French capital and at once came into close contact with the key figures of contemporary art; this was an experience that influenced, enriched and also confused him. But in his art—even where clear signs of influence may be detected—he remained impressively self-assured; he maintained his autonomy even in relation to his lodestar, Cézanne. This perturbed spirit was artistically at peace with himself. He might have taken his pick of the options that presented themselves to him, but his strength consisted in the fact that, for him, no such choice arose. In an age of experiment, he hardly ever experimented.

In every work, his sole concern was to form a piece of visible reality—almost invariably a human body—into a perfect, definitive and lasting image. Both of his fellow participants in this transaction, the other person and the painting, had an equal claim to his respect. The human individual, whether as a portrait or as a nude, had to be 'all there'; but so had the painting, with its own demands, which for him were harmony, balance and beauty. It is this that gives his works their

high degree of objectivity. They have little to do with his subjective temperament, but a great deal to do with his artistic commitment, with the acuteness of his eye, and with his sovereign command of the language of art. It is characteristic of this artist that he is always supremely in control of what he does. And that control derives, not least, from the fact that no part of his utterly uncontrolled life ever finds its way into his paintings.

Modigliani went his own way, undistracted by all that was happening around him. With the benefit of hindsight, it can now be seen that his mission—in an age in which all traditional values were being called into question—was to give the human image one more chance. And he refused to allow any formal or expressive concerns whatever to induce him to go beyond the human image, at a time when by historical necessity that image was under threat. To him, the integrity of the person was inviolable, even though he subjected it to formal interventions in the early work and to 'Modiglianesque' distortions in the late work. He made no attempt to interpret the person he showed, nor to penetrate his or her inner depths; to him the outer appearance, admittedly seen in a highly individual view, was the whole person. He maintained this intensely classical, Renaissance and—it may be said—humanistic vision in an atmosphere in which fragmentation and distortion were on the agenda everywhere. To him, that agenda was no reason to sacrifice his holistic human image.

At the same time, in every one of his works he made a statement of allegiance to form, which to him was always a static form. Everything 'destructive'—decomposition, formal fragmentation, painterly turbulence of all kinds—was profoundly alien to him. He himself, one might well say, possessed Form. He himself had Style. All who knew him, and who saw him even in his most abject moments, speak of his 'nobility'—the same *noblesse* that characterizes his art. It is surely not out of place to speak of this as a fundamental sense of artistic identity, something that the whole bearing of his paintings prevents us from dismissing as mere 'aestheticism'. It is an ethos: an ethos of beauty. It would be tempting to regard this as a specifically Italian feature of his nature and of his art were it not for the Futurists, who preached the exact opposite—unless, that is, we interpret their rejection

of traditional Italian artistic values as a confirmation of those same values. However apposite, the concept of *italianità* is too narrow a definition of Modigliani's art, but his art is incontestably Latin.

And then there is Modigliani's sad life, around the streets of Paris. We are constantly made aware how little of that life has found its way into his paintings, and for this the explanation must be that his life was very much more filled with art than with all those experiences and sufferings, external to art, that most fascinate his commentators and their readers. Why should his paintings show traces of his illness, his drinking, his drug-taking? Why should they reflect his 'womanizing', whatever that means? What had all this to do with his art, which—more than anything—*was* his life?

Whenever Modigliani is spoken of there is much talk, more so than with other artists, of the way he lived his life, and it is often supposed in consequence that this life must also be present in his art. In fact, though his art has very little to tell us on this topic, it tells us a great deal about his mental attitude. That attitude—his deep sense of artistic responsibility, his ethos of beauty—marks all his work. Modigliani's life was not just his biography, with all its anecdotes and its legends; not just the drunken nights with his friends, Kisling and Rivera and Maurice Utrillo and all the others; not just the stormy relationship with Beatrice Hastings, or the tragic relationship with Jeanne Hébuterne; not just the illnesses and other perils that beset him. The truly individual thing about his life was the way he fought back through his paintings—which is not to say that he painted as therapy. What matters is not that he was sick, but that the sickness never affected his art. Cézanne, not van Gogh!

His friends, almost all of them, speak of his great pride; in terms of his art, this meant his detachment. Detachment from the trivia of life in general; detachment, too, from the tragedy of his own life. None of it ever found its way into his art. Any mingling of life and art was incompatible with his lofty aesthetic ideal.

Paintings

8 Landscape in Tuscany *c. 1898*

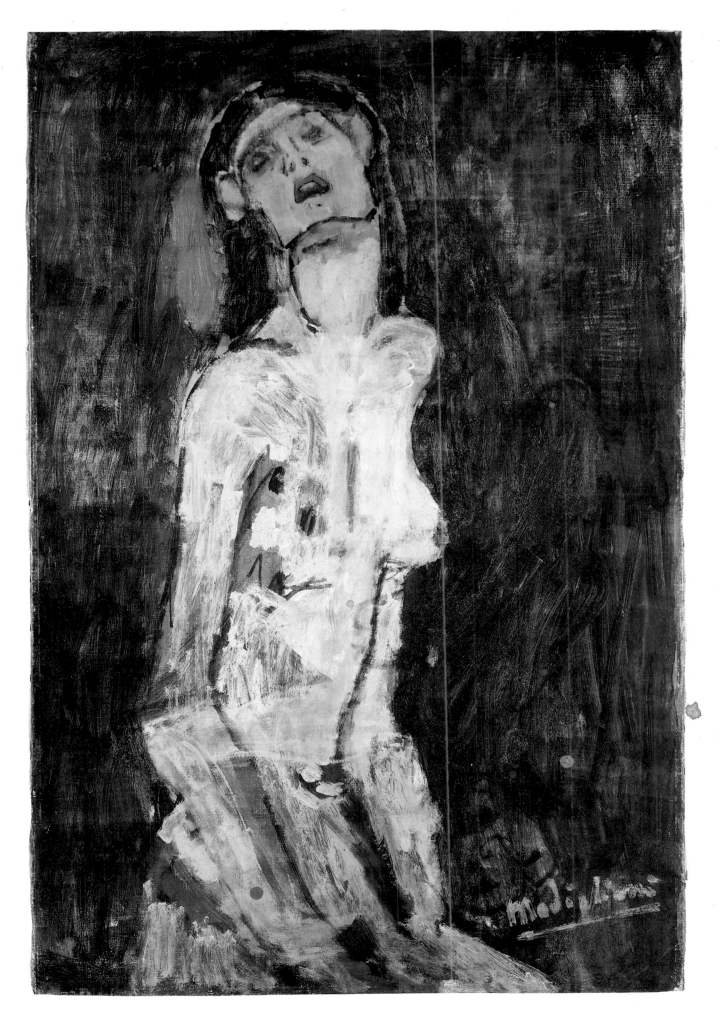

9 Nude (Nudo Dolente) *1908*

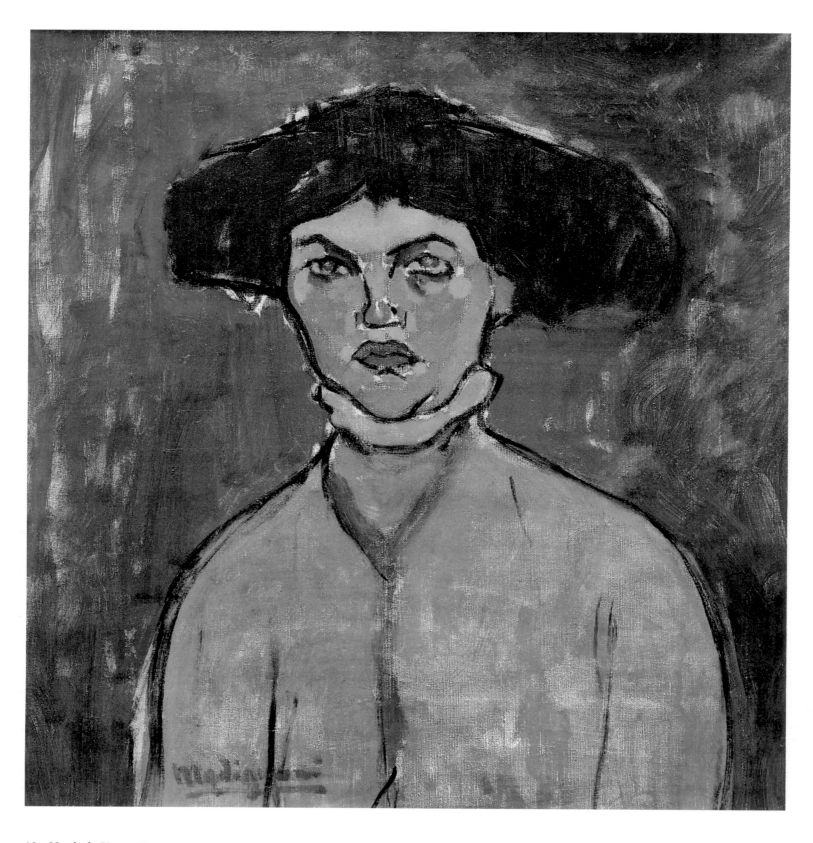

10 Head of a Young Woman *1908*

11 Portrait of Paul Alexandre *1911/12*

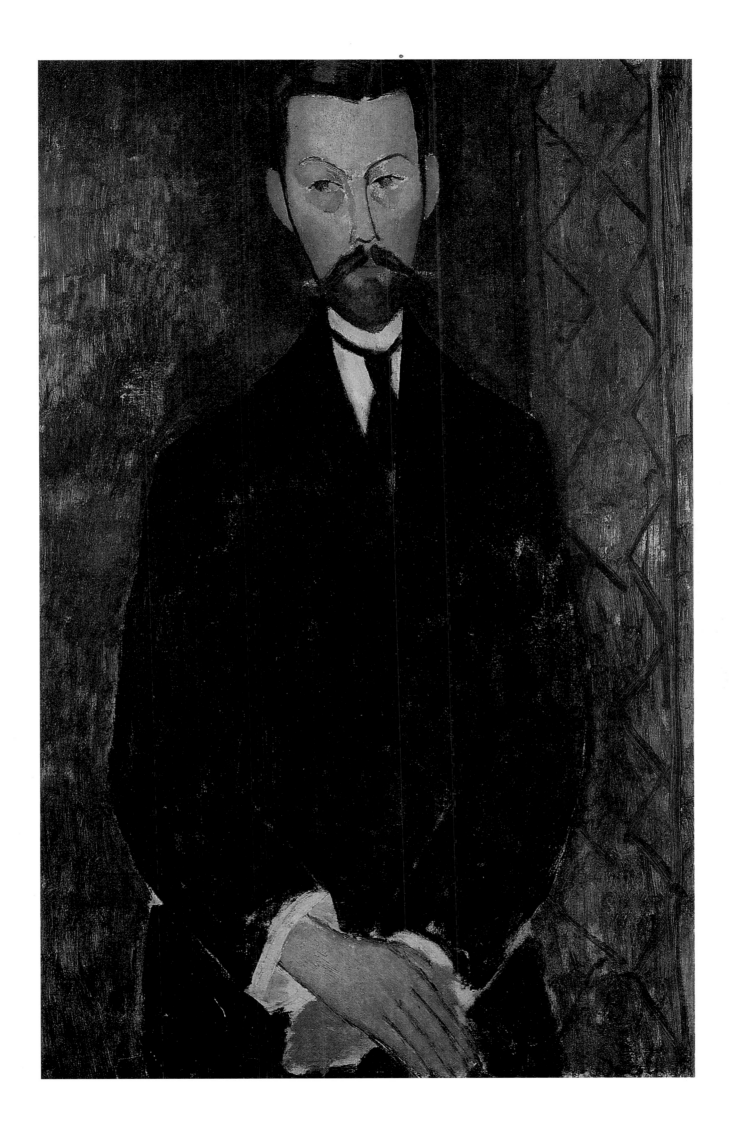

12 Nude *c. 1908*

13 The Jewess *c. 1908*

14 The Cellist *1909*

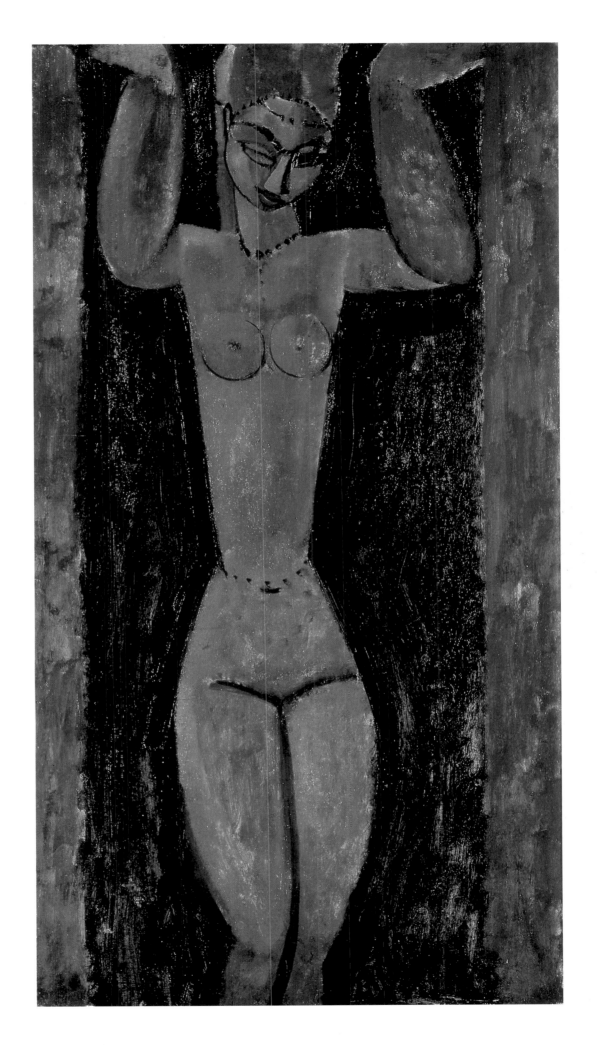

15 Caryatid *c.1912*

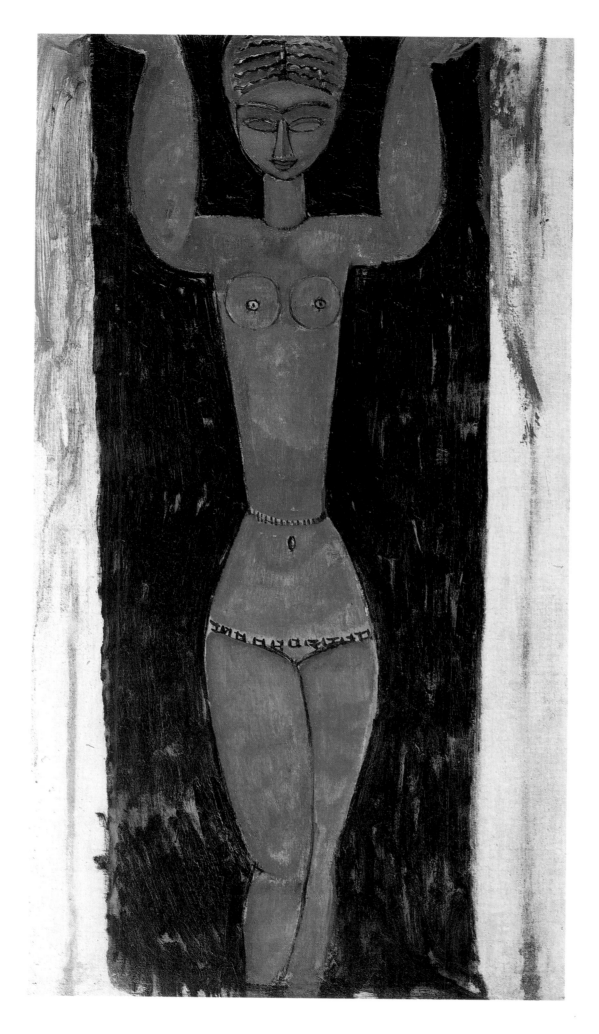

16 Caryatid *1913*

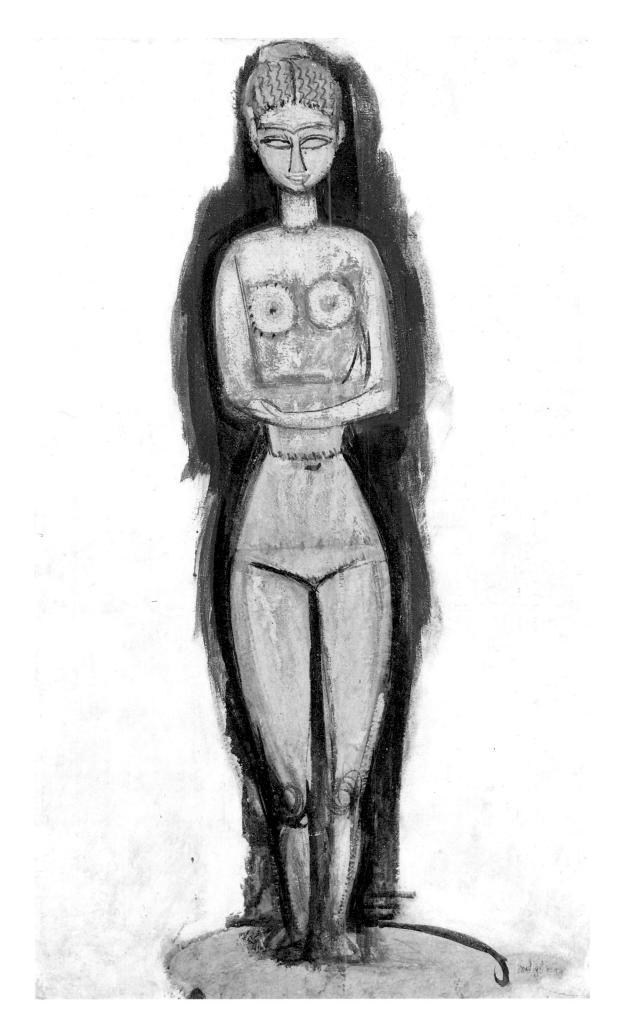

17 Standing Nude *1911/12*

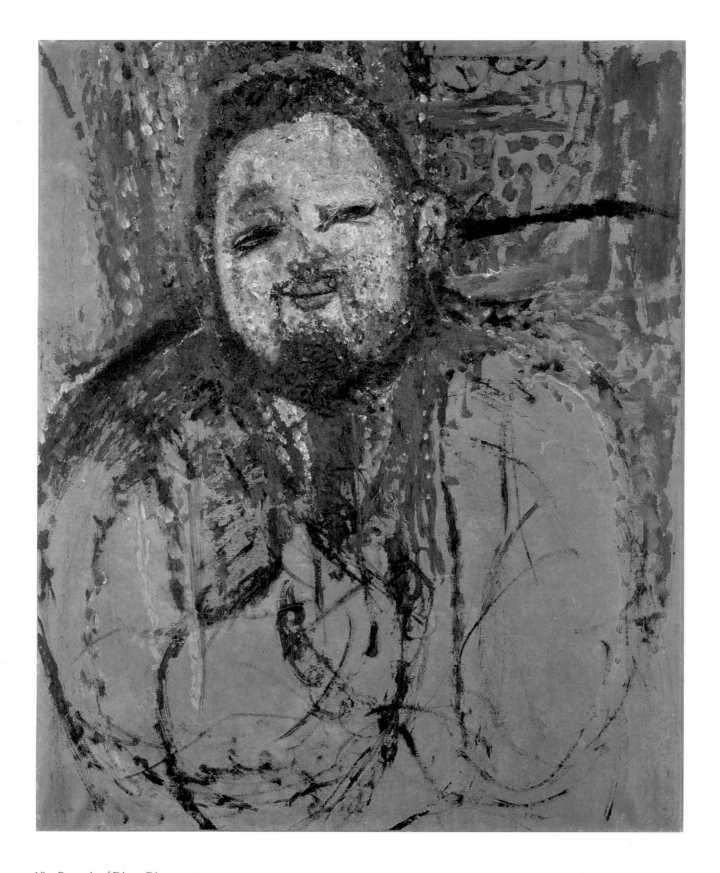

18 Portrait of Diego Rivera *1914*

19 Portrait of Diego Rivera *1914*

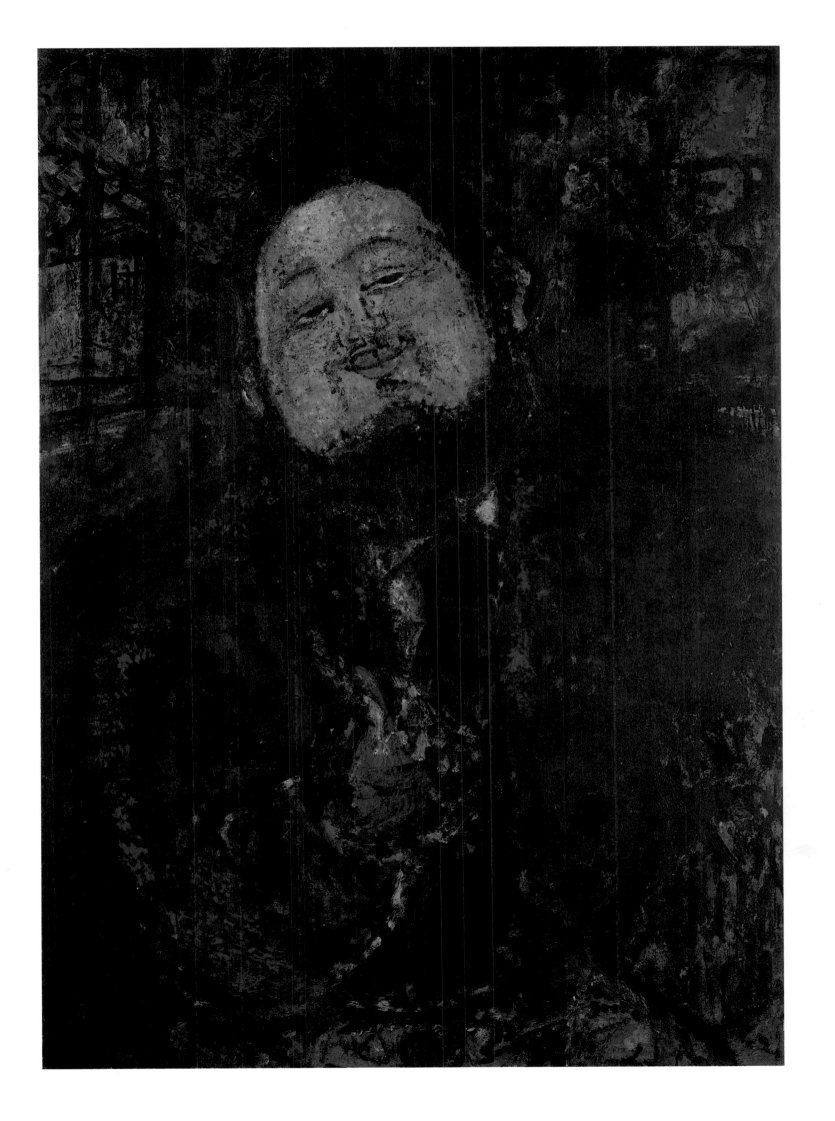

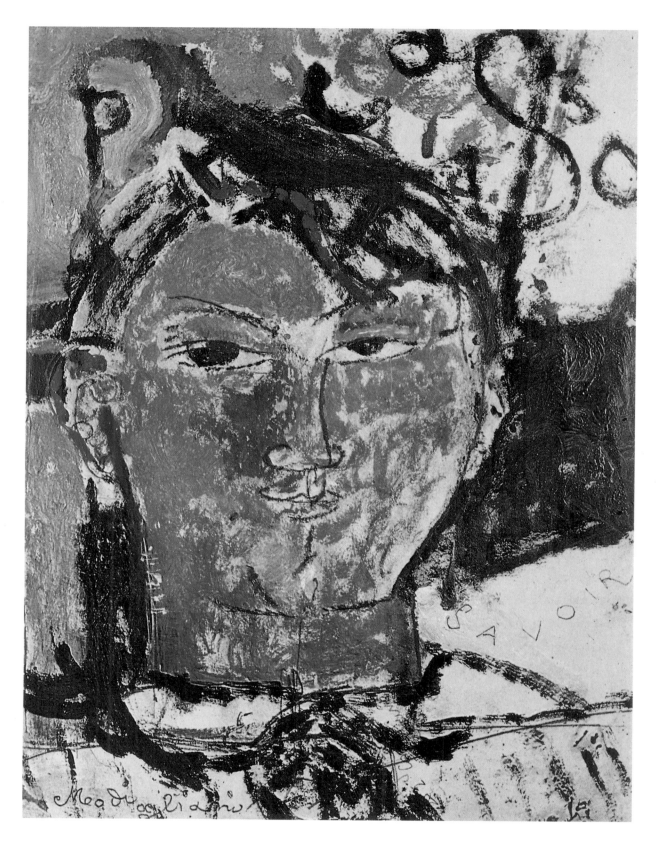

20 Portrait of Pablo Picasso *1915*

21 Portrait of Frank Burty Haviland *1914*

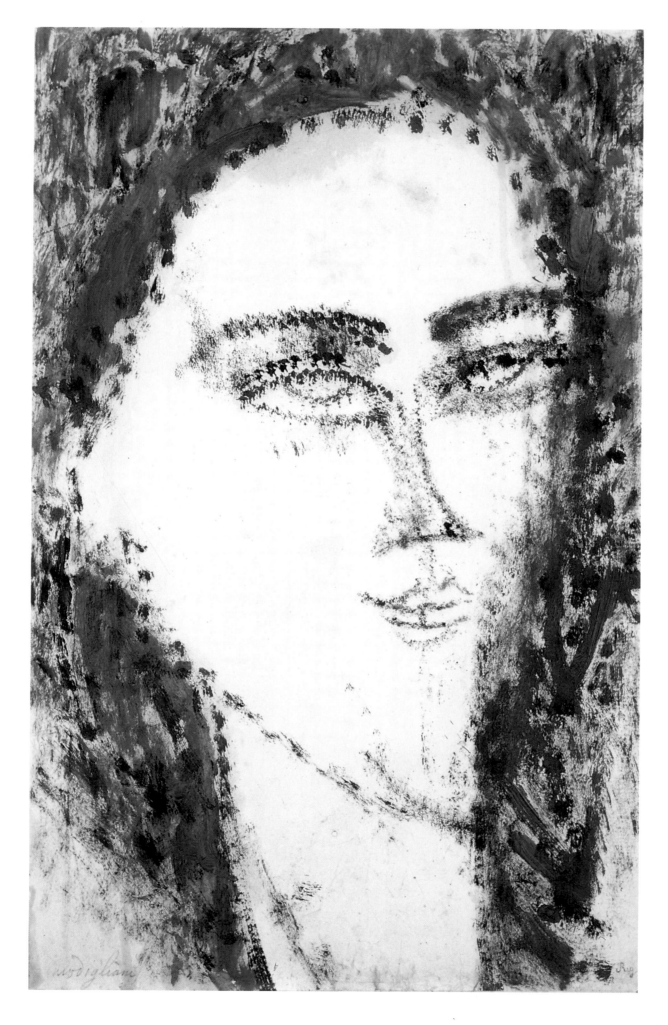

22 Head *c. 1915*

23 Portrait drawing of Beatrice Hastings *c. 1916*

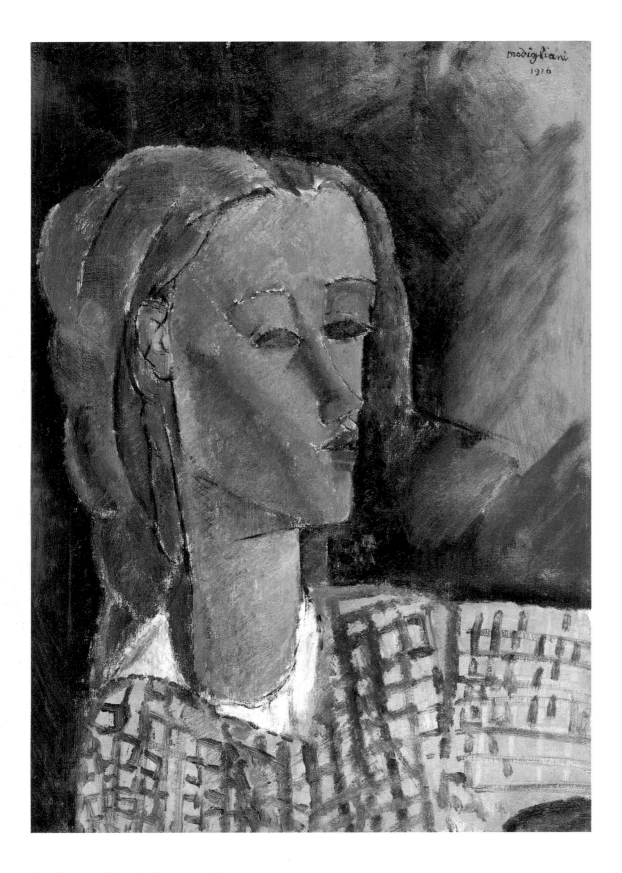

24 Portrait of Beatrice Hastings *1916*

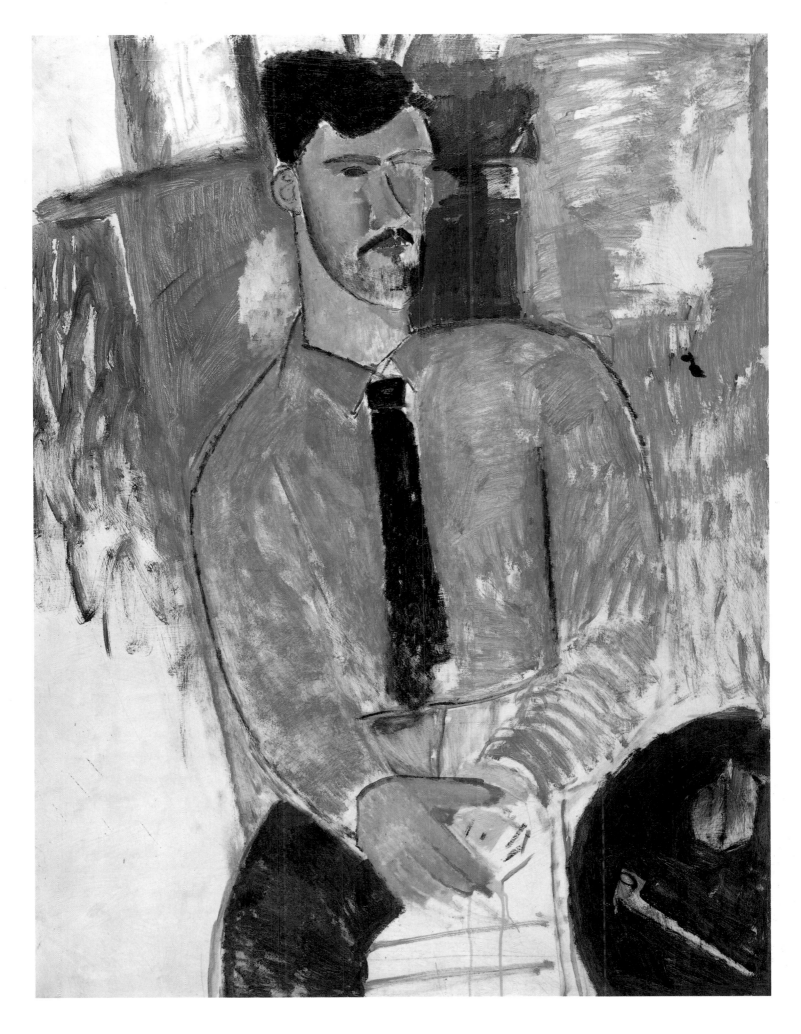

25 Portrait of Henri Laurens *1915*

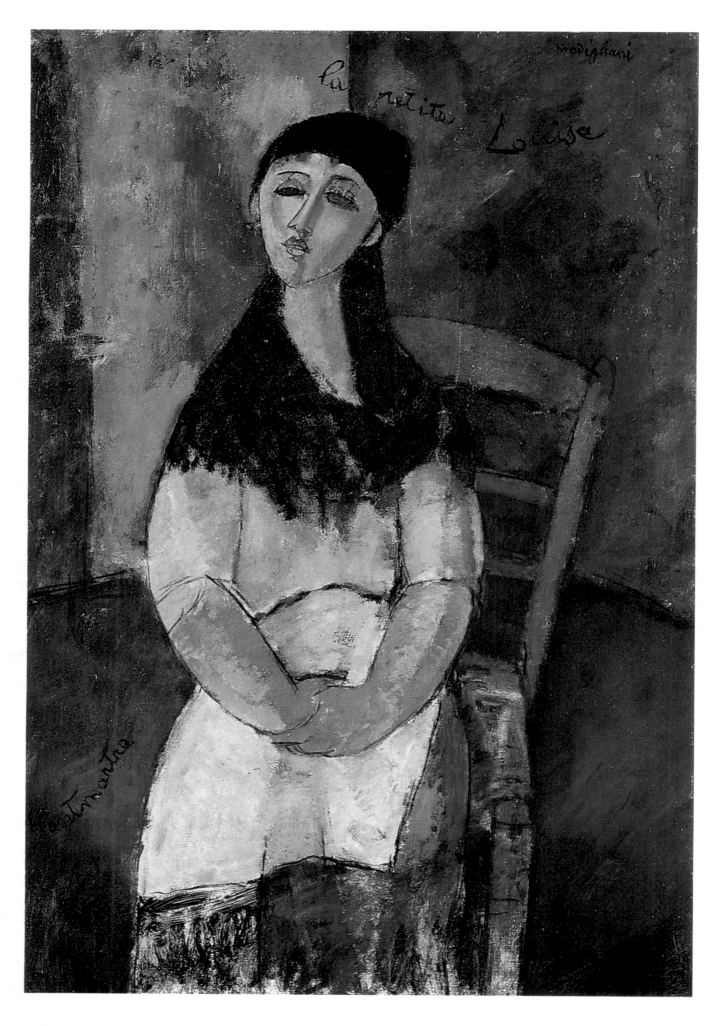

26 Little Louise *1915*

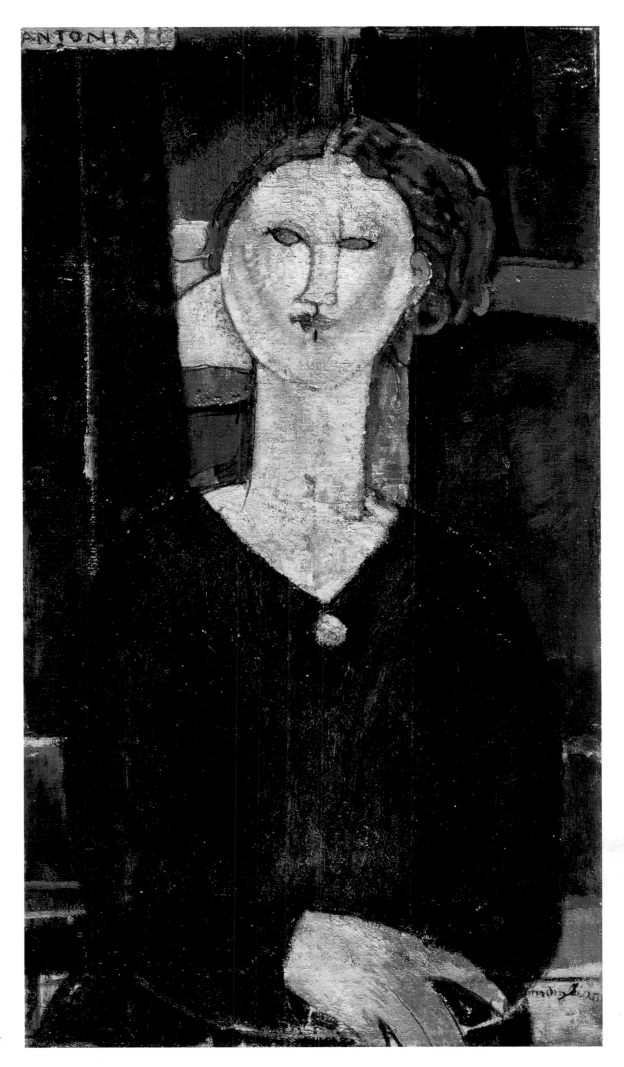

27 Antonia *1915*

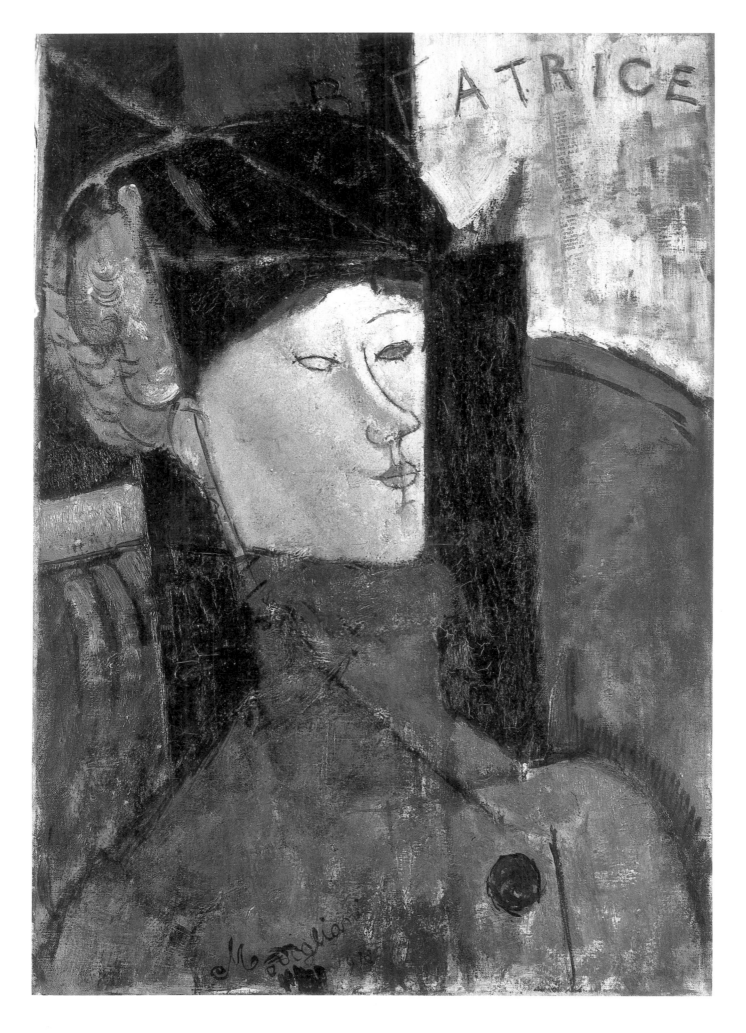

28 Portrait of Beatrice Hastings *1916*

29 Head *1915*

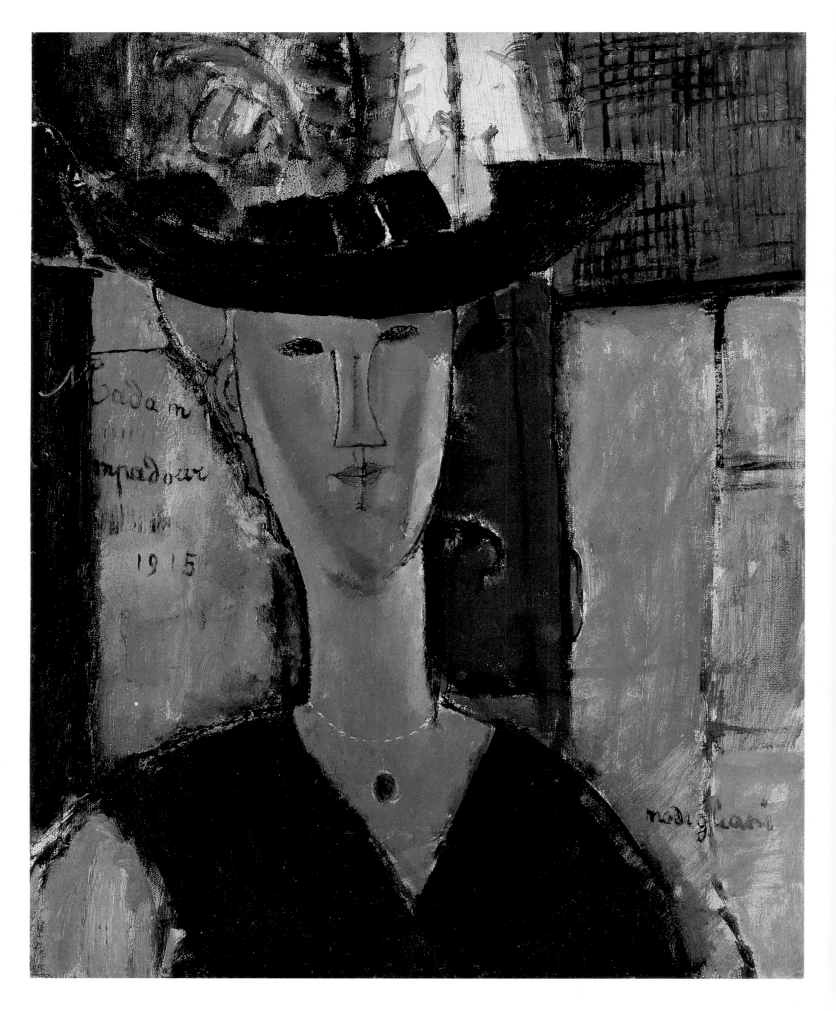

30 Madam Pompadour *1915*

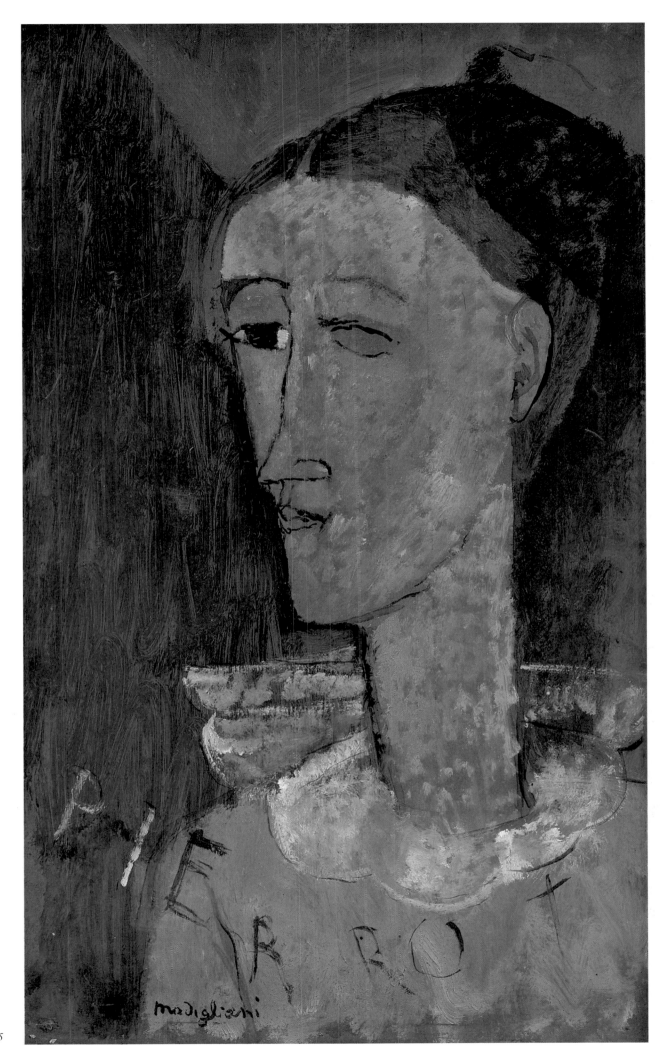

31 Pierrot *1915*

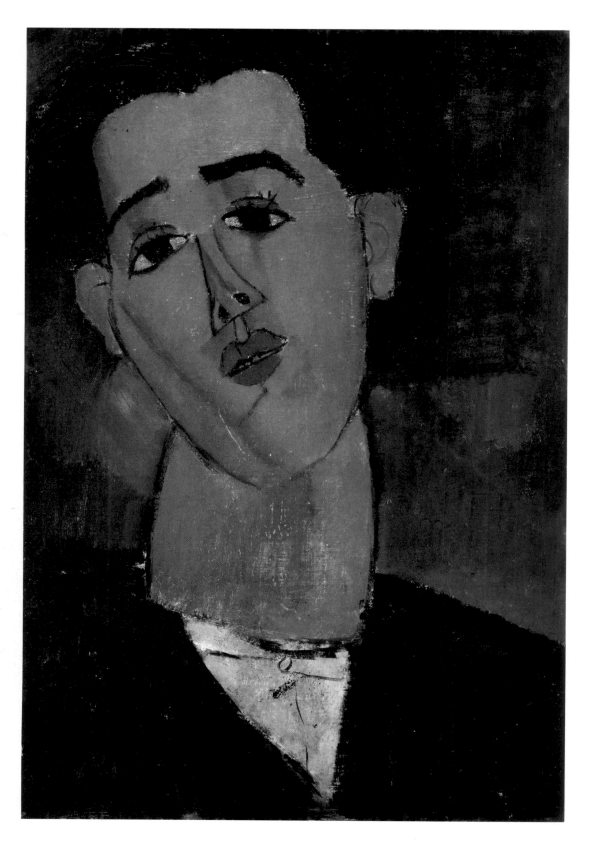

32 Portrait of Juan Gris *c. 1915*

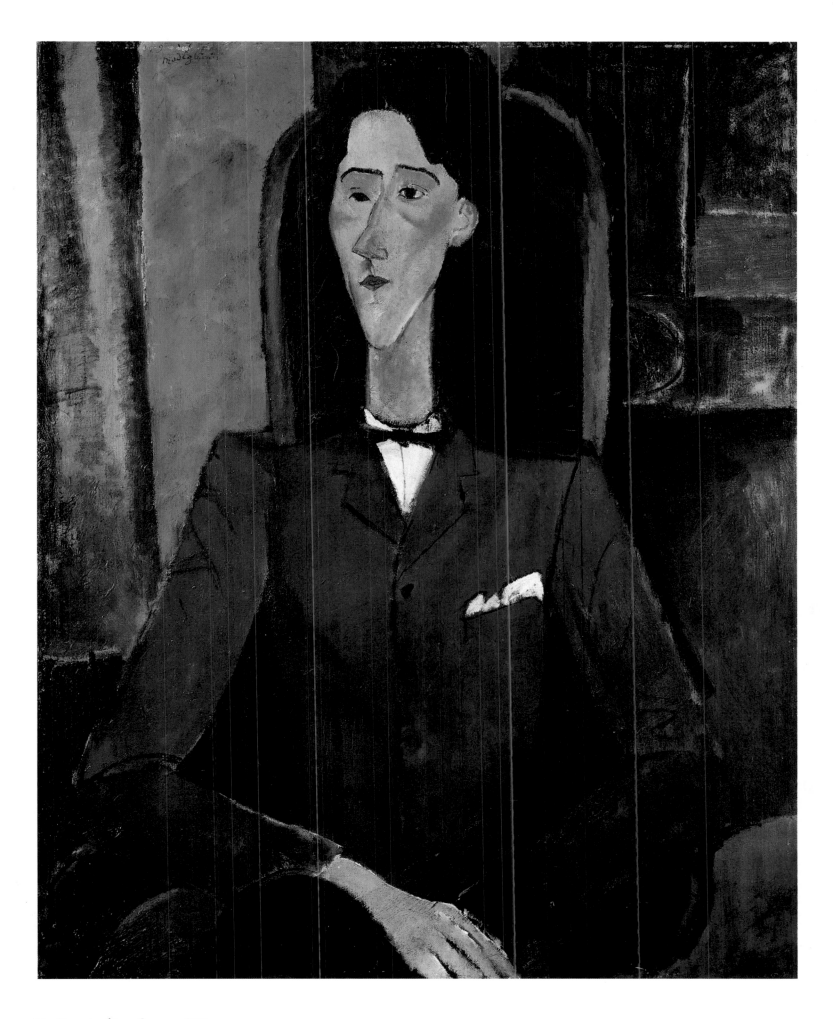

33 Portrait of Jean Cocteau *1916*

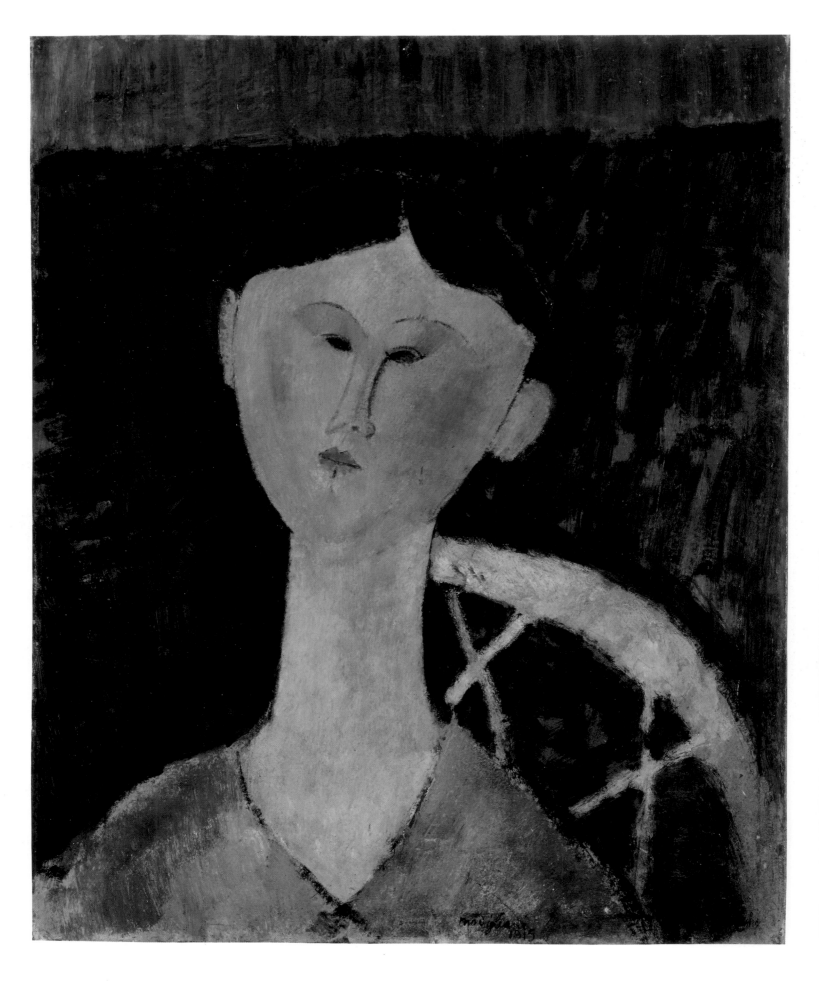

34 Portrait of Beatrice Hastings *1915*

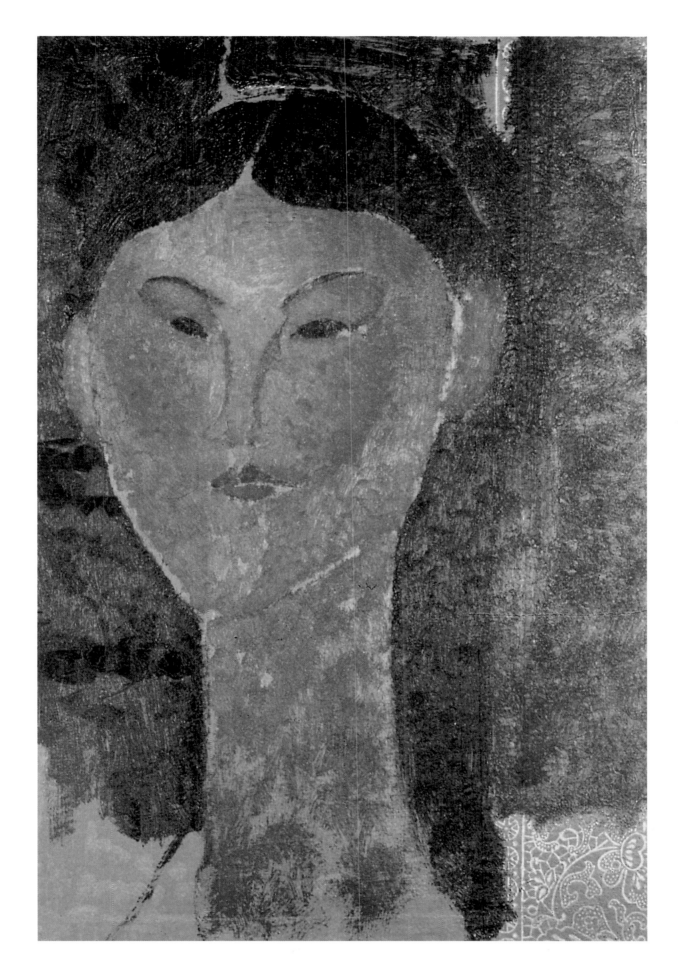

35 Portrait of Beatrice Hastings *1915*

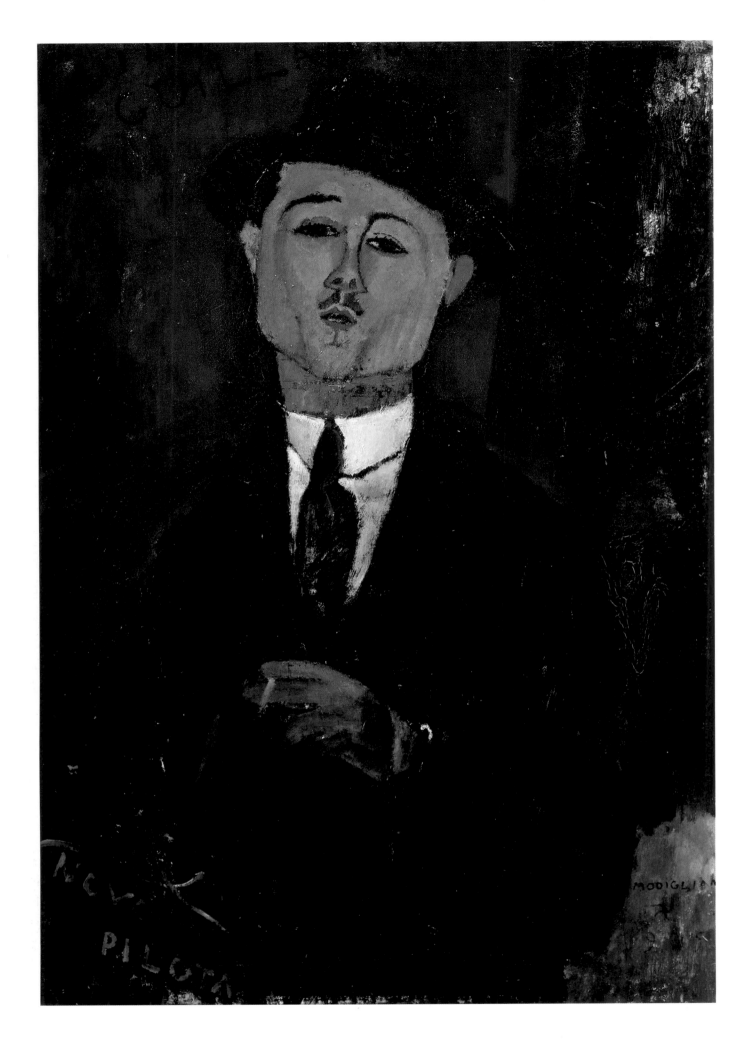

36 Portrait of Paul Guillaume—Novo Pilota *1915*

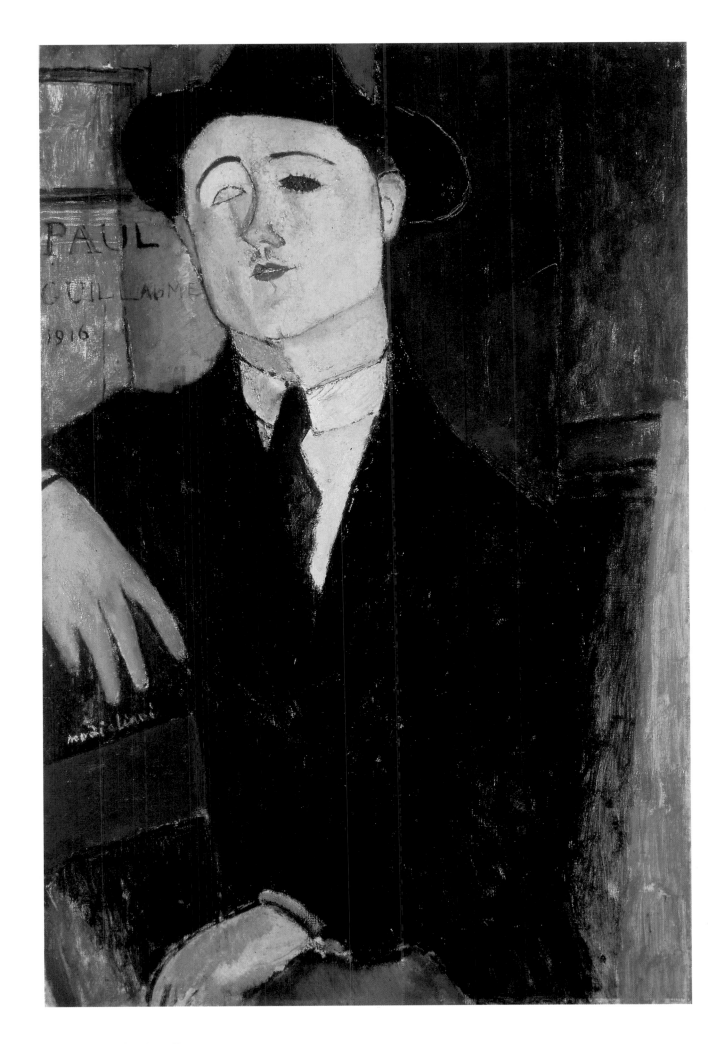

37 Portrait of Paul Guillaume *1916*

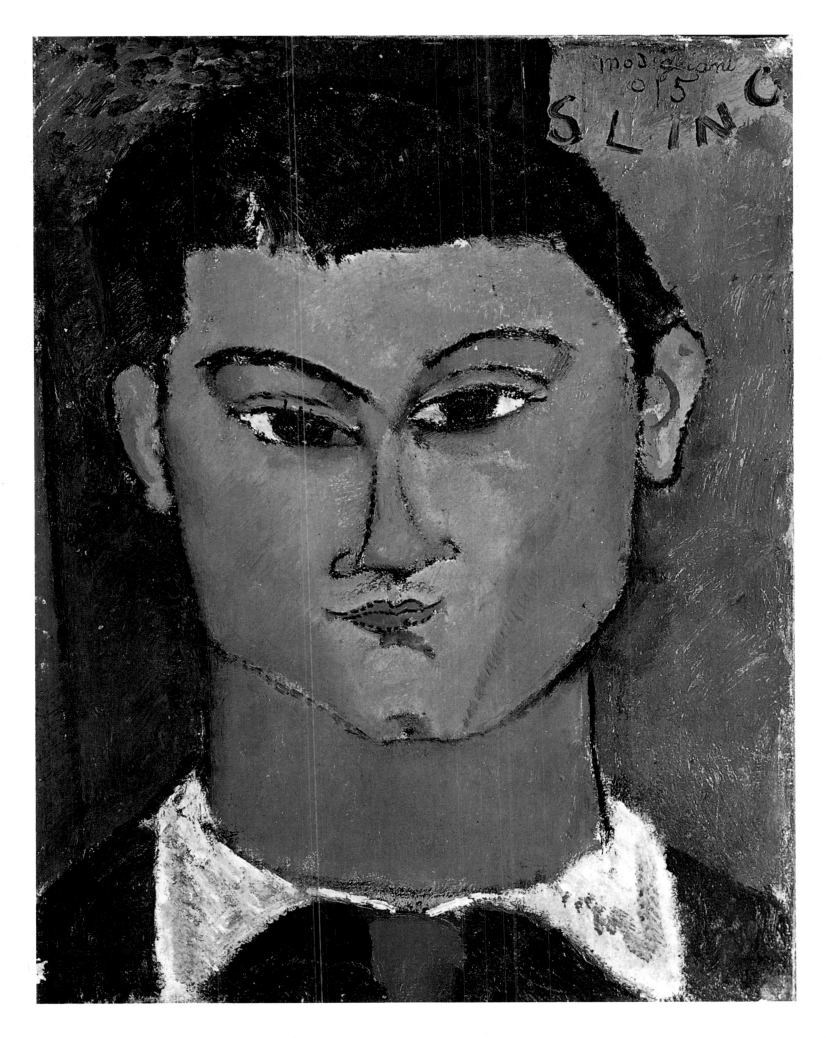

38 Portrait of Moïse Kisling *1915*

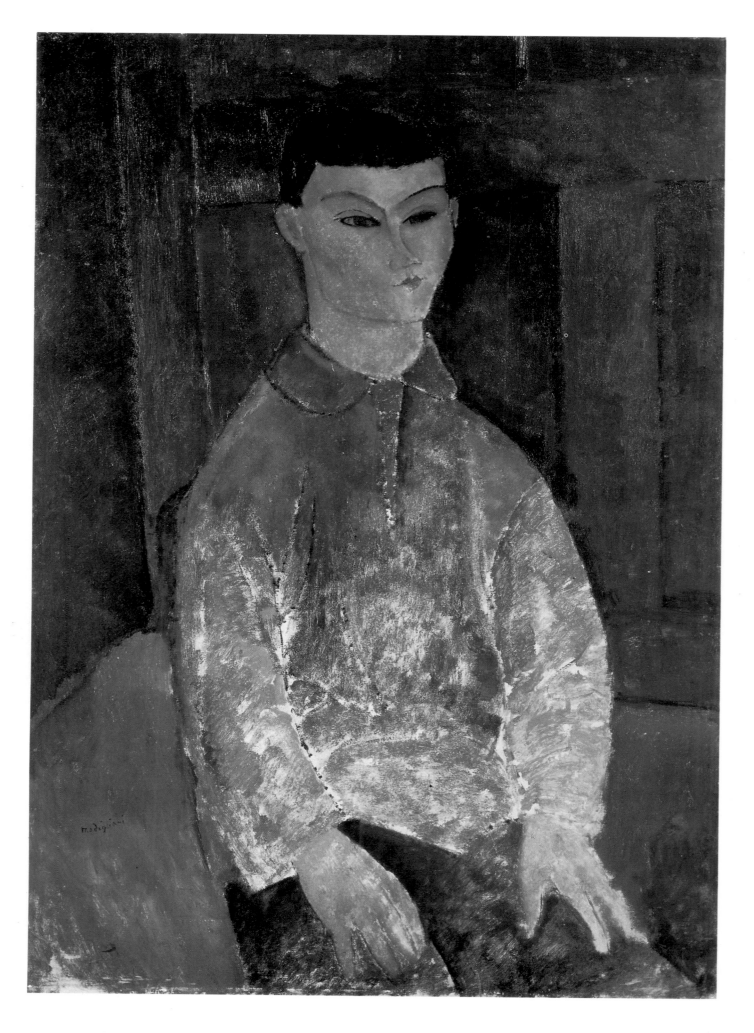

39 Portrait of Moïse Kisling *1916*

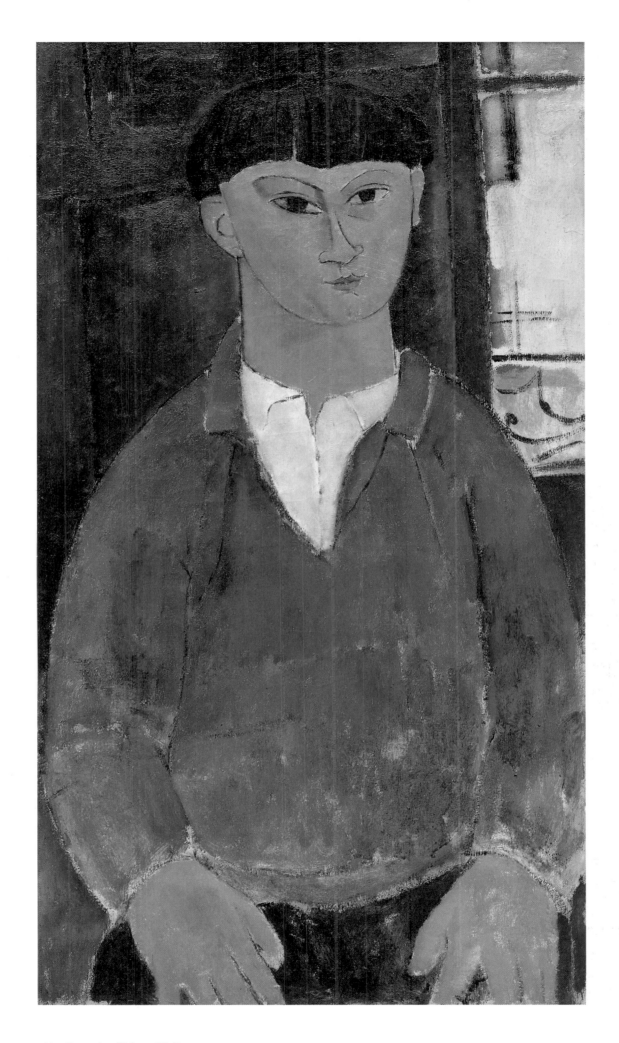

40 Portrait of Moïse Kisling *1916*

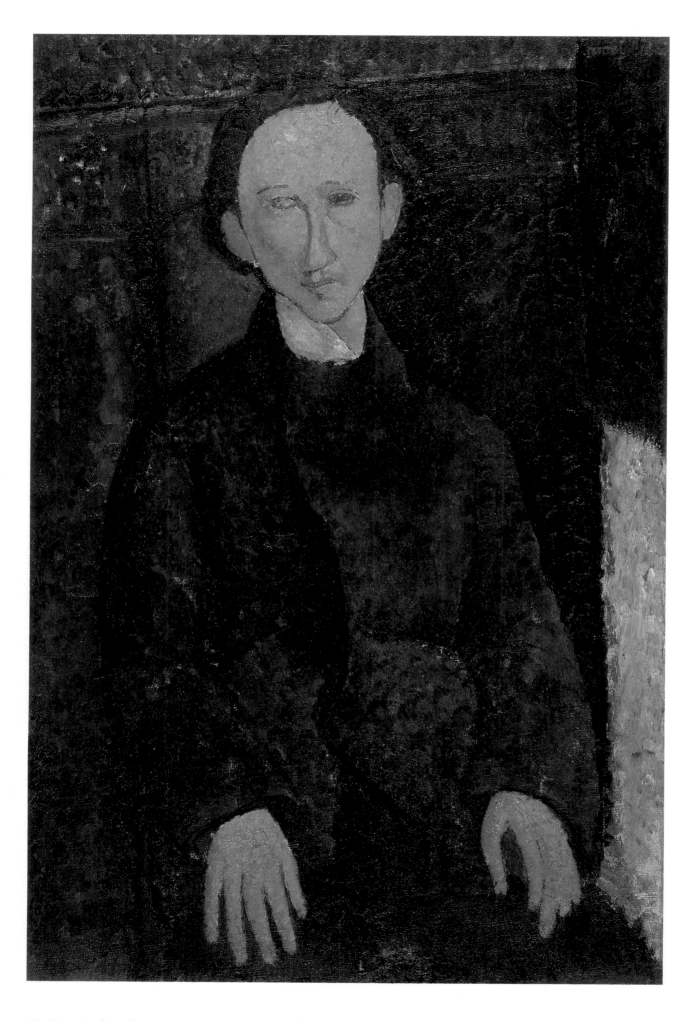

41 Portrait of Pinchus Krémègne *1916*

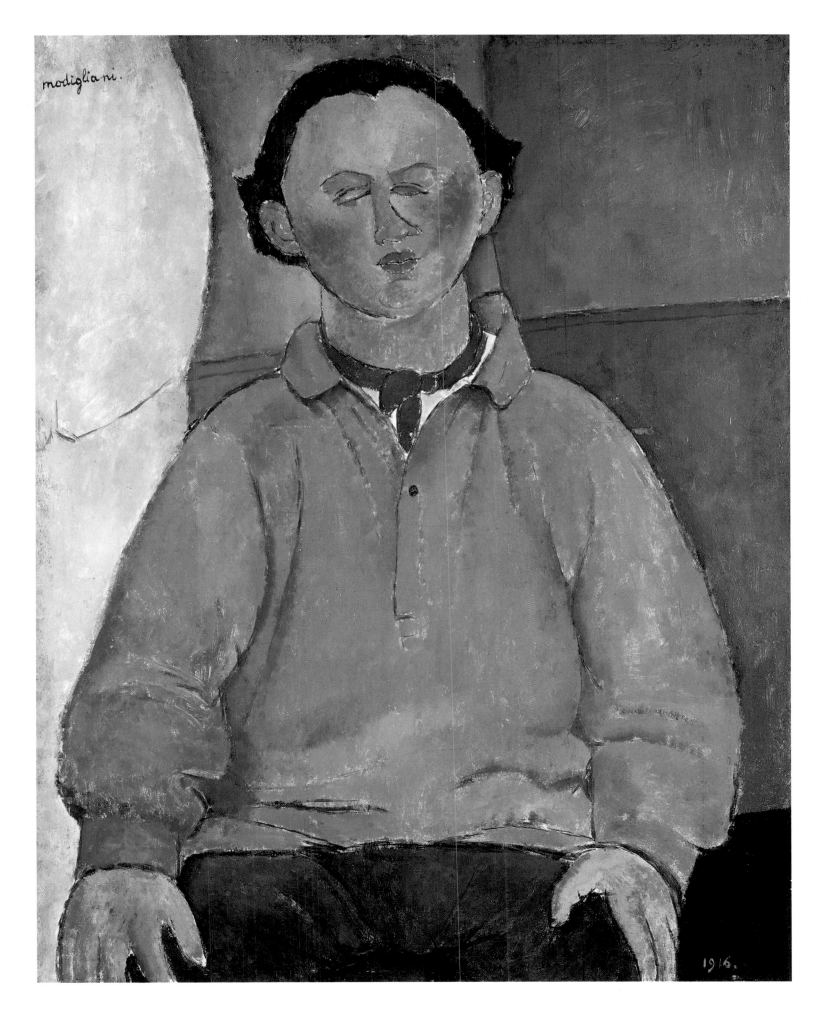

42 Portrait of Oscar Miestchaninoff *1916*

43 The Servant *1916*

44 Girl with Black Apron *1918*

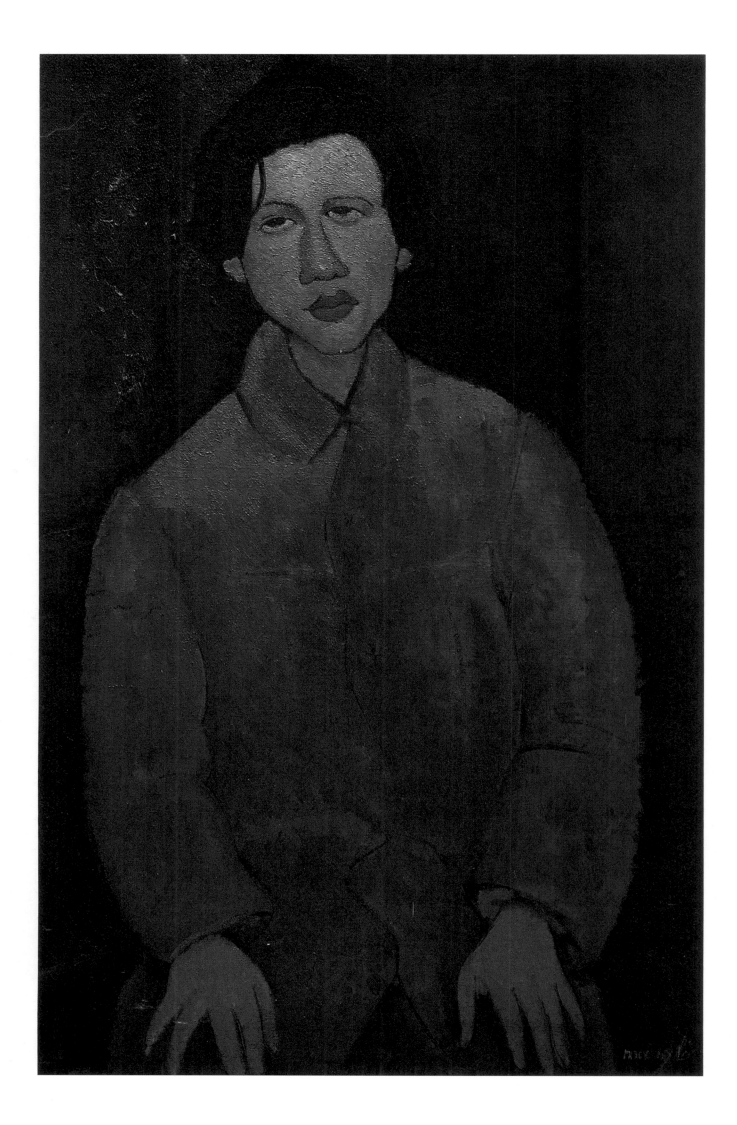

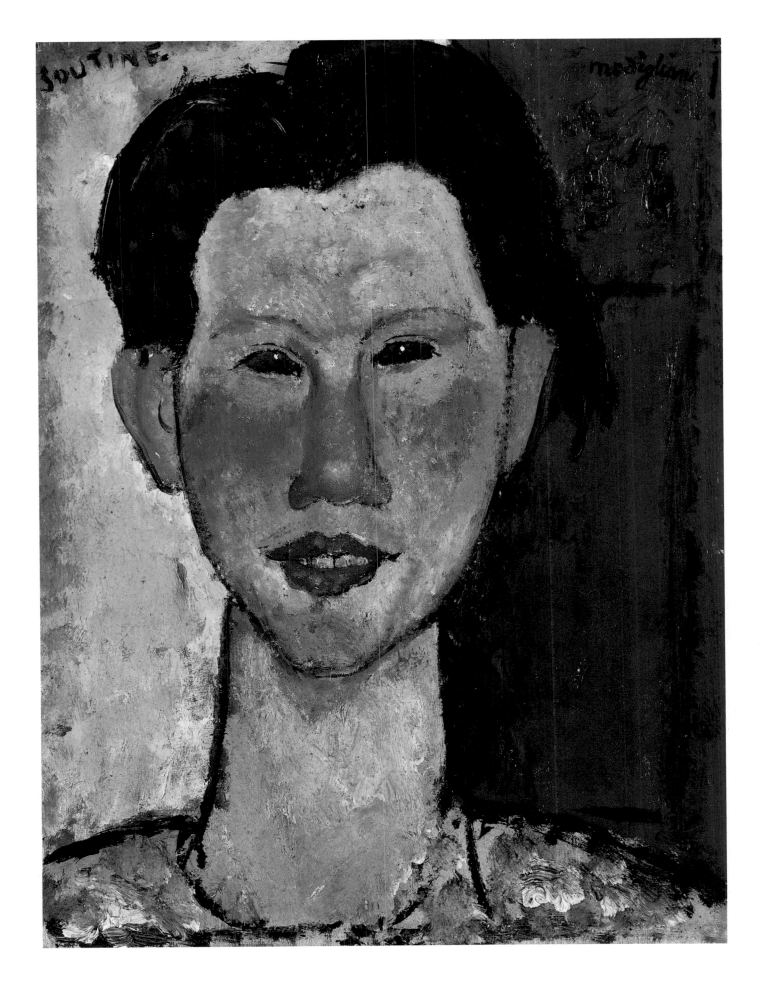

47 Portrait of Chaim Soutine *1915*

46 Portrait of Chaim Soutine *1916*

48 Portrait of Leopold Zborowski *1916*

49 Portrait of Leopold Zborowski *1916/17*

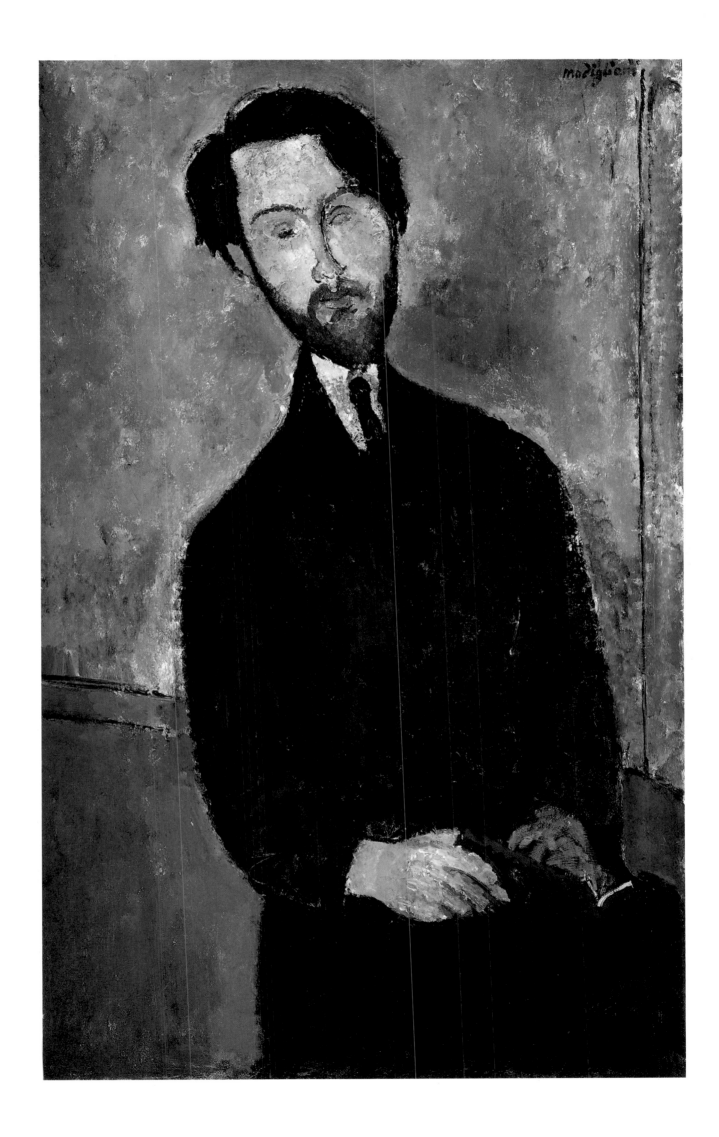

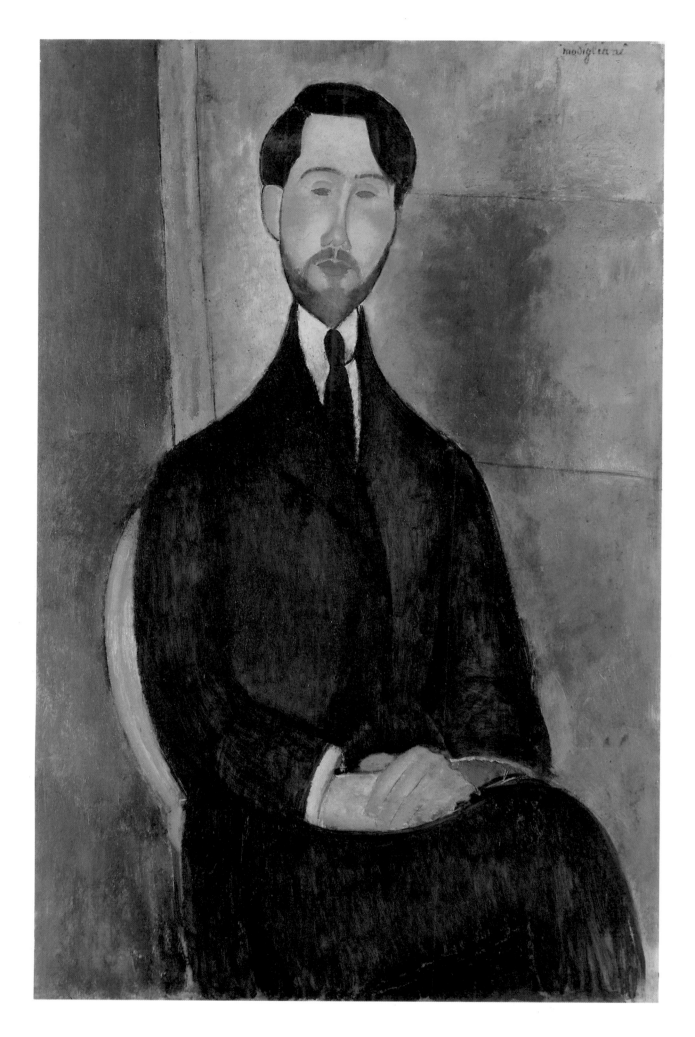

50 Portrait of Leopold Zborowski *1919*

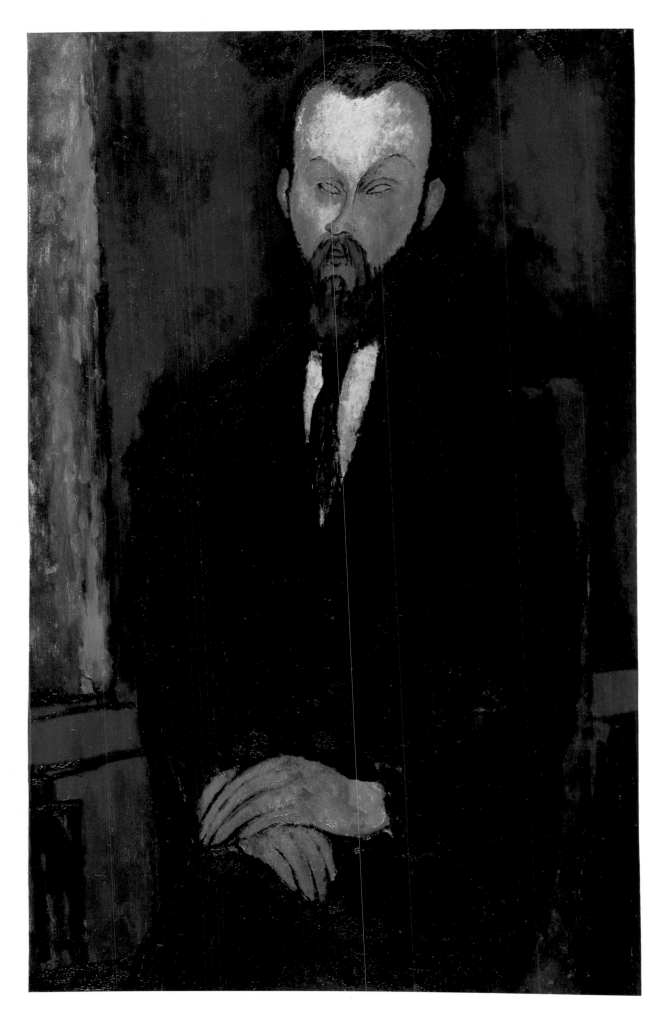

51 Portrait of M. Wielhorski *1918*

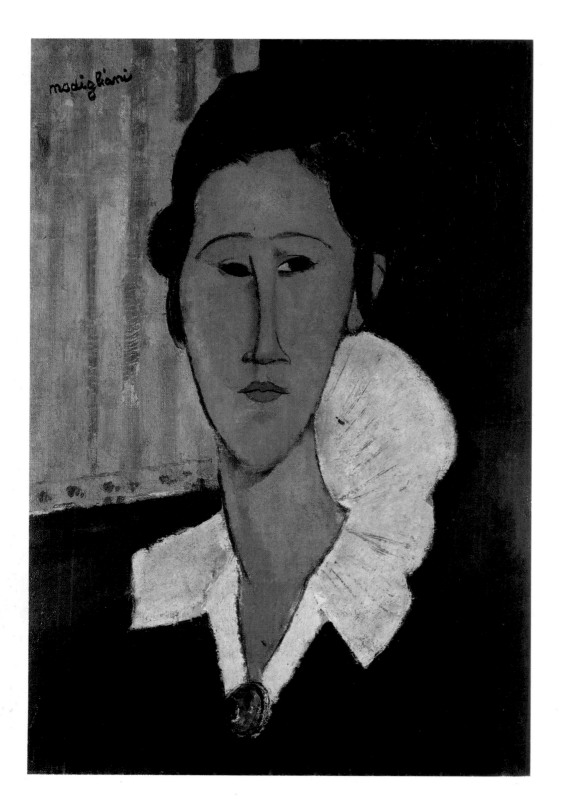

52 Portrait of Anna Zborowska *1917*

53 Portrait of Anna Zborowska *1917*

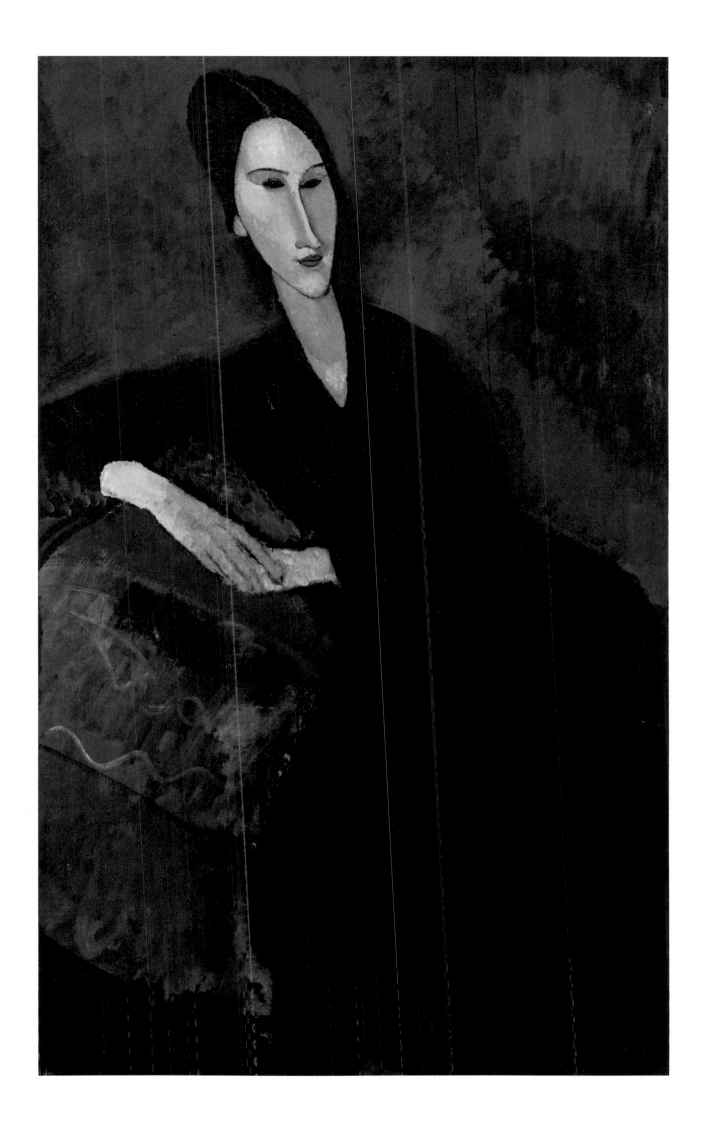

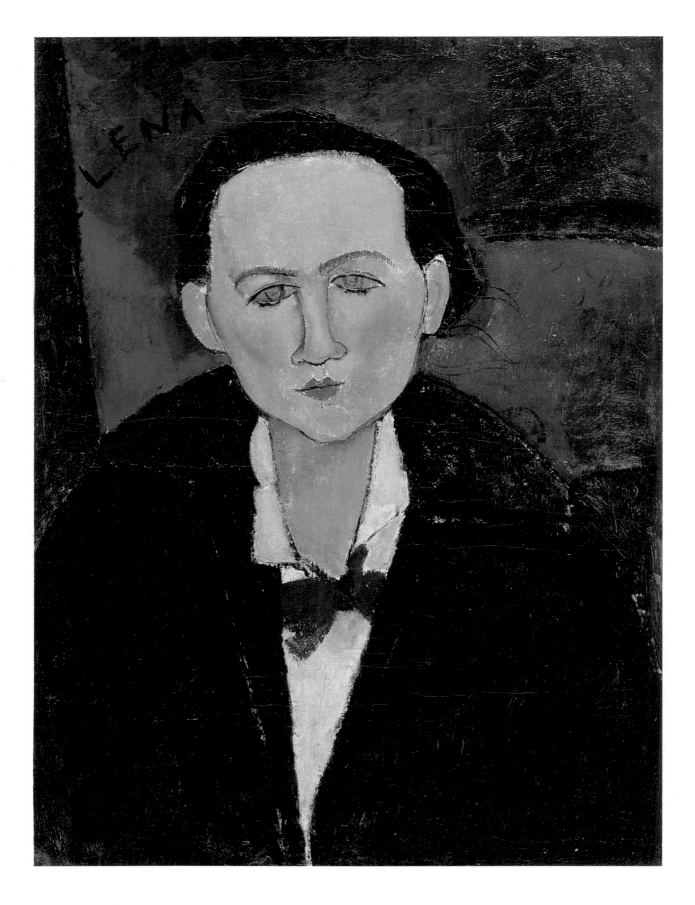

54 Portrait of Elena Pavlowski *1917*

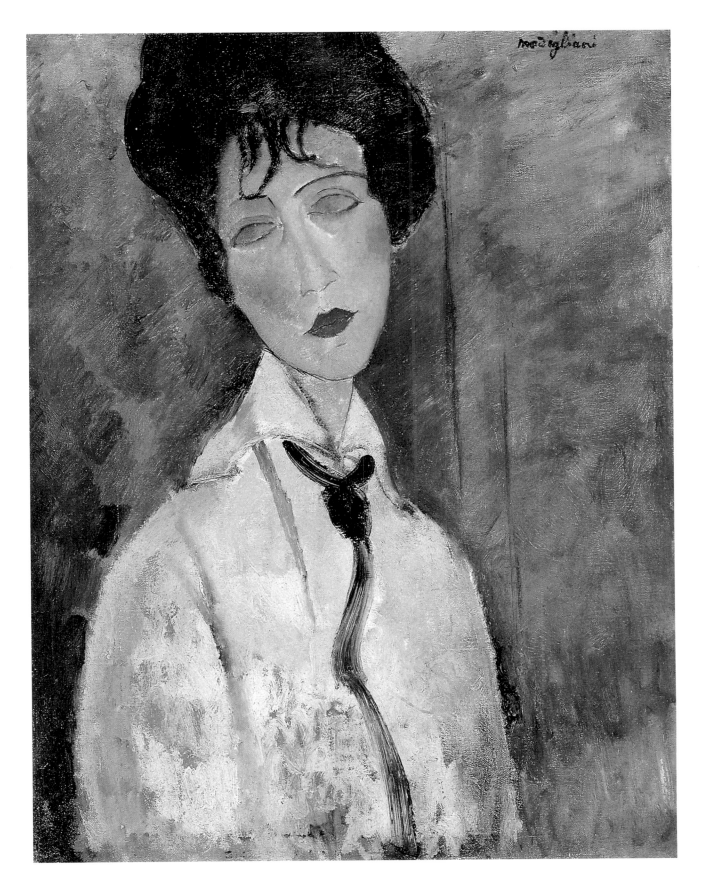

55 Portrait of a Woman with Black Tie *1917*

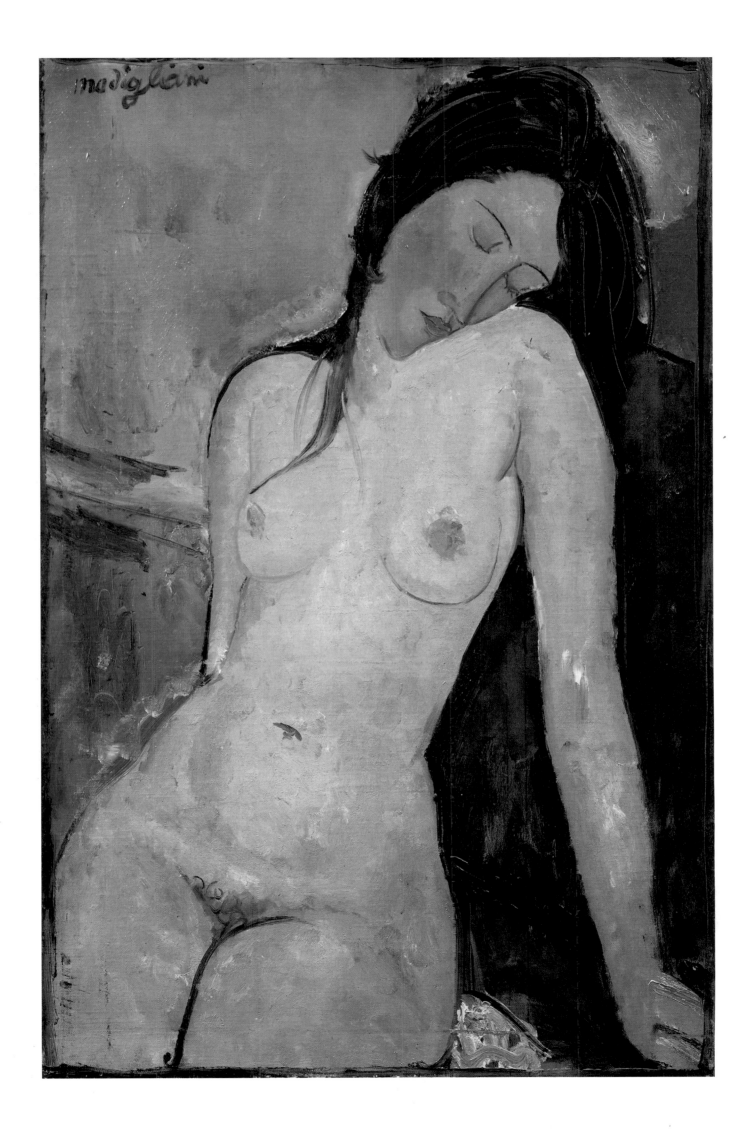

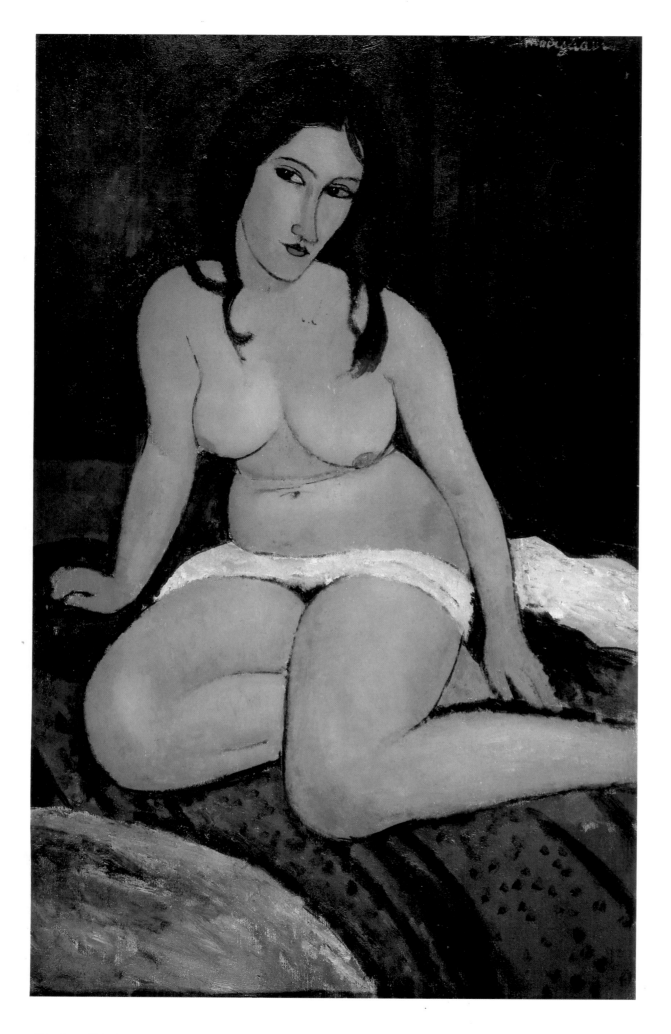

57 Seated Nude *1917*

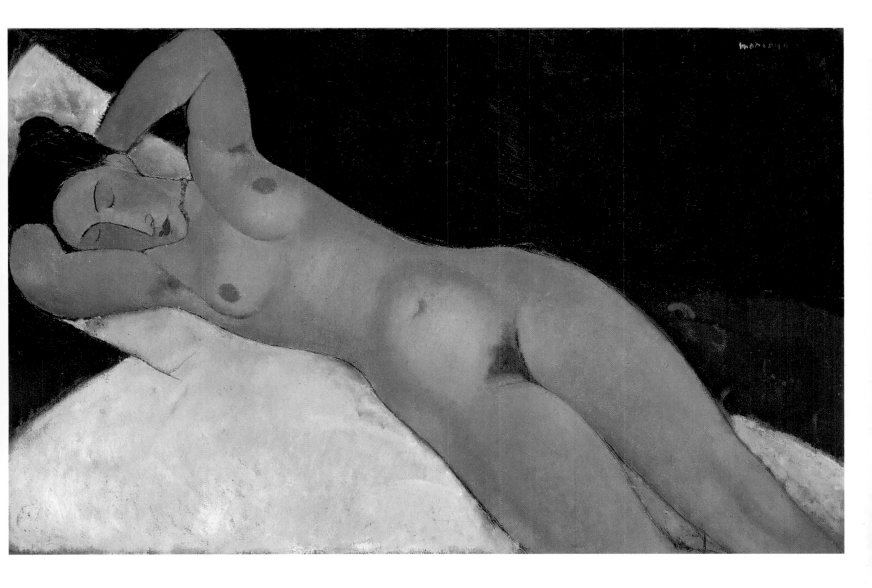

58 Nude with Necklace *1917*

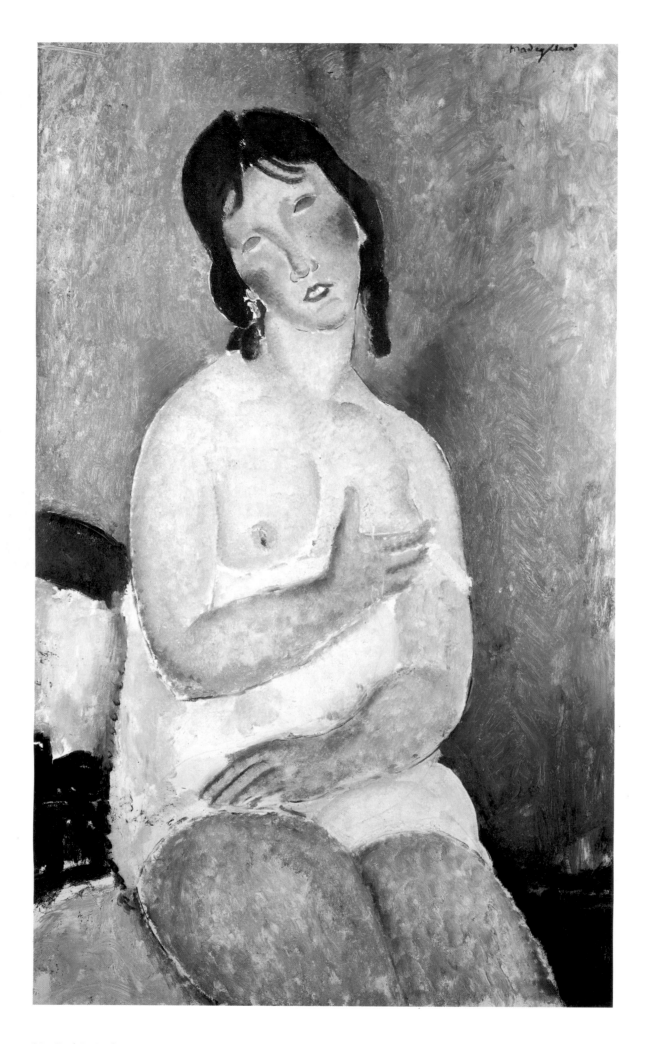

59 Red-Haired Young Woman in a Shift *1918*

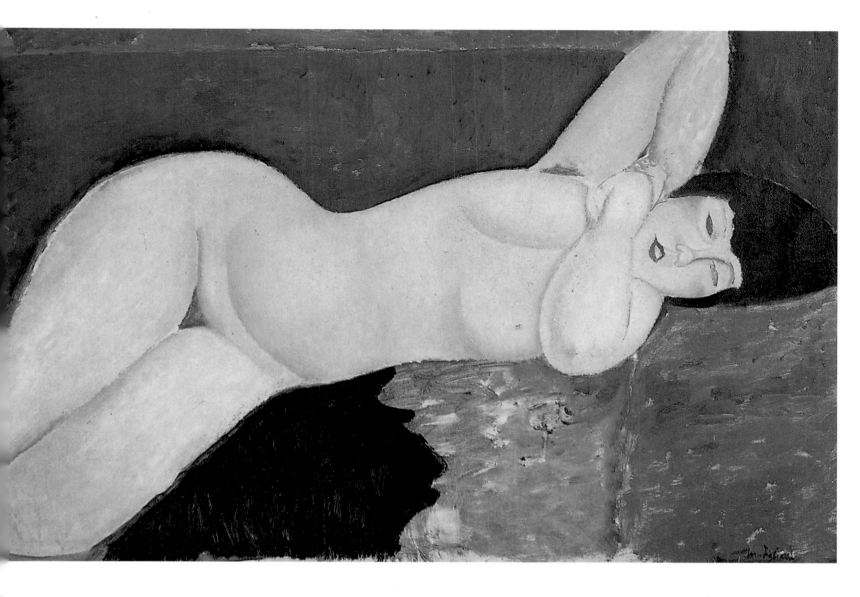

Nude *1917*

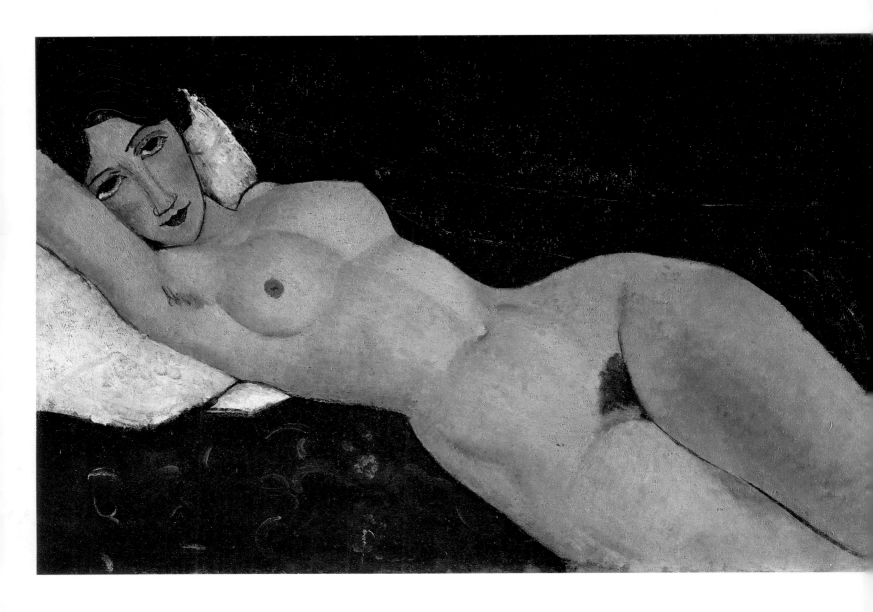

61 Reclining Female Nude *1917*

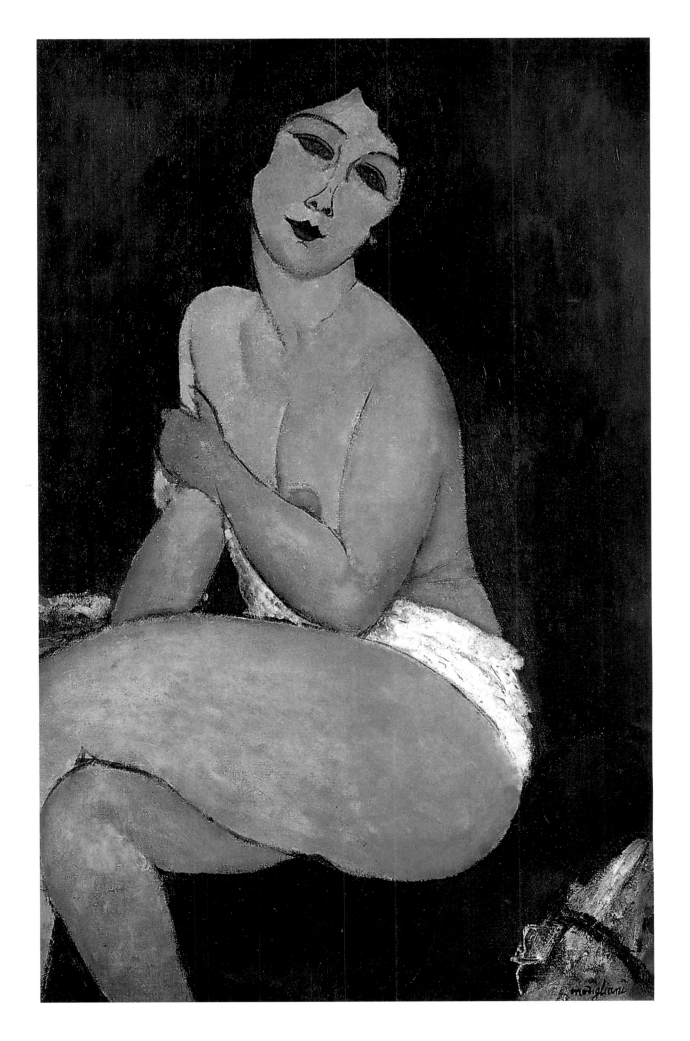

62 Seated Nude *1917*

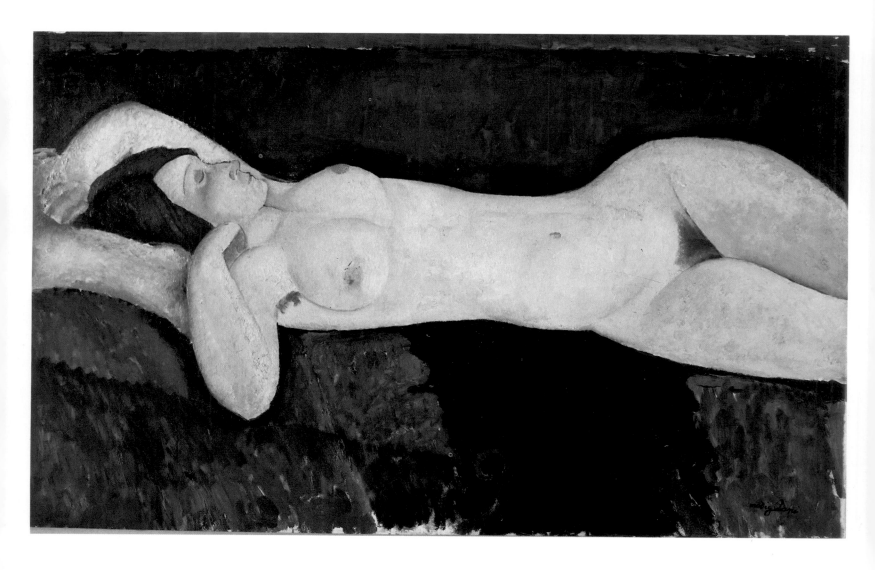

63 Reclining Nude—Le Grand Nu *c. 1919*

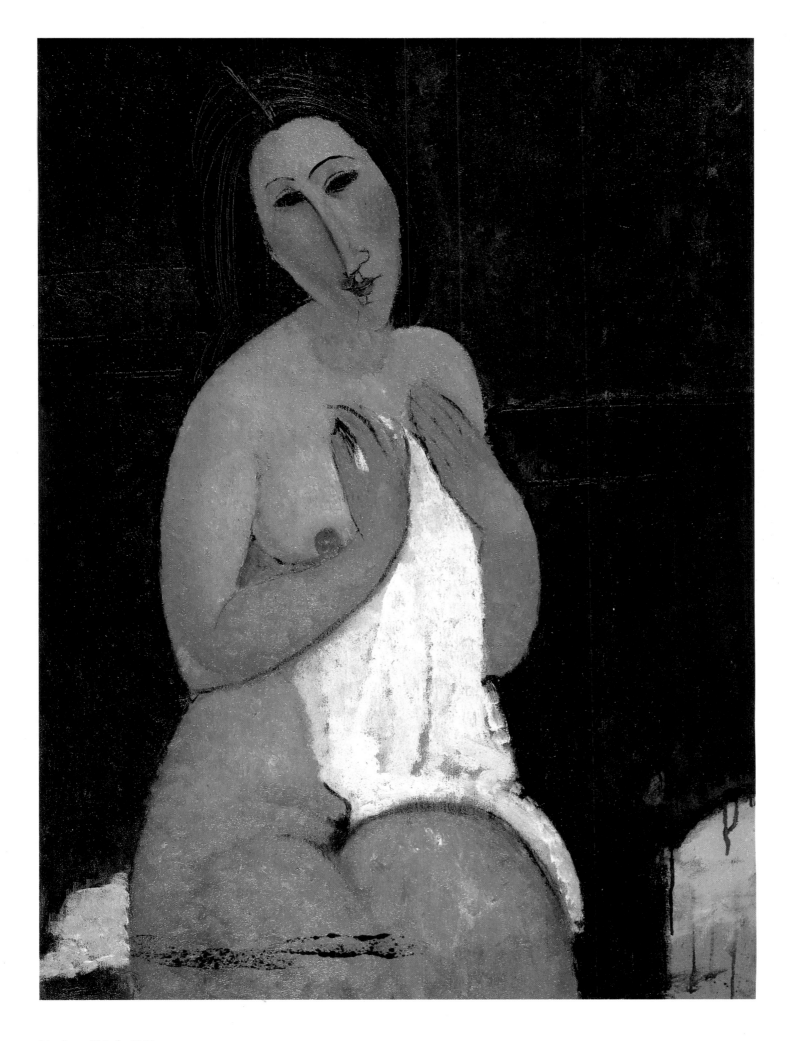

64 Seated Nude *1917*

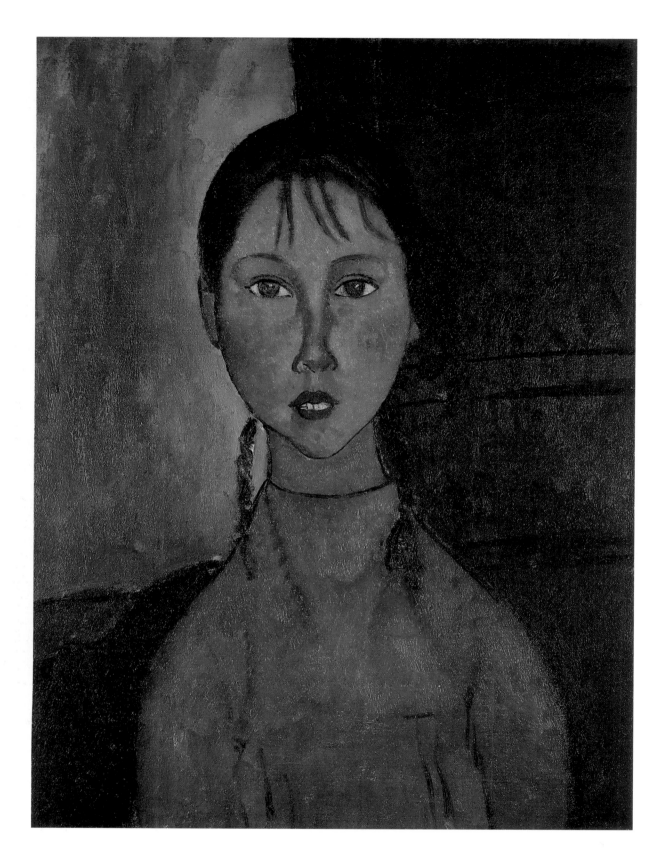

65 Girl with Pigtails *c. 1918*

66 Standing Nude—Elvira *1918*

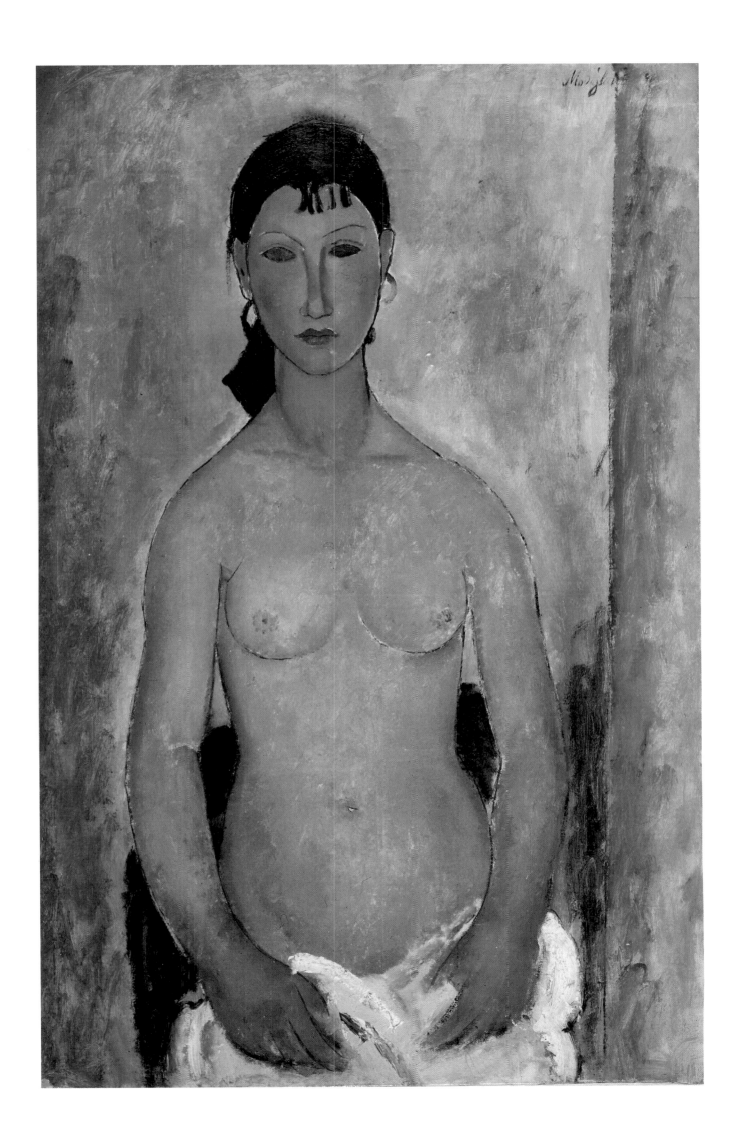

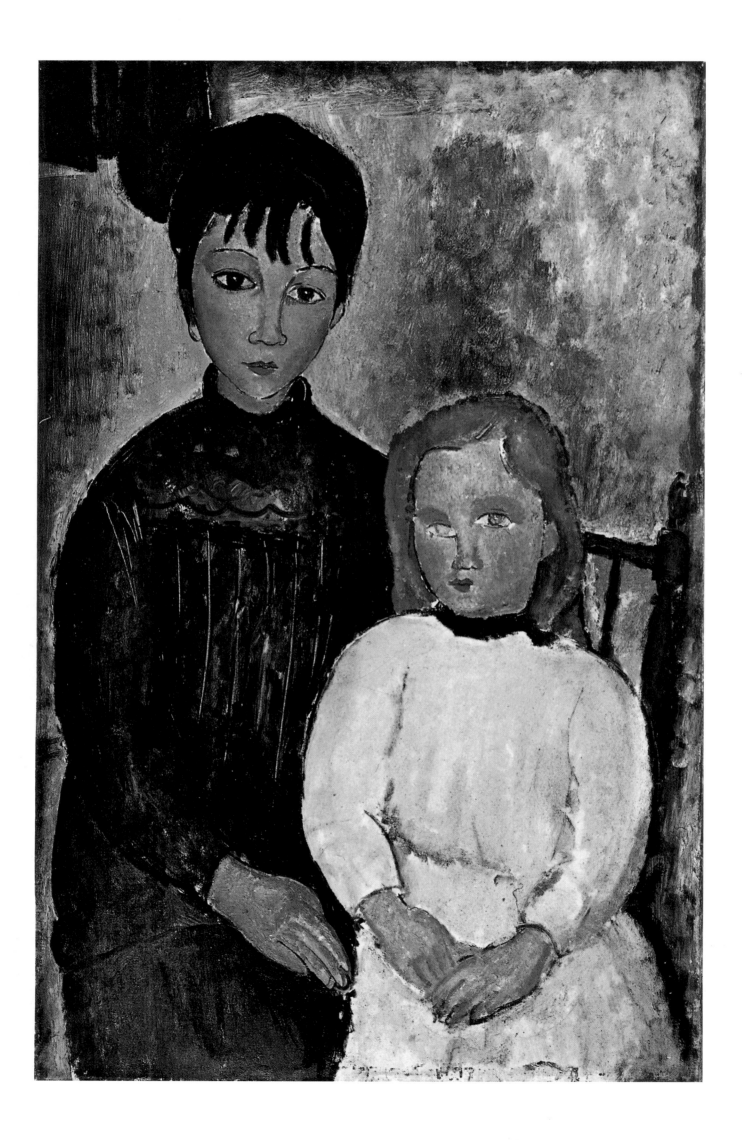

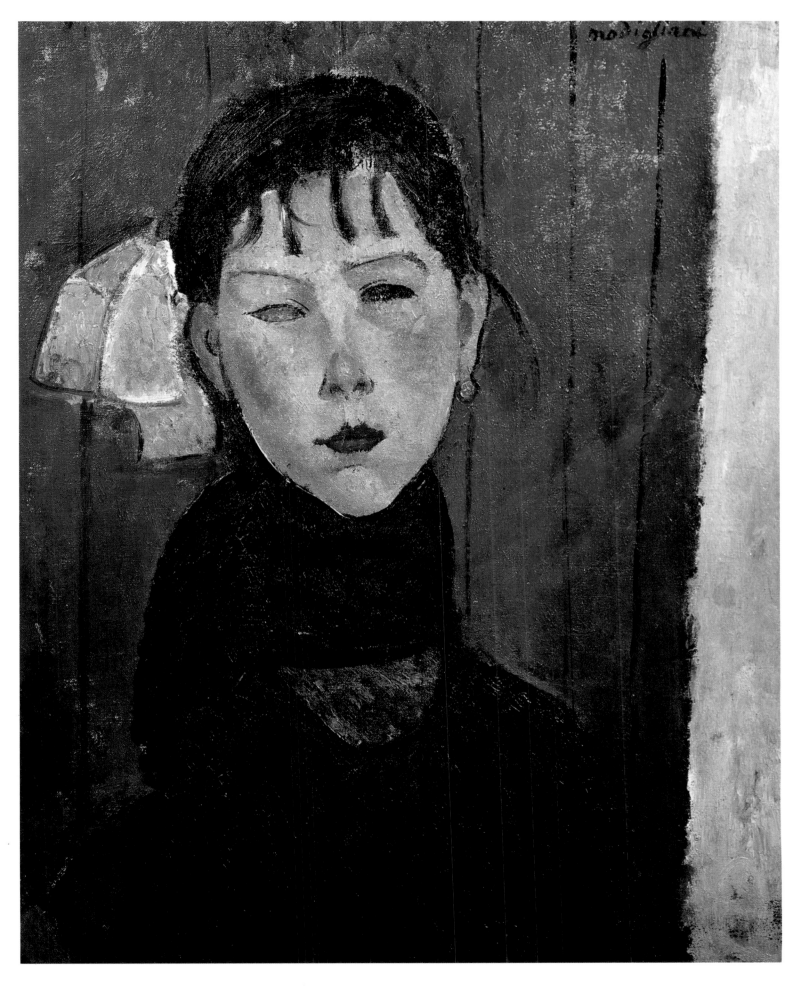

68 Marie *1918*

67 Two children *1918*

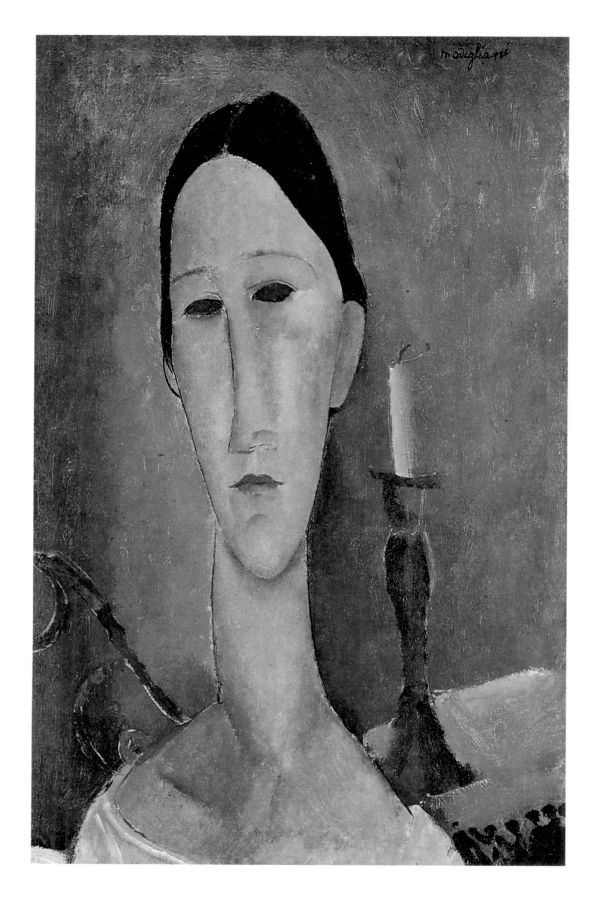

69 Portrait of Anna Zborowska *1919*

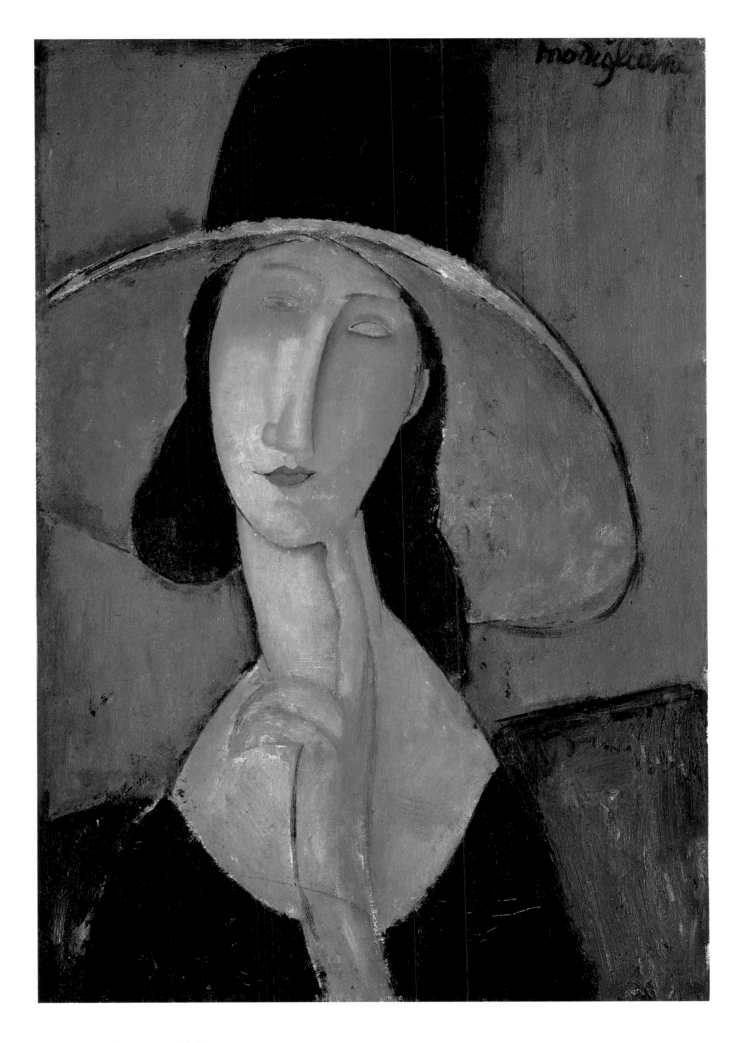

70 Portrait of a Woman with Hat *1917*

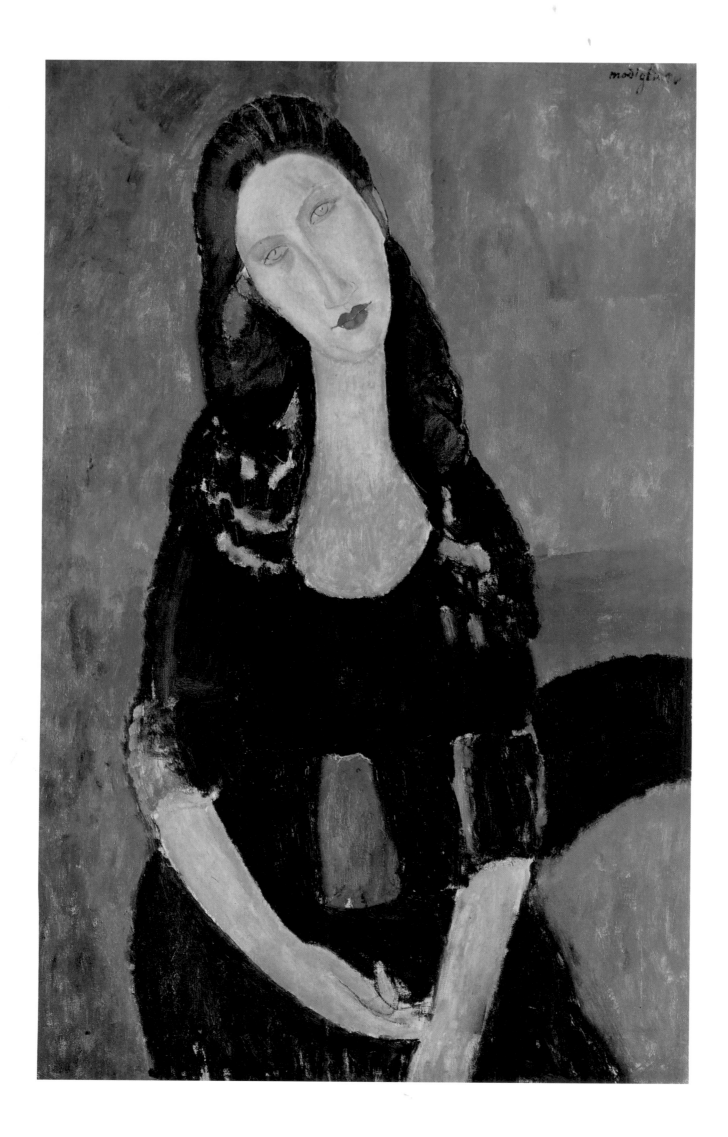

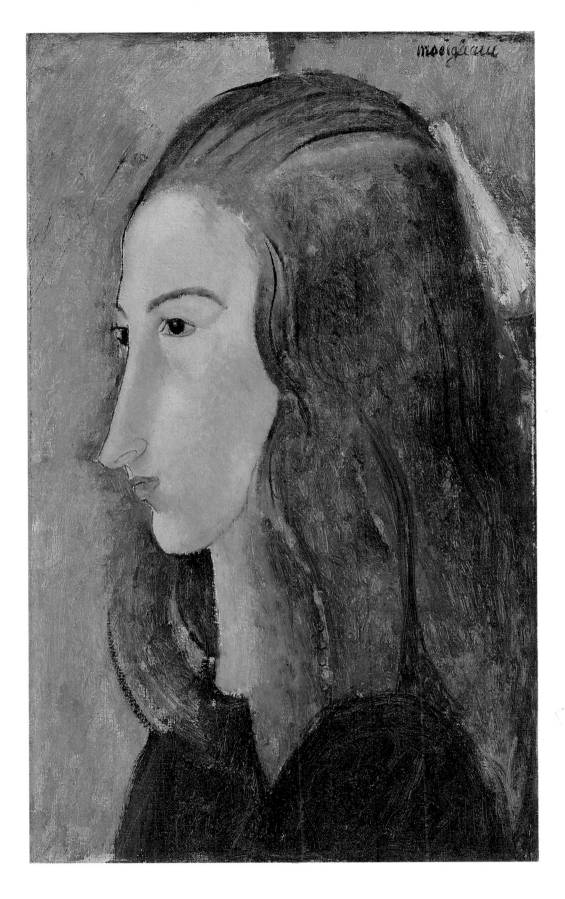

72 Portrait of Jeanne Hébuterne *1918*

71 Portrait of Jeanne Hébuterne *c. 1918*

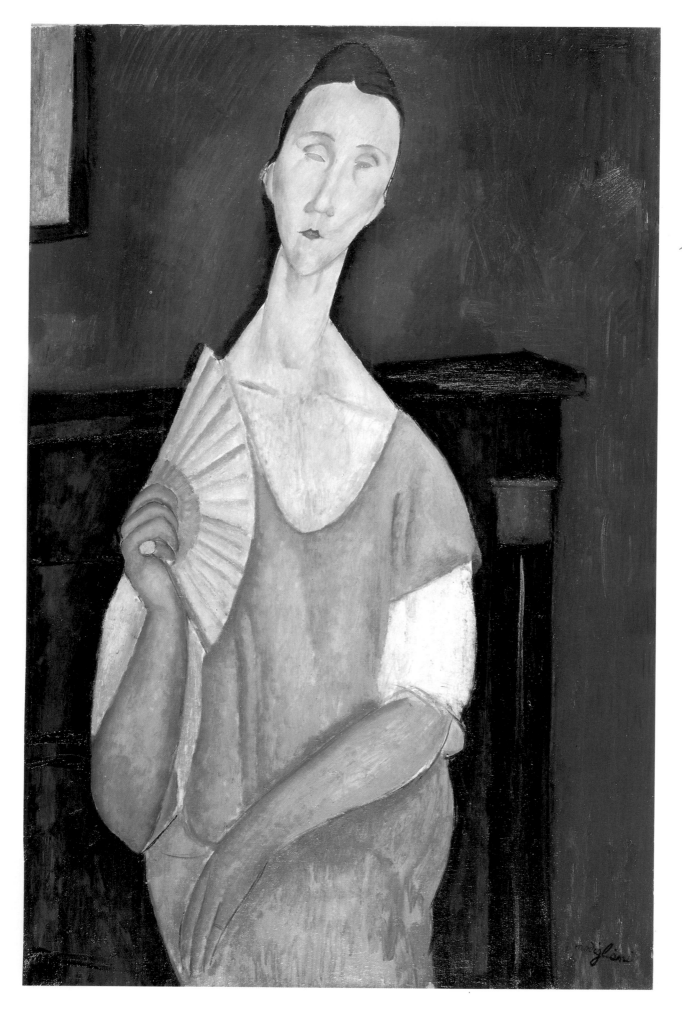

This one

73 Portrait of Lunia Czechowska *1919*

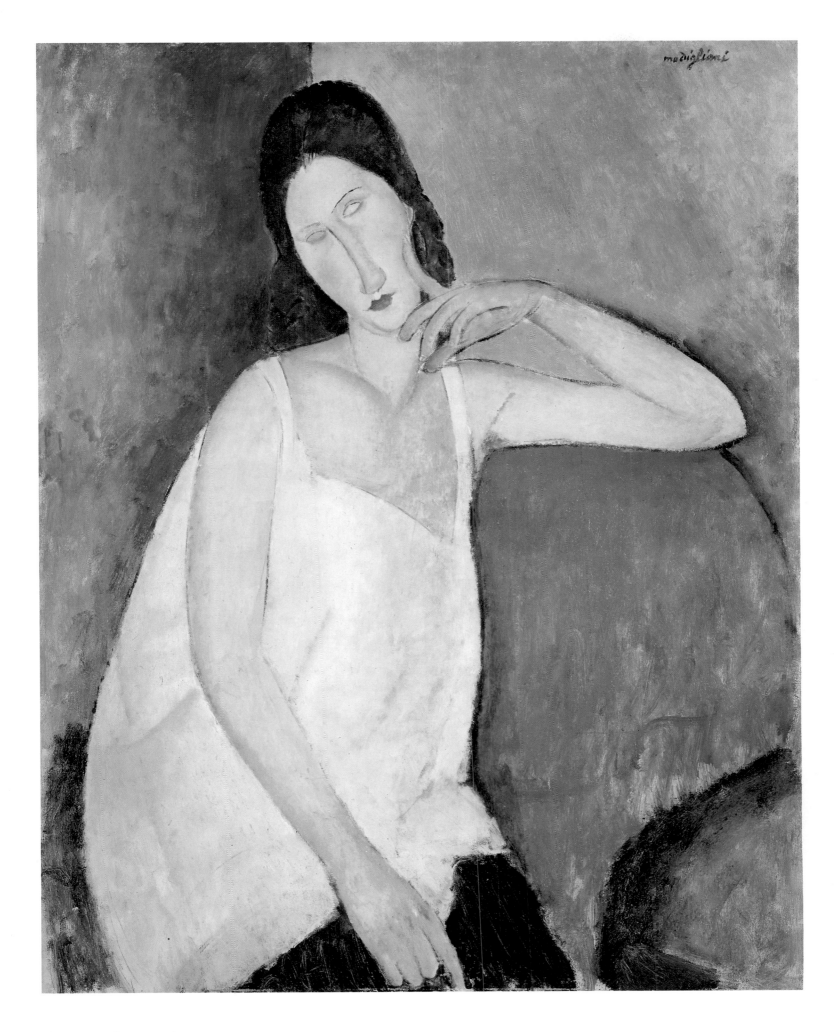

74 Portrait of Jeanne Hébuterne *1918*

75 Seated Young Woman *1918*

76 The Servant Girl *c. 1918*

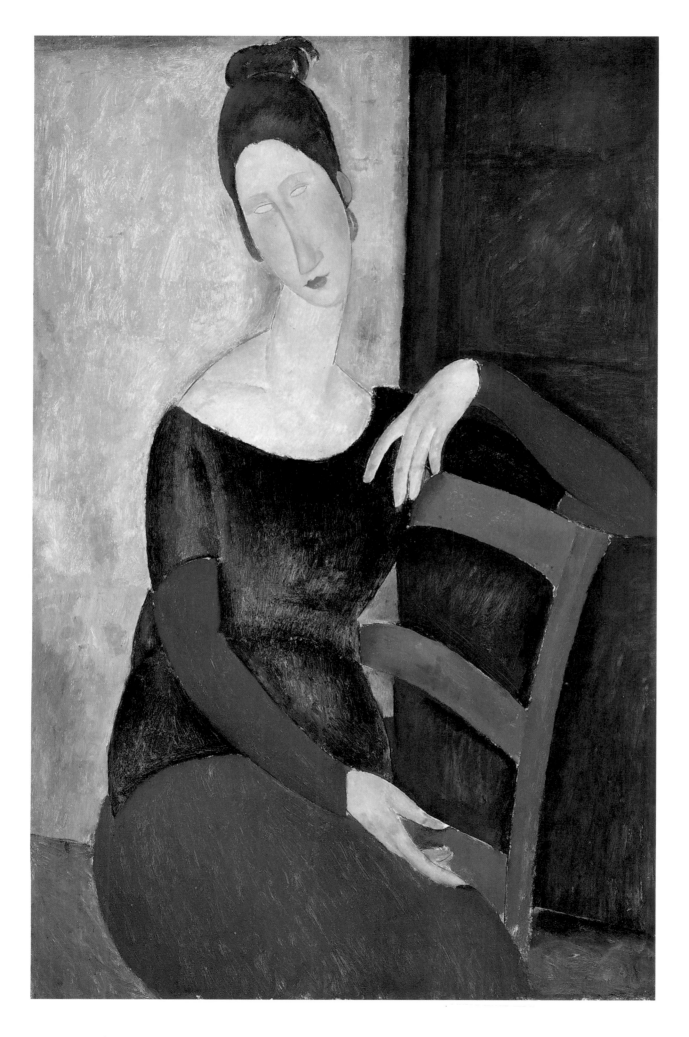

78 Portrait of Jeanne Hébuterne *1918*

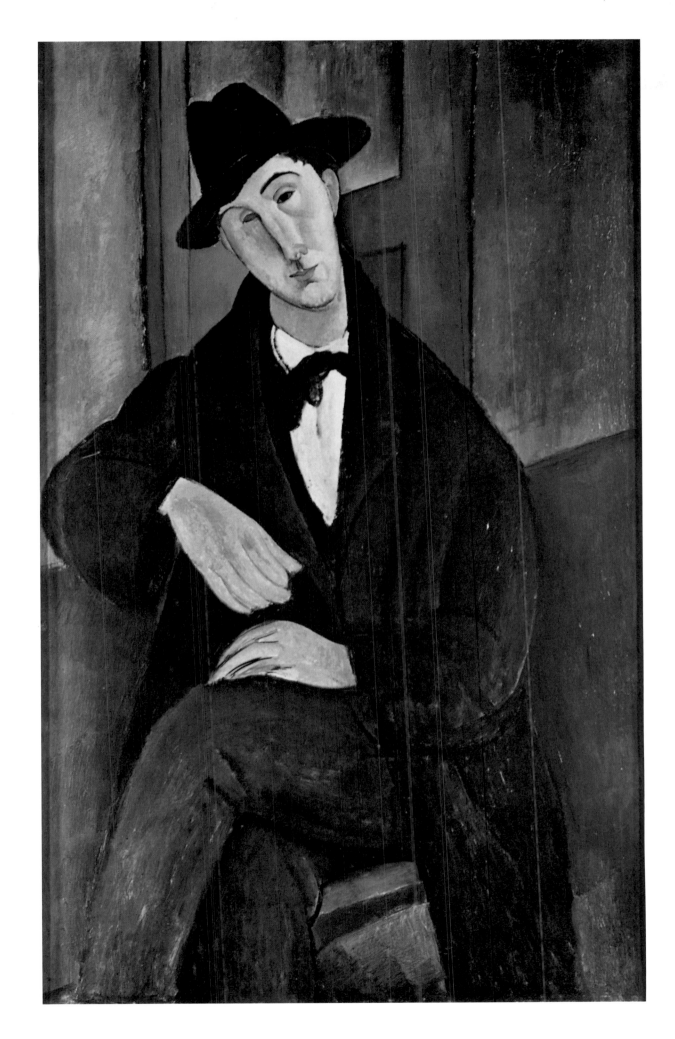

79 Portrait of Mario Varvogli *1919/20*

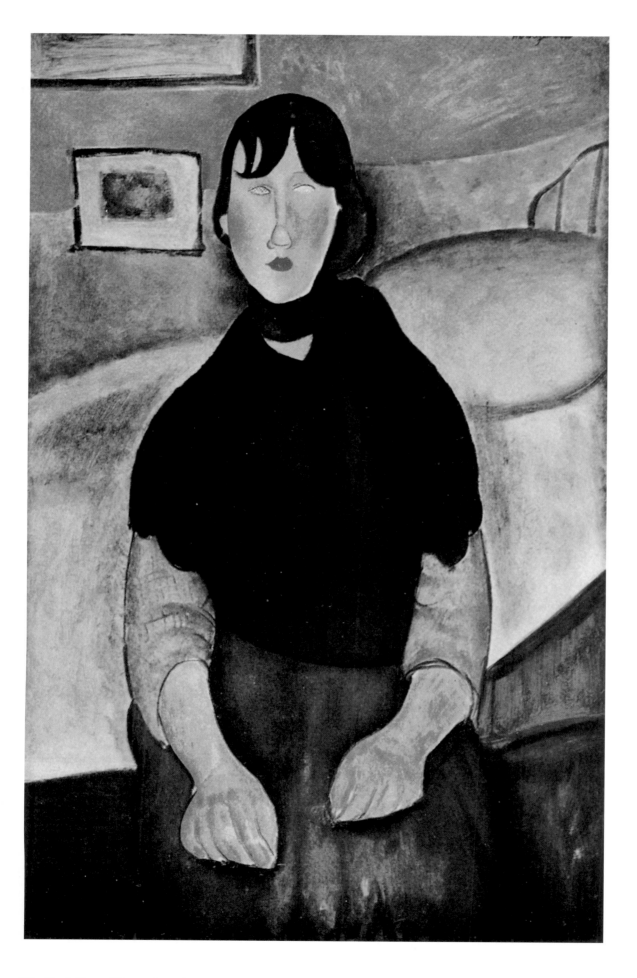

80 Dark Young Woman Seated in Front of a Bed *1918*

81 Portrait of Thora Klinckowström *1919*

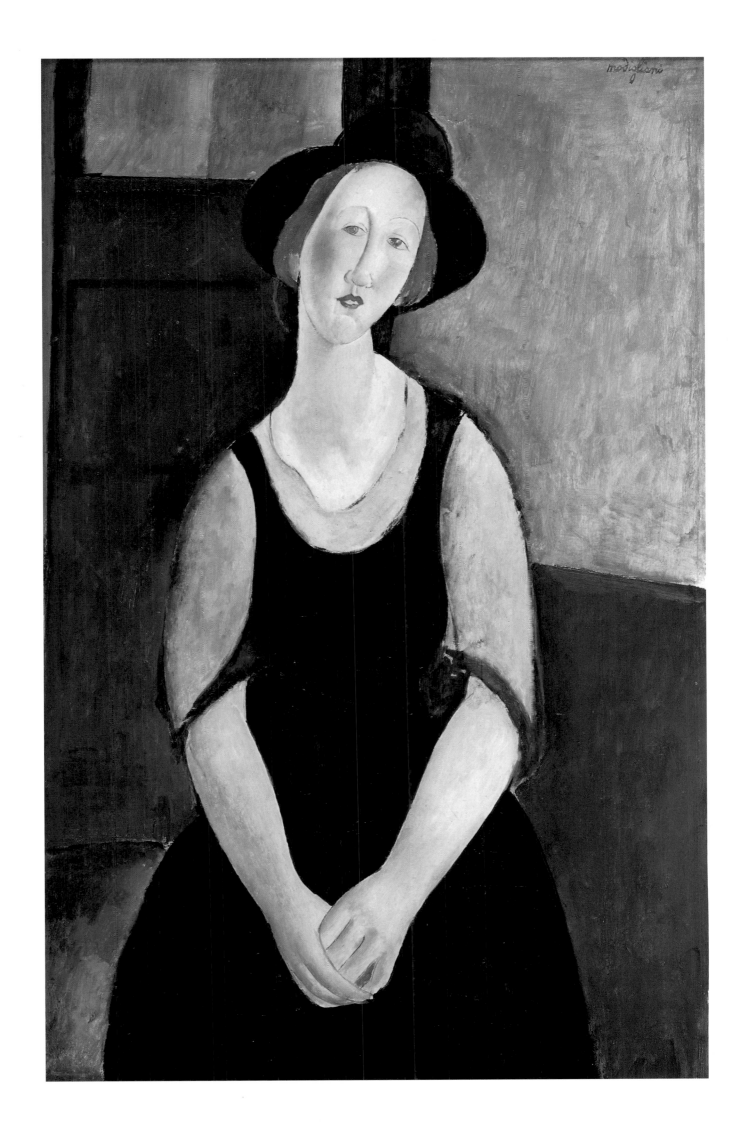

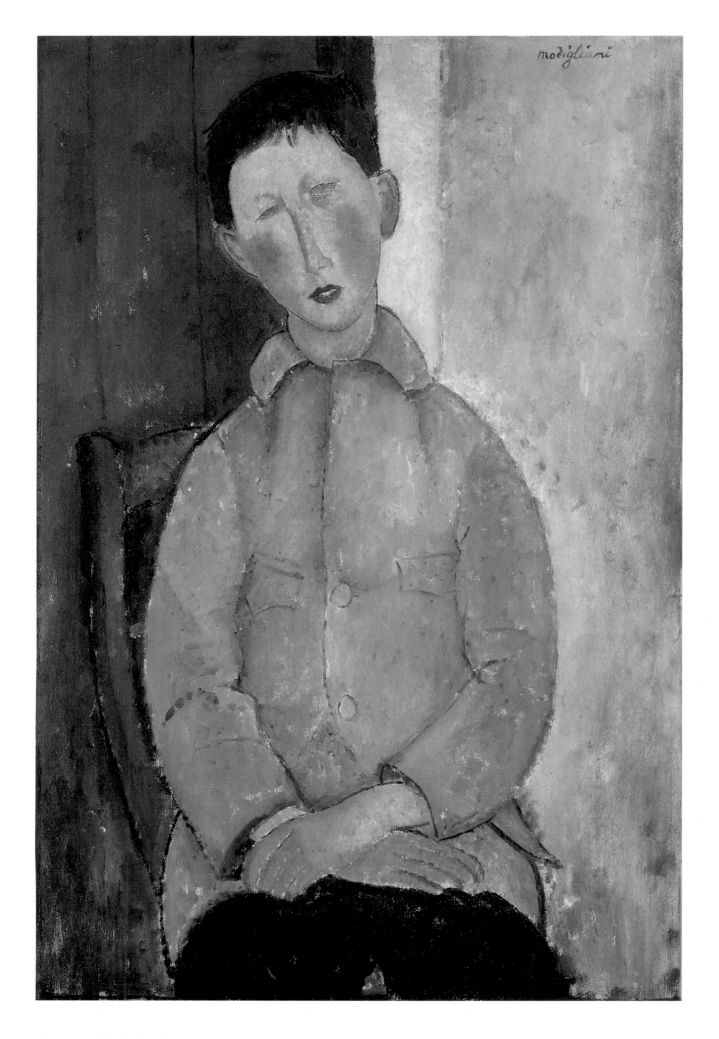

82 Boy in Blue Jacket *1918*

83 Young Peasant *c.1918*

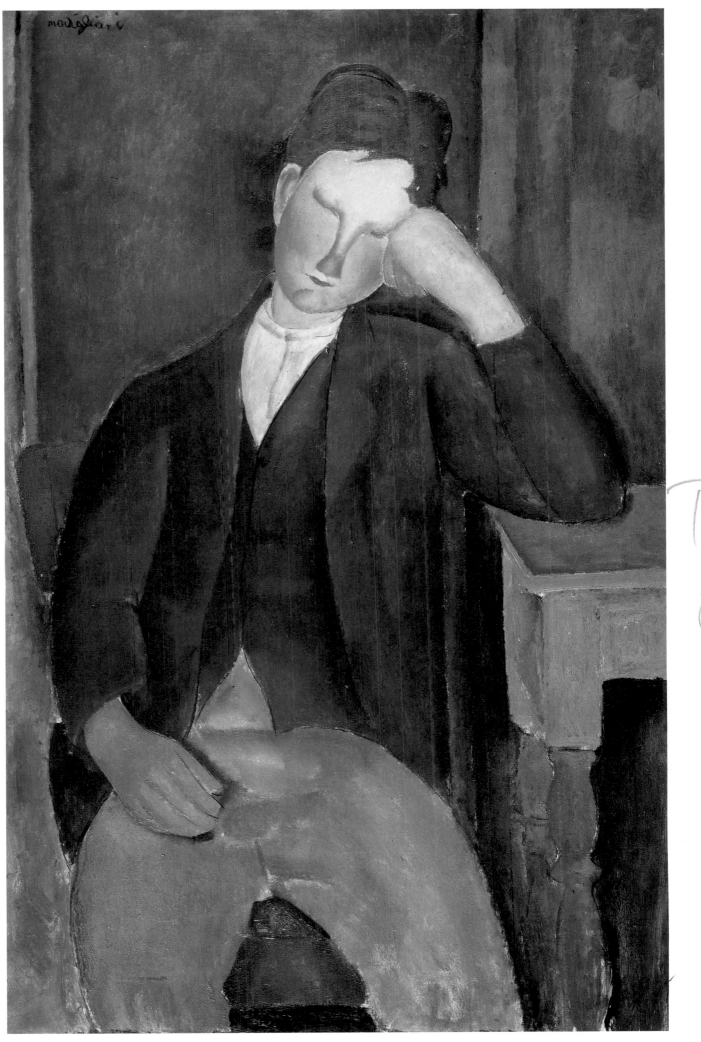

84　The Boy *c. 1918*

85 The Little Peasant *c. 1918*

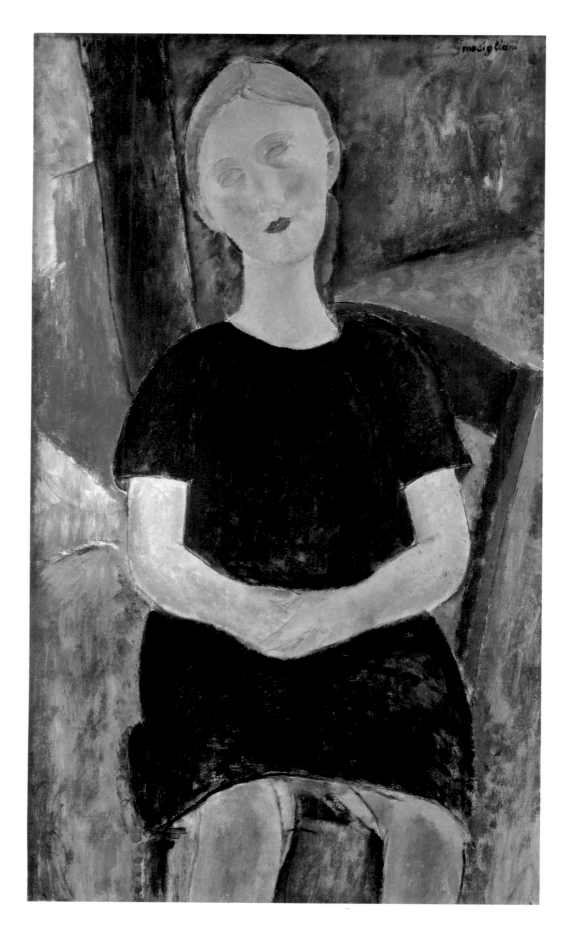

86 Seated Young Woman *c. 1918*

87 The Pretty Vegetable-Seller *1918*

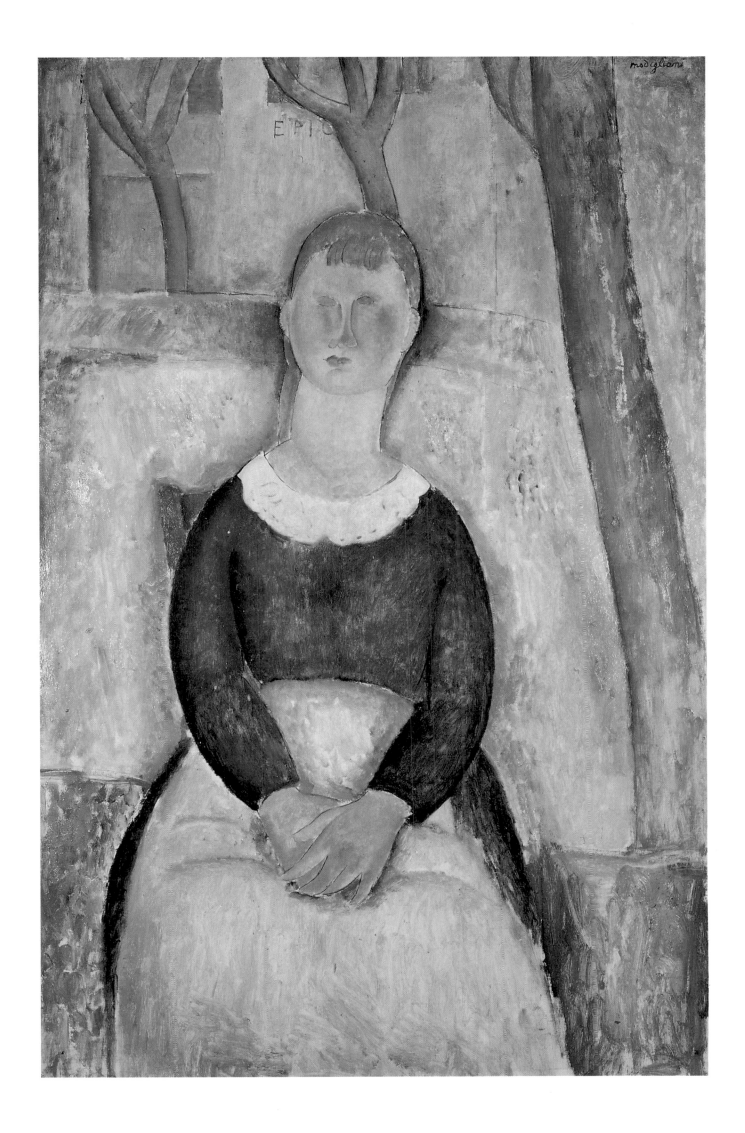

88 Landscape *c. 1919*

89 Landscape *1919*

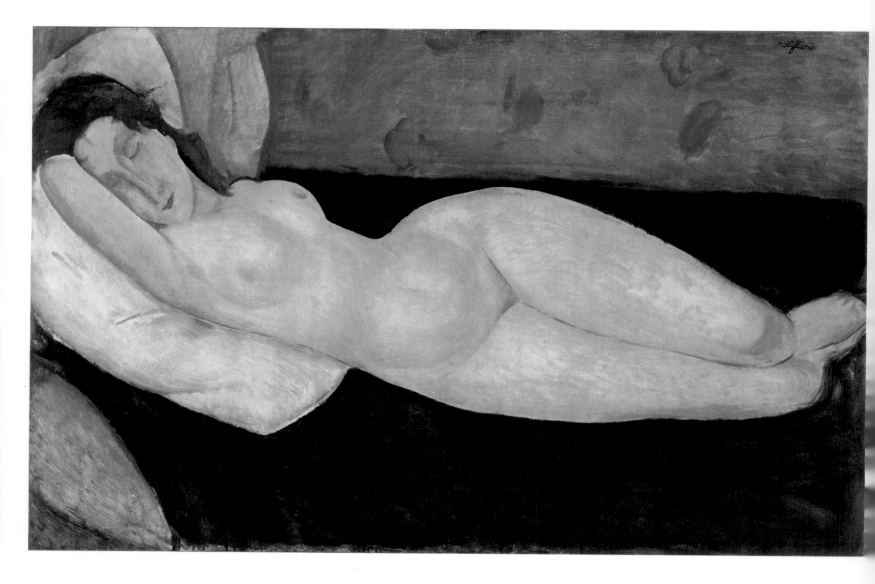

90 Nude *1919*

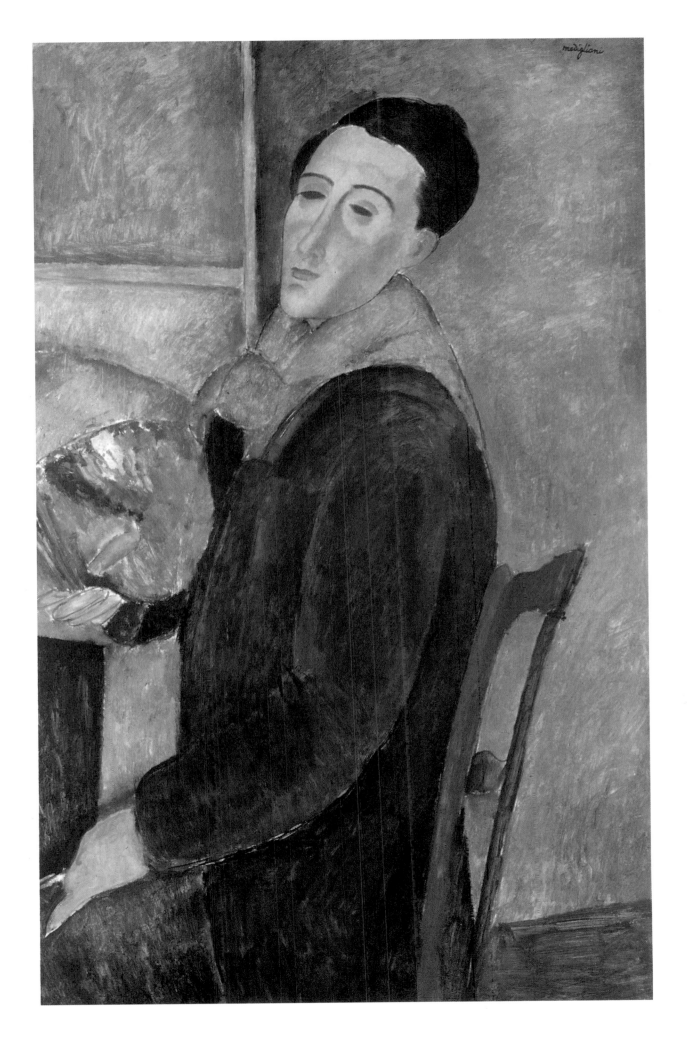

91 Self-portrait *1919*

Sculptures

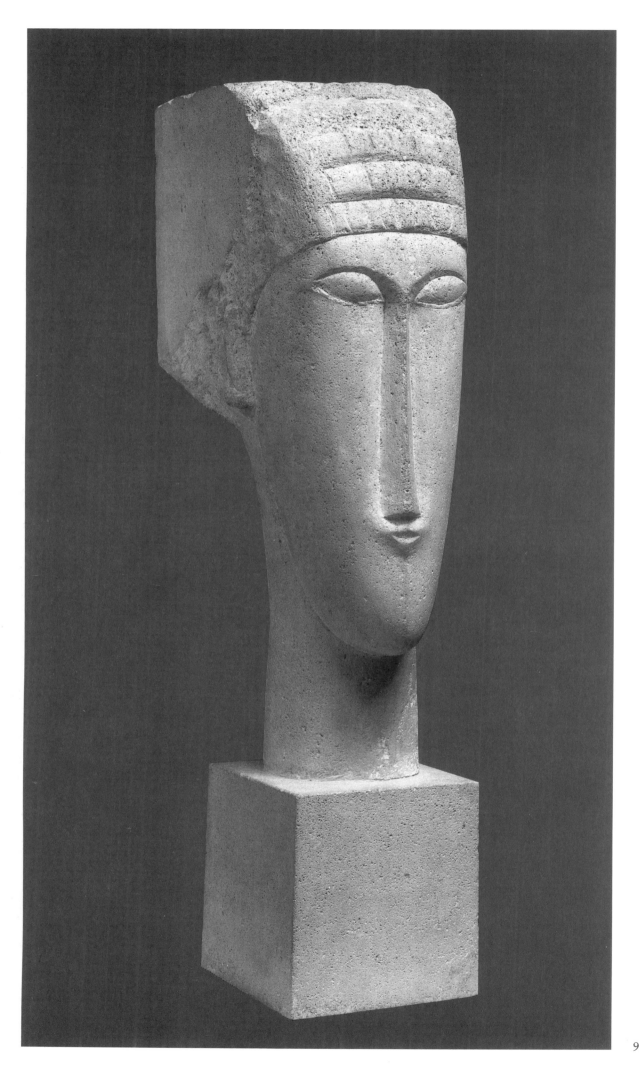

92 Head *1911/12*

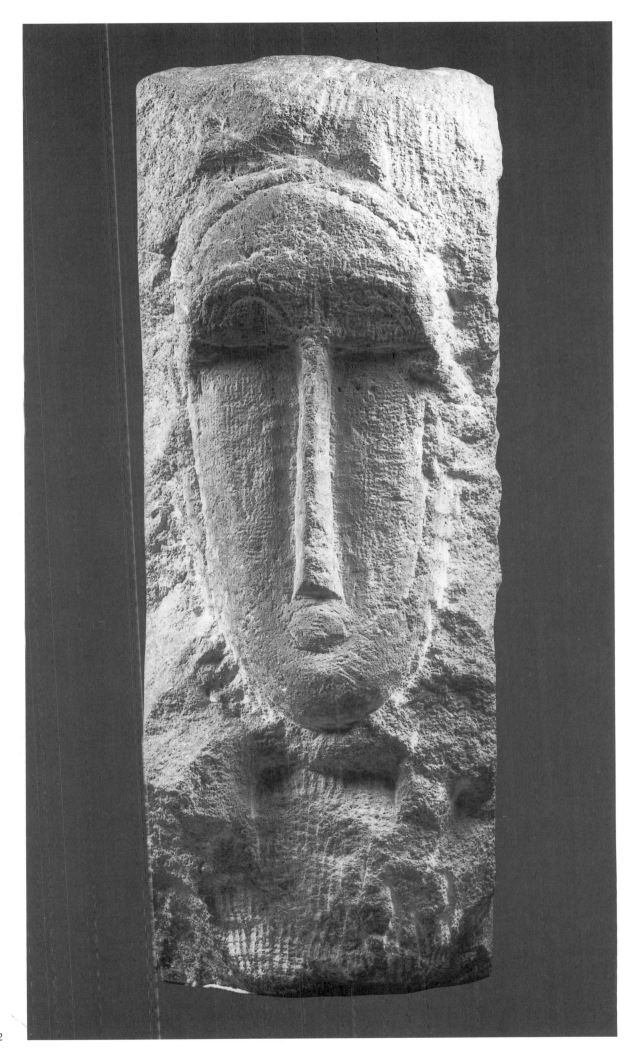

93 Head *c. 1911/12*

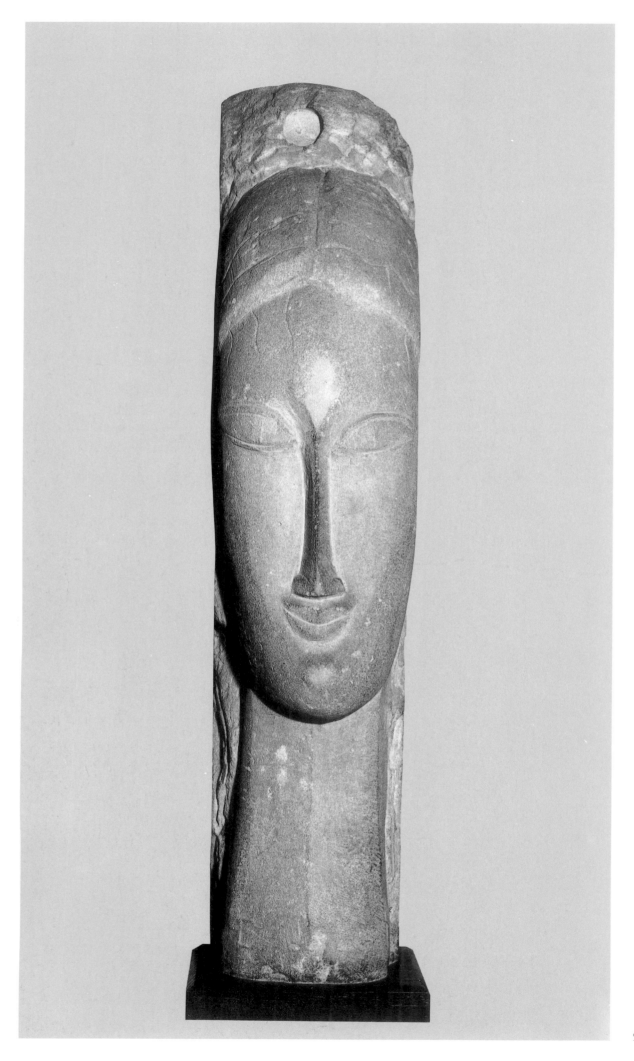

94 Head *1911/12*

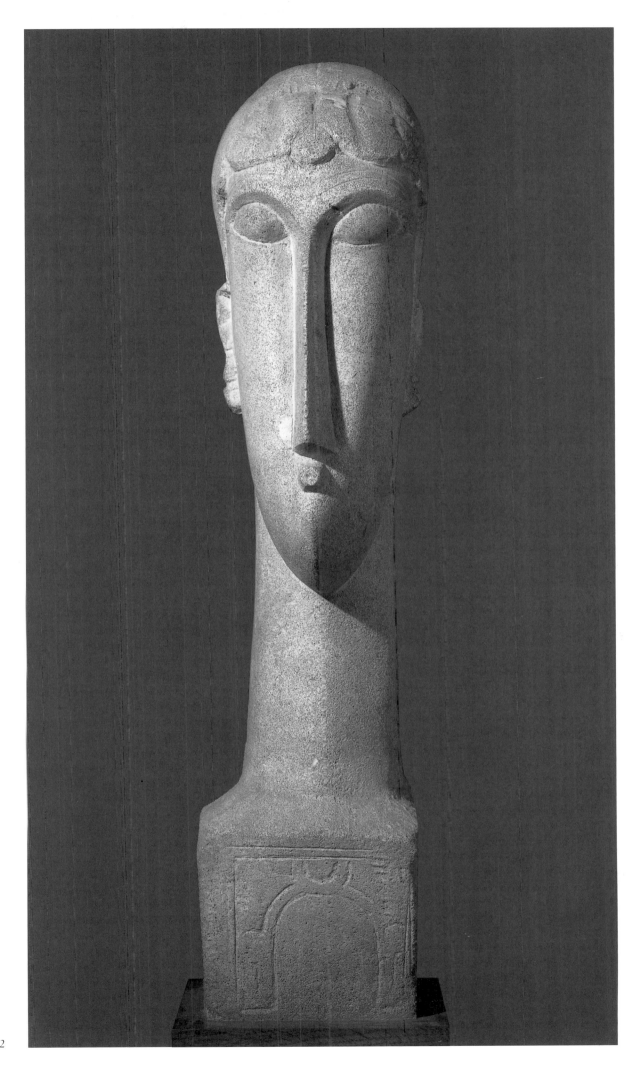

95 Head *1911/12*

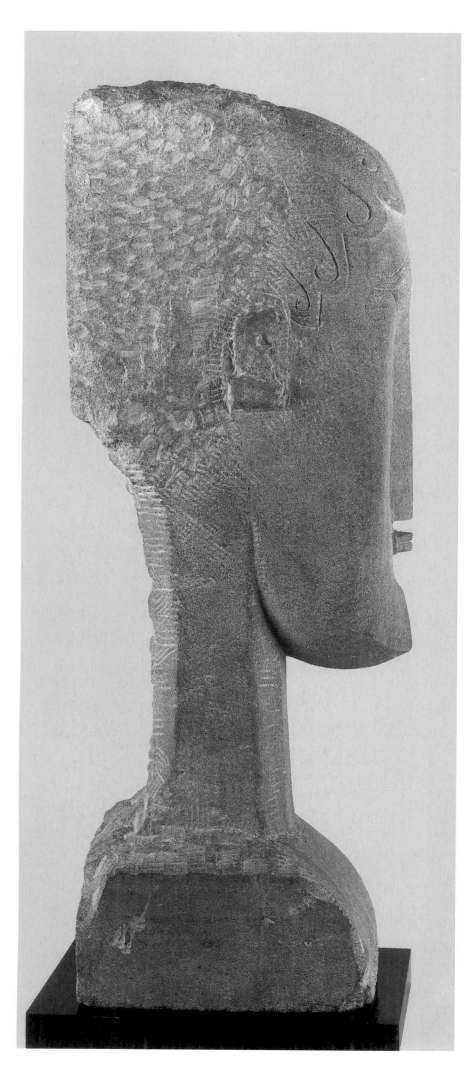
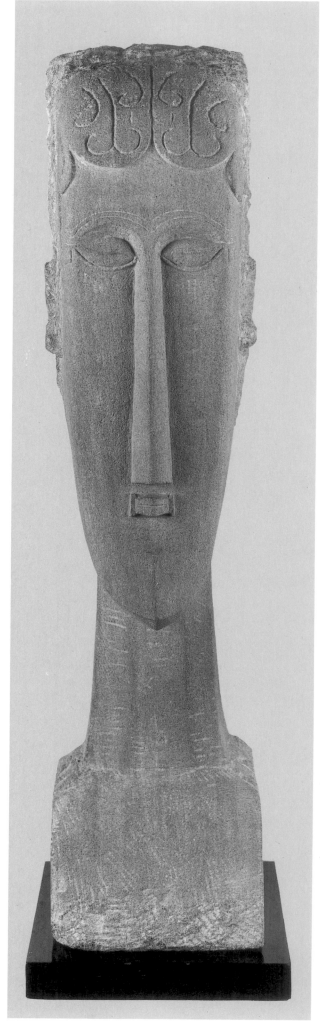

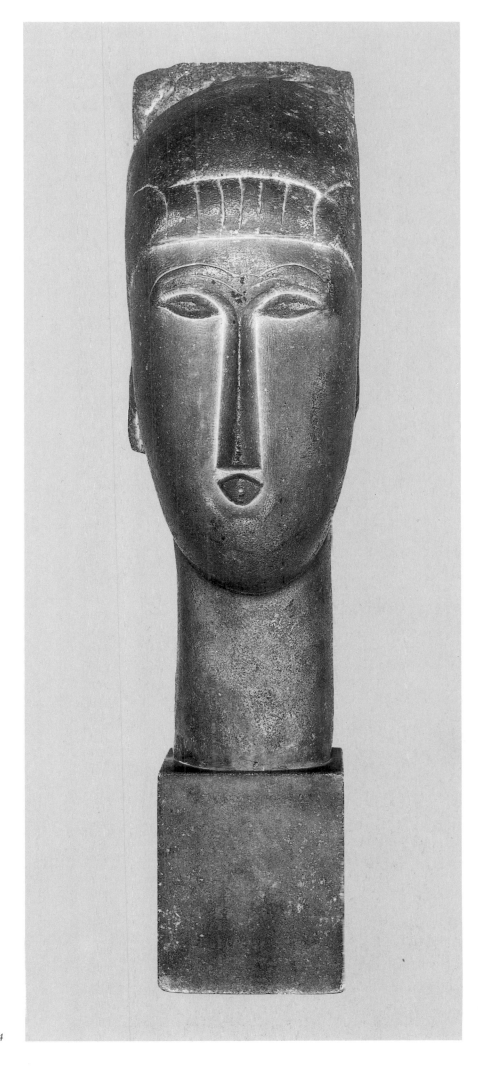

96 Head *c. 1913*

97 Head *1909/14*

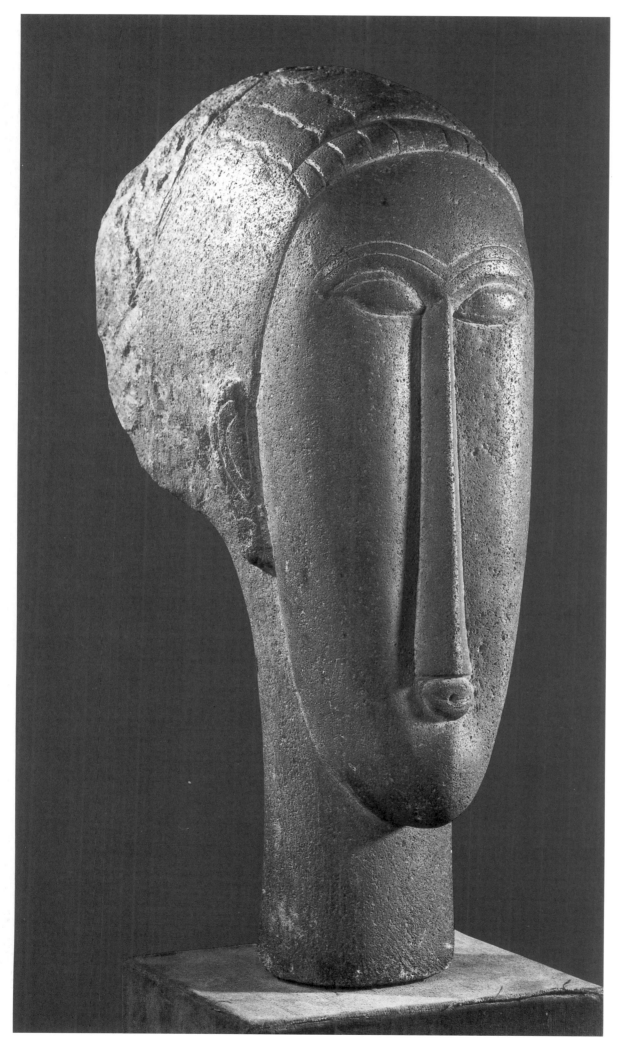

98 Head *1911/12*

99 Head *1911/12*

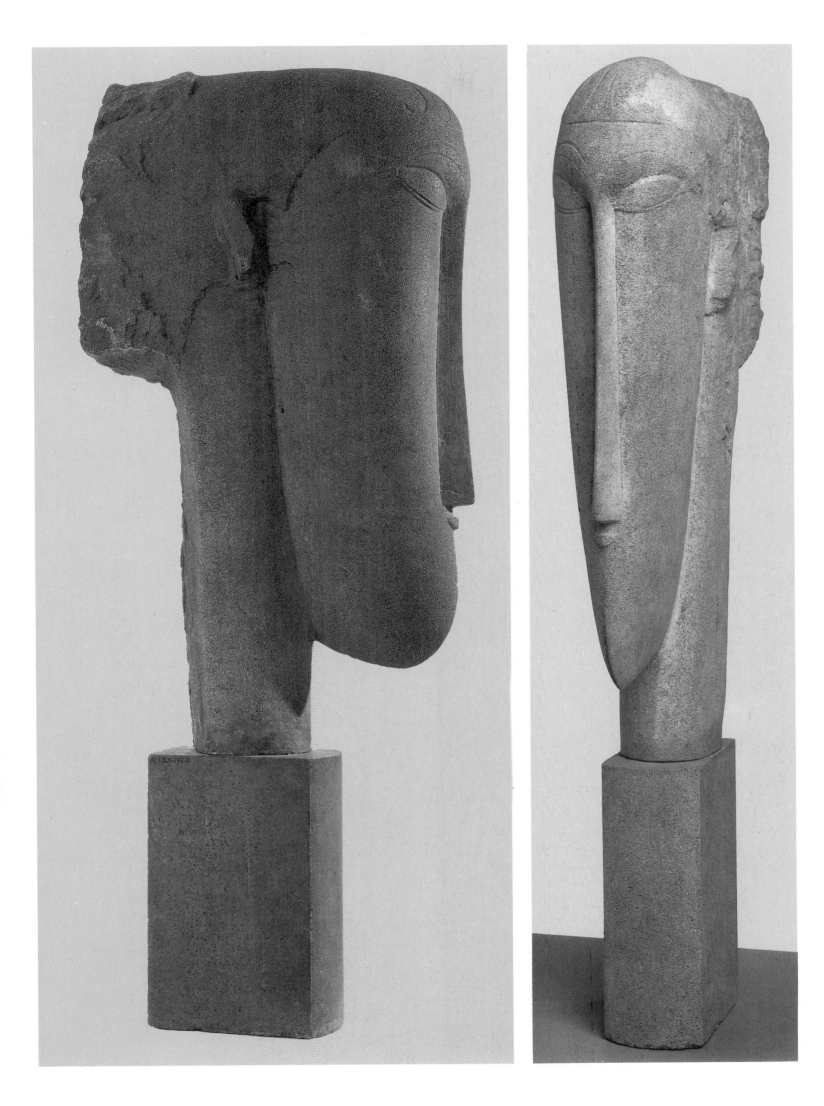

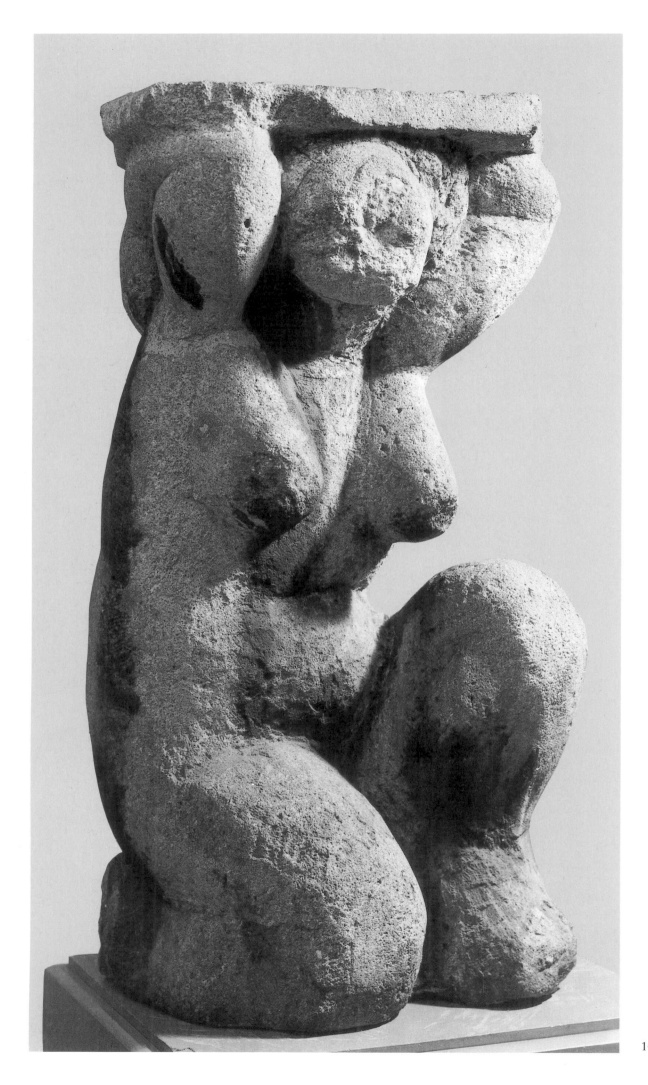

100 Caryatid *1914*

Drawings

101 Nude *c. 1896*

102 Two Women and Three Studies of Heads *c. 1908*

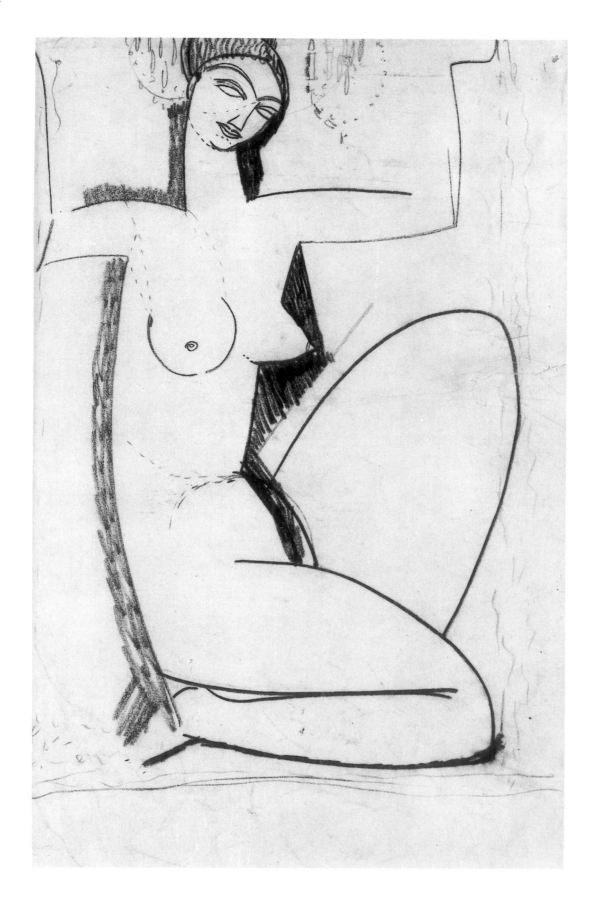

103 Caryatid *c. 1912/13*

104 Sheet of Studies with African Sculpture and Caryatid *c. 1912/13*

105 Pink Caryatid *1913*

106 Pink Caryatid *1913/14*

107 Caryatid *c. 1914*

108 Seated Nude *c. 1910/11*

109 Caryatid Study *c. 1913*

110 Seated Nude *1914*

111 Seated Nude *c. 1914*

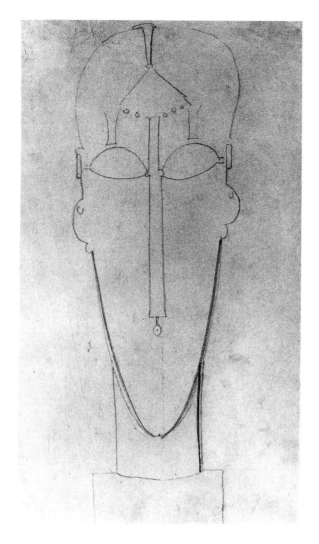 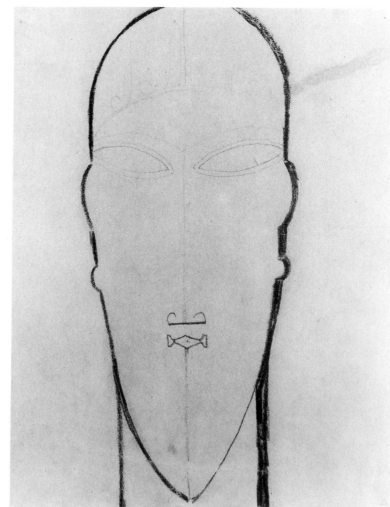

112 Study of a Head *1911/12* 113 Head *1910/12*

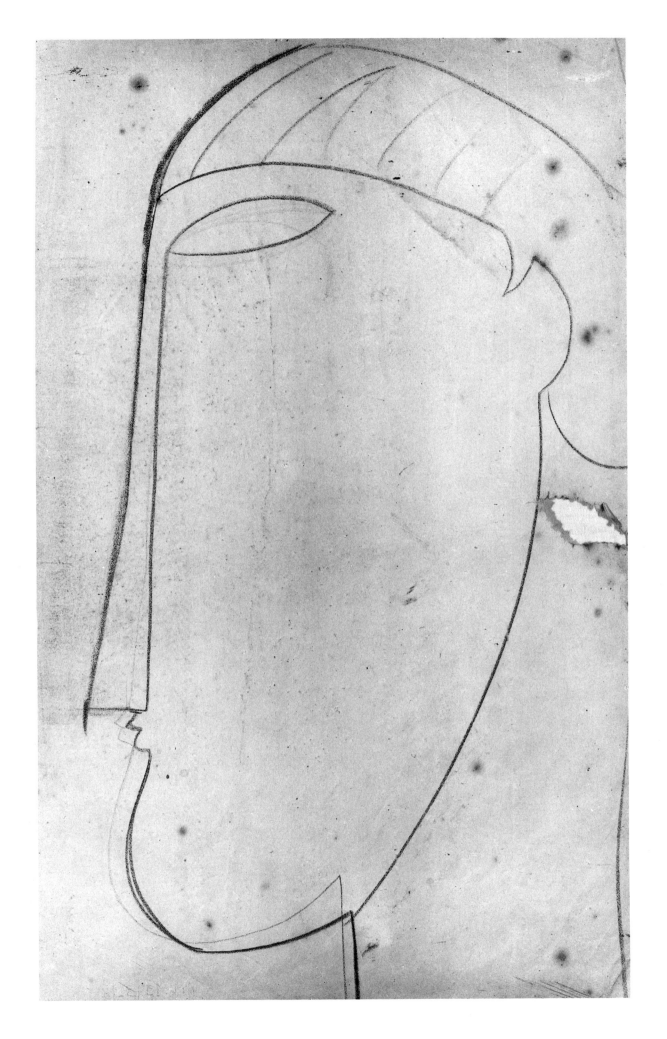

114 Head in Profile *c. 1912/13*

115 Portrait drawing of Beatrice Hastings *c. 1915*

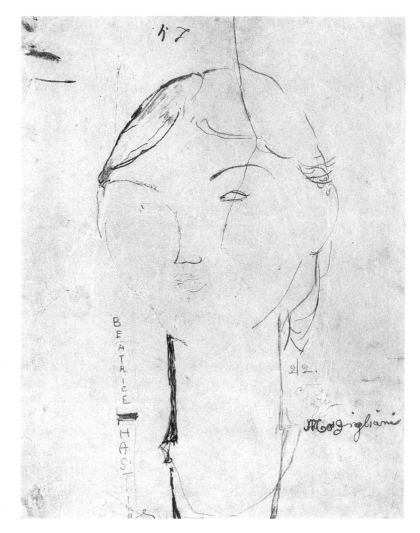

116 Portrait drawing of Beatrice Hastings *c. 1915*

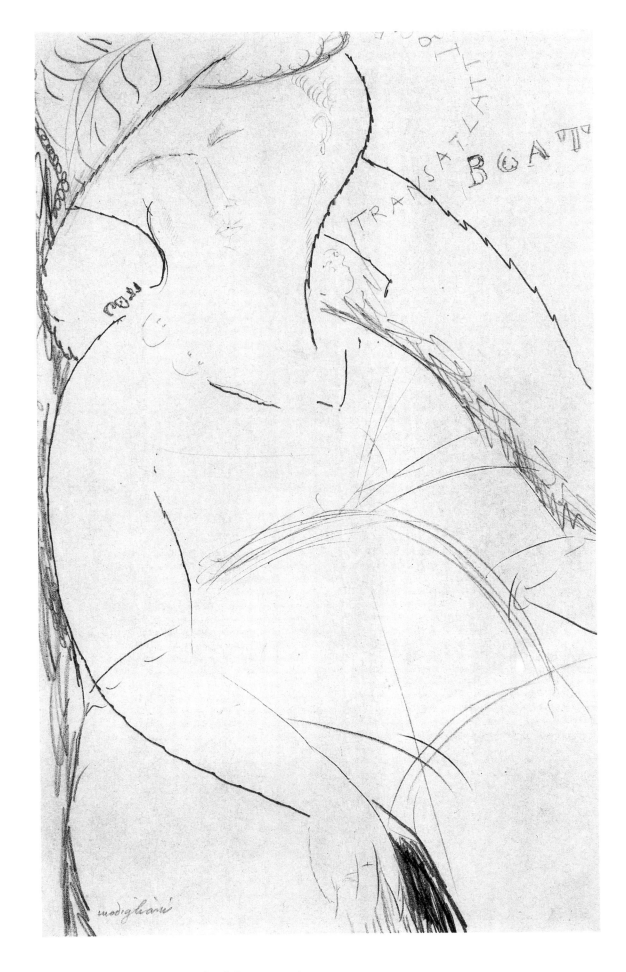

117 Seated Woman—Transatlantic Boat *c. 1915/16*

118 Portrait drawing of Blaise Cendrars *1918*

119 Young Man Walking—Il Giovane Pellegrino *1916/17*

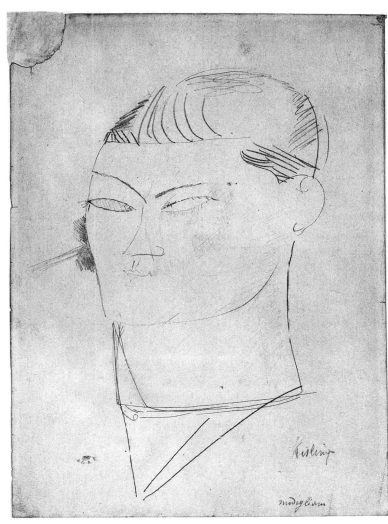

120 Portrait drawing of Moïse Kisling *c. 1916*

121 Portrait drawing of Paul Guillaume *1916*

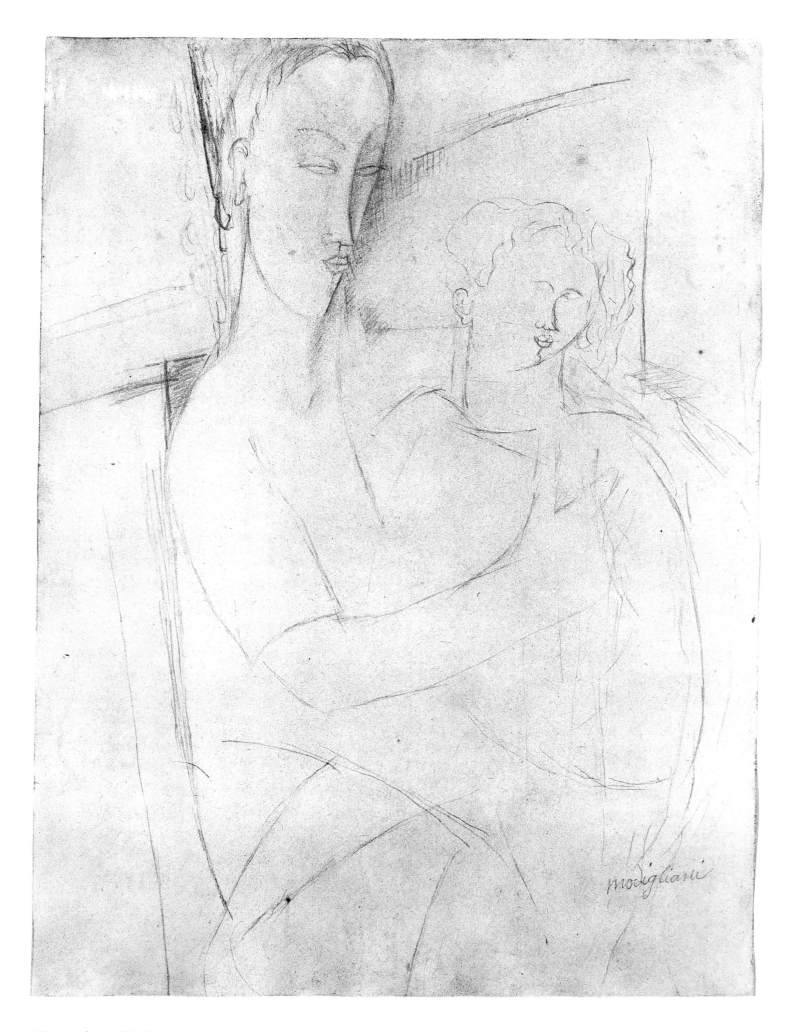

122 Mother and Child *1916*

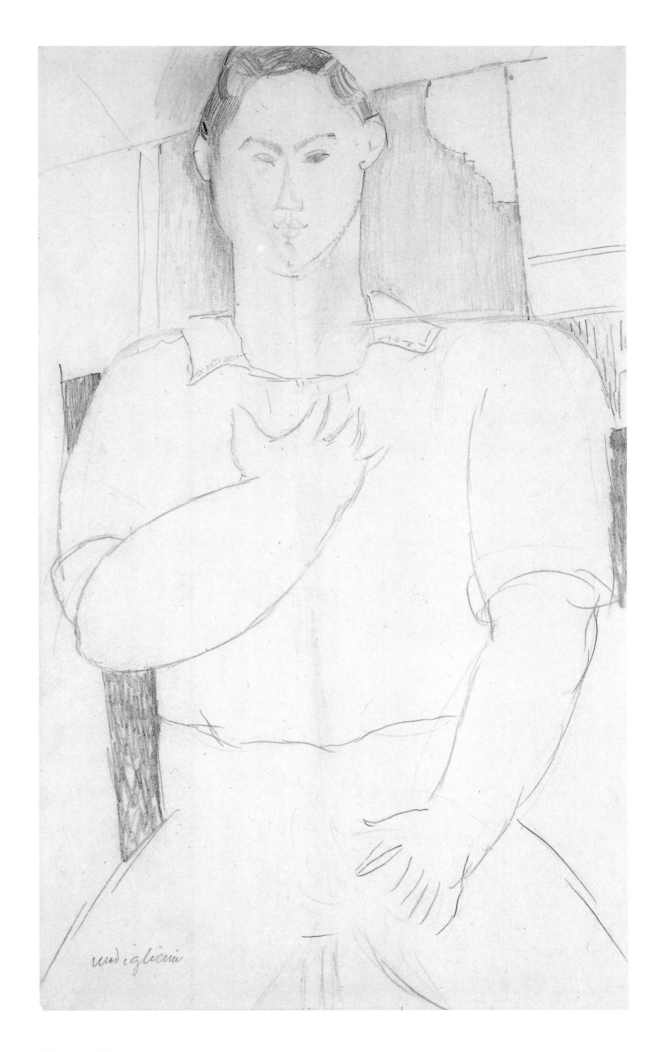

123 Seated Young Man *c. 1915*

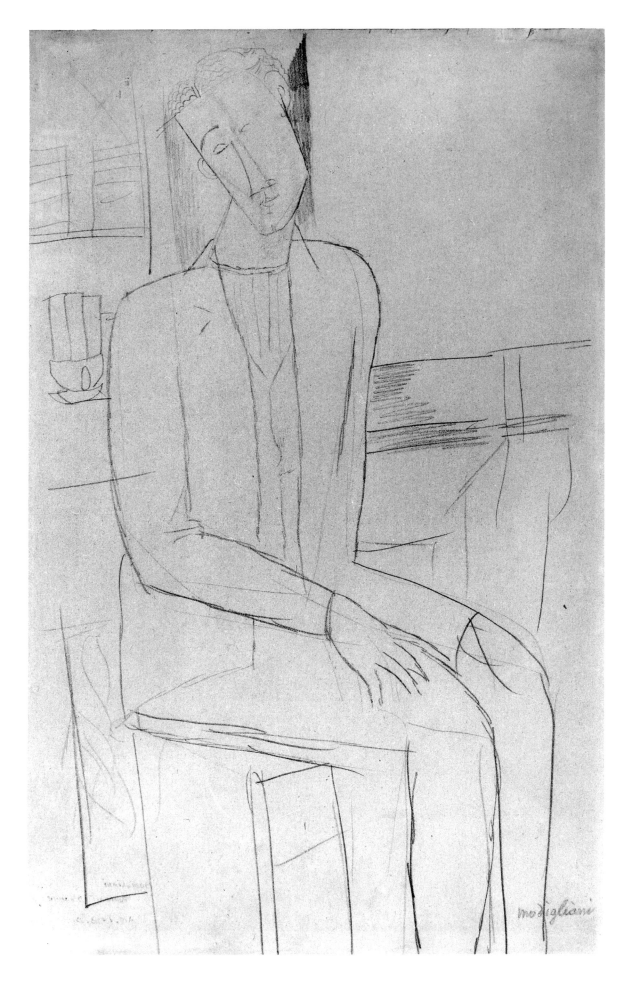

124 Seated Man *c. 1915/16*

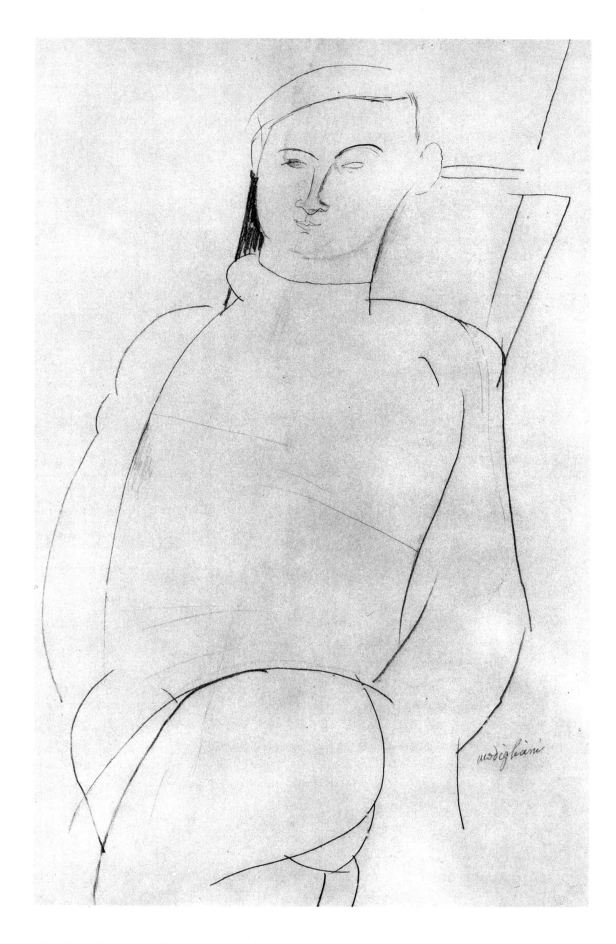

125　Portrait drawing of Jacques Lipchitz *c. 1917*

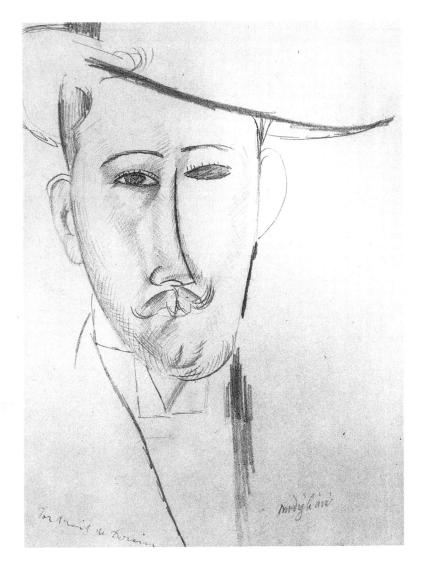

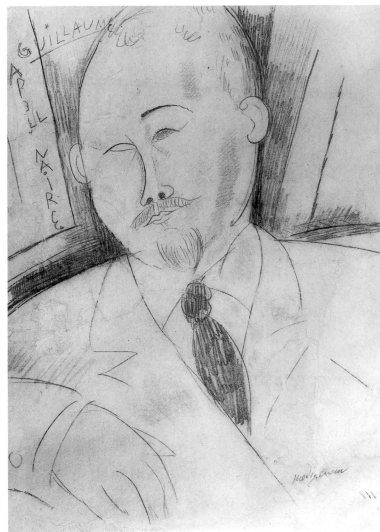

126 Man with Hat—André Derain *c. 1918*

127 Portrait drawing of Guillaume Apollinaire *1915*

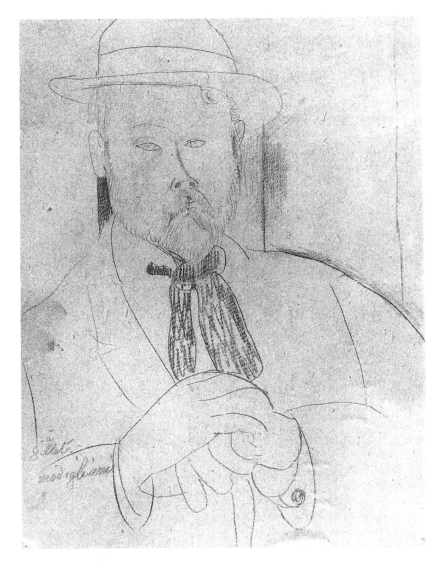

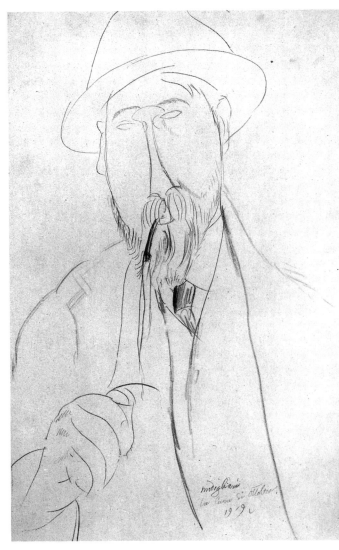

128 Portrait drawing of Gillet *c. 1918*

129 Man with Pipe—Dilewsky *1919*

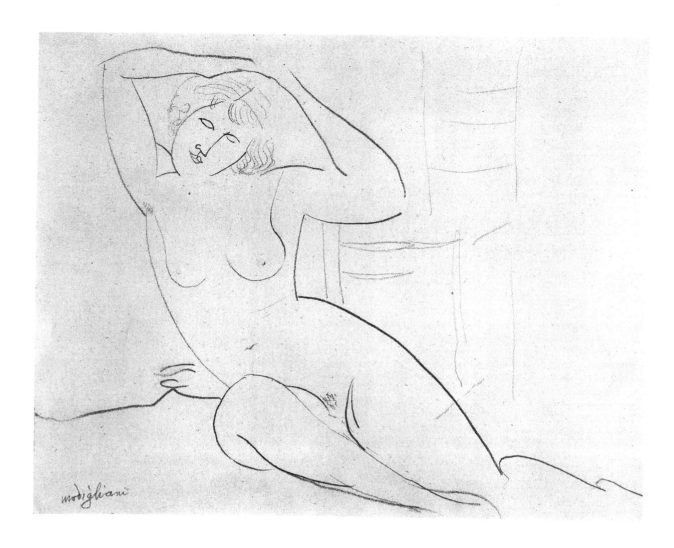

130 Seated Nude *c. 1917*

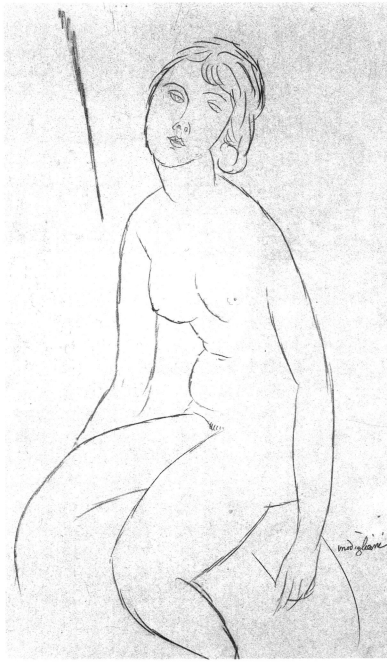

131 Seated Nude *1918*

132 Seated Nude *c. 1918*

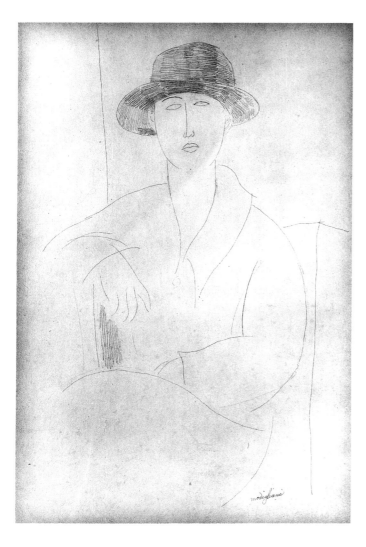

133 Woman with Hat *1916/17*

134 Half-figure of a Young Girl *1919*

135 Portrait drawing of Mario Varvogli *1920*

Appendix

Modigliani by his Contemporaries

Anna Akhmotova

Writer, 1889-1966

In 1910 I saw him very rarely, just a few times. But he wrote to me during the whole winter.[1] He did not tell me that he was writing poems.

I know now that what most fascinated him about me was my ability to read other people's thoughts, to dream other people's dreams and a few other things of which everyone who knew me had long since been aware. He repeatedly said to me: '*On communique.*'[2] And often: '*Il n'y a que vous pour réaliser cela.*'[3]

We both probably failed to realize a crucial point: everything that was happening was for both of us but the prehistory of our lives—of his very short life, of my long life. Art had not yet ignited our passions, its all-consuming fire had not yet transformed us; it must have been the light and airy hour of dawn. But the future, which announces its coming long before it arrives, was knocking at the window. It lurked behind the lanterns, invaded our dreams and took on the frightening form of Baudelaire's Paris which lay in wait somewhere in the vicinity. And Modigliani's divine attributes were still veiled. He had the head of Antinoos, and in his eyes was a golden gleam—he was unlike anyone in the world. I shall never forget his voice. He lived in dire poverty, and I don't know how he lived. He enjoyed no recognition whatsoever as a painter.

At that time (1911) he lived in the Impasse Falguière. He was so poor that in the Jardin du Luxembourg we sat on a bench and not, as was usual, on chairs since you had to pay for them. He complained neither about his poverty nor about the lack of recognition, both of which were clearly ap-

parent. Just once in 1911 he said that the previous winter had been so tough for him that he had been unable to think even of that which was dearest to him.

He seemed to me to be encircled by a girdle of loneliness. I cannot recall him ever greeting anyone in the Jardin du Luxembourg or the Latin quarter even though everyone knew everyone else there. I never heard him mention the name of an acquaintance, a friend or a fellow painter, and I never heard him joke. I never once saw him drunk, and he never reeked of wine. He evidently did not begin drinking until later, although hashish had already cropped up in his stories. He did not appear to have a steady girlfriend as yet. He never recounted amorous episodes from the past (which everyone else did). He never discussed mundane matters with me. He was communicative, not on account of his domestic upbringing but rather because he was at his creative peak

At this time he was busy working on a sculpture in the small yard next to his studio (in the deserted lane you could hear the echo of his hammer), dressed in his working clothes. The walls of his studio were full of incredibly tall portraits (they seemed to stretch from the floor to the ceiling). I have never seen any reproductions—did they survive? He called his sculpture '*la chose*'[4]—it was exhibited, I think, in 1911 at the Indépendants. He ask me to come and view it, but at the exhibition he did not come over to me because I had not come alone but with friends. The photograph of this 'thing' which he gave me disappeared at the time I lost most of my possessions.

He used to rave about Egypt. At the Louvre he showed me the Egyptian collection and told me there was no point in seeing anything else, '*tout le reste*'. He drew my head bedecked with the jewellery of Egyptian queens and dancers, and seemed totally overawed by the majesty of Egyptian art. Egypt was probably his last fad. Shortly afterwards he became so independent that his pictures betray no external influence. Today this period is referred to as Modigliani's *Période nègre* (Negro Period).

Commenting on the Venus de Milo, he said that women with beautiful figures who were worth modelling or drawing always seemed unshapely when clothed. Whenever it rained (it often rained in Paris) Modigliani took with him a huge old black umbrella. We would sit together under this umbrella on a bench in the Jardin du Luxembourg in the warm summer rain, while nearby slumbered *le vieux palais à l'italienne.*[5] We would jointly recite Verlaine, whom we knew by heart, and we were glad we shared the same interests
It astonished me that Modigliani could find ugly people beautiful and stick by this opinion. I thought even then that he clearly saw the world through different eyes to ours.

Everything that was fashionable in Paris and which attracted the most enthusiastic praise did not even come to Modigliani's attention.

He did not draw me from life but alone at home. He gave me these drawings as a gift; there were sixteen of them. He asked me to frame them and to hang them in my room. They were lost in Zarskoye Selo during the first revolution. The one that survived is less characteristic of his later nudes[6] than the others.

We talked mostly about poems. We both knew a lot of French poetry: Verlaine, Laforgue, Mallarmé, Baudelaire. Later I met a painter who loved and understood poetry just as Modigliani did— Alexander Tyschler. That happens very rarely with painters.

He never recited Dante to me. Maybe because I still knew no Italian.

Once he said to me: '*J'ai oublié de vous dire que je suis juif.*'[7] He told me straight away that he had been born near Livorno and was twenty-four years old. (He was actually twenty-six.)

He told me he had been interested in aviators (today we say pilots) but was disappointed when he met one: they were simply sportsmen. (What did he expect?)

. . . and all around us raged Cubism, all-conquering but alien to Modigliani

Modigliani was contemptuous of travellers. He thought travelling was a substitute for real activity. He always carried *Les Chants de Maldoror* about with him. At the time this book was a rarity. He described how at Easter he had gone to early morning mass in a Russian church to watch the procession of the cross, since he loved ornate ceremonies. And how a 'seemingly important personage' (probably from the Embassy, had exchanged an Easter kiss with him. Modigliani probably never really understood what that signified

For a long time I thought I would never hear anything from him again But I was to hear a great deal of him

1 I remember some sentences from his letters. One was: '*Vous êtes en moi comme une hantise*' (You are for me like a flood).
2 We understand one another.
3 Only you can manage that.
4 'The thing'.
5 The old Italian palace.
6 The well-known art historian, my friend N. I. Khardshiev, wrote a very interesting study of these drawings which is appended to this essay.
7 'I forgot to tell you that I am a Jew.'

From: Anna Akmatova, *Poem without a Hero*, 1940-62

Paul Alexandre

Modigliani's doctor, patron of the artist

In the period from 1908 to the early months of 1914 I saw him almost every day and he confided to me his tastes, his plans, his enthusiasms and his dislikes, his sorrows and his joys.

From the day we first met I was struck by his outstanding artistic gifts, and I begged him not to destroy his notebooks and sketches. I put at his disposal the modest resources I had, and so I own almost all the paintings and drawings of this period. They make it possible to follow his development during these decisive years step by step and stroke by stroke. It is unusual to have kept together, rather like the stages of an engraving, the successive stages of the very lively thinking of an artist searching for his own style—which, moreover, was very quickly revealed.

From: Enzo Maiolino (ed.), *Modigliani vivo*, p. 34

[Modigliani] thought of himself more as a sculptor and graphic artist than a painter and believed that each piece of sculpture should be unique, a single example worked directly and exclusively in stone.

Quoted by Osvaldo Patani in: *Modigliani a Montparnasse 1909-1920*, p. 16

Maurice Barraud

Painter, 1889-1954

During the war, even before it, throughout that uneasy period when the smell of gunpowder was in the air, the curious figure of Modigliani made its appearance. Just when the orchestra of ideas was playing to the tune of Fauvism, Negro sculpture had recently been discovered, the snake was biting its own tail with primitive affectation, Cubism reigned and all the boats launched by the shipowners of art were crossing frontiers like aeroplanes, there occurred a sort of return to the Middle Ages and Modigliani's elongated figures appeared, like so many madonnas wandering in an unsettled world. The byzantine flavour of his art owed much to his race, as did his exquisite painterly sense.

We often saw his paintings in Geneva, in the offices of the editor of *l'Eventail*, and our good friend Carco wrote such a fine and fair appreciation of the Italian painter, in edition number 11 of the second year of this journal, that he opened the eyes of many art lovers, who thenceforward began to enjoy Modigliani's painting.

In spite of all that, the drama of his life continued, because there was a kind of greatness in him.

What is admirable in his work is the unbroken progress of his development; the spiritual uncertainty of the period sustained him without affecting him. He lived for the love of painting; ideas may come and go, but works of art remain.

From: Giovanni Scheiwiller (ed.), *Omaggio a Modigliani (1884-1920)*, n. p.

Adolphe Basler

Art critic, 1876-1951

When I made Amedeo Modigliani's acquaintance in 1907 he was a young man with that masculine handsomeness which one admires in Bellini's pictures. He came from Livorno, his native city, and settled in the Butte Montmartre where he quickly became popular. One came across him at Frédé's, at the Lapin Agile or at the Place Ravignan in the company of Max Jacob, Picasso and other inhabitants of, or visitors to, this quarter.

At this time the name Modigliani did not mean very much. The Fauves were triumphant with Matisse; while Cubism, headed by Picasso and Braque, conquered everything and left Derain for dead. The only conspicuous thing about Modigliani was his manner, which was that of a handsome and sophisticated young man who was successful with women. As a wit he sought the company of other mentally agile people, but he was already addicted to alcohol and looked for artificial stimulation in the form of hashish which, like other drugs, was readily available in Montmartre. As a painter he made little impression at the exhibition of the Indépendants in 1909. If I remember right, he merely exhibited a few pictures which exuded more intelligence than character. In the same room there were pictures by Delaunay and Le Fauconnier and a huge picture by Henri Rousseau. However, the attention of the dealer Granié was caught by Modigliani's pictures. Granié, who later became a public prosecutor in Toulouse, was a most peculiar figure. A magistrate, he became the most passionate advocate of the young painters.

Later Modigliani moved to Montparnasse, to the Quartier Vaugirard. He had a studio in the Cité Falguière next to Czobel, the Hungarian Fauve. The two neighbours did not get on at all. Modigliani seemed about to turn away from painting. He was preoccupied by African sculpture, and Picasso only confused him. At this time the Polish sculptur Nadelmann exhibited his works in the Galerie Druet. The Natanson brothers, former managers of the Revue Blanche, drew the attention of Gide and Mirabeau to this new talent. Nadelmann's experiments also impressed Picasso. And indeed the spherical structures in Nadelmann's drawings and sculptures anticipated the later endeavours of the Cubist Picasso. Modigliani was astounded by Nadelmann's first sculptures; they inspired him. His interest veered towards ancient Greek forms and to Khmer sculpture, which was slowly becoming known among painters and sculptors. He adopted many features, but he continued to admire most the refined art of the Far East and the simplified proportions of Negro sculpture.

For many years Modigliani restricted himself to drawing. He drew round and soft arabesques and many caryatids, whose elegant outlines he merely heightened through blue or pink tones, intending to execute them in stone.

In this way his drawing became very sure, very melodious and at the same time highly personal, sensitive, full of charm and freshness.

Then one day he began to hew heads and figures directly from stone. He worked with the chisel only up to the outbreak of war; but the few extant sculptures give a clear impression of his grandiose ideas. He was taken with simple, schematically compact forms which were, however, not completly abstract.

During this period, while he followed his vocation as a sculptor, Modigliani lived happily. Thanks to his brother's financial support he was able to work freely. Although he drank and his state of health sometimes gave cause for concern, there were at that time no serious consequences. He soon began working again, for he loved his profession. Sculpture was his sole ideal; he placed all his hopes in it. It was only really at this time that I truly respected him. In addition to his artistic talents he had many other winning ways. He was a naturally cultivated individual. One never saw him without a book in his pocket. He read a lot and enjoyed taking part in discussions on literature, art and philosophy. He did not have to wait for the Surrealists to make the acquaintance of the Comte de Lautréamont. One day when Modigliani was ejected from the Dôme because he had molested other guests in his drunken state, André, the waiter, picked up a book which had fallen of out of Modigliani's pocket: *Les Chants de Maldoror*. In his studio in the Cité Falguière I saw books in every corner—Italian and French, the sonnets of Petrarch, the *Vita Nuova*, Ronsard, Baudelaire, Mallarmé, and even philosophical works: Spinoza's *Ethics* and an anthology of Bergson. Talking to him was a real pleasure.

Unfortunately Modigliani's condition deteriorated a few months before the outbreak of war. He had moved from the Rue Falguière to a tiny studio on the Boulevard Raspail. The austerity of these lodgings was pitiful. His furniture consisted solely of a mattress and a jug. In the yard he worked away at his stone sculptures, but one encountered him increasingly rarely in a sober condition. In order to make a living he began to portray anyone who would sit for him. But he soon frittered away the few francs he received for such drawings on alcohol. He was the scourge of the bistros. His friends, used to his excesses, forgave him, but the landlords and waiters, who hailed from a different social stratum to that of the artists and writers, treated him like a common drunk. One day he dragged me along to the Rue de Buci, where he had an appointment with Martin Wolf, the employee of

the antiquarian Brummer, and an English poetess. This Wolf, a figure straight out of a story by E. T. A. Hoffmann, spent his day dusting Egyptian, Greek and African sculptures and in the evenings posed as an artist. He was frail and ill and could hardly stand up. He drank nothing but kept Modigliani company after jealous arguments with his poetess (Beatrice Hastings).

Then came the war. This event altered everything. Modigliani fell under the spell of the English poetess. He was surrounded by an ever-increasing number of admirers from all over the world. Everyone wanted to be portrayed by him. And thus he became famous. One day he decided to take up painting. He went to the painter and art collector Frank Burty Haviland who lived next to Picasso in the Rue Schoelcher. Frank lent him some paints, brushes and canvases. Modigliani wanted to translate the experience which he had gathered as a sculptor into painting. Another factor was that wartime restrictions forced him to try his hand at a less complicated form of art than sculpture, a form of art that was less expensive and easier to carry out. Haviland also possessed the most wonderful collection of African sculptures. They captivated Modigliani; he could not see enough of them. Soon he could think only in terms of these forms and proportions. He was transfixed by the pure and simple architectonic forms of the Cameroonian and Congolese fetishes, of those attenuations found in the elegantly stylized figurines and masks along the Ivory Coast. Slowly they led him to develop a form with elongated lines, with gently distorted proportions. The details were influenced by his admiration for African sculpture. Right from the start the oval head and the uniform, geometric nose developed from the African fetishes gave his portraits a special character. As an accomplished draughtsman— more so than a painter—Modigliani was able to emphasize the soft outlines and to break up the monotony of his symmetrical forms through ingenious distortions; in fact, by using an appealing colour scheme he actually made them very attractive. An air of exotic grace, an affectation tempered by powerful expressiveness, and a delicate charm are exuded by all these male and female figures, which he painted according to the same pattern with the exception of a few portraits and three or four nude studies. All Modigliani's works resemble one another very closely. His art seems to degenerate into Mannerism, although this is highly captivating for art lovers seeking easily accessible art. Modigliani turned to painting only after abandoning his real gift: from 1915 up to his death in 1920 he was forced by circumstances to exchange the chisel, which was his true vocation, for the brush.

The artist was very active and always managed to find an appreciative public. He needed such adulation and could not stand being ignored. His amiable eccentricity was a little contrived. There was something of the actor about him. His drunkenness, which was at least as much show as it was genuine, once caused Picasso to remark acidly: 'It is strange that you never see Modigliani drunk in the lonely Boulevard Saint-Denis, but always at the corner of the Boulevards Montparnasse and Raspail!'

It is true that he needed an audience around him, but he also had many real friends. Just about every Montparnassian had his portrait drawn or painted by Modigliani. And there were few who did not

clink glasses with him at least once. Everyone liked him—the owner of the hotel in which he lived, his hairdresser, the people in the bistros. They all have pictures by him or pleasant memories of him, be it the female Russian painter Vassilyev, who fed him in her canteen during the war, or all the amicable topers in the quartier, or the little Burgundian sculptor X, the north African painter Z, or the Communist philosopher Rappoport with whom Modigliani seldom saw eye to eye, or even the policeman who locked him up when he got drunk. His popularity stretched even to the police station: several high-ranking officers were avid collectors of his pictures. Dear old Modigliani could not have dreamed up a better public than the one he had during the war. Individuals from every country in the world—Americans, Swedes, Norwegians, Poles, Russians, Mexicans, Redskins—were all daily visitors to the Rotonde.

Whenever Modigliani was drunk he insulted everyone—hence his constant rows with Libion, the landlord of the Rotonde, which often ended badly for Modi. And whenever he was banned from the Rotonde, he would kick up a din somewhere else. But the hatred which he felt for the landlord of the Rotonde was nothing compared with his contempt for the art dealer Y. Behind Modigliani's unkempt facade there was a sensitive soul who was easily hurt by mean behaviour. This almost paranoid sensitivity led him to reject all vulgarity. One day the dealer Y came across a picture on which Modigliani had glued a folk song and then painted garlands of flowers around it. He thought it better to replace the song by one of Baudelaire's poems. The painter was outraged: 'Never! Get rid of it at once, you conceited fool!'

'Okay, if you think I'm a fool I won't buy any more of your pictures!' answered the dealer.

'I don't give a damn. Go to hell!' And with this emphatic reply, the artist departed.

But he found a better replacement. A Pole (Léopold Zborowski) had set up in Montparnasse as an art dealer. He took the pictures to established collectors or to people he thought worthy of becoming such. The war was in full cry, and everyone was passionately collecting pictures by young painters. This was a golden opportunity for all the hungry artists who could no longer get anything to eat in the debt-ridden canteens. Now even foreign artists began selling pictures, which before the war was very rare with the exception of van Dongen, Picasso, and two or three other Spaniards.

Suddenly the critic and dealer Coquiot loudly proclaimed the discovery of a great Russian painter. 'It is good to buy a picture by Cézanne,' he announced, 'but it is even better to buy a picture by Epstein.' The dealer Chéron launched the Japanese painter Foujita, and Paul Guillaume other Russians. As the number of patrons increased, so did their belief that they could discover a new van Gogh, a new Cézanne among the poor wretches sipping coffee in the Rotonde. And Modigliani's reputation continued to rise. People who before the war would not even have acquired a Derain, who would have laughed at the idea of paying a hundred francs for a Utrillo, now bought up pictures by Modigliani—and at a very reasonable price. For never was an artist less interested in financial success. He wanted to stand out only through his intellect, to be accepted as a great painter, to live among people whom he astonished or really loved. Nor

was there ever a less envious artist than he. He was well aware of his weaknesses and envied Utrillo for his remarkable gifts. But Modigliani's affection for him was quite genuine. He would often put Maurice up when the latter fled from Montmartre. And it was a sight for sore eyes to see the two drinking companions accuse each other of being drunkards at two in the morning!

Modigliani's premature end, which was followed by the tragic death of his wife, increased his standing all the more. Delicate, sensitive, cultivated, an aesthetically exquisite talent, he proved to be an accomplished draughtsman and seemed destined to become a sculptor, a vocation to which he dedicated himself passionately before he started painting. In his painting he compensated for his weaknesses as a colourist through an always harmonious interplay of contrasts. His pictures, whose main feature is their powerful aestheticism, exude a certain radiance and aura. And indeed his talent, which is not devoid of sophistication, is one of the most magical in modern art.

(1927)

From: Giovanni Scheiwiller, *Amedeo Modigliani—Selbstzeugnisse, Photos, Zeichnungen*, pp. 40-70.

Ugo Bernasconi

Painter, 1874-1960

He was a true artist, in that he expressed a very personal vision of the world, nearly always with great power, and sometimes with marvellously appropriate painterly skills. Suffering and disfigured humanity, often even grotesque to the point of morbidity. It does not matter; it is humanity as it actually is, and it has the right to enter our experience and call upon our human sympathy.

From: Giovanni Scheiwiller (ed.), *Omaggio a Modigliani (1884-1920)*, n. p.

Constantin Brancusi

Sculptor, 1876-1967

'One evening,' Brancusi told us, 'some artists from Cité Falguière chipped in to buy two casks of wine and asked some friends over. We caroused, we danced and whirled about the kegs, singing 'Dig-a-dig-a-dee, we don't give a f—k, dig-a-dig-a-da...' Someone suggested going over to Les Halles [the old central market] for onion soup. And so we did, washing it down with plenty of wine. As we were all emerging from a tavern, we—Modigliani and I – broke away from the crew and grabbed one of those baskets of vegetables that truck farmers set out on the sidewalks back then. There we were, handing out vegetables to all the passers-by on our

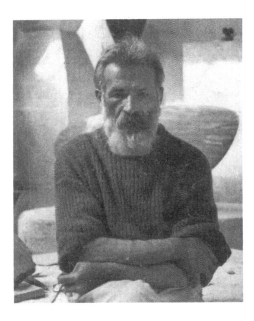

way back to Montparnasse. Things had got to the point where we were shinning up a street lamp to take down a hairdresser's sign when the police came running. Modi got away, but they nabbed me, locked me up, took away my papers. I thrashed about, insulted the cops; they chucked a pail of water in my face. Since I insisted on seeing the chief of police, they threatened to put me in the paddy wagon that stopped by every morning on its way to headquarters. This line of reasoning calmed me down immediately, and in the wee hours of the morning they threw me out. I was in such a state that I waited for a clothing store to open and bought myself a raincoat, so I could walk past my concierge without losing face'

From: Pontus Hultén, *et. al.: Brancusi*, New York (Abrams) 1987, pp. 129-30

Georges Braque

1882-1963

With all my heart I join the friends of Modigliani in paying homage to my friend the great painter.

From: Giovanni Scheiwiller: *Amedeo Modigliani—Selbstzeugnisse, Photos, Zeichnungen*, p. 79

Francis Carco

Writer, 1886-1958

During a recent exhibition of his works in Rue Taitbout, Modigliani was ordered by the police to remove several of his nudes because they were scandalizing the passers-by. The exhibition continued none the less, but although a few admirers could be found to buy some of the infamous canvases, the venture was less successful than had been hoped. It is not really surprising. And the intervention of the police cannot be blamed, for it served only to excite the curiosity of those involved and to increase their interest.

The exhibition comprised a few nudes, several portraits and about thirty drawings I don't imagine that Modigliani will ever try other genres.

But the portraits, as much as the nudes, which he flung so thoughtlessly into the marketplace would themselves suffice to exalt his art. Should his art offend you by its cynicism or by his use of a palette of only two or three tones to which he clings blindly if he distorts in an attempt to achieve a definition of grace; if he makes sacrifices in the name of creativity, and if nothing interests him but nuance, besides rhythm or the secret structure of movement 'which displaces line', you should look to your own imperfect understanding of the subtle communication of the sensitive handling by this painter of the object of his worship. It is not a question of realism, in the sense given the word in relation to painting. Yet I know of nobody, prior to Modigliani, who could give such intensity of expression to the face of a woman.

The art of today is no more than a meticulous copy, a forgery. It makes ridiculous the extreme angst with which living painters, at the drop of a hat, contemplate their navels. Why condemn a painter to live like a goat in the open air, tethered to a stake with only five metres of string, going round and round all day? The only artists we admire have broken the string. They have left, after a drunken evening or an all-too-clear vision of the future, and gone to some remote island, far from the people who know as much about painting as someone from Toulouse knows about music; away from the world to Montmartre, or to solitary, cold Montparnasse, the quartier which is home to people from all over the world.

Sensible people, family people—in short, the 'man in the street'—have customarily said, when talking about a friend or relation who scribbles verse (or rather, nonsense) in an attic, or who daubs a bit in Rue Bonaparte: 'miserable soul!' Isn't this how the arts came to be connected with misery? What misery? Although some people still think of Modigliani in this old-fashioned, romantic way, misery is not the overriding theme. But is it not a great misfortune for a man to discover, by some kind of higher instinct, new rhythms, almost a whole new language, in the back room of a bistro?

There and nowhere else . . . or, if you prefer, in a studio lit obliquely by the reflections of a snowy day; I always feel that this painter hoped to erase from memory his previous day's work. Do you remember the portrait of the woman whose head, tilted to the right, is joined to her body by what looks like the neck of a guillotined person? Does it remind you of those other attentive faces with star-

ing eyes, those mouths made up in brownish-red, those chests caught in mid-sigh? He was tormented by a fierce, almost uncontrollable love for his subject and was trying to free himself from it. Murky painting, shot through by a glance or rent by black laughter, typical of the image one retains of Modigliani's unforgettable early style; like when native weapons, masks or scraps of material pillaged during a battle are pinned up on the wall.

Picasso's Saltimbanques were leading the way down quite narrow tracks at this period; insanity could be found beating against the walls of a hotel bedroom, while speaking in a quite reasonable and natural manner. The laws of equilibrium were on the move . . .

'When painting becomes popular,' wrote Théophile Gautier in his *Etudes sur les Musées*, 'religious subjects are abandoned in favour of historical or living personalities, always somewhat idealized; there follows the domination of nature. Landscape, which hitherto had simply served to provide a green background for figures, now gains in importance and exists in its own right; the figures themselves become redundant. Lines which used to be straight begin to curve and then to twist. Gilded backgrounds give way to blue backgrounds, and then the figures obscure them. These changes can be observed in the history of painting in every country and at all periods. Contrary to what might seem logical, the ideal is the starting point and nature the end.'

Modigliani, having achieved his painting style by eclectic borrowing, took off from the point reached by his mentors and worked his way steadily towards a new ideal—an ideal that demands that we seek for more than a mere likeness in a portrait, that we appreciate the juxtaposition of surfaces, the relationship between masses and a certain feeling behind it which, scorning the subject matter, fosters all our hopes. There is no painter worthy of the name who, having synthesized all the thousand influences from previous centuries in his work, does not reject those influences in order to find a new direction.

The new directions favoured by the artists of today still amaze quite a lot of people. But if we leave the theorists to their fainting fits, a painter like Modigliani seems daily to grow more representative of contemporary art.

At the same time as he was using pinks and blacks for the tormented figures in his painting, in his drawing he was gradually making less use of lines. He merely suggested. His distinguished personal style retained its ability to move, its nobility. The whole character of his work was subservient to this style. Then on to the canvas went the astonishing studies in which the nakedness gives the impression of revealing only the gentle curve of a stomach, breasts, a smile on a mouth more suggestive even than female genitalia. Pure animal grace, in all its indulgences and its blessed frailty, has never found a painter more anxious to express it. Look at the hands, clasped or moving towards each other; the movement of the face; the eyes, one almost closed as the moment of pleasure approaches; the finger . . . the thighs, beckoning more tenderly than a pair of outstretched arms, and the delicate little fold hiding 'love's moist retreat'.

. . . Modigliani painted these pictures in about 1913. Since then—for his paintings (at any rate his nudes) were difficult to exhibit—his drawings have

been widely praised, and in my opinion they will never decline in value. I have watched Modigliani drawing. His acute sense of detail is demonstrated by the way he models a shoulder joint or the innocent curve of a young breast. One scarcely visible line expresses and gives life to the whole structure of the body, the gentle rise and fall of the stomach, even the depths of the soul. I wish to express my admiration for Modigliani's drawings. In them the grace is achieved through his style, and this style can be found in all his works as he transfers to the canvas his feelings for objects, his vision of the world, his rhythms and his colours.

Modigliani's determined use of curved lines, intersecting and juxtaposing, the planes the lines separate or join, the elongation of the strokes and most of all the solid way shapes are established or shifted remind us that in Livorno, where he first began to discover his destiny, he carved stone figures of very great beauty. As a painter, he never forgets that all forms of art have to respect certain rules common to them all. The plasticity of his forms, determined by depth of tone rather than by colour, is thus strikingly and immediately clear: so intensely clear, in fact, that he could alter his painting techniques without in any way threatening the character of his work.

Imagine him in his early days creating a face from a bituminous blend of paint, building it up into a worked relief; then imagine this face relegated to the background, its features indicated by the slightest outlines. We can see from this how far Modigliani's ideas on the subject have developed.

The backgrounds grow lighter. Livelier. They are sustained by a thousand subtle details and their artless mobility contributes to the life of the subject. The face, too, glows with a new spirit. The light, which Modigliani almost always wanted quite uniform and even, pierces the line, making it ever more sensitive, and, without disturbing its arabesques, gives it ever more subtle depths.

It has been said of Modigliani that his distortions ceased to shock our affection for our own human image. This is not to say that Modigliani relinquished the particular characteristics of his art. He simply increased the scope of his palette, and reaffirmed it. This led to the clear revolution in his art, in my opinion the elevation of his painting. The almost flat colours of his early work, strengthened by fierce contrasts or enlivened by each other, are disappearing. He has made them more worthy of the great artist we know him to be Should he return to painting the nudes he used to paint, I imagine that they will make us forget their determined frigidity, and that their attitudes will be less severe. I am not trying to compare these apricot-skinned queens with other naked, servile women. The kingdom painted by Modigliani at the foot of his models' chaises longues belongs only to them; and I am not referring to their nude poses. But the art they borrowed from their author, which allows them to compete with their rivals, is not the art into which they were born. It repudiates its primitive or literary origins, and Gauguin (of whom we are thinking, even if we haven't said so), along with the Spaniards—who inspired the forerunners of the new movement in painting twelve years ago—can no longer be more than distant figures in the development of Modigliani's painting.

From: Francis Carco, 'Modigliani', *L'Eventail*, 15 July 1919

Modigliani outraged the feelings of certain collectors, thus giving rise to a scandalized outcry. These eccentricities concerned only the man; it is not up to us to judge them. His work remains for us. What power it has over us! Remember Modigliani's nudes and portraits. A painter of character, of attitudes, of graceful rhythms; I know of few who, as detached as he was from any influence, have imposed a style more sober and more directly involved in its subject matter. He sacrificed everything to the requirements of this style, pushing his research so far that the distortions he used no longer could shock the human affection we have for our own likeness. And in so doing he managed to achieve his greatest ambition.

Renoir, whom he met in the Midi, was generous in encouraging him ... and so was the public. This could be seen in the recent exhibition in London, as it was in the last Salon d'Automne, and also, unhappily, at the opening of a one-man show of some twenty of his paintings which, by an odd coincidence, took place on Tuesday in the Devambez Gallery at the same time as his burial.

From: Pierre Sichel, *Modigliani,* New York (Dutton) 1976, p. 514 f

Carlo Carrà

Painter, 1881-1966

I met him in 1912 at the Closerie des Lilas, a haunt of the Parisian artistic avant-guarde. This café in the Latin quarter was frequented by Apollinaire, Léger, Gleizes, Metzinger, Salmon, Roger Allard, Maurice Raynal, Riciotto Canudo, Archipenko and many other painters and poets. The talk was then of Cubism, and Modigliani expressed considerable reservations about it, especially because he saw in the pictures its apostles were painting another dissolution of the object such as had occurred in Ex-

pressionism. He also complained that Cubism was reducing the problem of colour to a question of a few grey and brownish tones—a fact that could be proved from the paintings of Picasso and Braque, by then its two greatest exponents. This is not to say Modigliani failed to recognize that these painters were raising the standards of painting, even if on a narrow front, to a level that was then unknown in most artists. Basically, Modigliani was criticizing Cubism because of a clear need to defend his own conception of art; and it is quite remarkable that, from that time on, there should be discernible in this troubled artist a profoundly held attitude towards the realization of images that one would look for in vain in other, more intellectually balanced painters of the period.

The last time I saw him was in the spring of 1914. I was particularly struck by the deterioration in his physical condition. His eyes were ablaze, his mouth set in a bitter twist. Untreated tuberculosis and alcohol abuse had ravaged his face.

I used to see him nearly every day at the Café de la Rotonde in Montparnasse. Americans, Poles, Spaniards, Russians, artists from every corner of the globe treated him with great respect, and he greeted them all with a smile and a warm handshake. But it was easy to see how distanced he was from this noisy, idle crowd.

From: *Modigliani—dipinti e disegni*, p. 105

Blaise Cendrars

Writer, 1887-1961

I knew Modigliani from the time of his arrival in Paris: he was rich. He lived in the Hôtel du Perron, in the Rue du Dôme. He had inherited money from his father and must have possessed about a hundred and sixty thousand francs at the time. He was a very elegant young Italian, wearing a little hand-stitched jacket, pleated at the waist, narrow and fitted, with sleeves that only just reached his wrists, in the way Italian tailors make them to allow the cuffs of the shirt to flap, which has a grand effect when the wearer gesticulates. I knew Modigliani was a rich man, very rich.

From: Jeanine Warnod, *La Ruche & Montparnasse*, p. 77

One summer afternoon I met Modigliani at the end of the Rue Dauphine.

'Do you have any money?' he asked me.

'Fifty francs; and you?'

'A hundred!'

'Great, then let's go and wet our whistles,' I said to him.

We went into the nearest shop to buy some wine and sat down on the banks of the Seine behind the Vert-Galant opposite a raft on which women were washing laundry. And we at once opened two or three bottles.

'Do you have some string?' Modigliani asked me.

'No, why?'

'So that we can cool the bottles in the Seine.'

Modigliani got up in order to borrow some string from the owner of the raft. We lowered the bottles into the water and from time to time pulled one out, opened and emptied it, and each time we drank noisily to the health of the old washerwomen on the float opposite as they knelt beside their tubs and did their washing.

Washerwomen have sharp tongues. And as you can imagine, all this was accompanied by gales of laughter and gay banter, by words and obscene gestures on the part of the old ladies, to which we responded as well and as bluntly as we could. We got more and more drunk, and Modigliani then offered a bottle to the ugliest of the washerwomen provided that she let him kiss her on the lips. They all egged him on; Modigliani tried to walk straight across the water to his chosen hag and sank suddenly before our eyes. Guffaws of laughter greeted this unexpected turn. I alone plunged into the water to save Modigliani since I knew that he could not swim. I grabbed him by the hair, but then I myself was in a precarious situation as I have only one arm. I kicked out strongly with my legs and we came to the surface where the raft owner, who had jumped into his boat, finally pulled us out.

The old women were now screaming with delight while our clothes, which we had taken off, dried out. Modigliani, stark naked and looking for all the world like St John the Baptist, emptied the bottle that he had held clutched in his hand the whole time. He loudly proclaimed his intention of making a second attempt.... Finally we were ejected. It was high time. Modigliani did not know what he was doing, and the old ladies were trying to catch us....

'Are you coming, Amedeo?' I finally asked.

He then turned on me violently, because he could not stand being addressed by his first name....

From: Giovanni Scheiwiller, *Amedeo Modigliani—Selbstzeugnisse Photos, Zeichnungen*, p. 65 f

He painted my portrait as if he were sketching, very quickly. It took him about three hours, and between brush-strokes he recited poetry by Dante and Baudelaire.

From: *Modigliani—dipinti e disegni*, p. 9

Giorgio de Chirico

Painter, 1888-1978

There are no modern art movements in Italy. No dealers, no galleries. Modern painting does not exist. There is only Modigliani and I; but we are almost French.

Modigliani's painting is very beautiful.

From: *Modigliani—dipinti e disegni*, p. 105

Charles-Albert Cingria

Writer, 1883-1954

Modigliani has great significance for our times. He was a friend of the followers of Apollinaire, although he took no part in the Neo-classical movement led by his contemporaries from Parade. He was only very briefly interested in Cubism. When that was over—Cendrars wrote, 'The cube is crumbling'—instead of turning, as did Picasso and others, to the Italianism encouraged by Diaghilev, he took refuge in a pseudo-primitive sharpness more suited to his subject matter: the Florentines, the Pisans, the Venetian icon painters. His hieratism, as with El Greco—although the temptation to compare him in any other respect to El Greco is to be resisted—would in the end cause him to distance himself from Renaissance. This perhaps is the magic that he shares with the other survivors of Symbolism. But his art is more remarkable for its resistance to any influence, contemporary or indirectly contemporary, and in this Symbolism therefore plays no part. A bit of magic and a technique of stylized emaciation cannot characterize an entire period. It is not for this reason, in any case, but because of the inimitable personal stamp he put on his work that he remains so significant a figure in the history of modern art.

The label 'Fauve' is to be rejected too, although it could be heard echoing through the streets of Montparnasse. There is too much confidence, too much sensitive respect in his work. I would compare him more readily to the Japanese primitives whom the Tuscan primitives frequently bring to mind. Thus when Vincenzo Caldarelli, in a recent article, proposes that 'Modigliani's life and his art are like two parallel lines which finally come together,' I disagree. Modigliani's painting was never less Montparnassian than towards his death, when his life was more so, since it was Montparnasse that killed him. However, I do agree with Caldarelli when he speaks of his large though austere imagination, his raw tenderness, the formality of his line; I particularly applaud the way he stresses his muralist and what one can only describe as 'Italian' use of colour (*la sua italianissima e murale maniera di colorire*). These are sovereign qualities, he concludes, which merit our unreserved appreciation.

So many falsehoods have been told about his time in Montparnasse. I remember him as a courteous and diffident person. Certainly he drank, and sometimes grew excited, but no more nor less than others at that time. It was the quality of his excitement that was so remarkable. He never ceased to be a gentleman. Those who gave him this reputation as a drunkard were probably temperance supporters—more Italians than you would think take this line—and for them even drinking in moderation is excessive. I seldom saw him exceed the accepted amount for any civilized being, which is a litre per meal.

To begin with he was very well dressed, but then, finding artist's clothing more comfortable, he adopted it, although without exaggeration. After a trip to Italy where he spent some time in Livorno, he returned to France once more elegantly dressed. What finally killed him was a combination of lack of coal, damp, dripping walls, poor and insufficient food. By the end he could paint only when he was

at his dealer's: quickly and perfectly and in a single sitting.

His extravagant deeds have been exaggerated; they were rather acts of courage. An abduction—I believe that he did abduct Madame Hastings—should not be deemed an extravagance, and no more should an attack or self-defence with a knife if one's honour is at stake.

He was a poet, too. The following couplet is by him (and not by Cravan, nor Jacob, nor Apollinaire):

> There is in the corridor
> A man who wishes me dead.

He spoke very pure French, with neither a Parisian nor an Italian accent. In Italian, he was very knowledgeable. He was familiar with the three great poets and, although he found this amusing, was the embodiment of the distinction between ordinary knowledge and decorative knowledge (*il sapere ornato*).

He used to sing, but with no regard for timing, and always the same tune. His girlfriend played the violin. She too only knew one tune (not the same as his): the 'Pentecost Air' by Johann Sebastian Bach. She was gentle, shy, quiet and delicate, and a little sallow. When he died, she threw herself out of the window. Apparently—and this was reported by Caldarelli who was no more at his deathbed than I was—he murmured as he died, '*Cara Italia*' ('Dear Italy'). Indeed, his patriotism at that time was very expedient. He loved the king as portrayed on the bronze five-centime coins. A bit of a Talmudist by inclination, he had great respect for the Catholic religion.

That's all.

Paris, December 1933

From: Charles-Albert Cingria, Introduction to the catalogue of the Modigliani exhibition at the Kunsthalle Basel, 1934, p. 3 ff

Jean Cocteau

Painter, writer and film director 1889-1963

He who, on the terrace of that Rotonde destroyed like our dreams, mysteriously told the lines of our faces.

He who, not selling his drawings, gave them with the gesture of a prince.

He who, under the curls of a model of the Piazza di Spagna at Rome [special meaning for Cocteau: hangout of the homosexuals], pawed the ground till dawn, with the ire of a child who refuses to go to bed.

He who loved us and lent us his elegance.

He whose evanescing ghost a Spaniard came to retrieve, face to face with my own across a table as we dined at Kisling's.

He who drank incredibly, without baseness.

He who, rooted before the Balzac Statue by Rodin, bent in the posture of an oak before the storm, the bow fletching its arrow.

He who, no more than we, believed a public for art existed.

He who would be stupefied to know he has been betrayed by absurd legends—having fabricated his own by hand, as one weaves straw that can blaze up.

From: William Fifield, *Modigliani—The Biography*, New York (William Morrow) 1976, p. 287

Modigliani's drawing is supremely elegant. He was our aristocrat. His line, sometimes so faint it seems the ghost of a line, never gets bogged down, avoiding this with the alacrity of a Siamese cat.

Modigliani never consciously stretches faces, exaggerates their lack of symmetry, gouges out an eye or lengthens a neck. All that happens in his heart. That's the way he used to draw us, ceaselessly, at the Rotonde (there are hundreds of unknown portraits of us in existence). That's the way he judged us, experienced us, loved us and argued with us. His drawing was a silent conversation. A dialogue between his line and ours. And from this tree, planted so firmly on velvet legs, so difficult to uproot once it had taken root, the leaves fell and were strewn all over Montparnasse.

If his models end by looking like one another, this is in the same way that Renoir's models all look alike. He adapted everyone to his own style, to a type that he carried within himself, and he usually looked for faces that bore some resemblance to that type, be it a man or a woman.

In the same way it is possible to be fooled by the superficial similarity between one Chinese and another, one Japanese and another, one Negro and another. One may be similarly deceived by the profiles on the temple carvings in Egypt; but I recognized the family of Seti I on a fresco in Luxor.

This resemblance is so pronounced in Modigliani's work that, as with Lautrec, it becomes self-evident and strikes those who never knew the models.

But the resemblance is only a pretext through which the artist affirms his own identity. Not his physical identity, but the mysterious identity of his genius.

Modigliani's portraits, even his self-portraits, reflect his internal, not external, line: his noble, keen, slender, dangerous grace, like the horn of a unicorn.

In addition, I should like to repeat that Modigliani did not paint portraits to order. His drunkenness, his growling and roaring, his unwonted laughter—he exaggerated all these to protect himself from importunate bores whom he then insulted by his arrogance.

At the end of his short life he rushed to Zborowski's house and shut himself in; he set to work on a stream of nudes and female figures that is now flowing into museums all over the world.

Others will write of his aesthetics. Here I want to give precedence to the artist and his works, in which all the proud individuality of his nature is expressed.

From: Jean Cocteau, *Modigliani*, n. p.

When Modigliani painted my portrait he was working in the same studio as Kisling at Number 3, Rue Joseph-Bara. He sold it to me for five francs. I, alas, did not have enough money to pay for a cab to take the large canvas home. Kisling owed eleven francs at the Café de la Rotonde. He suggested to the proprietor that he should accept the portrait in payment of the debt. The proprietor accepted and the picture began a journey that ended in a sale worth seven million in America. All I possess is a colour photograph.

From: Jeanine Warnod, *La Ruche & Montparnasse*, p. 84

Gustave Coquiot

Art critic, 1865-1926

Modigliani was a most unusual and appealing character. Though leading a totally disorganized life, this painter/sculptor and sculptor/painter managed to paint marvellous nudes, and portraits of equal distinction.

Admittedly he was repetitive, but what total, utter originality! His paintings, for this very reason, are always attractive. And his drawing—skilful, subtle, amazing virtuosity, unique quality!

The only drawings that can compare with such exceptional skill, such lofty impertinence, are certain drawings by Lautrec. But Modigliani has more synthesis, refinement and style.

He possessed all the qualities of Italy, his native land: excitable, discriminating, full of enthusiasm. His nimble chisel cut swooping arabesques in white marble, and without fail the result would be a paragon of beauty and elegance.

Without doubt many of his nudes are coloured too uniformly, with that apricot shade in fashion at the time—which made so many young women's faces into such warm, wistful fruits; but this Far Eastern shade—oh patina of opium!—is it not preferable to the scaly pinks foisted on us by so many painters?

And Modigliani, on the other hand, also painted you, with your bloodless faces made pale by physical illness or by marriage. He portrayed you too, you melancholy virgins, with your heads wobbling on elongated necks, fragile as a flower's stem. Drop by drop he drained your blood, leaving you langui-

shing, exhausted, at death's door. An admirable painter of suffering!

But also, quite suddenly, Modigliani flung himself into life, passionate, powerful life, scarlet life. And you must have seen many paintings of this kind: boys glowing with health, with ruddy faces and hands; serving girls, their black or yellow hair clamped to their plain foreheads as if glued there.

I liked Modigliani for being a painter who never concerned himself with exhibitions; who never plagiarized his colleagues; who lived within himself and for himself, with all his virtues and flaws. And a selection of his works would bring constant joy to anyone with a passion for painting.

From: Gustave Coquiot, in *Les Indépendants*, pp. 98-9

Pierre Courthion

Art critic, born 1902

Modigliani was the beneficiary of a miracle that protected his painting from all blemish and vulgarity: no hint of coarseness; on the contrary—lofty distinction and irresistible emotional force.

From: Giovanni Scheiwiller (ed.), *Omaggio a Modigliani (1884-1920)*, n. p.

Lunia Czechowska

He drew on his large block with a very sure hand and never corrected the lines which he had made so hastily: with a few strokes he had finished a portrait.

I shall never forget the first portrait sitting I did for him. Gradually my timidity and bashfulness disappeared. I can still see him standing before me now with his short sleeves and his tousled hair as he attempted to capture my features on the canvas. From time to time he would reach out for a bottle and I soon noticed the effect that the alcohol had on him: he became so involved in his work that he forgot that I existed, having eyes only for his work. In fact, he was so engrossed and preoccupied with himself that he started speaking Italian to me! He painted with such passion and fervour that the picture fell from the easel on to his head when he bent forward to try to view it from close up. This startled me. He was sorry to have frightened me and so smiled at me gently and began singing Italian songs to make me forget the incident.

Modigliani became transformed, as it were, before his model: he strained feverishly to fathom his sitter's character so that he could then reproduce it on canvas. As a sitter you had the impression that your soul was being dissected, and you had the strange feeling that you were unable to hide your innermost feelings.

As I was preparing the meal he asked me to raise my head a little, and by the light of the candle he did a very nice drawing of me under which he wrote the following dedication: '*La Vita è un Dono: dei pochi ai molti: di Coloro che Sanno e che hanno a Coloro che non Sanno e che non hanno!*' (Life is a Gift: from the few to the many; from Those who Know and have to Those who do not Know and have not.)

From: Ambrogio Ceroni, *Amedeo Modigliani, peintre,* p. 27 ff, 43 ff

André Derain

Painter, 1880-1954

The memory of my friend Modigliani remains one of the tenderest and noblest memories of my life as a painter.

From: Giovanni Scheiwiller, *Amedeo Modigliani—Selbstzeugnisse, Photos, Zeichnungen,* p. 81

Ilya Ehrenburg

Writer, 1891-1967

I rarely had a conversation with Modigliani without his reading to me a few tercets from the *Divina Commedia*: Dante was his favourite poet. In *Poems about the Eves* there is one dated April 1915: 'You sat on a low step, Modigliani, your cries were those of a stormy petrel Oily gleam of lowered lamp, blueness of warm hair. Suddenly I heard the thunderous Dante's dark works roaring out, spilling over' Dante is not always thunderous; I remember some lines from the *Purgatorio*: the poet

and his companion, having climbed a height, sit down and gaze quietly upon the path that lies behind them. I should like to be sitting now with the living Modigliani (Modi, as his friends called him). Today he has been made the hero of a vulgar film. Some entertaining novels have been written about him. But how could a film director sit on a low stone step meditating on the tortuous ways of a stranger's life?

All this is true and all of it is false. It is a fact that Modigliani went hungry, that he drank and swallowed grains of hashish; but the reason for this was not love of debauchery nor longing for an 'artifical paradise'. He did not in the least enjoy going hungry—he always ate with a hearty appetite—and he never sought martyrdom. More than others, perhaps, he was made for happiness. He loved the sweet Italian language, the gentle landscape of Tuscany, the art of her old masters. He did not start with hashish. Of course he could have painted portraits that might have pleased the critics and buyers; he would have had money, a good studio and recognition. But Modigliani knew neither how to lie nor how to adapt himself; everyone who met him knows how very straightforward and proud he was.

I have seen him on bad days and on brighter ones; I have seen him calm, extremely courteous, clean shaven, with a pale face that had just a touch of coarseness about it, and gentle, friendly eyes. I have also seen him frantic, with black bristles sprouting all over his face: this Modigliani screamed piercingly, like a bird—perhaps like an albatross; it was not, after all, just for sake of allegory that I mentioned the stormy petrel in my poem.

I met Modigliani in 1912, when he was already an old Parisian. At one of our first meetings he made a drawing of me, which everyone thought a very good likeness. After that he drew me often; I had a whole folder of his drawings.

I was always astonished by the width of his reading. I don't think I have ever met another painter who loved poetry so deeply. He could recite by heart verses from Dante, Villon, Leopardi, Baudelaire, Rimbaud. His canvases do not represent fortuitous visions: they are a world appre-

hended by an artist who has a rare combination of childlikeness and wisdom. When I say 'childlikeness' I do not of course, mean infantilism, a native lack of ability or a deliberate primitivism; by childlikeness I mean freshness of perception, immediacy, inner purity. All his portraits are like their models (I judge by those I knew—Zborowski, Picasso, Rivera, Max Jacob, the English writer Beatrice Hastings, Soutine, the poet Frans Hellens, Dilewsky, and finally Modi's wife Jeanne). He was never distracted by any trappings or anything external; his canvases reveal the nature of the person. Diego Rivera, for instance, is large and heavy, almost savage; Soutine retains his tragic expression of incomprehension, the constant yearning for suicide. But what is extraordinary is that Modigliani's models resemble each other; it is not a matter of an assumed style or some superficial trick of painting, but of the artist's view of the world. Zborowski with the face of a good-natured, shaggy sheepdog; the lost Soutine, the tender Jeanne in her shift, an old man, a model, somebody with a moustache: all are like hurt children, albeit some of these children have beards or grey hair. I believe that the world seemed to Modigliani like an enormous kindergarten run by very unkind adults.

It is also true that even enlightened art connoisseurs failed to understand him. These who liked Impressionism could not bear Modigliani's indifference to light, the clean definition of his drawing, his arbitrary distortion of nature. Everyone was talking about Cubism; painters who were sometimes obsessed by the idea of destruction were at the same time engineers, architects and designers. To the lovers of Cubism, Modigliani was an anachronism.

Biographers note that 1914 was a successful year for Modigliani: he met the art dealer Zborowski who understood and liked his works at once. But Zborowski was himself a poor devil: a young Polish poet who had come to Paris dreaming of a voyage to Cythera and found himself in the doldrums —in front of a cup of coffee at the Rotonde. He had no money. He rented a small flat where he lived with his wife. Modigliani often worked there. Then Zborowski would put his canvases under his arm and run round Paris from morning until night, trying in vain to interest genuine art dealers in the Italian painter's work.

Finally, it is also true that Modigliani sometimes fell prey to unrest, horror and rage. I remember a night in a studio littered with rubbish; there was a crowd of people including Rivera, Voloshin and various models. Modigliani was very excited. His friend Beatrice Hastings kept saying with a pronounced English accent: 'Modigliani, don't forget that you're a gentleman. Your mother is a lady of the highest social standing.' These words acted on Modi like a spell. He sat in silence for a long time. Then he could not bear it any longer and started breaking down the wall. First he scratched away the plaster, then he tried to pull out the bricks. His fingers were bloody and in his eyes there was such despair that I could not stand it and went out into the filthy courtyard strewn with fragments of sculpture, broken crockery and empty crates.

He created a multitude of people; their sadness, their frozen immobility, their hunted tenderness, their air of doom move the gallery visitors.

From: Ilya Ehrenburg, *Men, Years, Life,* London (Mac-Gibbon & Kee) 1962, Vol. 1, p. 149-54

Jacob Epstein

Sculptor, 1880-1959

Modigliani I knew well. I saw him for a period of six months daily, and we thought of finding a shed on the Butte de Montmartre where we would work together in the open air, and spent a day hunting around for vacant grass plots for huts, but without result. Our enquiries about empty huts only made the owners or guardians look askance at us as suspicious persons. However, we did find some very good Italian restaurants where Modigliani was received with open arms. All bohemian Paris knew him. His geniality and *esprit* were proverbial. At times he indulged himself in what he called 'engueuling'. This form of violent abuse of semeone who had exasperated him was always, I thought, well earned by the pretentiousness and imbecility of those he attacked, and he went for them with gusto. With friends he was charming and witty in conversation, and without any affectations. His studio at that time was a miserable hole within a courtyard, and here he lived and worked. It was then filled with nine or ten of those long heads which were suggested by African masks, and one figure. They were carved in stone; at night he would place candles on the top of each one and the effect was that of a primitive temple. A legend of the quartier said that Modigliani, when under the influence of hashish, embraced these sculptures. Modigliani never seemed to want to sleep at night, and I recall that one night, when we left him very late, he came running down the passage after us, calling us to come back, very like a frightened child. He lived alone at that period, working entirely on sculpture and drawings. In appearance Modigliani was short and handsome, and contrary to general belief or the impression given by his pictures, robust and even powerful. Later he had any amount of the girls of the quartier after him. His brother, at his death, arrived in Montparnasse to look after a child said to be Modigliani's, but so many girls came claiming maternity to Modigliani's children that the brother gave it up in despair.

When I knew him he had not attained fame outside Montparnasse, and only rarely sold a work.

Drawings which he had made in the morning he would try to sell at café tables for anything he could get for them. We had our meals at Rosalie's, the Italian woman who had once been a beautiful model, and there Rosalie would admonish Modigliani. She had a motherly love for her compatriot and would try to restrain him from his 'engueuling' her other clients. She tried to make Modigliani settle down and be less nervy and jumpy. He was peculiarly restless and never sat down or stayed in one spot for long.

Rosalie had a large collection of Modigliani's drawings in a cupboard, set against multitudes of free meals, I suspect, because, as I have said, the old Italian had a very kind heart for him. When he died in 1921, she naturally turned to this cupboard for the drawings, as dealers were after them, but, alas for Rosalie's hopes, the drawings, mixed with sausages and grease, had been eaten by rats.

A painting by Utrillo, which I remember on her walls, was later cut out of the plaster and sold to a dealer. Modigliani would say, 'A beef steak is more important than a drawing. I can easily make drawings, but I cannot make a beef steak.'

Hashish, he believed, would lend him help in his work, and certainly the use of it affected his vision, so that he actually saw his models as he drew them. Also he was influenced by *Les Chants de Maldoror*, which he carried in his pocket and to which he would refer as *'une explosion'*.

I was amazed once when we were at the Gaîté Montparnasse, a small popular theatre in the Rue de la Gaîté, to see near us a girl who was the image of his peculiar type, with a long oval face and a very slender neck. A Modigliani alive. It was as if he had conjured up one of his own images. Modigliani's liveliness, gaiety and exuberant spirits endeared him to hosts, and his funeral was characterized as *'une funéraille en prince'*. Artists, tradesmen and café waiters joined in the long procession. *Les agents* stood at the salute as the long cortege passed. Picasso seeing that, and recalling that Modigliani and the police had not got on well together during his lifetime, called the funeral *'la revanche de Modigliani'*.

I was in London when Modigliani died. At that time in Shaftesbury Avenue, Zborowski, Modigliani's dealer, had a gallery. I was in this gallery in 1922, when a telegram came through from Paris saying: 'Modigliani dying. Sell no more of his works. Hold them back.' These works had been very inexpensive up to his death. From then on the prices rose to the amazing figures they have reached now.

From: Jacob Epstein, *Let There Be Sculpture*, London (Michael Joseph Ltd.) 1940, p. 61 f

Florent Fels

Art critic

Modigliani's face became concave, as if it were being emptied from below, and his eyes took on a strange beauty; he was a man who cut a magnificent figure, even when his brown suit bore the marks of poverty, the traces of great inspiration.

From: Giovanni Scheiwiller (ed.), *Omaggio a Modigliani, (1884-1920)*, n. p.

Othon Friesz

Painter

he loved art for art's sake:
with the voice of desire he exalted the flesh—
unable to imagine nor endure a life
without the distress that brings about the joy of
painting.
he was brilliant and unhappy
his weaknesses were those that genius
excuses because they bear fruit.

From: Giovanni Scheiwiller (ed.), *Omaggio a Modigliani (1884-1920)*, n. p.

Waldemar George

Act critic

It is in his studies for nudes that the genius of the artist is most evident. These nudes 'at one stroke' are drawn with all the assurance of an artist completely in control of his subject. Modigliani never destroys the feeling for form with a mishandled anatomical detail. No distinctive trait of the model can deflect his line or break the rhythm of his poetic drawing. And yet these nudes, the most beautiful by any artist since Ingres, are neither arbitrary nor abstract; on the contrary, they are concrete, true to life.... Though he may stylize forms, he stylizes them with respect for their own individual nature. His great recumbent nudes, built up in waves of undulating curves, have a hieratic simplicity.

I have already described how at the beginning his technique was coarse and flat. Towards the end of his life his colours become more delicate. He gives up covering his surfaces with uniform tones, applied over broad areas. He shades and modulates. But he always modulates in local colours. His speckled flesh tones are sometimes tinged with pink. The artist seems to take almost culinary pleasure in mixing the different ingredients. Master of all his media, he is already bordering on mannerism.

In the space of less than ten years, Modigliani goes through a complete cycle in both his art and his personal life. Yet his successive styles add up to a perfectly harmonious whole. The same mentality, the same inspiration presides over his various endeavours. Whether he is allying himself with Negro art, or submitting to the school of Cubism, his general direction remains the same. His drawing is sensitive, his form eloquent. This Gothic spirit, whose dominant quality is his taste for the vertical, is first and foremost an Italian. His figures are idealized, indeed disembodied. The disproportionate elongation of their limbs, Modigliani's apparent desire to make the body look as if it were constructed from pillars, the sense of surface—all are symptomatic of his Gothic mentality. He was Gothic at the outset, as were the great fourteenth-century masters such as Barna and Duccio. His later work, stylistically more elegant, is more reminiscent of fifteenth-century painters: Filippo

Lippi or even Botticelli. But that analytical spirit that drove Luca Signorelli and Paolo Uccello, for instance, to experiment with new theories of perspective and anatomy never troubled the conscience of our contemporary. Sometimes dramatic, in a fashion only primitives can manage, sometimes figurative, Modigliani's painting, born on French soil from the brush of an Italian genius, steeped in the greatest tradition, with the vital force of French genius, that magic crucible from which world painting takes nourishment every day, has preserved its ethnic origins.

From: Waldemar George, 'Modigliani', *L'Amour de l'Art*, VI, October 1925

Michel Georges-Michel

Art critic

Bakst, who had prophesied Chagall's great future to me, said to me one fine day: 'Stay here in my studio. I am expecting someone, someone special. He is an Italian sculptor and painter from Livorno, Modigliani. He is doing a portrait of me. Look at his sketch, how carefully executed it is. All my features are so sharply reproduced, without any retouching, as if with a stiletto. He must be poor, but he looks like a prince. He really must be someone special'

A tall, erect young man entered the studio. His gait, like that of a Spanish dancer, made him look like an Indian from the Andes. A clinging sweater covered his torso. From his pale face, framed by a mass of hair, a piercing look emanated from beneath his broadly arching sharp eyebrows. Later I discovered that this concentrated gaze, which was directed above our heads, was the unfortunate result of his drug-taking.

Modigliani quickly brushed aside the polite introductions as if he was burning with impatience to start work. He did not touch the tea or cake which Bakst brought him. Slowly but surely he began painting; the muscles of his chin and his hands were very tense. He answered our questions courteously but tersely; his entire attention was concentrated on the picture. He allowed himself to be distracted from his work only when Bakst began speaking about Maurice Utrillo. And when someone who had just come into the room asked him why Utrillo always depicted sad subjects, Modigliani answered, not so much with bitterness as with fury: 'One paints only what one sees. Take the painters out of their hovels! Yes, art lovers and dealers are shocked that instead of landscapes we paint only ugly suburbs with trees all black and twisted and covered in soot and smoke, and interiors in which the living room is right next to the toilet! Since we are forced to live like rag-and-bone men in such lowly dwellings, these are the impressions which we reproduce. Every age gets the painters it deserves, and the subjects drawn from the life which it gives them. During the Renaissance the painters lived in palaces, in velvet, in the sun! And today, just look at the filth in which a painter such as Utrillo must live, at the hospitals he has been

forced to attend, then you will no longer ask why he paints only dirt-encrusted walls, disease-ridden streets, barred window after barred window!'

Modigliani loved Utrillo very much. Their first meeting was quite peculiar. First, in order to demonstrate their admiration for each other, they exchanged jackets. Then the one said to the other:

'You are the greatest painter in the world!'

'No, you are the greatest painter in the world!'

'I forbid you to contradict me!'

'I forbid you to defend me!'

'If you say that once more I will box your ears!'

'You are the biggest'

They started fighting. Then they made up in a wine shop. They drank numerous bottles and exchanged jackets several more times Then they left.

'So you agree, you are the greatest painter in the world?'

'No, you are!'

Slap! Smack!

They started fighting again. They rolled into a ditch, fell asleep there and woke up shivering the next morning to find that they had been robbed by thieves.

From: Giovanni Scheiwiller, *Amedeo Modigliani—Selbstzeugnisse, Photos, Zeichnungen, pp. 61-4*

Alberto Giacometti

Sculptor and painter, 1901-1966

He was the last great Promethean hero. He certainly had a wonderful intelligence and openness of spirit. Besides painting portraits, he made pages of drawings; and that is what I always try to do. Draw, draw all the time; that is the secret.

From: *Modigliani—dipinti e disegni*, p. 10

Ramón Gomez de la Serna

Writer, 1888-1963

The small bar at the Rotonde was full of people. One or two cab drivers, when they heard the argument, half turned their heads without interrupting the stirring of their coffee. Modigliani wanted some mental stimulus, and Rivera was holding a stick like the tree spotted by Hernan Cortez.

The young, pre-raphaelite blond who was with Modigliani was wearing two sunflowers in her hair, at the temples. She was listening quietly.

The great Diego's liver must have been as swollen that day as an accordeon about to emit its loudest note.

Modigliani in the heat of the dispute, got his shoulder tangled in the curtains of the bar window.

In the middle of the quarrel Picasso took up the stance of a gentleman awaiting a train, his bowler hat pulled down over his ears and leaning on a stick as if he were fishing.

Diego was shouting!

Modigliani was rocking backwards and forwards like a tipsy sailor.

—Landscape does not exist!

—Landscape exists!

Modigliani, like a drunken diver, flung his arms wide, swimming at the bottom of the sea among the sea anemones and starfish.

Rivera, like a powerful monster, pushed him away.

Picasso prayed silently, without opening his umbrella stick. I did not know what to do, floundering as I was in my Spanish language. I tried to smile through the wreckage.

Rivera's stick measured the length of the marble-topped tables, as if preparing tombstones.

This was the last time I saw Modigliani, plunged in matutinal desperation, a vivid sadness in his eyes, finding forms in his shirt-sleeves; his nonchalance lent a miraculous quality to the absinthe-coloured dawn, dawn that broke at midday and travelled the backbone of the day, giving to his eyes the clarity with which he could contemplate the human form.

From: *Paris—Montparnasse*, February 1930, p. 6

Paul Guillaume

Art dealer and collector, 1891-1934

Because he was very poor and got drunk as often as he could, he was for a long time looked down upon —even in the artistic community, where some prejudices are more deeply rooted than is generally believed. Amedeo Modigliani, born in Livorno, was a Jew and liked to think of himself and his art as Jewish.

Rather strangely, he was the protégé of a distinguished woman poet, Beatrice Hastings, who had been a circus rider in the Transvaal, and with whom he had some stormy, not to say tragic, times. He left many portraits of her which will have to be taken into account when the story of his life is writ-

ten, for love and passion played an important role in it. In 1915 he left Montparnasse to set up a studio that I rented for him at 13 Rue Ravignon. It was a historic wooden building that had been witness to difficult, and heroic, moments in the lives of Picasso, Max Jacob, the Douanier Rousseau, and many painters who are today more or less famous.

From then on he gave up sculpture, drew less frequently and began to paint—to paint as he lived, sentimentally, violently, erratically, wastefully. I use this last word advisedly, because it characterizes accurately Modigliani's extraordinary life.

The painter was, in fact, a poet. He loved and judged poetry not with the cold partiality of a university professor, but with a spirit mysteriously equipped to appreciate all that was sensitive and adventurous. Nevertheless, by nature he had the gusto of an Old Testament prophet.

His pencil drawings, which he scattered carelessly around, were often embellished with snippets of remembered poetry or philosophy. When improvising poetry he took a comical liberty with rhymes. I remember:

> Il y a dans le corridor
> Un homme qui m'en veut à mort.

And:

> Ma plus belle maîtresse
> C'est la paresse.

From: Enzo Maiolino (ed.), *Modigliani vivo*, p. 169 ff

Nina Hamnet

Painter, 1890-1956

Modigliani was living in the Rue St Gothard [actually 16 Rue du St Gothard] and Edgar and I went to see him. He had a large studio which was very untidy and round the walls there were gouache drawings of caryatids. They were very beautiful

and he said, 'Choose one for yourself.' The bed was unmade and had a copy of *Les Liaisons Dangereuses* and *Les Chants de Maldoror* upon it. Modigliani said that this book was the one that had ruined or made his life. Attached to the end of the bed was an enormous spider-web and in the middle an enormous spider. He explained that he could not make the bed as he had grown very attached to the spider and was afraid of disturbing it. This was the last time that I saw him as, soon afterwards, he went to Nice.

From: Pierre Sichel, *Modigliani*, New York (Dutton) 1976, p. 319

Beatrice Hastings

Writer, 1879-1943

A complex character. A pig and a pearl. Met in 1914 at a 'crémerie'. I sat opposite him. Hashish and brandy. Not at all impressed. Didn't know who he was. He looked ugly, ferocious, greedy. Met again at the Café Rotonde. He was shaved and charming. Raised his cap with a pretty gesture, blushed to his eyes and asked me to come and see his work. Went. Always a book in his pocket, Lautréamont's *Maldoror*. Despised everyone but Picasso and Max Jacob. Loathed Cocteau.

From: Carol Mann, *Modigliani*, London and New York (Thames & Hudson) 1980, p. 106

Leon Indenbaum

Sculptor, 1890-1981

A new era began for me from that moment in 1913. I left La Ruche for Number 53, Rue Montparnasse, where the wicked genius Beatrice Hastings lived and took drugs with Modigliani.

One day I went to see him working in a nettle-filled waste ground in Boulevard Raspail; he was carving elongated heads and stone caryatids on the spot. When I went into his shed I saw pinned on the wall a letter threatening him with eviction if he did not pay his rent.

I wanted to help him by buying a head. He turned to me with amazement in his beautiful eyes: 'What for?'—'It would give me pleasure. How much?'—'Would 200 francs be all right?' I had enough money to pay him

When the war came, Modigliani gave up sculpture and used to sit in front of La Rotonde, drawing pad in hand, sketching people in exchange for a drink.

One evening he came up to me: 'I've sold the head you bought from me, which you left with me'—'You have done the right thing.'

From: Jeanine Warnod, *La Ruche & Montparnasse*, p. 43

It was there, late at night, that he stopped me, made me sit next to him, put his hand on my shoulder (in the friendly manner you use towards those you are fond of) and sat silent for a long time, abstracted and distant. Then he said, 'You've got canvas and paint; tomorrow you'll see how a portrait should be painted.' The next morning he knocked at the door of my studio, newly shaved, wearing a blue check shirt, correct, unobtrusive and dignified. He worked at the portrait three mornings running. At the end of the third sitting he signed this real masterpiece and held it out to me. 'It's for you,' he said.

I tried to defend myself by offering to pay. 'I shall get angry,' he said, and was quite adamant. While we were living as neighbours this was a little provisional account between us that I thought I would never again speak to him about.

Much later, when he learned that I had parted with the portrait for three soldi, he understood the reason for it. 'I'll do you another one,' he said very kindly.

His method of painting was unusual.

I have seen great artists at work and they all have, according to their temperaments, some obsessive habit; some pull a face, others thresh around, drip with sweat and even have hysterics.

Modigliani placed me at one end of the studio and went to the opposite end himself. He glanced at me at brief intervals and as he painted he hardly moved.

His brush, held upwards like a bow, played out to perfection his wondrous vision. An unseen hand guided it, I am sure.

From: Enzo Maiolino (ed.), *Modigliani vivo*, p. 110 ff

Max Jacob

Writer and painter, 1876-1944

Picasso said: 'There's only one man in Paris who knows how to dress and that is Modigliani.' He didn't say that as a joke. Modigliani, poor as he was, even to the extent of having to borrow three sous for the underground to go to the literary evenings at the Closerie des Lilas, was not only refined, but had an eclectic elegance. He was the first man

in Paris to wear a shirt made of cretonne. God knows this fashion has got all over the world, and with what variations! He had colour harmonies in dressing that were all his own. And since I am talking about clothes, I'll tell the tale of a corduroy coat. It belonged to Picasso, was as stiff as armour, and had a turned-down collar lined with woollen cloth, very Spanish in style, and it buttoned—if you *could* button it—right up. Picasso, having got a bit fatter, gave it to me. But I could never wear this hard shell and I made a present of it to Dedo, who wore it with his usual chic. We gummed inside it the story of this coat.

Dedo (in these days) had done little but sculpture and enormous drawings, vaguely coloured. These works denoted a knowledge of Oriental and Negro art. Everything in Dedo tended towards purity in art. His insupportable pride, his black ingratitude, his haughtiness, did not exclude familiarity. Yet all that was nothing but a need for crystalline purity, a trueness to himself in life as in art. He was cutting, but as fragile as glass; also as inhuman as glass, so to say. And that was very characteristic of the period, which talked of nothing but purity in art and strove for nothing else. Dedo was to the last degree a purist. His mania for purity went so far as to make him seek out Negroes, jail-birds, tramps, to record the purity of the lines in his drawings.

I think that Dedo was frightened of colour that was not pure. *Chez* Dedo this wasn't to be in the fashion but a real need of his temperament.

From: Pierre Sichel, *Modigliani*, New York (Dutton) 1976, p. 180

Augustus John

Painter, 1878-1961

The stone heads affected me deeply. For days afterwards I found myself under the hallucination of meeting people on the street who might have posed for them, and that without myself resorting to the Indian Herb. Can 'Modi' have discovered a new and secret aspect of 'reality'?

From: Pierre Sichel, *Modigliani*, New York (Dutton), 1976, p. 213

Paulette Jourdain

My classes did not take place at a fixed time; sometimes they were in the morning, sometimes in the afternoon. As I did not have to go to school the next morning—it was a Thursday, I remember—I went to Modigliani's studio in the Rue de la Grande Chaumière for the first sitting.

The studio was high up, on the top floor. The stairs were steep and dark. I was frightened as I went up; those stairs terrified me.

One went through a little room to the studio, which was vast, high and dismal. I remember that, as well as the easel, there was a small round table on which the artist put his equipment: palette, brushes, paints, etc.

Modigliani looked at me. He was certain that I would come for the sitting and had already prepared a canvas on the easel.

'Sit down,' he said.

I threw myself into a chair and sat with my hands in my lap. Modigliani never enforced a pose, but let the sitter assume a natural attitude. The way I was sitting was quite all right, and he set to work.

He chatted to me while he was working, asking me questions about my studies and my family. He often laughed at my replies.

I remember many other things, even fifty years later, but I cannot remember what I said that amused him and put him in so good a humour. Goodness knows what nonsense I must have told him to make him laugh like that!

When he was working Modigliani sometimes talked to himself or recited poetry that he knew by heart, always in Italian. Above all he recited Dante, a pocket edition of whose *Divine Comedy* he always carried with him.

In connection with the drawings: Modigliani kept in his studio a meat hook (a genuine butcher's hook that he may have stolen from somewhere), on which he impaled discarded drawings that he later used as . . . toilet paper.

From Enzo Maiolino (ed.), *Modigliani vivo*, pp. 78-86

Moïse Kisling

Painter, 1891-1953

Must I write a few lines about you, Amédée?
So many writers—so many poets—
so many friends have already written about you . . .

What further could I add?
—Wretched and great Amédée!
Ten years already! since we accompanied you to your last resting place . . . these years have confirmed the glory of your magnificent works!
—Why are you no longer here to see your fame increasing?
Your fame which will increase for ever and ever!

From: Giovanni Scheiwiller (ed.), *Omaggio a Modigliani (1884-1920)*, n. p.

Vicomte de Lascano Tégui

One January night Modigliani's crazed light-green eyes followed a group of painters as they left the Rotonde. He was drunk. The painters wanted to take him home. But he would not listen to reason. He set off behind the group as they disappeared into the night, staggering this way and that. The storm howled around his ears. The blue canvas shirt which he always wore blew in the wind. He dragged his overcoat behind him like the hide of some slayed animal

My friends the painters went to the house of the draughtsman Berito in the Rue de la Tombe-Issoire, near the Rue d'Alésia. Modigliani pestered them as far as the house door; but he refused to go in with them. He remained standing on the pavement. At midnight Modigliani was still there. A policeman wanted to take him to the station. My friends freed him, and he went with them. It was not easy. The 'delirium tremens', the unleashed frenzy, appeared on his foaming lips. He was furious with the whole world. No friend, not a single friend. And on this cold night he demanded of his companions that they sit down with him on a bench which in his delirium appeared to him like the departure quay for some wondrous country. Despite their pleas and entreaties Modigliani remained sitting on the bench. He was quite alone, beside him only the railings of the church of Montrouge.

Modigliani's last landscape began to take shape before his distraught eyes.

This landscape had the skeletal trees of Raphael, Utrillo's grey walls, lugubrious churches like those Monet painted; huge policemen with blue, white and red hands from one of Jean Veber's butcher's shops. This landscape was peopled only by the beggars of Soutine, the Russian painter who was now himself just a filthy and fearsome beggar. The landscape had the smell of a marble slab from the 'Morgue'. It was ice-cold, and was lit by the greasy light of the street-lamp. Amid this dreary scene a woman came and sat next to the drunkard, a woman after Rops, perhaps the *Mors Syphilitica*, her clothes by Toulouse-Lautrec. Her hands were heavy. She laid them on his shoulders and pressed the whole weight of her body against the lungs of the freezing man. Modigliani was afraid of this woman. He climbed into a strange ship with black flag and crossed bones. In his pneumonic fever this ghostly ship set sail. And from this bench he went to the Charité and carried this abandoned landscape with him in his colourless eyes. It stayed in his eyes as if fixed on a photographic plate. Death projected it on to the enamel-coloured walls of the hospital room where it waited patiently for him.

From: Giovanni Scheiwiller, *Amedeo Modigliani—Selbstzeugnisse, Photos, Zeichnungen*, p. 76 f

Osvaldo Licini

Painter, 1894-1958

One evening at the Café du Petit Napolitain, where some painters were dining, Modigliani drew my portrait. His face was all screwed up. The famous grimaces Modigliani made when painting were never a pose.

'To draw is to possess,' he cried, 'an act of knowing and possessing that is more real than sexual intercourse, that only dreams and death can bestow upon us.'

From: *Modigliani—dipinti e disegni*, p. 106

They say that Modigliani used to get drunk for the sheer love of drinking. It is possible to surrender to drink. I saw him in all stages of drunkenness, cynical, bitter, sometimes maudlin; but I noticed that when he was gloriously drunk he entered a wonderful world of pure poetry, ecstasy, delirium. Alone with his fantasies and himself, he entered into a blissful state of grace that was vouchsafed to no one else; and we who were abstemious, ordinary, prudent, looked like smiling fools. What he said and the way he enjoyed himself turned each of Modigliani's bouts into a masterpiece. In his work he showed that by focusing exclusively on man, on his expressions and human feeling, and by making him the centre of the world it was possible to create great painting of lasting and universal significance.

Quoted by Osvaldo Patani in: *Modigliani a Montparnasse 1909-1929*, p. 17

Jacques Lipchitz

Sculptor, 1891-1973

The first time we met was when Max Jacob introduced me to him, and Modigliani invited me to his studio at the Cité Falguière. At that time he was sculpting, and of course I was especially interested to see what he was doing.

When I came to his studio—it was spring or summer—I found him working outdoors. A few heads in stone—maybe five—were standing on the cement floor of courtyard in front of the studio. He was adjusting them one to the other.

I see him as if it was today, stooping over those heads of his, explaining to me that he had conceived all of them as an ensemble. It seems to me that these heads were exhibited later the same year in the Salon d'Automne, arranged in step-wise fashion like tubes of an organ to produce the special music he wanted.

Modigliani, like some others at the time, was very taken with the notion that sculpture was sick, that it had become very sick with Rodin and his influence. There was too much modelling in clay, 'too much mud'. The only way to save sculpture was to start carving again, direct carving in stone. We had many very heated discussions about this, for I did not for one moment believe that sculpture was sick, nor did I believe that direct carving was by itself a solution to anything. But Modigliani could not be budged; he held firmly to his deep conviction. He had been seeing a good deal of Brancusi, who lived nearby, and he had come under his influence. When we talked of different kinds of stone—hard stones and soft stones—Modigliani said that the stone itself made very little difference; the important thing was to give the carved stone the feeling of hardness, and that came from within the sculptor himself: regardless of what stone they use, some sculptors make their work look soft, but others can use even the softest of stones and give their sculpture hardness. Indeed, his own sculpture shows how he used this idea.

It was characteristic of Modigliani to talk like this. His own art was an art of personal feeling. He worked furiously, dashing off drawing after drawing without stopping to correct or ponder. He worked, it seemed, entirely by instinct—which was however extremely fine and sensitive, perhaps owing much to his Italian inheritance and his love of the painting of the early Renaissance masters. He could never forget his interest in people, and he painted them, so to say, with abandon, urged on by the intensity of his feeling and vision. This is why Modigliani, though he admired African Negro and other primitive arts as much as any of us, was never profoundly influenced by them—any more than he was by Cubism. He took from them certain stylistic traits, but he was hardly affected by their spirit. His was an immediate satisfaction in their strange and novel forms. But he could not permit abstraction to interfere with feeling, to get between him and his subjects. And that is why his portraits are such remarkable characterizations and why his nudes are so sexually frank. Incidentally, I would like to mention two other artists whose work influenced Modigliani's style, and who are not often mentioned in this connection: Toulouse-Lautrec and Boldini, who years ago enjoyed the reputation of being one of Europe's most fashionable society portraitists.

In 1916, having just signed a contract with Léonce Rosenberg, the dealer, I had a little money. I was also newly married, and my wife and I decided to ask Modigliani to make our portrait. 'My price is ten francs a sitting and a little alcohol, you know,' he replied when I asked him to do it. He came the next day and made a lot of preliminary drawings, one right after the other, with tremendous speed and precision, as I have already stated. Two of these drawings, one of my wife and one of myself, are reproduced in this album. Finally a pose was decided upon—a pose inspired by our wedding photograph.

The following day at one o'clock, Modigliani came with an old canvas and his box of painting materials, and we began to pose. I see him so clearly even now—sitting in front of his canvas, which he had put on a chair, working quietly, interrupting only now and then to take a gulp of alcohol from the bottle standing nearby. From time to time he would get up and glance critically over his work and look at his models. By the end of the day he said, 'Well, I guess it's finished.' We looked at our double portrait which, in effect, was finished. But then I felt some scruples at having the painting at the modest price of ten francs; it had not occurred to me that he could do two portraits on one canvas in a single session. So I asked him if he could not continue to work a bit more on the canvas, inventing excuses for additional sittings. 'You know,' I said, 'we sculptors like more substance.' 'Well,' he answered, 'if you want me to spoil it, I can continue.'

As I recall it, it took him almost two weeks to finish our portrait, probably the longest time he ever worked on one painting.

This portrait had been hanging on my wall for a long time until one day I wanted my dealer to return to me some sculptures in stone which I no longer felt were representative. He asked me more money than I could afford, and the only thing I could do was to offer as an exchange the portrait by Modigliani—who by that time was already

dead. My dealer accepted, and as soon as I had my stones back I destroyed them. And that's how it happens that this portrait came finally to be in the collection of the Art Institute of Chicago.

From: Jacques Lipchitz, *Amedeo Modigliani*, New York (Abrams) 1952, pp. 5-10, 14-16

Fabio Mauroner

Graphic artist and art critic, 1884-1948

This cultured and refined artist struck up a warm friendship with me. At the time he was painting a large portrait of the lawyer, Franco, the style of which was clearly influenced by Eugène Carrière (1849-1906) and in the same style he was making interesting studies of nude models, who were always to be found in his studio.

That sharp and open-minded spirit boasted of being descended on his mother's side from Spinoza.

There was something instinctively seductive in the way he acted and spoke.

He would spend the evenings, and stay late into the night, in the remotest brothels, where, he said, he learned more than in any academy.... After a while I had occasion to show him some volumes of Vittorio Pica's *Attraverso gli albi e le cartelle*, the first and perhaps the only interesting Italian study of modern engravers and graphic artists. He was so impressed that he decided to leave Venice for Paris, where he might get to know better the artists who had most struck him—above all, Toulouse-Lautrec.

It was not easy, however, to solve the financial problem, because only his mother had a sympathetic understanding of the needs of a son who was effectively exiled by the bitter hostility of the rest of the family. One day he told me, with a touching reverence that was unusual in him, that his mother had visited him. I learned that she had given him a small amount of money for the journey and a fine edition of Oscar Wilde's *The Ballad of Reading Gaol*. I bought his easels and a few studio oddments, and Modigliani left for Paris. There I saw him again years later, when he was once more my studio neighbour, threatened by illness and poverty but scornful of making any allowances to public taste.

From: *Modigliani—dipinti e disegni*, pp. 90, 112

Ludwig Meidner

Painter, 1884-1966

In 1906 Modigliani travelled via Switzerland to Paris, where he intended to stay. I think it was in Geneva that a wealthy German woman, who was travelling with her young daughter, invited him to

accompany them, and Modigliani was quite happy to accept this offer. He had just come from home, and was at that stage immaculately dressed, a lively, good-looking young man of twenty-two years of age who subsequently paid less attention to the not-so-young mother than to her youthful daughter. It greatly amused him to flirt with the daughter without her mother noticing, and he never tired of telling us about it.

We got to know one another in the autumn of that year, in a dark, bohemian café on the Butte Montmartre—the unforgettable Lapin Agile —which at this time was not yet geared especially towards foreigners. For four sous you could sit there with a cup of strong coffee and engage in heated discussions about art until dawn. As day broke we would go home through the narrow lanes; this was the crowning glory of these nights, which I was never to experience again.

In the first decade of the twentieth century, the bohemian lifestyle, which was born in the nineteenth century, was still fashionable, and here in Paris, in Montmartre and in Montparnasse, the last blossoms of that fading world were represented by a few refined and spoiled sons of the old bourgeoisie. Our Modigliani—or 'Modi', as he was generally known—was both a characteristic and a highly gifted representative of the *vie bohème* of Montmartre—and probably also the last genuine bohemian. At this time he was not yet the drinker that he later became, nor the gloomy, cynical and sarcastic person his biographer Pfannstiel describes, but rather lively and enthusiastic, always sparkling, full of imagination, wit and contradictory moods. And so you could get on with him without any great difficulties.

We were of the same age and had the same interests. Since I came from the suffocating provincial atmosphere of an art school in eastern Germany, I was overwhelmed by his open attitude towards everything, in particular whenever he spoke about beauty. Never before had I heard an artist speak with such ardour about beauty. He showed me

photographs of early Florentine masters whose names I did not know. It was even more interesting to listen to what Modi had to say about them. Of the modern artists he was especially fascinated by Toulouse-Lautrec and Gauguin. We had just seen Gauguin's wonderful retrospective in the Salon d'Automne (1906), which enthralled us all. But Modi was also interested in Whistler and his fine grey tones, even though the painter was no longer in the public eye. He also admired Ensor and Munch, who were almost unknown in Paris, and of the younger artists we preferred Picasso, Matisse, Rouault and some of the young Hungarian Expressionists who were just coming into fashion.

Modigliani seemed to be in the direst of financial straits. I often heard him barter with his acquaintances on this account, but we never discussed money. Although I was not badly off at this time Modi never addressed such requests to me—I don't know why. He was very proud in this respect. A year later, when his plight was quite desperate, he would absent himself for days on end in order to find some money, either by selling his drawings or by selling the works of another artist to an art dealer. (...)

Modigliani used to eat in one of the little restaurants in Montmartre. At first he always remembered to pay; later he lived off credit until the month was up, and then he would disappear without paying his debts. He would then repeat this manoeuvre in a neighbouring quarter in another inn. This conduct was reprehensible, but what was an impoverished bohemian to do in order to get a midday meal? After all, everyone must eat his fill once a day, especially such a nervous, fiery spirit and artist by the grace of God, who invents new forms and never has a single dull thought.

Modi had the talent of making friends everywhere. He knew everyone, and wherever he went he was received with acclamation. But the cheated landlords would try to hunt out the happy-go-lucky fellow in his humble quarters and then they would kick up a hellish din. And so we often had to keep our voices low and, whenever he asked us, to peep through the keyhole to see whether such a ruffian was approaching.

At this time Modigliani, whose life story is now related like a legend and has already inspired many a novel, was not yet the drinker that he became in his later years—as I said before—and his somewhat morbid female companions were also unlike the ladies whom he painted in later works. Individuals such as Modigliani do not allow themselves to be changed, influenced or persuaded to lead a more orderly life or work more regularly. Modi need not have died so young—at the age of thirty-six—if he had lived a more sensible life.

The life of a bohemian, such as I led myself, can have certain attractions. But as one matures one is no longer inclined to overestimate this lifestyle— one regrets rather having wasted so much youthful energy.

In his first Paris period Modigliani, who had studied at the Venetian and Florentine academies, painted only small portraits with thin colours on very rough canvas or more frequently on smooth card. The results, which recalled somewhat Toulouse-Lautrec or, in their grey-green tones, Whistler's works, were markedly different from the pictures of the Fauves, which could be viewed at the exhibitions of the Indépendants. They had style

and, compared with the latter, were measured and refined in both colour and draughtsmanship. In order to give these pictures depth and transparency Modi covered them when they were dry with coloured varnish, to such an extent that some pictures were covered with ten coats of varnish and, with their transparent golden appearance, recalled the old masters.

His drawing technique was also peculiar. He drew from life on thin paper; but before it was finished he placed another white sheet beneath it and a piece of graphite paper between the two, then he traced the drawing, greatly simplifying the lines. Though his painting technique impressed me very much, I found this method of drawing very truncated and affected. Whereas in later years he developed his own style of painting, his drawing technique remained essentially unchanged. Once he set to it, he could produce dozens of portraits in this way. (...)

In his studio at 7 Place Jean-Baptiste Clément he did two portraits of me in oil; the larger of the two was displayed on a wall at the Salon d'Automne in 1907 where it went largely unnoticed. His studio was a tumbledown shack on a treeless, ugly scrap of ground, and although it was furnished in the most spartan manner, oppressive and neglected like a beggar's hovel, one was always glad to go there for one found an artistic atmosphere in which one was never bored. (...)

I never discovered whether his relatives supported him, or if not, why this was so. He himself maintained that his parents were wealthy. One of his brothers was the well-known Socialist Deputy Modigliani who was later persecuted by Mussolini. Modi never spoke of his family in disparaging or ironic terms, which many young artists do in order to vent their spleen. And he was full of love and admiration for anything connected with his native country.

He had his everyday cares and woes, but they never clouded his exuberance and gaiety. He loved life too much, and still saw it through the optimistic eyes of a romantic.

After I left Paris we still wrote to each other for a time, partly in connection with his small oil paintings which I had still not managed to sell. Later —perhaps in 1909—I heard from a third party that his decrepit studio had collapsed about his ears one night, and that the fire brigade had had to be called to rescue him from the ruins. Luckily, he was unharmed.

Around this time Modigliani began sculpting. Influenced by African art, he attempted a sort of Cubist portrait sculpture which, however, I do not think takes up a very significant place within his overall life's work.

(1943)

From: Giovanni Scheiwiller, *Amedeo Modigliani—Selbstzeugnisse, Photos, Zeichnungen*, pp. 47-52

Eugenio Montale

Writer, 1896 - 1981

Modigliani's late work goes well beyond the Early Impressionists' perception of the total experience as dissolved into fine points of colour. In him there is often a perfect balance between the angelic and the diabolic imagination of the artist, and the colour, form and, above all, line that restore to us a 'correlative' of crystal-clear objectivity. How much of the past, how much spent history, what a weight of time and error there is in this art! It is, like little other, painting of today, and this is precisely why it is easy to foresee that it will be painting for all time. Let us admit that, for the moment, it is almost always non-Italians who realize this.

From: Giovanni Scheiwiller (ed.), *Omaggio a Modigliani (1884-1920)*, n. p.

Manuel Ortiz de Zarate

After the Madeleine, Montmartre and the Rue Ravignan, Modigliani moved into a studio beneath mine in the Rue de la Grande-Chaumière.... He was dreadfully ill.... Every week I had coal sent to him. Then I had to go away for a week. When I came back I went to see him. He was in a pitiable condition. He was lying with his wife on a filthy bedstead. I was greatly distressed. 'Are you at least eating?' I asked him. Someone was just handing him a tin of sardines, and I noticed that the two mattresses, and all the floor, were covered with shining, oily shapes—empty tins and lids.... Modigliani, deathly sick, had been eating nothing but sardines for a week!

I had the concierge take him a pot-au-feu, and fetched a doctor I trusted. 'Hospital immediately,' he advised. As we took Modigliani to the Charité he said in a pitiable, croaking voice: 'I have only a very tiny piece of brain left.... I know it means the end.' And then he added: 'I have embraced my wife and we are united in eternal joy.'

I understood that...later.

Sadly, all our care was in vain. I visited our poor friend together with his wife and Madame Zborowski. I went alone to enquire about his condition.

Two weeks earlier we might perhaps have saved him.... He suffered terribly. After an injection he fell asleep for ever.... When I could not speak to his wife she said: 'Oh, I know very well that he is dead, but I know too that he will soon live again for me.' (1930)

From: Giovanni Scheiwiller, *Amedeo Modigliani—Selbstzeugnisse, Photos, Zeichnungen*, p. 78 f

Anders Osterlind

Painter, 1887-1960

Renoir's property was two hundred metres from my house, overrun by olive trees and rosebushes. This dwelling haunted Modigliani's imaginative spirit. He wanted to meet the master of Cagnes.

Returning one day from the village, where he had at great length admired his favourite poster of 'Pernod fils', he said to me, 'Take me to Renoir.'

That very evening Renoir received us in his dining room where he was brought after his work. It was a big bourgeois room. On the walls were some of his canvases. Also a delicate, grey landscape of Corot which he liked.

The master lay crumpled in an armchair, shrivelled up, a little shawl over his shoulders, wearing a cap, his whole face covered with a mosquito net, two piercing eyes behind the veil.

It was a delicate thing putting these two face to face: Renoir with his past, the other with his youth and confidence; on the one side joy, light, pleasure, and a work without peer, on the other Modigliani and all his suffering.

After Renoir had had some of his canvases taken down from the wall (so they could be examined more closely), a grim, sombre Modigliani listened to him speak.

'So you're a painter too then, eh, young man?' he said to Modigliani, who was looking at the paintings.

'Paint with joy, with the same joy with which you make love?'

'Do you caress your canvases a long time?'

'I stroke the buttocks for days and days before finishing a painting.'

It seemed to me that Modigliani was suffering and that a catastrophe was imminent. It happened. Modigliani got up brusquely and, his hand on the doorknob, said brutally, 'I don't like buttocks, monsieur!'

From: Pierre Sichel, *Modigliani*, New York (Dutton) 1976, p. 409 f

Renato Paresce

Painter and journalist, 1886-1937

As soon as he placed himself in front of the canvas Modigliani regained his perfect clear-headedness. While painting he would recite poetry by Poliziano and Dante, or make up verses in the style of Apollinaire or Reverdy. Not a brush-stroke was carelessly placed, not one left to the mysterious play of chance or to the uncertainties that might have led to an unwanted effect. He drew very carefully on the canvas with a unified and continuous line and then filled in the outline with the patience of a peasant, taking care not to hide it under a mass of incoherent or disorderly brush-strokes. He achieved his aim with a spare but precise and essential line rather than through form. With the perfect sinuosity of his line, almost ethereal but strongly sensual, Modigliani managed to give reality a vibration and

a profound poeticism expressed, before him, perhaps only by the Sienese painters. And he approached the entanglements of the imagination by way of the spirit.

From: Enzo Modigliani (ed.), *Modigliani vivo*, p. 50

Pablo Picasso

Painter, Sculptor and graphic artist, 1881-1973

Modigliani had a sharp eye, great charm and in spite of his own disorganized life he enriched the lives of others.

Quoted by Osvaldo Patani, in: *Modigliani a Montparnasse 1909-1920*, p. 17

Enrico Piceni

Those who do not understand say, 'If only he had lived!' But Modigliani, this Rimbaud of painting, could not live long; a predestined fate hung over him. All his art is there to prove it, its charm as delicate and pervasive as a perfume. There are Olympian artists, such as Goethe and Titian, who are precocious and long-lived, and who work on a broad canvas; and there are visionaries, such as Rimbaud and Modigliani, who are precocious and fleeting, and who work with a narrower intensity. The former rule over our three-dimensional world with a power that belongs to genius but which is part of normality; the second escape to a fourth, unknown dimension, enter a non-human world and return to us transfigured. Modigliani was one

who passed a season in hell, and he brought back the echoes of a tormented yearning for an impossible paradise.

Modigliani's destiny cannot be imagined as other than it was: like an arch broken off as it is reaching perhaps its highest point, pointing forever and in vain towards the unknown.

From: Giovanni Scheiwiller (ed.), *Omaggio a Modigliani (1884-1920)*, n. p.

Filippo de Pisis

Painter, 1896-1956

There are many people, especially in Italy, it must be said, who have a superficial knowledge of Modigliani's work that is based on a few unfinished canvases or, worse, on reproductions.

As with other modern artists, to love Modigliani you have to know him, and that means catching him at his best moments, when his distortion of the truth is a *felix culpa*, a happy fault, or when his palette, which was often a little dull, brightens up and he joins the ranks of the great masters.

All I would need in order to demonstrate what a painter he was would be the portrait of a young girl that I saw in a recent exhibition.

This slight figure, somewhat self-absorbed, so real in its rather sad and almost mystical simplicity, made me think of certain saints of the better Sienese painters of the fourteenth century. A sweet and melancholy charm that is not easily forgotten radiated from her clear eyes, her delicate pink cheeks, the blond plaits tied under her cap and her sky-blue frock.

Here the painter touched the heights of poetry, Pascoli's 'sun and light'.

And what can be said about some of his drawings? With a simplicity of style that is all their own, they could be compared to Etruscan art, and yet they are so completely modern in spirit!

From: Giovanni Scheiwiller (ed.), *Omaggio a Modigliani (1884-1920)*, n. p.

Ezra Pound

Writer, 1885-1972

Premature death of Modigliani removed a definite, valuable and emotive force from the contemporary art world.

From: Giovanni Scheiwiller, *Amedeo Modigliani—Selbstzeugnisse, Photos, Zeichnungen*, p. 81

Giuseppe Raimondi

Since Ingres there has been no painter who possessed so sharp and delicate a drawing style as Modigliani. Please do not misunderstand me. I am talking about a standard of drawing, a physical gift, in short, for creating a fine and clear-cut line, that is not to be confused with the intellectual and spiritual outlook of Ingres.

From: Giovanni Scheiwiller (ed.), *Omaggio a Modigliani (1884-1920)*, r. p.

Gino Rossi

Painter, 1884-1945

I had been in Paris a year and often went to the Concerts Rouges in the Rue de Tournon. Here, you bought a drink for one franc twenty-five and had the right to listen to the music. One evening in the winter of 1908-09 I sat by chance next to Modigliani. The music was by Boccherini. Coming as we did not only from the same country but from the same area, we soon got to know each other. Modigliani and I spoke to each other in an Italian peppered with Florentine expressions. I discovered that the artist had been in Paris for a few months. Our first conversation was about mutual friends in Florence and Boccherini's music. I could see the strength of his sensitivity in the way he talked about this composer through half-closed eyes. Still chattering, we made our way back to Montparnasse and parted without arranging another meeting. Later, we met again at La Rotonde, a small café run by the two Libion brothers.

After moving house at least five times I settled in 1911 at the Cité Falguière and so became a near neighbour of Modigliani. That year the dog-day heat was almost tropical, but we were too short of money to take a holiday.

Modigliani sculpted in the open air on a little raised terrace. At this period he was strongly influenced by Archaism, and gave his heads elongated noses. As I went by I always called out, 'Don't forget the nose, Amedeo....'

His only response was a shrug of the shoulders.

From: Enzo Maiolino (ed.), *Modigliani vivo*, p. 140 f

André Salmon

Writer and art critic, 1881-1869

There is only one contemporary 'painter of women' from life (which rules out van Dongen), the Italian Modigliani; a painter of nudes who would have been even less acceptable than Renoir if he had

been painting at the time when, as well as the *Livre d'Or des AF*, the *Nu au Salon* was published.

Modigliani, whose origins were quite bourgeois, has been exhibiting between the Fauves and the Cubists for more than ten years. But if I had to name a famous successor to Renoir, I'd say that, true to Cézanne's example, Modigliani would be hard to beat.

Modigliani is our only painter of nudes.... A police inspector, or maybe an inspector from the Beaux Arts, once had Modigliani's contributions taken down in I don't remember which gallery. And yet what spiritually glows forth from so much beautiful, rich, plump material, slimmed down by the controlled magnificence that the artist has striven hard to refine, he who admired the naivety and the resourcefulness of the Italian artisan painters.... (1920)

From: Ambrogio Ceroni, *Tout l'œuvre peint de Modigliani*, p. 10 f

Having just married the young Renée-Jean, Kisling invited the wedding guests to his studio. Max Jacob was also there and delighted his friends with one of his incomparable impersonations. Modigliani, who was already drunk long before the civil marriage ceremony, interrupted him several times and, with a subservience which was highly unusual coming from him, begged to take part in the performance: 'Max, please can I play Dante? I know Dante so well.... No one knows Dante as well as I do. Please, Max, may I?'

In place of Max, who would no doubt have given in to him, the assembled throng answered 'No!' Whenever Max Jacob performed it made us all laugh, whereas Modigliani would have spoiled everything. So did he capitulate? No way! When the guests asked Max Jacob to play Shakespeare, Modigliani could no longer restrain himself. We were also all in agreement and let him have his way. 'Max,' the brilliant drunkard said, 'let me play the ghost!' How could anyone refuse this man, who so rarely pleaded for anything?

The drunken Modigliani was brilliant. He rushed into the small room adjoining the studio, the 'bridal suite'. He came out again swathed in classic sartorial fashion in a white sheet. At the door he started playing the part of the ghost of Hamlet's father:

—'God or man, which art thou?'—with such panache that Max Jacob, at times an outstanding actor, at once ceased his impressions. He clearly realized that he could not outshine Modigliani.

Now Modigliani was free to shout, now he alone dominated the stage, playing to an elite audience. Straight away our Amedeo instinctively found the right words. At first they seemed meaningless, but by pronouncing or screaming them in his own unique way he made them serve his purpose, namely to communicate to the spectators that a dead being can continue to plague the living from beyond the grave, and also to astound and scare them. And so suddenly he began yelling—I don't think you hear this call nowadays but at the time you heard it every day in the streets of Paris—'Barrels, barrels, have you any barrels?'

This was so beautiful, so perfect that no one laughed immediately.

'Barrels! Barrels!...' A voice from beyond the grave, in the guise of a cooper! The accursed ghost, condemned for all eternity to roll before him his cask full of hideous memories, full of sin, full of pangs of conscience and tears! The brand-new Madame Kisling, *née* Renée-Jean, broke this awe-inspiring spell with the pained scream of a young bride and dutiful housewife: 'My bridal linen!'

The ghost of Modigliani was already on the stairs. On the floor below he knocked at the door of Ernest de Chamaillard still crying: 'Barrels, barrels, have you any barrels?' We only caught up with him when he reached the front door. We recovered the bride's linen, but Modigliani disappeared muttering jumbled verses to himself.

From: Giovanni Scheiwiller, *Amedeo Modigliani—Selbstzeugnisse, Photos, Zeichnungen*, p. 60 f

Alberto Savinio

Writer and painter, 1891-1952

Modigliani was the scapegoat for all the sins of vanity. Both Jewish and Italian—anti-Pharisee *par excellence*—he suffered the common fate of all 'good' Jews, to replay the tragedy of Christ; to become a Christian. His painting and, above all, his drawings are an expression of Christianity through line.

From: *Modigliani—dipinti e disegni*, p. 107

Giovanni Scheiwiller

Art critic

A painting by Modigliani either delights or offends. The artist's aggressive, authoritarian personality permits no compromise. In order to understand it the spectator must be endowed with the same vi-

sual and sensual qualities that empower the artist himself. Otherwise no comprehension is possible....

This artist painted nude portraits of exceptional beauty.

They can be divided into two categories.

Some of his models, in all the splendour of youth, clearly must have filled the painter with passionately carnal thoughts as well as with spiritual feelings. Let us put the nudes from this source into the first category....

The second category consists of works possessed of a calm musicality; these would certainly never disturb the bourgeois conscience. Modigliani's nudes, unlike anybody else's, testify to perfect spiritual communion between the painter and the person acting as his model. This is not simply commonplace beauty pepped up with a bit of sensuality; the artist has transferred all his own aesthetic joy to the model. Just as a mystic abases himself before the Mystery, so Modigliani deifies womanhood. Through his admirable draughtsmanship, his subtle touch lays bare the painful fragility of each being. Some nudes of this type (as, for instance, that entitled *Nu Rose*) contain more religious feeling, more ecstasy than many of the famous Buddhas of Angkor, Ceylon, Java....

From: Ambrogio Ceroni, *Tout l'œuvre peint de Modigliani*, p. 11

Gino Severini

Painter, 1883-1966

I met Modigliani at the end of 1905 or 1906, and we quickly became good friends. He was a cheerful companion, even in his sadder moments. Naturally, our conversations centred on the artistic preoccupations of the period, and he constantly inveighed against 'the Picasso thing'. We had many lively discussions on this topic, and I used to remind him of the sculpture worked directly in stone and inspired by Negro carving, from which, after all, he had

himself profited. Throughout his life his painting had a quite Tuscan elegance, and the Matisse-like freshness and immediacy of his Fauve period make me think that, had there been time for his art to mature, it would have reached the greatest heights. . . .

I had been in Paris scarcely two months when I met Modigliani quite by chance. I was going up the Rue Lepic towards the Sacré Coeur when, in front of the famous Moulin de la Galette, I cut across another dark young man, with a hairstyle that could only have been Italian. We looked straight at each other, and then, a few paces further on, we both looked round and turned back. The usual thing to say on such occasions, perhaps because there is nothing else one can say, is, 'You're Italian, aren't you?' The answer is, 'Yes, and so are you.' Our encounter went more or less like this, but then we discovered that we were both painters, both from Tuscany and both living in Montmartre. His studio was nearby; from the Rue Lepic you could see a sort of greenhouse or glass cage on the top of a wall at the end of a garden. It was a small studio, but very pleasant. The two sides that were glazed meant that it could serve equally as a greenhouse or a studio without being precisely either. Anyway, Modigliani had arrived in Paris with a little more money than me, so he had been able to set up this small establishment, not very comfortable but adequate. He was not at all satisfied with it himself, though, and to tell the truth I liked my own sixth floor better. Nevertheless, he lived there in complete isolation, whereas I, blesséd among women' as I was, had too many people around me. He suggested we should meet again soon. . . .

Many times I accompanied him to the door of an art collector who lived in the Avenue de Villiers, on the other side of the Place Clichy. (I later learned that he was Paul Guillaume). . . . He always came down with five or ten francs, which he spent on dinner or a visit to the Lapin

Modigliani was not a vicious man, not a vulgar drunkard nor a decadent. The absinthe of which he sometimes drank a double measure was a means, not an end. He used the stimulation it gave him to peer ever more deeply into himself. Anyway, its use was quite common among all artists at this time. It is true that he always had a little hashish in his pocket, but he used it rarely, and only on those exceptional occasions when he needed the oriental serenity it gives, when everything was going wrong for him and he no longer had faith in himself

I do not know what Modigliani did, but. . . . he was always very poor. He was working little and discontented with himself, but it seemed to me that he was, in fact, making considerable progress. Certainly his ideas were becoming clearer. He had at last given up the naturalistic, external vision that he had brought from Italy, and was firmly committed to a course that I will call, for clarity, Matisse-like, in that he was searching for a lyrical and expressive style that was to be supported by an abstract and spiritual use of colour. In short, he was fully committed to the perceptive and chromatic values of Fauvism

Modigliani's sudden death saddened the great family of artists living in Montparnasse and throughout Paris. As with Apollinaire's death, the news got round quickly, but it was too late for me to see my friend again. So one grey, cold and foggy morning in January I went to the Hôpital de la Charité to join his other friends in accompanying the body to the cemetery. The whole of Montparnasse was gathered in the dismal courtyard. I was not able to remain in the sad procession long, because I felt too ill; emotion was aggravating a condition that had been considerably worsened by the coming of winter. So I went straight home, though it was quite impossible to consider doing any work that day. I think it was that same evening that we heard of another terrible tragedy. The gentle 'Coconut', who was pregnant, had thrown herself from a window and died instantly. For a long, long time the artistic community mourned inwardly, but deeply, the loss of these two, who were equally loved and respected by everyone.

From: *Modigliani—dipinti e disegni*, p. 107 f

Ardengo Soffici

Painter, 1879-1964

I visited Venice for the first time in 1903 with a painter friend of mine, and he introduced me to his colleague Modigliani, who was then living there. At that time he was a handsome, kindly-looking young man, of average height, slim and dressed with a sober elegance. He was serenely charming to everyone and spoke very intelligently and calmly.

During my stay in Venice we spent many pleasant hours together, either strolling round the wonderful city to which he acted as my guide, or in a cheap restaurant he took us to. There, eating fried fish the strong tang of which I can still smell, my new friend entertained us with talk of his researches into the painting technique of the Italian primitives, his passionate study of fourteenth-century Sienese art, and, especially, the venetian Carpaccio, of whom he then seemed particularly fond. I noticed on these occasions that he ate frugally in the Italian style and drank wine diluted with water or water alone

My return to France and the various circumstances of life prevented any continuity in our relationship. Although he later came to Paris we met only rarely, and for quite a long time we lost sight of each other.

Then one summer evening, as I was sitting with some friends outside the Café de la Rotonde in Montparnasse, someone broke out of the crowd of customers, dashed towards my table, seized my hand with great warmth and spoke to me by name. I only then realized that it was Modigliani, but, oh dear, how he had changed! His clothes in a terrible state, his shirt unbuttoned, his neck bare, his hair tousled, his eyes rolling and feverish; he looked like a madman. His face, once so handsome and bright, had become hard, tormented and violent. His soft mouth was twisted into a bitter grimace, and his words were incoherent and full of misery. As he came close to me and spoke with a touching passion, I was struck in the face by the stench of brandy and ether fumes. He was drunk, of course, as on most days at this period, I was told. His effusiveness was painful, and we parted without having managed to speak of anything that really mattered, such as our lives, our ideas and our art.

This, our last meeting, took place in June 1914. Two months later war broke out, and just after the war Modigliani died.

From: *Modigliani—dipinti e disegni*, p. 108

Chaim Soutine

Painter, 1894-1943

It was Modigliani who gave me confidence in myself.

From: Giovanni Scheiwiller (ed.) *Omaggio a Modigliani (1884-1920)*, n. p.

Curt Stoermer

Painter

I met Modigliani in 1909 at the house of Mlle de Anders whose receptions he always attended. He was intoxicated. He loved the state of drunkenness. He was already addicted to drugs. His nostrils flared, he breathed rapidly and sniffed the air like an animal. His eyes were wide open. He answered promptly, and his conversation was most refined. His voice was bright and metallic. His laugh was like a fire that sparks off a blaze. It was said that he had been working on one and the same picture for six months. I was very surprised to hear this. I could not understand why anyone, unless he was an academic, could work away at the same thing for so long. I still knew little about France. I did not yet know that every good Frenchman is an academic at heart, that for each of them the precision of painting and the skill of craftsmanship are more important than the impulse itself. Manet and Cézanne were the same. And like them, Modigliani was an academic, although he was even further removed from the realistic approach.

Anyway, I visited him the next day in his studio and saw the picture, which was already something of a celebrated mystery. It was the *Cellist*, a painting of the utmost subtlety whose mood was comparable to the pictures of Picasso's Blue Period, but with much greater differentiation in the colour. The strangely enraptured musician seems to have become fused with his instrument. Looking at later works I discovered that the strongly spiritual mood of *The Cellist* was a stage of development which he (M.) soon abandoned. He hated resentment. What did a painter have to do with mood? He expunged the content, his painting became objective; he compressed his drawing into the precise contours which flowed unconsciously from his nervous and expressive hands. Drawing was his forte.

Modigliani was wont to get drunk; he also took drugs. He loved to be intoxicated. Only when he was preoccupied by work did he forget everything, even the pills. He did not belong to that generation of French poets and artists which based a whole literature around artificial stimulants. Modigliani drank simply for the hell of it. He despised sentimentality. Inebriation sharpened his concentration and the clarity in his Roman head. His brain was never dulled. He was able to step over his own shadow.

His capacity to hate was strong; love was never his strong point. He was often bad-tempered and angry, but never banal or brutal. He was not patient, but he was magnanimous. I mentioned someone who played Chopin. '*Chopin est mauvais,*' he said bluntly. A professor at the Sorbonne gave a celebrated lecture on Nietzsche: '*C'est le marteau barbare!*' was his verdict on Nietzsche. He had been to Germany: '*On fume très bien*' was all he had to say. He had no time for world-weariness. A well-proportioned Roman of great beauty, he loved the world and the world loved him.

His antagonist in the world of Montparnasse was Archipenko, who was then equally unknown as Modigliani. There was little love lost between the two. But they had one thing in common: stimulants. Archipenko preferred absinthe but did not eschew drugs. He lived in Paris as if on an island, in a Russian diaspora. He was archetypally Russian and wore his hair long. His beard obscured most of his pale face. A green pince-nez hid his eyes. He sang beautiful Russian songs in his deep bass voice and played the harp. There was always some voluptuous woman at his side. He lived in a former monastery at the Dôme des Invalides very near to Rodin; later he moved into a studio in Mont-rouge. What a contrast to Modigliani! The Roman versus the Russian; the one a crystalline intellectual, the other a chaotic deluge. Archipenko was dominated by Eros; his art arose from the demonic nether regions, his work was euphoric. Modigliani was quintessentially Latin.

Modigliani did not like him, and he hated Archipenko's sculptures. The sensual repelled him. He did not believe in dark powers, and found the instinctive urge primitive.

I loved his painting and admired his draughtsmanship, but his sculpture was alien to me. He was prompted to sculpt by his antagonism towards Archipenko, although his formal inspiration was African art. This influence was so strong that some of his works could have been made in Benin. Even his more mature works evince this exotic influence. By contrast, as a painter he was thoroughly European, an exponent of exquisite Latinate culture. Archipenko was also enriched by primitive exotic art, but his work was filled with life.

Modigliani's studio in the Cité Falguière was empty. It was like a crystal dice, devoid of antiques, carpets, screens or any other of the usual accoutrements of an atelier *à la bohème*. One wall was of glass, another was sparsely furnished with drawings. A divan, table and chair—he never had more than that. He did not have the slightest acquisitive instinct. He did not collect but instead, like a child, destroyed everything that he deemed superfluous. Anyone could have a picture from him for simply bringing him a clean new canvas. He stood outside the social maelstrom. He lived within his cool Latin isolation without knowing it, since his genius never left him.

He was also a regular customer at the hot-food stall of Madame Rosalie, an Italian woman who was always overjoyed to see him and babbled away to him in their native tongue. In return for many a free dish of macaroni, he painted the walls of her basement with frescos. After his death a German art historian removed them, together with the plaster.

Sometimes he was near to starvation. His eyes flickered feverishly and he was in bad spirits. With an expression of bitter suffering, he scurried along the boulevards looking for salvation. It was hard to help him. Grim and proud, he could never forget the humiliation caused by his impoverishment.

He was generous, even with perfect strangers. He shared the little money he had, and which he considered a fortune, with everyone.

He would declaim verses from the *Divina Commedia* to his friends. He knew them by heart. Books lay in a corner of his room: Petrarch, Ronsard, Baudelaire, Mallarmé, Spinoza, Bergson. He knew them all. He carried scraps of books in his pocket. He used to tear books apart so that he could better carry them. This was the fate, for example, of Claudel's first work, 'L'arbre', which had just appeared in the *Mercure de France*. He invariably had a chunk of the *Tête d'or* in his pocket and would seek to impart his enthusiasm to anyone he met by reading out loud the wonderful dialogues amid the coachmen in the Rotonde bar, on the public benches in the Jardin du Luxembourg or at night under the street-lamps in the Boul. Mich. However, his enthusiasm faded as rapidly as it arose. I was surprised and disappointed. I was still very young.

He destroyed everything he loved. The same fate befell the women who crossed his path. To share an experience with Modigliani was no cosy affair, but such days and nights produced thick piles of the most magnificent drawings in which he captured the female form in a host of variations with a quick and sure hand. That was his unrivalled achievement. After the two years I knew him he went on to live another ten. One January night in 1920 the poor man was found on a bench in Montparnasse and taken to the Hôpital de la Charité, where he died. His last lover opted to share his fate by her own hand. She crowned his life, for she was convinced that she would be united with Modigliani for all time.

(1931)

From: Giovanni Scheiwiller, *Amedeo Modigliani—Selbstzeugnisse, Photos, Zeichnungen*, pp. 53-57

Leopold Survage

Painter, 1879-1968

Modigliani was then living at 216 Boulevard Raspail in a little house at the end of the garden. When I went to see him the building was in the process of being pulled down, and the room he lived in had one wall missing. He had replaced it with a curtain of some material, and this studio—for it was there that he worked, and slept on the floor—was full of splinters and blocks of stone, and those famous, beautifully shaped heads, whose outline and form were a starting point for his painting.

He immediately began to paint. A born psychologist, perceptive and subtle, he had by this time found his true path. He read the character of someone near him very accurately and quickly. This psychological gift was such that you could say that his sitters resembled their portraits rather than vice versa. He underlined and exaggerated the characteristics of his sitters and brought out what was hidden by secondary and subsidiary features.

These portraits go far beyond the acuteness of caricature, for in their truthfulness they attain a high level of style. Sometimes he would say, 'I've found the means that will allow me to express myself.' And again, 'What I see before my eyes is an explosion which forces me to take control and organize.' It was by geometry, proportion and rhythm that he achieved his aims.

His work was executed rapidly because it was preceded by deep reflection. His psychological instinct led him to investigate the characters of his sitters first of all by talking with them for a shorter or longer time. But once he had come to a decision and had a conception of the portrait, he worked straight off. He once told me that a connoisseur, who had commissioned a portrait and paid in advance, had pestered him to begin work. 'His por-

trait was already finished, it only had to be unhooked,' he said, tapping his forehead with his finger.

He usually began by sketching, with a very fine brush, a drawing similar to his well-known pencil drawings; sometimes soft and tender, sometimes hard and violent, according to the character of his sitter and his own mood. The more studied and deliberate elements were combined with a fair measure of improvisation. Starting from an initial conception of main lines and angulations, which represented the sitter and extended outwards to take in surrounding objects such as chairs, tables, wall corners and door and window frames, he scattered, rhythmically and in a strictly geometrical style, a flood of detail that was painted with great delicacy and force. So fond was he of fathoming the unfathomable that it did not weary him to do seventeen or even nineteen portraits of the same person at near intervals.

This work made for great nervous strain, for it required an uninterrupted flow of rapidly changing perceptions at the psychological level to be expressed by a procedure that pushed the geometrization of forms to its extreme.

From: Enzo Maiolino (ed.), *Modigliani vivo*, p. 64 f

Simone Thirioux

31st December, 207 Boulevard Raspail
Dearest Friend,
My thoughts turn to you on this new year which I so hope might be a year of moral reconciliation for us. I put aside all sentimentality and ask for only one thing which you will not refuse me because you are intelligent and not a coward: that is, a reconciliation that will allow me to see you from time to time.

I swear on the head of my child, who is for me *everything*, that no bad idea passes through my mind. No—but I loved you too much, and I suffer so much that I ask this as a final plea.

I will be strong. You know my present situation: materially I lack nothing and earn my own living.

My health is very bad, the tuberculosis is sadly doing its work.

But I can't go on any more—I would just like a little less hate from you. I beg you to think well of me. Console me a little, I am too unhappy, and I ask just a particle of affection that would do me so much good.

I swear again that no hidden thought disturbs me.

I have for you all the tenderness that I must have for you.

Simone Thirioux

From: Jeanne Modigliani, *Modigliani: Man and Myth*, New York (Orion Press) 1958, p. 115

Giulio Toffoli

I arrived in Paris in October 1913. As a painter, I took lodgings in Montparnasse, which was a well-known artistic quarter, and thanks to my acquaintance with an Italian sculptor, I began to visit the artistic cafés such as La Rotonde, Le Dôme and La Closerie des Lilas. At that time La Closerie had an international clientele of painters, poets and writers. The huge bar used to get especially crowded on Tuesdays, when traditionally Paul Fort, advertised as 'Prince of Poets', read his work. On one of these evenings, when the poet was reading to a completely silent audience, a fashionably dressed, good-looking young man came in and casually crossed the whole width of the room before sitting down.

It was the first time I had seen this young man, whose name was Modigliani.

I saw him again sometimes 'chez Rosalie', in the Rue Campagne Première

Modi came to the bar only occasionally and he usually arrived penniless. Rosalie used to scold him and say that if he drank a little less he would be able to pay for what he did drink, and she knew from experience just what was involved in allowing him credit. Then he would suggest exchanging a meal for a drawing, since they both had the same value. She would reply that she already had too many of his drawings and did not know what to do with them. But Rosalie was fond of him and never let him go away hungry; and in return he gave her one of his drawings.

I remember I was once going to Rosalie's and I met him coming back from there. Patting his stomach he called out cheerfully from a distance, 'I've eaten, Toffoli.'

When Rosalie died there was no sign of the drawings. In that primitive kitchen perhaps they were useful only for lighting the fire.

From: *Modigliani – dipinti e disegni*, p. 108 f

Lionello Venturi

Art historian, 1885-1961

His art is all reflex, the grandeur and generosity as much as the sensual violence. But, because this is art, his virtues and vices cannot be expressed as positive or negative attributes as they can in any moral code. Idealism contributes to the creation of the artistic fantasy just as much as unbridled sensuality; in fact, the co-existence of the two gives rise to what is held today to be the admirable equilibrium of his art. I have heard violently contradictory views expressed about Modigliani's nudes: one person is moved by their chastity, a second seems shocked by their lack of modesty. The paintings, however, cannot be judged from any moral standpoint, because they do not belong to nature, nor are they associated with any particular nature: the chimerical reality of their forms and colours succeed rather by a different but parallel route. And if this fantasy is imbued with palpable reality, this

implies that Modigliani's art is not visionary art, but that it pulsates with concrete reality.

Cézanne had taught him to construct forms in depth, but his love of line for its own sake led him inexorably towards decoration. The imaginary construction of mass and volume distanced him from objective beauty, from grace and elegance; line restored all these ideal qualities to their place, but inevitably eliminated architecture, bringing the image back to the surface. Modigliani felt that he could not abandon the third dimension, but he wanted at the same time to pursue the line on the surface; he drew an elegant curve but it would occupy several planes at once, superimposed on one another. He created the simultaneous impressions of a flat area of colour spread over the surface, and a mass of volume: he would accentuate one pure colour and couple it with a neutral area in order to suggest tonal harmony; he filled space and immediately brought the image back to the surface; he added distortions to the form of the image, not to the pose.

Nowadays it seems clear that, given the principles laid down by Cézanne, he could not have achieved decorative grace in any other way. If he had kept to measured proportions his line could have developed either in depth or on the surface but could not have comprehended all three dimensions at once. If his decorative line had been added later to the inner structure of a painting, it would have reduced the effect to the status of a banal school. In order for the line not to appear to have been added later, but to have been created at the same time as the main structure of the painting, it needed to be not simply an ornamental outline: it had to elevate the masses to a new order, new proportions. The elongation of Modigliani's images, excessive by classical standards, was essential to someone trying to express simultaneously both inner depth and surface, solid construction and surface decoration, conscious reality and imaginative grace.

The period when Modigliani lived, when soldiers were emerging from the trenches, was a period of contradiction, confusion and moral uncertainty; Modigliani suffered from all of these. He was nevertheless able to step aside from the prevailing artistic fashions of the day, in particular from the artificial, frigid abstractions of Cubism and Futurism. His very sensuality kept him from the prevailing '-isms', kept him firmly steeped in nature. He would emerge from it sometimes in his better moments and a wave of pure sentiment would gush forth, sentiment as pure as his previous passage through the rocks had been harsh.

From: Ambrogio Ceroni, *Tout l'œuvre peint de Modigliani*, pp. 12-13

Lamberto Vitali

Art critic

The key to Modigliani's painting, the reason why he distorts his models—elongated faces tilted on cylindrical necks like columns to support the head—the imponderable spirituality that radiates

from his works, a pleasure comparable only to that afforded by graceful figures in a slow dance—all this has but one name: arabesque.

I believe that this is the reason why Modigliani, though he belongs in some respects to our time (to the period directly traceable to Rimbaud and Baudelaire)—and this is his great strength—also belongs to the family that gave birth to the Japanese and to two Italians who share the same style of pictorial expression: I mean Simone Martini and Sandro Botticelli. But the Sienese painter Simone Martini has particular affinities with Modigliani, abandoning narrative painting to become a 'decorative' painter ('decorative' in the sense given the word by Berenson)

A painter's drawing is like the secret diary of a writer: in both the artist presents himself naked, without pretence and unadorned: embellishment would anyway be ill tolerated by the aristocratic contrast of black and white

Preoccupation with chiaroscuro effects is seldom to be found in Modigliani's drawings: often there is an even, fine line drawn in a single stroke, like a thin thread, of an extraordinary purity, which encloses forms in a rhythmical interplay of exquisitely elegant arabesques. The curves intertwine and interweave rhythmically, almost musically, between pauses and reiterations, intersection and suspension: suggesting more than they actually depict, synthesizing without ever analysing. And as the warbling cadences of the pan pipes can evoke the nostalgic notion of an ideal world, so Modigliani's arabesques surpass everyday reality, uplifting the model to a different and higher world in which women suffused with a strange languor display bodies of virginal purity.

From: Lamberto Vitali, *Disegni di Modigliani*, p. 8 f

Maurice de Vlaminck

Painter, 1876-1958

Imagination nowadays is nearly always fantastic, lyrical, seldom dramatic. This was brought home to me when I read that a restrospective exhibition of Modigliani's paintings is to take place shortly.

At a time when men are admired for, and all too frequently judged by, the external evidence of wealth they display, Modigliani might appear to a worldly observer to be a miserable failure, a bohemian, a character fit only for hospital or the Institute for Forensic Medicine.

Modigliani was an aristocrat. His work bears powerful witness to this. His canvases are works of the greatest distinction. Vulgarity, banality and coarseness are totally absent from them.

I can see Modigliani now, sitting at a table in the Café de la Rotonde. I can see his pure Roman profile, his look of authority; I can also see his fine hands, aristocratic hands with sensitive fingers —intelligent hands, unhesitatingly outlining a drawing with a single stroke.

I can see him (he was no fool) distributing his sketches to surrounding friends in exchange for a

drink. With the gesture of a millionaire he would hold out the sheet of paper (on which he sometimes went so far as to sign his name) as he might have held out a banknote in payment to someone who had just bought him a glass of whisky.

During the last year of his life he was continually in a state of febrile agitation. The least vexation would make him wildly excited.

One day he sketched a portrait of an American woman who was briefly at the Rotonde, and when he had finished it he offered it to her graciously. She urged him to put his signature on it.

Infuriated by her greed, which he sensed immediately, he took the drawing and scrawled a signature across the whole sheet in enormous letters, as big as those on the placards saying 'Apartment to let'.

One morning in the winter of 1917, on a traffic island in Boulevard Raspail, he was watching the taxis driving past, proud and haughty as a general watching manoeuvres. An icy, biting wind was blowing. As soon as he saw me he came towards me and said, as straightforwardly as if he were talking about something quite superfluous to his requirements: 'I'll sell you my overcoat; it's too big for me and would suit you very well.'

In his house Modigliani was once offering a pile of drawings to a dealer for an extremely modest price. The dealer was arguing, bargaining, hoping for a reduction. Modigliani, without a word, picked up the pile of papers and straightened them carefully, made a hole through the entire pile, threaded a string through the lot and went and hung them up in the lavatory.

I knew Modigliani well.

At the present time when everything is so heavily made up, disguised, when life seems a series of superlatives—supertax, supercarburettors, sensationalism, surrealism—certain words have lost their true meaning. I no longer know how to use the words Art, Artist.

Today the word Art can conveniently replace the word Bourgeois. It saunters from the fire station to the cocaine dealer's, pops in to the hat-shop, pays a quick visit to the hairdresser and hardware shop and then wanders round the department store: the Art of Housekeeping or Cookery, Decorative Art, the Art of Hairdressing, etc., etc

For a moment let us imagine that the word has not been subverted and that it has regained its colour, its meaning and its sex.

Modigliani was a great artist.

From: Maurice de Vlaminck, 'Souvenir de Modigliani', *L'Art Vivant*, November 1925, p. 1 f

André Warnod

Writer and art critic, 1885-1960

When Modigliani died he was given a magnificent funeral. Flowers, huge wreaths, a cortege of artists behind the hearse and policemen standing to attention to salute the procession—these were the trappings that bid farewell to Modigliani as he made his triumphal entry into the next world. Some posthumous fame is a long time in coming; Modig-

liani's began on the very day of his death. The troubled and chaotic life he had been living for such a long time had calmed down towards the end. He was able to work more or less peacefully; admirers, and a dealer who was his friend had confidence in his future and bought his paintings on a regular basis. His painting, having shared the vicissitudes of his life, blossomed. The confidence shown in him was not misplaced; great things could be expected from him. Death decided otherwise, but at least it kept away long enough for him to express his extraordinary personality and his acute sensitivity in some very beautiful paintings.

There are nudes and portraits. Modigliani preferred to paint his fellow human beings; he is a painter of the human form whose works, though incomplete, will certainly be significant. His work is exceptional and too personal, I believe, to spawn disciples; may heaven confound any followers who try to pastiche his work. His painting was held up to ridicule for years, and, when it was exhibited, was often mocked by the public, but now it is officially recognized and will remain so.

'The work of a lunatic, a drug addict,' people would say. 'Caricature!' The artist's right to distort his models when the distortion seems so natural, and expresses the model's inner feelings so powerfully, will not be discussed here.

Modigliani's figures are singularly appealing: their extreme sensitivity leaves a very disquieting impression. They are suffused with delicate but intense life; extraneous detail has been excluded, only the bare essentials remain. His naked young women have the restless grace of a young animal. The models often appear to be on the edge of extreme suffering: emaciated faces, very long bodies with small heads nodding like flowers too heavy for the stems they grow on. Disturbing reminders of the sensitivity and sensuality of the painter.

This exhibition, which contains about forty selected works, is intended to remind us what Modigliani was. It includes some of the red, recumbent nudes, supple as climbing plants that entwine in their caresses, sensual, feverish, fiercely carnal; but it also includes a plump, blond nude, guileless as she chastely holds up her white chemise. Long faces, portraits burning with the same internal fire that burnt within the painter, displaying brutal yet sumptuous combinations of blacks, reds, blues, as brilliant as enamel, contained within sensitive, passionate strokes.

From: André Warnod, *Modigliani*, n. p.

Berthe Weill

Galery owner

Zborowski asks if I will have an exhibition of Modigliani's paintings and drawings; of course, I accept.

Hanging on Sunday and private view on Monday 3 October 1917. Voluptuous nudes, angular faces, portraits full of flavour. A carefully chosen gathering. It begins to get dark. Lights turned on in the

gallery. A passer-by, fascinated to see so many people in the shop, stops in amazement. Two passers-by . . . three passers-by The crowd grows. Opposite me, the Chief Constable grows restive: 'What's that? A nude!' (there is a nude portrait just opposite his window). He details an affable plain-clothes policeman with this message to me: 'The Chief Constable requests you to remove that nude!'

'Oh? Why's that?'

(In louder, clearer tones): 'The Chief Constable requests you to remove that one as well!'

(My God! He hasn't seen everything yet! And yet none of them is in the window!) The paintings are taken down. Those present snigger, without fully comprehending: I don't either. Outside, the swelling crowd heaves menacingly: danger!

Still quite affable, the policeman returns: 'The Chief Constable *invites* you to go up and see him' ('invites' sounds better).

'But you can see that I haven't time.' (Louder, and a tone higher.)

'The Chief Constable *invites* you to go up and see him.'

I cross the road, braving the jeers and gibes of the crowd, and go up. The office is full of people waiting. I enquire:

'You invited me to come up?'

'Yes! And I command you to take down all that shit!'

I venture to remind him that 'there are art lovers who do not share your opinion But what's the matter with the nudes?'

'With the nudes! They've got ppppubic hair!' [sic]

And so, swaggering, encouraged by the approving laughter of the poor sods huddled outside, at his mercy, he carries on triumphantly: 'And if my orders are not carried out at once I shall call a brigade of policemen to seize the lot . . .'

Imagine the scene: every policeman in the brigade with a Modigliani nude under his arm.

I shut the shop at once and the guests imprisoned inside help me take down the paintings

Once they are all down, the exhibition continues; only two drawings are sold . . . 30 francs apiece. In order to compensate Zborowski . . . I buy five paintings.

From: Jeanine Warnod, *La Ruche & Montparnasse*, p. 86

Ossip Zadkine

Sculptor, 1890-1967

It was in the spring of 1913. Montparnasse was experiencing its last few quiet days as the 'English quarter' before the avalanche broke which disrupted every nook and cranny and destroyed everything. That spring I met Modigliani for the first time. He had come from Italy, and he wore a grey velvet suit. His facial features were distinctive: jet-black hair framed his powerful forehead, and his chin, which was cleanly shaven, cast a blue shadow across his ivory-coloured face. We met in the Boulevard Saint-Michel, the place where young

people from all over the world met and where friendships were made. Then we saw one another again in the Rotonde Modigliani now wanted to devote himself to sculpting. He no longer wanted to live in Montparnasse, and all his old pictures lay in some hotel, Cité Falguière. He now had a studio at 216 Boulevard Raspail. And I was to go to see him and look at his sculptures.

Number 216 does not exist any more, the little extension through which an alley led into a small wide yard where two or three studios hugged the wall. Behind that was a piece of open ground. Trees covered the glass roofs with their black branches and green leaves, as if trying to protect these poor but oh-so-hopeful and energetic young artists from the sun, rain and wind.

Modigliani's studio was a glass box. As I approached I saw him lying on a tiny bed. His fine velvet suit floated forlornly in a wild but frozen sea and waited for him to awaken. All around, on the walls and the floor, were large white sheets of paper filled with drawings like so many white horses in a film frame of a stormy sea that has been stopped for an instant. When he awoke, the features of his fine, handsome, oval face were distorted beyond recognition. The goddess hashish spared no one.

He picked up the drawings and showed me his sculptures: stone heads that were perfect ovals; perfectly shaped eggs on the side of which the nose jutted out like an arrow towards the mouth which, as if out of shame, he never finished, for some mysterious reason never revealed.

We saw one another again later at Picasso's house in the Rue Schoelcher where African masks exhibited their magnificent grimaces before beginning their conquest of Paris. Later, in the studio of Madame X, a poetess and a charming woman, I saw those large drawings of caryatids whose bodies and children's heads struggled to uphold a dark-blue Italian sky. In this studio he also began portraying Madame X, and he also did other, multi-coloured sculptures.

Gradually his passion for sculpting waned. Portrait drawings of Rivera, Kisling and Soutine displaced the stone heads, which could all be seen

outside, unfinished, bathing in the dirt of a Parisian courtyard and merging with the glorious dust A large stone statue, the only one he had carved, lay with its face and belly towards the grey sky. The incompleted mouth seemed full of unspeakable terrors.

When I could stand it no longer, I joined up. I was demobbed in December 1917. Again I met Modigliani. He was thin and emaciated and could no longer take much alcohol—one glass was enough to make him drunk. But he continued to sit with friends at the table and to draw. Occasionally he sang in a hoarse voice; he could hardly get his breath. He sang incomprehensible words to which no music could be matched. But he did not care; he merely followed the song that welled up within him like a subterranean rumble.

One day pandemonium broke out in the quarter. A hairdresser had papered the walls of his shop with Modigliani portraits. Furtively the craze began to spread. The run on the pictures of the '*Peintre Maudit*' had begun. A swelling shoal of sharks which, though small, were developing voracious appetites encircled Modigliani. For his friends he was lost

In a studio in the Rue Huyghens an exhibition was organized at which we all—Modigliani, Kisling, Durey and I—were given one wall each. For the first time, 'The Six' demonstrated their works. Cocteau and Cendrars recited poetry. It was at this time that people starting 'promoting' Modigliani. I think he was well aware of the true character of these 'promoters', but he did not say a word. And he loved Mademoiselle H., his girlfriend who at this time was his only real friend.

Then the galleries and exhibitions finally got their hands on him. And here I would rather end my reminiscences.

(1930)

From: Giovanni Scheiwiller, *Amedeo Modigliani—Selbstzeugnisse, Photos, Zeichnungen*, pp. 57-60

Leopold Zborowski

Art dealer and collector

On a July evening, the milling crowd in the street, frantic and careworn.

These people need warmth, new passions.

On either side, a café.

A young man sitting near me rises up from his chair, takes a few steps and then stops in the middle of the boulevard.

The noise of motor cars and trams does not frighten him—the young man picks up a notebook, opens its blue covers—some loose leaves fall on the warm cobbles.

A kind of swoon . . .

Or evening prayers.

Come, bring this man to my house.

Policeman,

Friends.

The door closes like an eye closing at night.

This is how, on a July evening, Modigliani became entangled in my life.

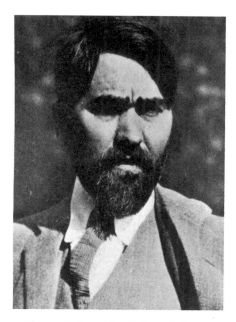

Afterwards, I would walk through the streets to his studio daily.

A huge, sleepy attic.

This was a period of suffering for him.

Modigliani the sculptor was dying, his health betrayed him.

See his sculpture, it's a spectre, a ghost, I cannot touch it any more.

His melancholy eyes looked dreamily at the simple caryatids—those long heads, those women with folded arms.

He loathed rhetoric, a multitude of words will not illuminate a dark street—adieu, lastborn—don't weep for him.

The secret of crimson life dies fast.

At the right moment you must succumb.

He returned to painting.

He had been a painter in his youth, but to rediscover his early promise—that was the difficult part.

His lungs burning like torches, he had no time to waste.

His life just a brief moment.

In his sculpture he heard the guiding call of the East, and let himself follow.

The future.

The garret is full.

Rome, Italy.

What are you complaining about, you wretch?

A worthy child of so many journeys, the kiss lives on in his eyes—pure sunshine.

Modigliani is working.

Waves of glory pour over the white canvas.

Here in their laughing glow are the naked women.

A miracle of propriety.

His palette explodes with passion.

Fire springs from his heart.

He follows his inner vision, knowing a noble love.

The solemn gazes of the women in Modigliani's portraits confess the love they feel and to which they yield.

Marvellous harmony unleashed by his sensitive understanding.

Yet some men call to him sometimes then disappear.

I see them passing by, trampling the pictures into the ground with their elegant feet.

The artist's work.

Modigliani, in love with line, is not ignorant of its significance.

A spiritual thrill brings his imagination to vibrant life

Conqueror that casts the mysterious joy of beauty in his eyes.

Oh! How cruel is his life.

Dreadful stony silence,

Are you blind, mankind?

Winter is coming.

January 1920.

Three days before his death he is working.

He loses consciousness in front of his canvas.

Defeated—released from suffering.

The World walks on.

From: *Paris—Montparnasse*, p. 19

Christian Zervos

Art critic

In order to appreciate the influences which shaped Modigliani one must endeavour to forget the Parisian milieu and to concentrate instead on the Italian art of the Cinquecento, this art born of Giotto's naive realism which finally withdrew into the realm of refined fantasy. In Modigliani's subtle, pensive faces we can rediscover that unique element which Botticelli introduced into Italian painting....

Hence we must restrict the influence that Paris had on Modigliani to the effects of its felicitous atmosphere which served to heighten the sensitivity, to fire the enthusiam and to create a spirit of competition. It is absolutely correct that Modigliani found these elements, which were conducive to his development, in Paris. But that is not everything.

Over time the naturally emotional essence of his character became so dominant that everything within him was taken to the extreme. And the more acute his sensitivity became, the more intense his feelings. For this reason the development of Modigliani's last works did not lead to a change of form or technique; we find here only changes which express a sharper perception of feelings which, now united, suffuse the entire composition, whereas in his earlier works the emotion was often only sporadic and limited to an external feature.

In his last works we can discover a sort of self-abandonment or subjection to visual perception, a self-abandonment to the impulsive forms of expression that transcend any preconceived idea and seemingly extend to spiritual facets.

His previously carefully 'elaborated' pictures have now become spontaneous works. Rapid improvisation has supplanted the primitive laboriousness born of reflection, the search for experience, problems and aspirations. The portraits and nude studies are now flung down with rapid strokes as if by reflex, and these brilliant expressive forms of the unconscious are among Modigliani's best work....

The profound sadness of his life and fate is reflected in all his works and endows them with their true meaning. This melancholy covers and pervades the faces of his models like a wafer-thin sheen and bestows on them all an unspeakably pathetic tone. Among his nude studies there is not a single female face that does not betray the shadow of the artist's secret sorrow, and this pained, resigned or apathetic mournfulness gives them an incomparably chaste aura....

Modigliani's work, which is so deeply pervaded by the sensitivity of his feelings, is a source of delight which we seek in vain among the best of today's painters.

From: Ambrogio Ceroni, *Tout l'œuvre peint de Modigliani*, p. 12

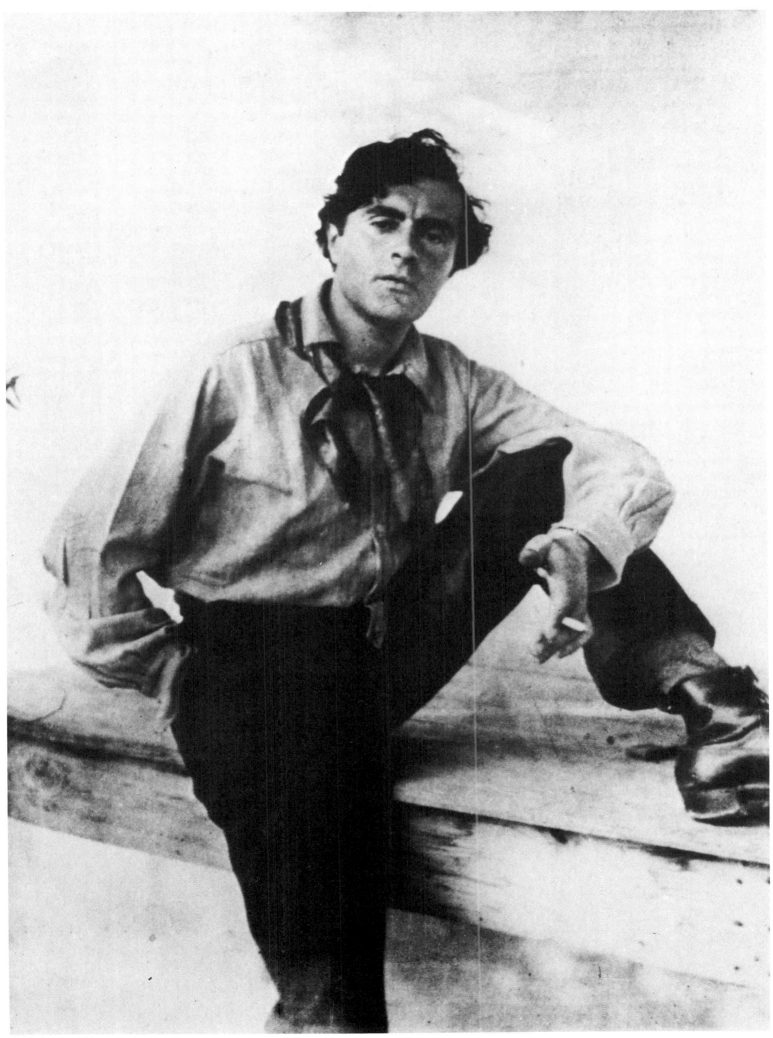

Modigliani, 1918

Chronology

First photograph of Modigliani, *c.* 1885,
with his nanny in Livorno

1884

Amedeo Clemente Modigliani was born in Livorno
on 12 July as the youngest of four children. His
father, Flaminio Modigliani, was involved in
money dealings and was under the constant threat
of financial ruination. Both his parents were
members of the Sephardic Jewish community.
Under the direction of his mother, Eugenia Garsin
Modigliani, he received a liberal and literary educa-
tion in Italian and French.

Modigliani was of delicate health and often con-
tracted chest infections. He exhibited his propen-
sity for drawing and painting at an early age.

1897

Modigliani's mother relented and allowed him to
study drawing.

1898

Amedeo entered the art academy in Livorno under
Guglielmo Micheli, a pupil of Giovanni Fattori. He
was trained in the tradition of the Impressionistic
Macchiaioli in landscapes, portraits, still lifes and
nude studies.

1899–1900

On the basis of his intensive study of the works of
Charles Baudelaire, Lautréamont, Oscar Wilde,
Henri Bergson, Gabriele D'Annunzio and others,
Modigliani developed a new self-awareness and be-
gan to play the role of the *peintre maudit* before his
friends in the Caffè Bardi in Livorno. Inspired by
such artists as Gino Romiti and Aristide Sommati,
he took an interest in contemporary artistic cur-
rents both inside and outside Italy. Modigliani
swapped ideas about artistic creativity with his
painter colleague Oscar Ghiglia.

1901

Modigliani travelled through southern and central
Italy for health reasons.

Certificate of admittance to the Venice
Academy for the academic year 1902/03

1902

On 7 May Modigliani matriculated at the Scuola
Libera di Nudo in Florence and studied under
Giovanni Fattori. In addition to his courses he also
studied the Tuscan old masters in the museums and
art galleries. He also visited Carrara and Pietra-
santa, and on seeing the quarries developed the
desire to become a sculptor.

1903

In March Modigliani went to Venice and became a
student at the Reale Istituto di Belle Arti di Venezia.

Modigliani at school
(front row, third
from the right)

Modigliani and fellow
painters in Romiti's studio,
Livorno, 1900. From left
to right: Benvenuti, Romiti,
Sommati, Modigliani, Bartoli

He met such artists as Umberto Boccioni and Ardengo Soffici. At the biennial exhibitions of 1903 and 1905 Modigliani viewed the art of the Symbolists, the French Impressionists and works of the sculptor Rodin and the English painter James Abbott McNeill Whistler. Impressed by reproductions of the works of Henri de Toulouse-Lautrec, Modigliani decided to leave Venice in order to go to Paris, the centre of avant-garde art.

1906

He arrived in Paris in the winter and settled in Montmartre. His circle of acquaintances included many artists and literary figures such as Pablo Picasso, Guillaume Apollinaire, André Derain and Diego Rivera. He was closely associated with Jewish intellectuals and artists like Max Jacob, Chaim Soutine, Moïse Kisling, Jacques Lipchitz. Soon after his arrival Modigliani enrolled at the Académie Colarossi. He made an intense study of Dante, Lautréamont's *Les Chants de Madoror* and literary works of the *fin de siècle*. Modigliani wrote some poems, four of which are extant.

1907

Modigliani got to know Dr Paul Alexandre, his doctor, promoter and patron. He became a member of the Société des Artistes Indépendants and exhibited drawings at the studio of his sculptor friend Amedeo de Souza Cardoso. He was also represented at that year's Salon d'Automne with a painting, *Portrait of L. M.*, and five drawings, head studies and portraits. Modigliani was particularly impressed by the works of Paul Cézanne, who died in 1906 and to whom the Salon d'Automne devoted a retrospective. Already at this stage his main preoccupations were portraits and nudes. His work showed the influence of Cézanne, Toulouse-Lautrec and Paul Gauguin and hinted at his interest in Picasso's Blue Period and Symbolist works.

1908

Six of Modigliani's works were on show in the Salon des Indépendants: the paintings *The Jewess* and *The Idol*, two female nudes, a sketch and a drawing.

1909

In the summer Modigliani went to Livorno. After his return to Paris he moved to Montparnasse and worked in the artists' quarter of the Cité Falguière. Here too, as he had done in Montmartre, Modigliani frequently changed his address. He made the acquaintance of the sculptor Constantin Brancusi, possibly via Paul Alexandre. Up until about the beginning of the First World War Modigliani worked predominantly as a sculptor and collaborated closely with Brancusi. His sculptures, which he carved directly in stone, were influenced by the primitive art of Africa and south-east Asia and by the art of the Italian Trecento.

1910

Modigliani was represented at the Salon des Indépendants with six paintings (*The Cellist, Moon Stone, Beggarman, Beggarwoman*, two studies).

1911

Modigliani exhibited his sculptures in the studio of Souza Cardoso.

Modigliani, *c.* 1900

1912

Modigliani showed a series of sculpted heads as *Têtes, ensemble décoratif* in the Salon d'Automne. He went back for the last time to Livorno and the quarries of Carrara.

1914

In May/June Modigliani participated in the exhibition 'Twentieth Century Art' at the Whitechapel Art Gallery in London. With the outbreak of war his friendship with Paul Alexandre ended.

Modigliani, Picasso and André Salmon, *c.* 1914

Modigliani, Max Jacob, André Salmon and Oritz de Sarate, *c.* 1916

only half-length portraits in favour of three-quarter-length and life-size portraits of children and adolescents from the local area. The four remaining landscapes by him date from this period. On 29 November his daughter Jeanne was born. In December Paul Guillaume organized another exhibition with Modigliani's works in the Faubourg Saint Honoré in Paris.

1914/1915

Modigliani got to know the English poet Beatrice Hastings and lived with her for the next few years. The art dealer Paul Guillaume became interested in Modigliani's works and arranged the first sales. His artistic success made him optimistic, as can be seen in his letters to his mother, to whom he was very close. Possibly on account of his continuing poor health and the increasing problems of procuring stone, Modigliani turned his back on sculpture and took up painting again. In his first works the colour was applied in a choppy, dabbed manner—befitting a sculptor—reminiscent of Pointillism. This technique was superseded by the angular style influenced by the Futurists and Cubists and harking back to the tradition of primitive sculpture. The subject of all his works was the portrait. As models

Modigliani used friends, acquaintances or people he got to know by chance in cafés. In addition to oil painting he also concentrated on drawing. The artist peddled his drawings in bars and cafés and in this way paid for his meals.

1916

Modigliani met Leopold Zborowski who replaced Paul Guillaume as his art dealer and did all he could for the artist in a self-sacrificing manner. Zborowski got him a studio and contributed towards his daily keep. In the following years Modigliani made very many portraits of him and his wife.

1917

Modigliani began his first series of nude studies. A second and third series followed in 1918 and 1919. He got to know Jeanne Hébuterne, a student at the Académie Colarossi. Against her parents' wishes the two moved in together. Between 3 and 30 December the Berthe Weill gallery in Paris showed the first individual exhibition of Modigliani's works for which Leopold Zborowski assembled some thirty paintings and drawings. The announcement was adorned by a poem from Blaise Cendrars. The exhibited nudes caused a public outcry, so that the exhibition was closed down by the police soon after it opened and was a financial flop.

1918

His progressive tuberculosis and the turbulent atmosphere in Paris during the war forced Modigliani to retire for a year to the Côte d'Azur near Nice and Cagnes. In the south of France Modigliani's colour palette became lighter and his figures got longer faces and thinner necks. Modigliani abandoned the hitherto accepted canon of painting

1919

Modigliani kept up his close contacts with Zborowski and his wife in his letters from the south of France. He was in a good frame of mind but often had no money. He sent his finished works to Paris to be sold.

In May Modigliani returned to Paris with Jeanne Hébuterne and his daughter. Though he was now seriously ill he kept up his dissipated lifestyle. In July he planned to legitimize his relationship with Jeanne Hébuterne, who was pregnant again. Further artistic triumphs, once more thanks to Zborowski's efforts, gave him fresh hope.

The exhibition 'Modern French Art', in which Modigliani participated, was put on at the Mansard Gallery in Heale. In September the Hill Gallery in London showed ten of the artist's works. He was also represented at the Salon d'Automne. In the winter Modigliani planned another visit to Italy.

Catalogue of Modigliani's first
one-man exhibition, held at Galerie Berthe Weill,
Paris, 1917

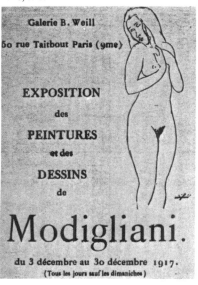

Jeanne Hébuterne dressed up as a
Russian, Carnival 1917

1920

His health deteriorated rapidly. On 24 January Amedeo Modigliani died in the Hôpital de la Charité. The next day Jeanne Hébuterne, in an advanced stage of pregnancy, committed suicide. The funeral, attended by a large number of his friends, took place at the Père Lachaise cemetery in Paris. The first exhibition after the artist's death was held in the same year at the Galeries Montaigne in Paris.

1922

In the 13th Biennale in Venice dedicated a small retrospective to Modigliani.

1923

The Musée de Grenoble became the first French museum to acquire a painting by him, the *Femme au Col Blanc* from 1917.

1930

A compendium of texts from Modigliani's friends, edited by Giovanni Scheiwiller, appeared under the title *Omaggio a Modigliani*.

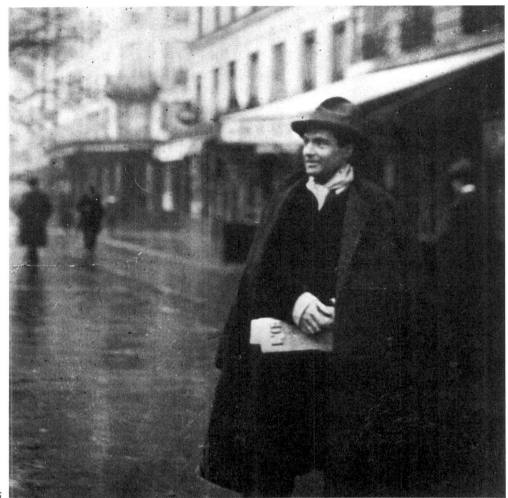

Modigliani, Paris, *c.* 1915

List of Exhibitions

All one-man exhibitions, as well as exhibitions in which Modigliani works were shown, are listed until 1945. After 1945, only certain exhibitions in which Modigliani participated are listed.

1907

Studio of Amadeo de Souza Cardoso, Paris (drawings)

Salon d'Automne, Paris, 1-22 October (one painting and drawings)

1908

Salon des Indépendants, Paris (five paintings and one drawing)

1910

Salon des Indépendants, Paris (six paintings)

1911

Studio of Amadeo de Souza Cardoso, Paris (sculptures)

1912

Salon d'Automne, Paris, October-November (Busts as 'Têtes, ensemble décoratif')

1914

Whitechapel Art Gallery, London: 'Twentieth Century Art', May-June

1917

Galerie Berthe Weill, Paris: 'Exposition des Peintures et des Dessins de Modigliani', 3-30 December

1918

Faubourg Saint-Honoré, Paris, December

1919

Mansard Gallery, Heale: 'Modern French Art'

Hill Gallery, London, September

Salon d'Automne, Paris

1920

Galeries Montaigne, Paris

Salon d'Automne, Paris

1921

Galerie l'Evêque, Paris: 'Rétrospective Modigliani'

1922

New Gallery, New York: 'Paintings by Derain, Modigliani, Matisse and Others'

Galerie Bernheim Jeune, Paris: 'Modigliani'

XIII Biennale, Venice

1924

Galeries des Champs-Elysées, Paris

1925

Galerie Bing, Paris: 'Modigliani'

1926

Grand Central Art Galleries, New York: 'Modern Italian Art'

Salon des Indépendants, Paris: 'Rétrospective Modigliani'

Galerie des Quatre Chemins, Paris: 'Modigliani'

1927

Arthur Tooth & Sons, London: 'Artistes du Novecento Italien'

Galerie Bing, Paris: 'Modigliani'

Kunsthaus, Zurich: 'Italienische Maler'

1928

Galerie des Archers, Lyon: 'Bonnard, Vuillard, Roussel et Modigliani'

Moscow: 'L'Art Français Contemporain'

1929

The Arts Club, Chicago

Galerie Georges Moos, Geneva: 'Modigliani'

Lefevre Gallery, London: 'Paintings by Modigliani'

De Hauke & Co., New York: 'Paintings by Amedeo Modigliani'

Galerie Bernheim Jeune, Paris: 'La Grande Peinture Contemporaine dans la Collection Paul Guillaume'

Tokyo; Nagasaki: 'L'Art Français au XXᵉ Siècle'

1930

Galerie du Centaure, Brussels: 'Trente Ans de Peinture Française'

Glasgow: 'XIXth and XXth Century French Painting'

Galerie Cardo, Paris: 'Les Charmes de l'Horreur'

Galerie Georges Petit, Paris: 'Cent Ans de Peinture Française'

XVII Biennale, Venice: 'Mostra Individuale di Amedeo Modigliani'

Kunsthaus, Zurich: 'Modigliani'

Kunsthaus, Zurich: 'Kunstausstellung'

1931

Demotte Galleries, New York: 'Amedeo Modigliani: 1884-1920. Retrospective Exhibition of Paintings by Amedeo Modigliani'

Museum of Modern Art, New York: 'Memorial Exhibition: The Collection of the Late Lillie P. Bliss'

Galerie Marcel Bernheim, Paris: 'Rétrospective Modigliani'

Prague: 'Exposition d'Art Français'

1932

Lefevre Galleries, London: 'Masterpieces by XXth Century French Painters: L'Ecole de Paris'

Musée du Jeu de Paume, Paris: 'Accrochage Temporaire'

1933

Palais des Beaux-Arts, Brussels: 'Modigliani'

1934

Kunsthalle, Basle: 'Modigliani'

Museum of Modern Art, New York: 'Machine Art'

Museum of Modern Art, New York: 'Modern Works of Art: 5th Anniversary Exhibition'

Museum of Art, Philadelphia: 'Speiser Loan Collection'

1935

Stedelijk Museum, Amsterdam: 'Tentoonstelling Moderne Fransche Kunst'

Museum of Modern Art, New York: 'Summer Exhibition'

Galerie Ernest de Frenne, Paris: 'Modigliani— Bonnard'

Musée du Petit Palais, Paris: 'Les Chefs d'Oeuvre du Musée de Grenoble'

Saint Louis (travelling exhibition): 'The Bliss Collection'

Kunsthaus, Zurich: 'L'Art Etranger à Zurich'

1936

Musée du Prince Paul, Belgrade: 'Peinture Moderne Française'

Harvard University, Dunster House, Cambridge, Massachusetts: 'Exhibition of Modern Paintings'

Society of Arts and Crafts, Detroit: 'Thirteen Paintings'

Museum of Modern Art, New York: 'New Acquisitions: Gift of Mrs John D. Rockefeller'

Valentine Gallery, New York: 'XXth Century French Paintings'

Studio House, Washington D. C.: 'Fourteen Paintings'

1937

Charlotte Square, Edinburgh: 'Paintings and Drawings by Modigliani and African Negro Sculpture'

Museum of Modern Art, New York (travelling exhibition): 'Drawings by American and European Artists'

Musée du Petit Palais, Paris: 'Les Maîtres de l'Art Indépendant, 1895-1937'

Museum of Art, Philadelphia: 'French Art'

1938

Museum of Fine Arts, Boston: 'XXth Century Paintings from the Museum of Modern Art'

Reid and Lefevre Galleries, London: 'The Tragic Painters'

Arthur Tooth & Sons, London: 'Amedeo Modigliani'

Montreal; Ottawa; Toronto: 'Paintings by French Masters—Delacroix to Dufy'

1940

Museum of Modern Art, New York: '12 Favorites: Paintings Selected by Students from the Museum Collection'

Galerie Aktuaryus, Zurich: 'Dessins et Estampes de Matisse et Modigliani'

1941

Institute of Arts, Alger House, Detroit: 'XIXth and XXth Century French Drawings'

City Art Museum, Saint Louis: 'XXth Century Art'

1942

Museum of Modern Art, New York: 'XXth Century Portraits'

Museum of Modern Art, New York: 'Recent Acquisitions: Painting and Sculpture'

Museum of Modern Art, New York: 'New Acquisitions'

Art Museum, Portland, Oregon: '50th Anniversary of the Portland Art Association'

1943

Galerie Berri, Paris: 'Petite Peinture, de 2 à 6'

Philadelphia: 'Paintings from the Chester Dale Collection'

USA (travelling exhibition): 'European and American Paintings'

Phillips Memorial Gallery, Washington, D. C.: 'East West'

1944

Institute of History and Art, Albany, New York: 'Beauty and is it Art?'

Leicester Galleries, London: 'Selected Paintings, Drawings and Sculptures from the Collection of the Late Sir Michael Sedler'

Kleemann Galleries, New York: 'Paintings and Drawings by Modigliani and Pascin'

The American British Art Center, New York: 'Amedeo Modigliani'

Museum of Modern Art, New York: 'XXth Century Drawings'

1945

Galerie Claude, Paris: 'Modigliani et ses Modèles'

Galerie de France, Paris: 'Modigliani'

1946

Casa della Cultura, Milan, Associazione fra gli Amatori ed i Cultori delle Arti Figurative Contemporanee, Milan: 'Modigliani'

Galerie Charpentier, Paris: 'Cent Chefs d'Oeuvre des Peintres de l'Ecole de Paris'

1947

La Chaux-de-Fonds: 'Exposition de Peinture Moderne'

Gimpel Fils, London: 'A. Modigliani'

Galerie Charpentier, Paris: 'Cent Chefs d'Oeuvre d'Art Français'

1948

Indiana University, Bloomington: 'French Art'

Art Center, Des Moines: 'XIXth and XXth Century European and American Painting'

Casa di Dante, Florence: 'Mostra dall'Otto al Novecento'

ICA, Academy Hall, London: '40 000 Years of Modern Art'

Galleria Nazionale d'Arte Moderna, Rome: 'Rassegna Nazionale di Arti Figurative' (V Quadriennale)

1949

Museum of Modern Art, New York: 'XXth Century Italian Art'

Galerie Charpentier, Paris: 'L'Enfance'

South America (travelling exhibition): 'Peinture Française Contemporaine'

1950

Stedelijk Museum, Amsterdam: 'Figuran uit de italiaanse Kunst'

Palais des Beaux-Arts, Brussels: 'Art Contemporain Italien'

Musée des Beaux-Arts, Lille: 'Un Demi Siècle de Peinture Française'

London; Edinburgh; Manchester: 'Contemporary Italian Art'

Musée National d'Art Moderne, Paris: 'L'Art Moderne Italien'

Museum of Fine Arts, Springfield, Massachusetts: 'In Freedom's Search'

Kunsthaus, Zurich: 'L'Art Européen du XIIIe au XXe Siècle'

1951

Museum of Art, Cleveland; Museum of Modern Art, New York: 'Modigliani: Paintings, Drawings, Sculpture'

Royal Academy of Arts, London: 'L'Ecole de Paris 1900-1950'

Milan; Rome 'Amedeo Modigliani' (VI Quadriennale)

Curt Valentin Gallery, New York: 'Sculptures by Painters'

1952

Lowe Gallery, Coral Gables, University of Miami: 'XIXth and XXth Century French Painting Exhibition'

1953

Norton Gallery and School of Art, Palm Beach, Florida; Lowe Gallery, Coral Gables, Miami: 'French Painting—David to Cézanne'

1954

Gables, Miami, Florida: 'Amedeo Modigliani'

Contemporary Arts Museum, Houston: 'Works of Modigliani'

Curt Valentin Gallery, New York: 'Sculptures and Sculptors, Drawings'

Fine Arts Associates, New York: 'Modigliani'

Society of the Four Arts, Palm Beach; Lowe Gallery, Coral Gables; Galerie Bernheim Jeune, Paris: 'Le Nu à travers les Ages'

Musée National d'Art Moderne, Paris: 'Le Dessin de Toulouse-Lautrec aux Cubistes'

1955

Antwerp: 'Sculpture en Plein Air' (Troisième Biennale)

Palacio de la Virreina, Barcelona: 'Pintura Italiana Contemporanea' (Biennale d'Art Hispano-Américain)

Kunsthalle, Berne: 'Modigliani, Campigli, Sironi'

Albright Knox Art Gallery, Buffalo: 'Fifty Paintings, 1905-1913'

Chattanooga, Tennessee (travelling exhibition): 'Modern Portraits'

The Art Institute, Chicago: 'Drawings by Amedeo Modigliani from the Collection of Mr and Mrs J. W. Alsdorf'

William Rockhill Nelson Gallery of Art and Mary Atkins Museum of Fine Arts, Kansas City: 'Contemporary Art by Jewish Artists'

Livorno: 'Onoranze a Modigliani'

Musée des Beaux-Arts, Vevey: 'Utrillo, Modigliani et Suzanne Valadon'

1956

Palais des Beaux-Arts, Brussels: 'De Toulouse-Lautrec à Chagall: Dessins, Aquarelles, Gouaches'

New Gallery, New York: 'Drawings by Modigliani and Pascin'

Perls Galleries, New York: 'Modigliani: The Sydney G. Biddle Collection'

Tournai: 'Les Maîtres de l'Art Contemporain'

Yverdon: 'Cent Sculptures de Peintres—de Daumier à Picasso'

1957

Hochschule für Bildende Künste, Berlin: 'Italienische Kunst im XX Jahrhundert'

Bibliothèque Royale de Belgique, Brussels: 'Frans Hellens'

Musée Cantini, Marseille: '50 Chefs d'Oeuvre Contemporains'

Messina: 'Scultura Italiana del Novecento'

Haus der Kunst, Munich: 'Moderne Italienische Kunst'

Perls Galleries, New York: 'Fifteen Major Selections'

Knoedler and Co., New York; Fogg Art Museum, Cambridge, Massachusetts: 'Modern Painting, Drawing, and Sculpture'

Marion Koogler McNay Art Institute, San Antonio, Texas: 'Amedeo Modigliani'

1958

Mead Art Building, Amherst College, Amherst, Massachusetts: 'XXth Century European Painting'

Brussels: '50 Ans d'Art Moderne' (Exposition Universelle et Internationale de Bruxelles)

Museum for Contemporary Arts, Dallas: 'Signposts of XXth Century Art'

Museum of Fine Arts, Houston: 'The Human Image'

Palazzo Reale, Milan: 'Mostra di Amedeo Modigliani'

Musée Cantini, Marseille: 'Modigliani'

Metz; Nancy: 'La Peinture de 1905 à 1914'

Chalette Gallery, New York: 'Sculptures by Painters'

Galerie Charpentier, Paris: 'Cent Tableaux de Modigliani'

Paris: 'Exposition Amadeo de Souza Cardoso'

Art Museum, Pasadena: 'XXth Century Italian Art'

Reims; Bar-le-Duc; Brive-la-Gaillarde: 'Dessins Contemporains'

Staten Island Museum, Staten Island, New York: 'A Chosen Few'

1959

Château-Musée, Blois: 'Peintres et Sculpteurs Italiens'

Fogg Art Museum, Harvard University, Cambridge, Massachusetts: 'Modigliani Drawings from the Collection of Stefa & Leon Brillouin'

Palais des Beaux Arts, Charleroi; Musée des Beaux Arts, Ixelles; Musée des Beaux Arts, Tournai; Musée des Beaux Arts, Luxembourg: 'De Maillol à Nos Jours'

The Arts Club, Chicago; Art Center, Milwaukee: 'Amedeo Modigliani'

Cincinnati Art Museum, The Contemporary Arts Center, Cincinnati: 'Amedeo Modigliani'

Kunsthalle, Hamburg: 'Die Französische Zeichnung des XX Jahrhunderts'

Biblioteca Nacional, Madrid: 'Sephardim'

Galleria Nazionale d'Arte Moderna, Rome: 'Amedeo Modigliani'

1960

Atlanta Art Association, Atlanta: 'The Art of Amedeo Modigliani'

Museum of Fine Arts, Houston: 'From Gauguin to Gorky'

Musée Masséna, Nice: 'Peintures à Nice et sur la Côte d'Azur, 1860-1960'

Musée National d'Art Moderne, Paris: 'Les Sources du XXᵉ Siècle'

Musée Rodin, Paris: 'La Sculpture Italienne Contemporaine'

Quimper; Rennes; Bourges; Dijon: 'Le Dessin Français, de Signac aux Abstraits'

1961

Stedelijk Museum, Amsterdam; Kunsthalle, Recklinghausen: 'Polarité: Le Côté Apollinien et le Côté Dyonisien dans les Beaux-Arts'

Museum of Fine Arts, Boston; County Museum, Los Angeles: 'Modigliani: Paintings and Drawings'

Tokyo; Kyoto: 'Art Français, 1840-1940'

Stadthalle, Wolfsburg: 'Französische Malerei von Delacroix bis Picasso'

1962

Hanover Gallery, London: 'Matisse and Modigliani'

Wildenstein Gallery, New York: 'Modern French Paintings'

1963

Kunsthalle, Dusseldorf: 'Malerei des XX Jahrhunderts, Erste Gesamtausstellung der Kunstsammlung Nordrhein-Westfalen'

Royal Scottish Academy, Edinburgh; Tate Gallery, London (The Arts Council of Great Britain in collaboration with Edinburgh Festival Society): 'Modigliani'

Steinernes Haus Römerberg, Frankfurt: 'Amedeo Modigliani'

Perls Galleries, New York: 'Amedeo Modigliani'

1964

Akademie der Künste, Berlin (West): 'Das Ursprüngliche und die Moderne'

Musée des Beaux Arts, Bordeaux: 'La Femme et l'Artiste, de Bellini à Picasso'

1965

Musée des Beaux Arts, Brussels; Musée des Beaux Arts, Mons: 'Un Demi-Siècle d'Amitiés Littéraires et Artistiques Franco-Belges'

Wilhelm Lehmbruck Museum, Duisburg: 'Pariser Begegnungen, 1904-1914'

1966

Perls Galleries, New York: 'The Nudes of Modigliani'

1967

Montreal, Canada (Exposition Internationale des Beaux-Arts)

1968

Museo Nacional de Bellas Artes, Buenos Aires; Museo de Arte Contemporaneo de la Universidad de Chile, Santiago; Museo de Bellas Artes, Caracas: 'Cézanne to Miro'

Congregation Shaarey Zedek, Southfield, Michigan: 'Works by Jewish Artists'

Seibu Gallery, Tokyo; National Museum of Modern Art, Kyoto: 'Modigliani'

Utrecht: 'Werken van Amedeo Modigliani in Nederlands Bezit'

National Gallery of Art, Washington D. C.; Metropolitan Museum of Art, New York; Museum of Fine Arts, Boston: 'Painting in France 1900-1967'

Kunst- und Museumsverein, Wuppertal: 'Exotische und moderne Kunst'

1969

Maison de la Culture, Bourges: 'Joie et Bonheur du Peintre'

Cairo; Teheran; Athens; Ankara; Istanbul: 'La Peinture en France de Signac au Surréalisme'

1970

Museum of Modern Art, Kyoto

Villa Fabricotti, Livorno: 'Amedeo Modigliani, 300 Immagini sulla Vita, le Opere, gli Amici del Pittore nel Cinquantesimo Anniversario della Morte'

Metropolitan Museum of Art, New York: 'Masterpieces of Fifty Centuries'

Grand Palais, Paris: 'Salon des Indépendants'

1971

Crédit Communal de Belgique, Brussels: 'Art Africain—Art Moderne'

Cultureel Centrum, Malines: 'De Menselijke Figuur in de Kunste 1910-1960'

Acquavella Galleries Inc., New York: 'Amedeo Modigliani'

Tel Aviv Museum, Tel Aviv: 'Les Grands Peintres Français du XXᵉ Siècle'

1972

Tiroler Landesmuseum Ferdinandeum, Innsbruck: 'Nach 1900'

Haus der Kunst, Munich: 'Weltkulturen und moderne Kunst'

USA (travelling exhibition: Palm Beach, Florida et al.): 'XXth Century Portraits'

1973

Hayward Gallery, London: 'Pioneers of Modern Sculpture'

Galerie Schmit, Paris: 'Tableaux de Maîtres Français, 1900-1955'

The National Museum of Modern Art, Tokyo; The National Museum of Modert Art, Kyoto: 'Paris and Japan in the History of Modern Art'

1974

Tate Gallery, London: 'Picasso to Lichtenstein, Masterpieces of XXth Century Art from the Nordrhein-Westfalen Collection, Düsseldorf'

Museum of Modern Art, New York: 'Seurat to Matisse: Drawing in France'

1975

Ingelheim: 'Mexikanische Tage'

Hayward Gallery, London: 'Pioneers of Modern Sculpture'

Musée Jacquemart-André, Paris: 'Le Bateau-Lavoir, Berceau de l'Art Moderne'

Art Gallery of New South Wales, Sydney; National Gallery of Victoria, Melbourne; Museum of Modern Art, New York: 'Modern Masterpieces'

Kunsthaus, Zurich: 'Les Naifs'

1976

Institute of Arts, Detroit: 'Arts and Crafts in Detroit: The Movement, The Society, The School'

Cultureel Centrum, Malines: 'Kunst in Europe, 1920-1960, een Confrontatie'

Musée National d'Art Moderne, Paris: 'Portraits et Masques'

1977

Musée Rath, Geneva: 'Du Futurisme au Spatialisme—Peinture Italienne de la Première Moitié du XXᵉ Siècle'

Museum of Modern Art, New York: 'The School of Paris: Drawing in France'

Galerie N. R. A., Paris: 'Modigliani, Dessins'

Tokyo (Mitsukoshi); Osaka (Mitsukoshi): 'Le Bateau-Lavoir'

Kunsthaus, Zurich: 'Vollendet-Unvollendet'

1978

Musée des Beaux Arts, Besançon: 'Mondzain et ses Amis'

Musée des Beaux Arts, Ghent: 'Le Bateau-Lavoir'

Museum of Modern Art, Oxford; Castle Museum, Norwich; Whitworth Art Gallery, Manchester; Herbert Art Gallery & Museum, Coventry: 'Paintings from Paris'

Musée Jacquemart-André, Paris: 'La Ruche et Montparnasse'

Musée National d'Art Moderne, Centre Georges Pompidou, Paris: 'Lipchitz'

Tokyo (Mitsukoshi); Osaka (Mitsukoshi); Sapporo (Mitsukoshi); Nagoya (Mitsukoshi): 'La Ruche—l'Ecole de Paris'

Galerie Pirra, Turin: 'Modigliani Inconnu'

1979

Pinacoteca Civica, Alessandria: 'Amedeo Modigliani, Disegni'

Hermitage, Leningrad; Pushkin Museum, Moscow: 'Peinture Française, 1909-1939'

Museum of Art, Oklahoma City, Oklahoma: 'Masters of the Portrait'

Mairie du XVᵉ arrondissement, Paris: 'L'Ecole de Paris dans le XVᵉ Arrondissement'

Musée National d'Art Moderne, Centre Georges Pompidou, Paris: 'Paris-Moscow—1900-1930'

Musée Idemitsu, Tokyo: 'A. Malraux et le Japon Eternel'

Tokyo (Daimaru); Osaka (Daimaru): 'Modigliani: Exhibition—Love and Nostalgia for Montparnasse'

1980

Pinacothèque Nationale—Musée Alexandre Soutzos, Athens: 'Impressionnistes et Post-Impressionnistes des Musées Français: De Manet à Matisse'

Musée Saint-Georges, Liège: 'Modigliani'

Musée Ingres, Montauban: 'Ingres et sa Postérité'

Galerie Daniel Malingue, Paris: 'Maîtres Impressionnistes et Modernes'

Musée National d'Art Moderne, Centre Georges Pompidou, Paris: 'Les Réalismes, 1919-1939'

Tokyo: 'Modigliani-Utrillo-Kisling'

1981

Musée d'Art Moderne de la Ville de Paris, Paris: 'Amedeo Modigliani'

1982

Rotonda di via Besana, Milan: 'Amedeo Modigliani. Disegni e Acquarelli nelle Raccolte Pubbliche e Private Italiane'

Galerie d'Art Moderne, Monte Carlo: 'Modigliani, Aquarelles et Dessins'

Tokyo: 'Cento Anni di Arte Italiana Moderna 1880-1980' (XIX Biennale)

1983

Centre Cultural de la Caixa de Pensions, Barcelona; Sala de Exposiciones de la Caja de Pensiones, Madrid 'Modigliani 1884-1920'

National Gallery of Art, Washington D.C.: 'Modigliani'

1984

Museo Progressivo d'Arte Contemporanea, Livorno: 'Modigliani. Gli Anni della Scultura'

Naples: 'Amedeo Modigliani—Disegni'

Galleria Pirra, Turin: 'Amedeo Modigliani. Centenario della Nascita'

Galleria dello Scudo, Verona: 'Modigliani. Dipinti e Disegni. Incontri Italiani 1900-1920'

1985

The Jewish Museum, New York: 'The Circle of Montparnasse. Jewish Artists in Paris, 1905-1945'

The National Museum of Modern Art, Tokyo; Aichi Prefectural Art Gallery, Aichi: 'Amedeo Modigliani 1884-1920'

Palazzo Reale, Turin: 'Modigliani. Dipinti e Disegni. Incontri Italiani 1900-1920'

1986

Casa Natale, Livorno: 'Modigliani'

1988

Casa Natale, Livorno: 'Modigliani'

Kasama Nichido Museum of Art, Kasama: 'Modigliani et ses Amis'

Palazzo Forti, Verona: 'Modigliani a Montparnasse'

1989

Royal Academy of Arts, London: 'Italian Art in the 20th Century'

Musée de Montmartre, Paris: 'Modigliani'

Palazzo Grassi, Venice: 'Arte Italiana—Presenze 1900-1945'

1990

Fondation Pierre Gianadda, Martigny: 'Amedeo Modigliani'

Musée des Beaux-Arts, Orléans: 'Modigliani'

1991

Kunstsammlung Nordrhein-Westfalen, Dusseldorf; Kunsthaus, Zurich: 'Amedeo Modigliani'

Selected Bibliography

Exhibition catalogues

Barcelona, Centre Cultural de la Caixa de Pensiones, and Madrid, Sala de Exposiciones de la Caja de Pensiones, *Modigliani. 1884-1920*, Madrid 1983

Boston, Museum of Fine Arts, and Los Angeles, University of California, *Modigliani. Paintings and Drawings*, text by Palma Bucarelli and Nello Ponente, 1961

Livorno, Museo Progressivo d'Arte Contemporanea, *Modigliani—gli anni della scultura*, Milan and Rome 1984

London, Tate Gallery, and Edinburgh, Royal Scottish Museum, *Modigliani*, introduction by John Russell, 1963

Naples, Institut Français de Naples, *Amedeo Modigliani—disegni*, Naples and Paris 1984

New York, Demotte Gallery, *Amedeo Modigliani (1884-1920). Retrospective Exhibition at the Demotte Gallery*, text by Maud Dale, 1931

New York, Galerie Curt Valentin, *Sculpture by Painters*, 1951

New York, de Hauke and Co., *Paintings by Modigliani*, with a preface by Christian Zervos, 1929

New York, Museum of Modern Art, and Cleveland Museum of Art, *Modigliani, Painting, Drawing, Sculpture*, by James Thrall Soby, 1951 (further eds 1954, 1963)

Paris, Galerie Charpentier, *Cent Tableaux de Modigliani*, 1958

Paris, Galeries Montaigne, *Modigliani*, text by André Warnod, 1920

Paris, Musée d'Art Moderne de la Ville de Paris, *Amedeo Modigliani. 1884-1920*, ed. Daniel Marchesseau, 1981

Rome, Museo Nazionale d'Arte Moderna, Valle Giulia, *Modigliani*, introduction by Palma Bucarelli, catalogue by Nello Ponente, 1959

Verona, Galleria d'Arte Moderna e Contemporanea, Palazzo Forti, *Modigliani a Montparnasse 1909-1920*, ed. Patrizia Nuzzo, Milan and Rome 1988

Verona, Galleria dello Scudo, and Turin, Palazzo Reale, *Modigliani—dipinti e disegni. Incontri italiani 1900-1920*, ed. Osvaldo Patani, Milan 1984

Books

Adam, Léonard, *Primitive Art*, London 1949

Akhmatova, Anna, *Requiem and Poem without a Hero*, transl. by D. H. Thomas, London 1976

Amedeo Modigliani (1884-1920), with an introduction by Jacques Lipchitz, Munich, Vienna and Basle n.d. [*c.* 1954]

Amedeo Modigliani, Modern Art Series, New York 1929

d'Ancona, Paolo, *Modigliani, Chagall, Soutine, Pascin—Aspetti dell' Espressionismo*, Milan 1953

Aprà, Nietta, *Tormento di Modigliani*, Milan 1945

Baldini, Umberto, *Pittori toscani del '900*, Florence 1978

Bartolini, Luigi, *Modì*, Venice 1938

Basler, Adolphe, *La Peinture: Religion Nouvelle*, Paris 1926, pp. 17-18

Basler, Adolphe, *La Sculpture Moderne en France*, Paris 1928

Basler, Adolphe, *Modigliani*, Paris 1931

Borgiotti, Mario, *Coerenza e modernità dei pittori labronici*, Florence 1979

Bucci, Anselmo, *Picasso, Dufy, Modigliani, Utrillo*, Milan 1955

Büchner, Joachim, *Malerei des zwanzigsten Jahrhunderts, Kunstsammlung Nordrhein-Westfalen*, Cologne 1968, pp. 207-12

Buisson, Sylvie, *L'Ecole de Paris de Modigliani*, Livorno 1988

Carco, Francis, *From Montmartre to the Latin Quarter*, London 1929

Carco, Francis, *L'Ami des Peintres*, Geneva 1944, 2nd. ed. Paris 1953

Carli, Enzo, *Amedeo Modigliani, con una testimonianza di Jean Cassou*, Rome 1952

Carrieri, Raffaele, *Opere di Modigliani in Italia*, Artisti Italiani Contemporanei, 10, Milan 1946

Carrieri, Raffaele, *12 Opere di Amedeo Modigliani*, Milan 1947

Carrieri, Raffaele, *Modigliani*, Milan 1950

Carrieri, Raffaele, *Pittura Scultura d'Avanguardia in Italia 1890-1950*, Milan 1950

Carrieri, Raffaele, *Iconografia italiana di Apollinaire*, Milan 1954

Cartier, Jean Albert, *Modigliani, Nus*, Paris 1958

Casson, Stanley, *Some Modern Sculptors*, London 1929

Cassou, Jean, *Modigliani*, Rome n.d.

Castieau-Barrielle, Thérèse, *La vie et l'œuvre de Amedeo Modigliani*, Paris 1987

Celant, Germano, and Pontus Hulten, *Arte Italiana: Presenze 1900-1945*, Milan 1989

Cendrars, Blaise, *Planus*, ed. and transl. by Nina Rootes, London 1972

Ceroni, Ambrogio, *Amedeo Modigliani, peintre, incorporating the memoirs of Lunia Czechowska*, Milan 1958

Ceroni, Ambrogio, *Modigliani*, London/New York 1959

Ceroni, Ambrogio, and Leone Piccioni, *I dipinti di Modigliani*, Classici dell'Arte, Milan 1970

Ceroni, Ambrogio, *Tout l'œuvre peint de Modigliani*, with a text by Françoise Cachin, Paris 1972

Ceroni, Angela, *Amedeo Modigliani. Die Akte*, Stuttgart 1989

Clark, Kenneth, *The Nude: A Study of Ideal Art*, London 1956

Cocteau, Jean, *Modigliani*, Paris 1950

Cocteau, Jean, *Quinze dessins et acquarelles précédés d'un portrait à la plume d'Amedeo Modigliani par Jean Cocteau*, Paris, May 1960

Crespelle, Jean-Paul, *Montparnasse vivant*, Paris 1962

Crespelle, Jean-Paul, *Modigliani, les femmes, les amis, l'œuvre*, Paris 1969

Csorba, Geza, *Modigliani*, Budapest 1969

Dale, Maud, *Modigliani*, New York 1929

Dale, Maud, *Before Manet to Modigliani*, New York 1929

Dalevèze, Jean, *Modigliani*, Lausanne 1971

Descargues, Pierre, *Amedeo Modigliani*, Paris 1951

Diehl, Gaston, *Modigliani*, New York 1969

Diehl, Gaston, *Modigliani*, Paris 1977

Douglas, Charles, *Artist Quarter*, London 1941

Earp, T.W., *The Modern Movement in Painting*, London 1935

Ehrenburg, Ilya, *Men, Years, Life*, London 1962

Epstein, Jacob, and A. Haskell, *The Sculptor Speaks*, London 1931

Epstein, Jacob, *Let There Be Sculpture: An Autobiography*, London 1940, rev. ed. 1955

Fifield, William, *Modigliani—The Biography*, New York 1976/London 1978

Franchi, Raffaello, *Modigliani*, Maestri Moderni, II, Florence 1944, rev. ed. 1946

Fusero, Clemente, *Il romanzo di Modigliani*, Milan 1958

Fuss-Amoré, Gustave, and Maurice des Ombiaux, *Montparnasse*, Paris 1925, pp. 200-1

Georges-Michel, Michel, *Les Montparnos. Roman de la Bohème cosmopolite*, Paris 1923, further eds 1929 and 1957

Giedion-Welcker, Carola, *Contemporary Sculpture*, New York 1955, rev. and enlarged ed. 1960

Gindertael, Roger V., *Modigliani e Montparnasse*, Milan 1969/Munich 1974/Paris 1976

Goldwater, Robert J., *Primitivism in Modern Painting*, New York 1938

Hall, Douglas, *Modigliani*, Oxford 1979, rev. and enlarged ed. 1984

Hamnet, Nina, *The Laughing Torso*, London 1932

Hellens, Frans, *Documents secrets 1905-1956: Histoire sentimentale de mes livres et de quelques amitiés*, Paris 1958

Hubbard, H. I., *Modigliani and the Painters of Montparnasse*, New York 1970

Hulten, Pontus, *Brancusi*, New York 1987

Huyghe, René, *Les Contemporains*, Paris 1939

Jedlicka, Gotthard, *Modigliani*, Erlenbach-Zurich 1953

John, Augustus Edwin, *Chiaroscuro, Fragments of Autobiography*, London 1952

Kimio, Nakayama, *Modigliani*, Tokyo 1974

Kodansha, *Modigliani*, Tokyo 1980

Lanthemann, Joseph, *Modigliani 1884-1920: Catalogue raisonné, sa vie, son œuvre complet, son art*, Barcelona 1970

Lanthemann, Joseph, *Modigliani inconnu*, with a text by Christian Parisot, 'Modigliani: analyse structurale de la plastique', Turin 1978

Leymarie, Jean, Geneviève Monnier and Bernice Rose, *History of an Art. Drawing*, London 1979

Lipchitz, Jacques, *Amedeo Modigliani*, London and New York 1953, 2nd ed. 1958

Lipchitz, Jacques, *Modigliani (1884-1920)*, London 1956

Lipchitz, Jacques, and Georges Boudaille, *Modigliani*, Paris 1966

Maiolino, Enzo (ed.), *Modigliani vivo*, Turin 1981

Mann, Carol, *Modigliani*, London 1980

Marchiori, Giuseppe, *Amedeo Modigliani*, Milan 1950, further eds 1952, 1953

Modigliani, Pascin, Soutine, n. p. [Palestine] 1944 (in Hebrew)

Modigliani, with a text by Franco Russoli and a preface by Jean Cocteau, Milan 1972

Modigliani, Jeanne, *Modigliani: Man and Myth*, New York 1958

Modigliani, Jeanne, *Modigliani racconta Modigliani*, Livorno 1984

Mondadori, Arnoldo, *Geniuses of Art*, Milan 1979

Mongan, Agnes, *Modigliani: Drawings from the Collection of Stefa & Leon Brillouin*, Fogg Art Museum, Harvard University, Cambridge, Massachusetts 1959

Nicholson, Benedict, *Modigliani*, London 1948

Nicoidski, Clarisse, *Modigliani*, Paris 1989

Note e Ricordi su Amedeo Modigliani (1884-1920), Genoa 1945

Parisot, Christian, *Amedeo Modigliani. Centenario della nascita*, Turin 1984

Parisot, Christian, *Modigliani*, Livorno 1988

Parisot, Christian, *Modigliani. Catalogue Raisonné. Dessins, Aquarelles, I*, ed. Giorgio and Guido Guastalla, Livorno 1990

Patani, Osvaldo, *Amedeo Modigliani, disegni*, Milan 1972

Patani, Osvaldo, *Le lucertole blu*, Milan 1973

Patani, Osvaldo, *La storia del disegno italiano 1900-1974*, Turin 1974

Patani, Osvaldo, *Modigliani, disegni*, Milan 1976

Patani, Osvaldo, *Disegni di Modigliani*, Milan 1982

Patani, Osvaldo, *Modigliani*, Milan 1985

Pavolini, Corrado, *Modigliani*, Milan 1966

Pfannstiel, Arthur, *Modigliani*, with a foreword by Louis Latourette and a provisional list of works, Paris 1929

Pfannstiel, Arthur, *Modigliani et son œuvre, étude critique et catalogue raisonné*, Paris 1956

Pfannstiel, Arthur, *Dessins de Modigliani*, Lausanne 1958

Piccioni, Leone, and Ambrogio Ceroni, *I Dipinti di Modigliani*, Milan 1970

Ponente, Nello, *Modigliani, Life and Work of the Artist*, London/New York 1969

Pozo, Gonzalo Millan del, *Modigliani inedito—tras las huelas de sa ostilo*, Madrid 1989

Raynal, Maurice, Jacques Lassaigne and Werner Schmalenbach, *De Picasso au Surréalisme*, Geneva 1950

Raynal, Maurice, *Modigliani*, New York 1951

Restellini, Marc, and Christian Parisot, *Portraits et paysages chez Zborowski*, Paris 1989

Roy, Claude, *Modigliani*, New York 1958

Russoli, Franco, *Modigliani*, New York/London 1959

Russoli, Franco, *Modigliani, Drawings and Sketches*, London/New York 1969

Salmon, André, *L'Art vivant*, Paris 1920, pp. 279-81

Salmon, André, *Modigliani, sa vie et son œuvre*, Paris 1926

Salmon, André, *Modigliani: a memoir*, London/New York 1961

San Lazarro, Gualtiero di, *Modigliani: Peintures*, Paris 1947

San Lazarro, Gualtiero di, *Modigliani*, Paris 1953

San Lazarro, Gualtiero di, *Modigliani Portraits*, London 1957

Schaub-Koch, Emile, *Modigliani*, Lille and Paris 1933

Scheiwiller, Giovanni, *Amedeo Modigliani*, Arte Moderna Italiana, 8, Milan 1927 (further eds 1932, 1935, 1936, 1942, 1950)

Scheiwiller, Giovanni, *Amedeo Modigliani*, Milan 1927 and Paris 1928

Scheiwiller, Giovanni (ed.), *Omaggio a Modigliani (1884-1920)*, Milan 25 January 1930

Scheiwiller, Giovanni, *Amedeo Modigliani*, Milan 1936, 2nd ed. 1950

Scheiwiller, Giovanni, *Amedeo Modigliani—Selbstzeugnisse, Photos, Zeichnungen*, Zurich 1958

Schwarz, Marck, *Modigliani*, Paris 1927 (in Hebrew)

Seuphor, Michel, *The Sculpture of this Century*, New York 1960

Sichel, Pierre, *Modigliani*, New York/London 1967

Silver, Kenneth E., and Romy Golan, *The Circle of Montparnasse. Jewish Artists in Paris. 1905-1945*, New York 1985

Sitwell, Osbert, *Laughter in the Room*, London 1949

Soffici, Ardengo, *Passi tra le rovire*, Florence 1952

Taguchi, S., *Modigliani*, Tokyo 1936

Trier, Eduard, *Zeichner des 20. Jahrhunderts*, Berlin 1956

Valsecchi, Marco, *Amedeo Modigliani*, Milan 1954

Valsecchi, Marco, *Amedeo Modigliani*, Milan 1955

Valsecchi, Marco, *Amedeo Modigliani*, Milan 1961

Vitali, Lamberto (ed.), *Forty-five Drawings by Modigliani*, New York 1959

Vitali, Lamberto, *Disegni di Modigliani*, Milan 1929, 2nd ed. 1936

Warnod, Jeanine, *La Ruche & Montparnasse*, Geneva and Paris 1978

Warnod, Jeanine, *Le Bateau Lavoir*, Paris 1986

Warnod, Jeanine, *Les Artistes de Montparnasse*, Paris 1988

Wentinck, Charles, *Moderne und primitive Kunst*, Freiburg 1974

Werner, Alfred, *Modigliani: The Sculptor*, New York 1962, London 1965

Werner, Alfred, *Amedeo Modigliani*, New York 1967

Zurcher, Bernard, *Modigliani*, Paris 1980 and London 1981

Articles

d'Ancona, Paolo, 'Peintres maudits: Modigliani-Utrillo', *Le Arti Plastiche*, 1 May 1925

d'Ancona, Paolo, 'A proposito di Modigliani', *Le Arti Plastiche*, 16 May 1925

Les Arts à Paris, special issue devoted to Modigliani, October 1935

Balas, Edith, 'The Art of Egypt as Modigliani's Stylistic Source', *Gazette des Beaux-Arts*, February 1981

Basler, Adolphe, 'Pariser Chronik: Modigliani und Matisse bei Bernheim Jeune', *Der Cicerone*, XIV, 6 March 1922

Basler, Adolphe, 'Modigliani', *Le Arti Plastiche*, 1 June 1927

Basler, Adolphe, 'Amedeo Modigliani', *Le Crapouillot*, August 1927

Basler, Adolphe, 'Modigliani', *Kunst und Künstler*, XXVIII, 1929-30, pp. 355-63

Basler, Adolphe, 'Amedeo Modigliani', *Paris-Montparnasse*, February 1930

Bertelli, Carlo, 'Modigliani: The Cosmopolitan Italian', in *Italian Art in the 20th Century*, ed. Emily Braun, Munich 1989, pp. 57-60

Brielle, Roger, 'Les peintres juifs. I: Modigliani, et l'inquiétude nostalgique', *L'Amour de l'Art*, June 1933, and in *Histoire de l'Art Contemporain*, ed. René Huyghe, Paris 1935

Brummer, E., 'Modigliani chez Renoir', *Paris-Montparnasse*, February 1930

Büchner, Joachim, 'Amedeo Modigliani—Karyatide', *Blätter vom Haus* (Kunstsammlung Nordrhein-Westfalen, Düsseldorf), IV, 1964

Carco, Francis, 'Modigliani', *L'Eventail*, 15 July 1919

Carco, Francis, *L'événement*, 25 January 1920

Carco, Francis, 'Le peintre du nu moderne: Modigliani, son art, sa diversité', in *Le Nu dans la Peinture Moderne (1863-1920)*, Paris 1924, pp. 112-18

Carrà, Carlo, 'Il Convegno', in *L'Arte mondiale alla XIII biennale di Venezia*, III, 6, June 1922, pp. 289-90

Carrà, Carlo, 'Amedeo Modigliani', *L'Ambrosiano*, 2 July 1930

Carrà, Carlo, 'La XVII Biennale di Venezia: Amedeo Modigliani', *L'Ambrosiano*, 9 July 1930

Carrieri, Raffaele, 'Amedeo Modigliani', in *Forme*, Milan 1949

Cartier, Jean-Albert, 'A. Modigliani, l'homme, l'artiste', *Le Jardin des Arts*, May 1958

Cavallini, Attilio, 'Modi', in *L'Ebreo e il Pittore di Madonne*, Milan n. d.

Cendrars, Blaise, 'Modigliani', *Vient de paraître*, September-October 1927

Chessa, Gigi, 'Per Modigliani', *Arte*, 1930, pp. 30-40

Cingria, Charles-Albert, Introduction to the catalogue of the Modigliani exhibition at the Kunsthalle Basle, 1934

Coquiot, Gustave, 'Modigliani', in *Les Indépendants (1884-1920)*, Paris 1920, pp. 98-9

Coquiot, Gustave, 'Modigliani et les portraits d'amour', in *Vagabondages*, Paris 1921, pp. 205-9

Coquiot, Gustave, 'Modigliani', in *Des peintres maudits*, Paris 1924, pp. 99-112

Coquiot, Gustave, 'Modigliani', *Kunst und Künstler*, XXIV, 1926, pp. 466-70

Costetti, G., 'Amedeo Modigliani', *L'Illustrazione Toscana*, October 1930

Courthion, Pierre, 'Modigliani', *Vient de paraître*, 66, 1927

Dale, Maud, 'Vérisme et Stylisation: Modigliani', *Formes*, October 1931

Dale, Maud, Preface to the catalogue of the Modigliani exhibition at the Palais des Beaux-Arts, Brussels 1933

Delbourgo, Suzy, and Lola Faillant-Dumas, 'L'Etude au Laboratoire de Recherche des Musées de France', in *Amedeo Modigliani, 1884-1920*, exh. cat., Musée d'Art Moderne de la Ville de Paris, Paris 1981, pp. 21-47

Diehl, Gaston, Preface to the cat. of the Modigliani exh. at the Galerie Claude, Paris 1945

Dorival, Bernard, 'Existe-t-il un expressionisme juif?', *Art Présent*, 1947, pp. 52-3

Dorival, Bernard, 'Musée d'Art Moderne – Sculptures de Peintres', *Bulletin des Musées de France*, December 1949

Dorival, Bernard, 'Musée d'Art Moderne – Trois œuvres de Modigliani', *Bulletin des Musées de France*, September 1950, pp. 163-4

Earp, T.W., 'London Exhibition: Modigliani drawings at Messr Tooth's Gallery', *Drawing and Design*, II, 7 January 1927, pp. 10-12

Einstein, Carl, 'Amedeo Modigliani', in *Die Kunst des XX. Jahrhunderts*, Berlin 1926 (2nd ed. 1931), pp. 47-8

Fels, Florent, 'Modigliani', *L'Information*, 17 December 1920

Fels, Florent, 'Chronique artistique – Modigliani', *Les Nouvelles Littéraires*, 158, 24 October 1925

Fels, Florent, 'Modigliani', *Querschnitt*, July 1926

Fels, Florent, 'Peintre baroque', in *Note e Ricordi su Amedeo Modigliani*, Genoa 1945

Fierens, Paul, 'Modigliani', *Les Nouvelles Littéraires*, 13 June 1931

Fine Arts, special issue of *The Studio*, spring 1931

Fry, Roger, 'Line as a Means of Expression in Modern Art', *The Burlington Magazine*, February 1919, pp. 62-9

'Gemälde von Modigliani', *Deutsche Kunst und Dekoration*, July 1925, pp. 203-4

Gengaro, Maria Luisa, 'A proposito della datazione di un disegno di Modigliani', in *Scritti di Storia dell'Arte in onore di Mario Salmi*, III, Rome 1963, p. 481 ff.

George, Waldemar, 'Modigliani', *L'Amour de l'Art*, VI, October 1925

George, Waldemar, 'Modigliani', *Les Arts à Paris*, October 1925

George, Waldemar, 'Voici Modigliani dans sa grandeur et sa misère...', *Beaux-Arts*, 22 April 1938

George, Waldemar, 'Points de repère', in *Note e Ricordi su Amedeo Modigliani*, Genoa 1945

George, Waldemar, 'Manet und Modigliani, Tradition und Revolution', in *Amedeo Modigliani*, exh. cat., Frankfurt, Frankfurter Kunstverein, Frankfurt 1963

Georges-Michel, Michel, 'Modigliani: restauration de la ligne', in *Les grandes époques de la peinture moderne*, Paris and New York 1945

Gigli, Lorenzo, 'Uomini di Montparnasse', *I Libri del Giorno*, IX, 3, March 1926

Giraffa, 'Per capire: Un "collo lungo"', *1927. Problemi d'arte attuale*, 20 November 1927

'Girl in a white dress. By Modigliani', *Vanity Fair*, 32, 1 March 1929, p. 67

Gómez de la Serna, Ramon, 'Modigliani et Diego Rivera', *Paris-Montparnasse*, February 1930

Gordon, Jean, 'Savage Art and Modigliani', in *Modern French Painters*, London 1923, pp. 99-103

Gramantieri, Tullio, 'Amedeo Modigliani e la scultura negra', *Anteprima*, November 1948

Guerrisi, Michele, 'Modigliani', in *La Nuova Pittura*, Turin 1932

Guillaume, Paul, 'Modigliani', *Les Arts à Paris*, 6 November 1920

Guillaume, Paul, 'Modigliani's créature type beauté féminine', *Les Arts à Paris*, 21, June 1935

Guzzi, Virgilio, 'Ritorno di Modigliani', *Il Tempo*, 25 June 1948

Hennus, M. Z., 'Amedeo Modigliani', *Maandblad voor beeldende Kunst*, 1934, pp. 3-11

'Hommage à Modigliani', *Rivista di Livorno*, IV, July-August 1954

'Italian Artists of Today: Amedeo Modigliani', *Italy America Monthly*, 15 February 1934

Jedlicka, Gotthard, 'La mort de Modigliani', in *Kunst und Künstler*, 1932, pp. 210-14

Justi, Ludwig, 'Modigliani', in *Von Corinth bis Klee*, Berlin 1931, p. 167

Keller, Horst, 'Amedeo Modigliani—Karyatide', in *Das Meisterwerk*, III, Recklinghausen 1965

Kiki, 'Modigliani e il suo ruggito', *Piccolo della Sera*, 1 October 1930

Lancellotti, Arturo, 'Egger-Lienz e Modigliani', in *Le Biennali Veneziane del Dopo-guerra*, Rome 1924, pp. 86-8

Lascano, Tégui, Vicomte de, 'Le dernier paysage de Modigliani', *Paris-Montparnasse*, February 1930

Lascano, Tégui, Vicomte de, 'Les Femmes de Modigliani', *Paris-Montparnasse*, 15 August 1929

Lassaigne, Jacques, Introduction to *Cent tableaux de Modigliani*, exh. cat., Galerie Charpentier, Paris 1958

Latourette, Louis, 'Modigliani a Parigi', in *Note e Ricordi su Amedeo Modigliani*, Genoa 1945

Licini, Osvaldo, 'Ricordo di Modigliani', *L'Orto*, January-February 1934

Liebermann, William S., Preface to *The Nudes of Modigliani*, exh. cat., Perls Galleries, New York 1966

Lipchitz, Jacques, 'I remember Modigliani', *Art News*, 1951

Longstreet, Stephen, 'Amedeo Modigliani', in *The Drawings of Modigliani*, Alhambra, California 1972

Lormian, Henri, 'Modigliani et sa légende', *Beaux-Arts*, 12 January 1934

Macintyre, Raymond, 'The work of Modigliani', *The Architectural Review*, LXV, 389, April 1929, pp. 204-5

Maltese, Corrado, 'Per un ripensamento di Modigliani', *Bollettino d'Arte del Ministero della Pubblica Istruzione*, XLIV, IV/1, January-March 1959, p. 93

Mann, Carol, 'Amedeo Modigliani and Jeanne Hébuterne. The reattribution of works to Modigliani's mistress', *The Connoisseur*, April 1980

Marinetti, F. T., 'Modigliani e Boccioni', *Gazzetta del Popolo*, 27 February 1930

Marinus, 'La rara figura de Modigliani', *El Semanario Nacional*, XVII, 953, 5 August 1928, supplement

Martinelli, Valentino, 'Modigliani e Laurens', in *Ecrits en hommage à Venturi*, Rome 1956, pp. 205-15

Mauroner, Fabio, 'Acquaforte', in *Atti dell' Accademia delle scienze e delle arti di Udine*, Udine 1955

Mazia, Violette de, 'Modigliani', *Les Arts à Paris*, 14 October 1927

McBride, H., 'Modigliani', *The Arts*, III, January 1923

McQuarie, E., 'The Boy, by Amedeo Modigliani', *Indianapolis Museum of Art Bulletin*, XXXIII, 1 April 1946

Meidner, Ludwig, 'Erinnerungen an Modigliani', *Das Kunstblatt*, February 1931

Meidner, Ludwig, 'Young Modigliani', *The Burlington Magazine for Connoisseurs*, April 1943

Meidner, Ludwig, 'Erinnerungen an den jungen Modigliani', *Neue Zürcher Zeitung*, 29 September 1946

Menni, Rosa G., 'Tre disegni di Modigliani', 1929. *Problemi d'Arte attuale*, III, 1-2, January-February 1929, pp. 14-16

Mercurio, 'Decimo anniversario della morte di Modigliani', *Le Arti Plastiche*, 1 February 1930

Michel, Wilhelm, 'Gemälde von Modigliani', *Deutsche Kunst und Dekoration*, July 1925

Modigliani, Amedeo, 'Trois poèmes inédits', *Les Arts à Paris*, 1 October 1925

Modigliani, Amedeo, 'Cinque lettere giovanili al pittore Oscar Ghiglia', ed. Paolo d'Ancona, *L'Arte*, May 1930, pp. 257-64

Modigliani, Amedeo, 'Lettere', *Belvedere* May-June 1930

Modigliani, Amedeo, 'Lettera al pittore Oscar Ghiglia', *Pattuglia*, 7-8, 1943

Modigliani, Amedeo, 'Ave et Vale. Poesia in francese', in *Note e Ricordi su Amedeo Modigliani*, Genoa 1945

'Modigliani', *Drawing and Design*, June 1928

'Modigliani Exhibition at the Lefevre Gallery', *Drawing and Design*, March-April 1929

'Amedeo Modigliani', ed. Umbro Apollonio, in *Un Demi-Siècle d'Art italien*, special issue of *Cahiers d'Art*, 1, 1950

Modigliani, special issue of *Rivista di Livorno*, July-August 1954

Mondaini, 'Modigliani guarda i suoi quadri', *Liguria*, February 1946

'Mostra Individuale di Amedeo Modigliani', in *Catalogo della XIII Esposizione Internazionale d'Arti della Città di Venezia*, Venice 1922, p. 57

Neppi, A., 'Il caso Modigliani', *Il Lavoro Fascista*, 16 May 1930

Neugass, Fritz, 'Amedeo Modigliani', *Deutsche Kunst und Dekoration*, January 1931

Neugass, Fritz, 'Les sources de l'Art de Modigliani', *Art et Artistes*, 149, 1934, pp. 330-5

O. L., 'Gemälde von Modigliani', *Deutsche Kunst und Dekoration*, July 1925

Oppo, C. E., 'Una mostra postuma di Modigliani (1921)', *Forme e Colori nel Mondo*, Lanciano 1928

Paris-Montparnasse, special issue devoted to Modigliani February 1930

Parisot, Christian, 'Modigliani: analyse structurale de la plastique', in Joseph Lanthemann, *Modigliani inconnu*, Turin 1978

Parronchi, Alessandro, 'La lezione di Modigliani', *Illustrazione Italiana*, November 1955

Patani, Osvaldo, 'I disegni di Modigliani', *L'Europeo*, 20 August 1970, and *I Quaderni del Conoscitore di Stampe*, Milan 1970

Pavolini, Corrado, 'Un gran colorista', in *Note e Ricordi su Amedeo Modigliani*, Genoa 1945

Pisis, Filippo de, 'La Pittura di Modigliani', *Corriere Padano*, 16 January 1934

Prezzolini, Giuseppe, 'Modigliani', in *La Cultura Italiana*, Milan 1930, p. 422

Ragghianti, Carlo Ludovico, 'Modigliani, 1918-1958', *Sele-Arte*, VII, 37, September-October 1958

Ragghianti, Carlo Ludovico, 'Revisione di Modigliani', *Sele-Arte*, VII, 40, March-April 1959

Raimondi, Giuseppe, 'Modigliani', *L'Italiano*, II, 12-13, 30 September 1927

Raimondi, Giuseppe, 'Amedeo Modigliani', *Communità*, XIII, 68, 1959, p. 72

Raynal, Maurice, 'Modigliani', in *Anthologie de la Peinture en France de 1906 à nos Jours*, Paris 1927, pp. 239-44

Razzaguta, Gastone, 'Amedeo Modigliani', in *Virtù degli Artisti Labronici*, Livorno 1943

Roger-Marx, Claude, 'Modigliani', *Apollo*, London, IX, 52, April 1929, pp. 216-19

Rötlisberger, Marcel, 'Les Cariatides de Modigliani', *Critica d'Arte*, VII, 1960

Russoli, Franco, 'Modigliani e la critica', in *La Biennale di Venezia*, October-December 1958, Venice 1958

Russoli, Franco, 'Modigliani', in *Mostra di Amedeo Modigliani*, exh. cat., Milan, Palazzo Reale, with a preface by Jean Cocteau, Milan 1958, Paris 1960

Russoli, Franco, 'Per un catalogo dell'opera di Modigliani', in *Scritti di Storia dell'Arte in Onore di Mario Salmi*, III, Rome 1963, p. 475

Russoli, Franco, 'Modigliani e il disegno', *Pirelli*, XX, 4, 1967

Russoli, Franco, 'Tradizione e modernità dell'immagine: Valadon, Modigliani, Utrillo', *L'Arte Moderna*, VIII, 68, 1969

Rutter, F., 'Modigliani', *Apollo*, I, 1929, pp. 216-19

Sachs, Maurice, 'Modigliani the fated', *Creative Art*, February 1932

Salmon, André, 'Modigliani', *L'Amour de l'Art*, 1 January 1922

Salmon, André, 'Un soir qu'il avait bu...', *Paris-Montparnasse*, February 1930

Salmon, André, 'Le vagabond de Montparnasse. Souvenirs inédits', *Les Œuvres Libres*, 212, Paris, February 1939

Sapori, Francesco, 'Amedeo Modigliani', in *L'Arte Mondiale alla XIII Esposizione di Venezia: Mostre Retrospettive*, Bergamo 1922, p. 24

Sartoris, Alberto, 'Amedeo Modigliani', in *Catalogue illustré de la deuxième Exposition d'Artistes du Novecento Italien à Genève à la Galerie Moos: juin-juillet 1929*, exh. cat., Geneva, Galerie Moos

Scheiwiller, Giovanni, 'Modigliani', *Messages d'Estétique*, 1, 1928

Schmalenbach, Werner, 'Modigliani', in *Bilder des 20. Jahrhunderts. Die Kunstsammlung Nordrhein-Westfalen in Düsseldorf*, Munich 1986, pp. 24-30

Soffici, Ardengo, 'Ricordo di Modigliani', *Gazzetta del Popolo*, 16 January 1930

Soffici, Ardengo, 'Modigliani', *Belvedere*, February 1930

Soldati, Mario, 'Grandezza di Modigliani', in *Note e Ricordi su Amedeo Modigliani*, Genoa 1945

Stoermer, Curt, 'Erinnerungen an Modigliani', *Querschnitt*, June 1931

Sweet, Frederick A., 'Modigliani and Chirico', *Bulletin of the Art Institute of Chicago*, XXXIII, November 1939

Szittya, Emile, 'Soutine et son Temps', in *La Bibliothèque des Arts*, Paris 1955

Tinti, M., 'Supremazia di Modigliani', in *Note e Ricordi su Amedeo Modigliani*, Genoa 1945

'Un Carnet inédit de Modigliani au Musée d'Art Moderne', *Art de France* (Chronique de l'an), 1964, pp. 369-71

Valentiner, W. R., 'Modigliani and Pascin', *Bulletin of Detroit Institute of Arts*, Detroit, October 1930

Vauxcelles, Louis, 'Le Gil Blas (20 mars 1908) Salon des Indépendants', *Les Arts à Paris*, 15 December 1918

Venturi, Lionello, 'Sulla linea di Modigliani', *Poligono*, February 1930

Venturi, Lionello, 'Modigliani a Venezia', *Belvedere*, May-June 1930

Venturi, Lionello, 'Mostra Individuale di Amedeo Modigliani', in *Catalogo Illustrato della XVII Esposizione Biennale Internazionale d'Arte*, Venice 1930

Venturi, Lionello, 'Il gusto di Modigliani', in *Note e Ricordi su Amedeo Modigliani*, Genoa 1945

Venturi, Lionello, Introduction to *Catalogue de l'exposition Modigliani*, exh. cat., Marseille, Musée Cantini, June 1958

Vitali, Lamberto, 'Amedeo Modigliani', *Domus*, March 1934

Vitali, Lamberto, Preface to *Catalogue de l'exposition Modigliani*, exh. cat., Milan, Casa della Cultura, 1946

Vitali, Lamberto, 'Modigliani', in *Preferenza*, Milan 1950

Vlaminck, Maurice de, 'Souvenir de Modigliani', *L'Art vivant*, I, 21, November 1925

Vlaminck, Maurice de, 'Modigliani nella vita intima', *Le Arti Plastiche*, VI, 7, 1 April 1929

Vlaminck, Maurice de, 'Réflexions sur Rousseau et Modigliani', *Beaux-Arts*, 157, 1936

Wagner, Hugo, 'Amedeo Modigliani: Bildnis Celso Lagar, Zeichnung, 1919', *Mitteilungen*, 119-120 (Bern, Kunstmuseum), July-August 1970

Warnod, André, 'Modigliani', text for the retrospective exhibition at the Galeries Montaigne in Paris, 1920

Warnod, André, *Les Berceaux de la Jeune Peinture: Montmartre-Montparnasse*, Paris 1925, pp. 233-4 and pp. 271-3

Warnod, André, Preface to *Catalogue de l'exposition Modigliani*, exh. cat., Paris, Galerie de France, December 1945

Weill, Berthe, 'Exposition Modigliani', *Pan!... dans l'œil...*, Paris 1933

Weill, Berthe, 'Modigliani chez Zborowski', in *Pan!... dans l'œil...*, Paris 1933

Weill, Berthe, 'Utrillo, Modigliani sont venus me voir', *Pan!... dans l'œil...*, Paris 1933

Werner, Alfred, 'Modigliani', *Tomorrow*, April 1951

Werner, Alfred, 'Modigliani as a Sculptor', *Art Journal*, 1960-61, pp. 36-39

Werner, Alfred, 'Nudist of Nudes', *Art Magazine*, November 1966

Wilkinson, Alan G., 'Paris and London: Modigliani, Lipchitz, Epstein, and Gaudier-Brzeska', in William Rubin (ed.), *'Primitivism' in 20th Century Art*, New York 1984, pp. 417-50

Yaky, Paul, 'Les maudits: Couté, Modigliani, De Paquit', in *Le Montmartre de nos vingt ans*, Paris 1933

Zanzi, Emilio, 'Lirica rivelazione', in *Note e Ricordi su Amedeo Modigliani*, Genoa 1945

Zborowski, Léopold, 'Modigliani' (poem), *Paris-Montparnasse*, February 1930

List of Plates

1
Bride and Groom 1915/16
Oil on canvas
55.2 x 46.3 cm
The Museum of Modern Art, New
York, Gift of Frederic Clay Bartlett,
1942

2
Caryatid 1911/12
Oil on canvas
72.5 x 50 cm
Kunstsammlung Nordrhein-
Westfalen, Düsseldorf

3
Caryatid 1914
Blue crayon
65.4 x 50.2 cm
Philadelphia Museum of Art. Gift of
Arthur Wiesenberger

4
Portrait of Max Jacob 1916
Oil on canvas
73 x 60 cm
Kunstsammlung Nordrhein-
Westfalen, Düsseldorf

5
Portrait of Lunia Czechowska
1919
Pencil
41 x 24 cm
Private collection

6
Nude 1917
Oil on canvas
60 x 92 cm
Collection Gianni Mattioli

7
Standing Female Nude
c. 1918/19
Pencil
39.5 x 25.5 cm
Private collection

8
Landscape in Tuscany
c. 1898
Oil on cardboard
21 x 35 cm
Museo Civico Giovanni Fattori,
Livorno

9
Nude (Nudo Dolente)
1908
Oil on canvas
81 x 54 cm
Richard Nathanson, London
Private collection

10
Head of a Young Woman
1908
Oil on canvas
57 x 55 cm
Musée d'Art Moderne, Villeneuve
d'Ascq, France, Donation of
Geneviève and Jean Masurel

11
Portrait of Paul Alexandre
1911/12
Oil on canvas
92 x 60 cm
Collection Mme Jeanne Bréfort

12
Nude
c. 1908
Oil on canvas
61 x 38 cm
Perls Galleries, New York

13
The Jewess
c. 1908
Oil on canvas
55 x 46 cm
Galerie Schmit, Paris

14
The Cellist
1909
Oil on canvas
130 x 81 cm
Switzerland, courtesy Galerie Jan
Krugier

15
Caryatid
c. 1912
Oil on canvas
81 x 46 cm
The Sogetsu Art Museum, Tokyo

16
Caryatid
1913
Oil on canvas
81 x 46 cm
Collection Samir Traboulsi

17
Standing Nude
1911/12
Oil on cardboard on wood
82.8 x 47.9 cm
Nagoya City Art Museum, Japan

18
Portrait of Diego Rivera
1914
Oil on cardboard
100 x 79 cm
Museu de Arte de São Paulo

19
Portrait of Diego Rivera
1914
Oil on cardboard
104 x 75 cm
Kunstsammlung Nordrhein-
Westfalen, Düsseldorf

20
Portrait of Pablo Picasso
1915
Oil on canvas
34.2 x 26.5 cm
Private collection

21
*Portrait of Frank Burty
Haviland*
1914
Oil on cardboard
62.2 x 49.4 cm
Los Angeles County Museum of Art,
Mr and Mrs William Preston Harrison
Collection

22
Head c. 1915
Oil on paper
42 x 27 cm
Musée Calvet, Avignon

23
*Portrait drawing of Beatrice
Hastings* c. 1916
Oil and pencil
43 x 27 cm
Katherine M. Perls

24
Portrait of Beatrice Hastings
1916
Oil on canvas
65 x 46 cm
Collection John C. Whitehead, courtesy
Achim Moeller Fine Art, New York

25
Portrait of Henri Laurens
1915
Oil on canvas
115.8 x 88.3 cm
Private collection, Switzerland, cour-
tesy of Galerie Rosengart, Lucerne

26
Little Louise 1915
Oil on canvas
74.6 x 51.7 cm
Private collection, Tokyo

27
Antonia 1915
Oil on canvas
82 x 46 cm
Musée de l'Orangerie, Collection
Jean Walter—Paul Guillaume, Paris

28
Portrait of Beatrice Hastings
1916
Oil on canvas
55 x 38 cm
The Barnes Foundation, Merion
Station

29
Head
1915
Oil on cardboard
54 x 42.5 cm
Musée National d'Art Moderne,
Centre Georges Pompidou, Paris

30
Madam Pompadour
1915
Oil on canvas
61.1 x 50.2 cm
The Art Institute of Chicago, The
Joseph Winterbotham Collection

31
Pierrot
1915
Oil on cardboard
43 x 27 cm
Statens Museum for Kunst, Copen-
hagen

32
Portrait of Juan Gris
c. 1915
Oil on canvas
54.9 x 38.1 cm
The Metropolitan Museum of Art,
New York, Bequest of Miss Adelaide
Milton de Groot (1876-1967), 1967

33
Portrait of Jean Cocteau
1916
Oil on canvas
100 x 81 cm
Henry and Rose Pearlman Foun-
dation, Inc.

34
Portrait of Beatrice Hastings
1915
Oil on canvas
55 x 46 cm
Art Gallery of Ontario, Toronto,
Gift of Sam and Ayala Zacks

35
Portrait of Beatrice Hastings
1915
Oil on canvas
40 x 28.5 cm
Collection Mayer

36
Portrait of Paul Guillaume—Novo Pilota 1915
Oil on cardboard, on plywood
105 x 75 cm
Musée de l'Orangerie, Collection Jean Walter—Paul Guillaume, Paris

37
Portrait of Paul Guillaume
1916
Oil on canvas
81 x 54 cm
Civico Museo d'Arte Contemporaneo, Milan

38
Portrait of Moïse Kisling 1915
Oil on canvas
37 x 28 cm
Pinacoteca di Brera, Milan

39
Portrait of Moïse Kisling 1916
Oil on canvas
104 x 75 cm
Private collection, courtesy National Museum of Modern Art, Tokyo

40
Portrait of Moïse Kisling 1916
Oil on canvas
81 x 46 cm
Musée d'Art Moderne, Villeneuve d'Ascq, Donation of Geneviève and Jean Masurel

41
Portrait of Pinchus Krémègne
1916
Oil on canvas
82 x 55.5 cm
Kunstmuseum, Berne

42
Portrait of Oscar Miestchaninoff 1916
Oil on canvas
81 x 60 cm
Private collection, Switzerland

43
The Servant 1916
Oil on canvas
73 x 54 cm
Kunsthaus, Zurich

44
Girl with Black Apron 1918
Oil on canvas
92.5 x 60.5 cm
Öffentliche Kunstsammlung, Kunstmuseum, Basle

45
Jacques and Berthe Lipchitz
1917
Oil on canvas
81 x 54 cm
The Art Institute of Chicago, Helen Birch Bartlett Memorial Collection, 1926. 221

46
Portrait of Chaim Soutine
1916
Oil on canvas
100 x 65 cm
Private collection

47
Portrait of Chaim Soutine
1915
Oil on wood
36 x 27.5 cm
Staatsgalerie, Stuttgart

48
Portrait of Leopold Zborowski
1916
Oil on canvas
65 x 42 cm
Private collection, Zurich

49
Portrait of Leopold Zborowski
1916/17
Oil on canvas
116.2 x 73 cm
The John A. and Audrey Jones Beck Collection

50
Portrait of Leopold Zborowski
1919
Oil on canvas
107 x 66 cm
Museu de Arte de São Paulo

51
Portrait of M. Wielhorski 1918
Oil on canvas
116 x 73 cm
Galerie Beyeler, Basle

52
Portrait of Anna Zborowska
1917
Oil on canvas
55 x 35 cm
Gallerie Nazionale d'Arte Moderna, Rome

53
Portrait of Anna Zborowska
1917
Oil on canvas
130.2 x 81.3 cm
The Museum of Modern Art, New York, Lillie P. Bliss Collection, 1934

54
Portrait of Elena Pavlowski
1917
Oil on canvas
64.7 x 48.8 cm
The Phillips Collection, Washington

55
Portrait of a Woman with Black Tie
1917
Oil on canvas
65.4 x 50.5 cm
Collection Fujikawa Galleries Inc.

56
Seated Female Nude
1916
Oil on canvas
92 x 60 cm
The Courtauld Galleries, London

57
Seated Nude
1917
Oil on canvas
73 x 116 cm
Koninklijk Museum voor Schone Kunsten, Antwerp

58
Nude with Necklace
1917
Oil on canvas
73 x 116 cm
The Solomon R. Guggenheim Museum, New York

59
Red-Haired Young Woman in a Shift
1918
Oil on canvas
100 x 65 cm
Private collection, Vaduz

60
Nude
1917
Oil on canvas
65 x 100 cm
Private collection

61
Reclining Female Nude
1917
Oil on canvas
60 x 92 cm
Staatsgalerie, Stuttgart

62
Seated Nude
1917
Oil on canvas
100 x 62 cm
Private collection

63
Reclining Nude—Le Grand Nu
c. 1919
Oil on canvas
72.4 x 116.5 cm
The Museum of Modern Art, New York, Mrs Simon Guggenheim Fund, 1950

64
Seated Nude
1917
Oil on canvas
92 x 67.5 cm
Musée d'Art Moderne, Villeneuve d'Ascq, Donation of Geneviève and Jean Masurel

65
Girl with Pigtails
c. 1918
Oil on canvas
60 x 45.5 cm
The Nagoya City Art Museum

66
Standing Nude—Elvira
1918
Oil on canvas
92 x 60 cm
Kunstmuseum, Berne

67
Two children
1918
Oil on canvas
100 x 65 cm
Private collection

68
Marie 1918
Oil on canvas
62 x 50.5 cm
Öffentliche Kunstsammlung, Kunstmuseum, Basle

69
Portrait of Anna Zborowska
1919
Oil on canvas
46.3 x 29.8 cm
Private collection

70
Portrait of a Woman with Hat
1917
Oil on canvas
55 x 38 cm
Private collection

71
Portrait of Jeanne Hébuterne
c. 1918
Oil on canvas
100 x 65 cm
Private collection, Zurich

72
Portrait of Jeanne Hébuterne
1918
Oil on canvas
45.8 x 28 cm
Yale University Art Gallery, Bequest of
Mrs Kate Lancaster Brewster

73
Portrait of Lunia Czechowska
1919
Oil on canvas
100 x 65 cm
Musée d'Art Moderne de la Ville de
Paris

74
Portrait of Jeanne Hébuterne
1918
Oil on canvas
91.4 x 73 cm
The Metropolitan Museum of Art,
New York, Gift of Mr and Mrs Nate
B. Spingold, 1956

75
Seated Young Woman
1918
Oil on canvas
92 x 60 cm
Musée Picasso, Paris

76
The Servant Girl
c. 1918
Oil on canvas
152.4 x 60.9 cm
Albright-Knox Art Gallery, Buffalo,
New York, Room of Contemporary
Art Fund

77
Seated Woman with Child
1919
Oil on canvas
130 x 81 cm
Musée d'Art Moderne, Villeneuve
d'Ascq, Donation of Geneviève and
Jean Masurel

78
Portrait of Jeanne Hébuterne
1918
Oil on canvas
100 x 65 cm
Norton Simon Museum, Pasadena

79
Portrait of Mario Varvogli
1919/20
Oil on canvas
116 x 73 cm
Private collection

80
*Dark Young Woman Seated in
Front of a Bed*
1918
Oil on canvas
99.6 x 64.1 cm
Los Angeles County Museum of Art,
Francis and Armand Hammer Pur-
chase Fund

81
*Portrait of Thora
Klinckowström*
1919
Oil on canvas
99.7 x 64.8 cm
The Evelyn Sharp Collection, New
York

82
Boy in Blue Jacket 1918
Oil on canvas
92 x 73 cm
Perls Galleries, New York

83
Young Peasant c. 1918
Oil on canvas
100 x 65
Musée de l'Orangerie, Collection
Jean Walter—Paul Guillaume, Paris

84
The Boy c. 1918
Oil on canvas
92 x 63 cm
Indianapolis Museum of Art, Gift of
Mrs Julian Bobbs in memory of
William Ray Adams

85
The Little Peasant c. 1918
Oil on canvas
100 x 64.5 cm
The Trustees of the Tate Gallery,
London

86
Seated Young Woman
c. 1918
Oil on canvas
91 x 53 cm
Private collection

87
The Pretty Vegetable-Seller
1918
Oil on canvas
100 x 65 cm
Private collection

88
Landscape c. 1919
Oil on canvas
61 x 38 cm
Perls Galleries, New York

89
Landscape 1919
Oil on canvas
60 x 45 cm
Galerie Karsten Greve, Cologne/Paris

90
Nude 1919
Oil on canvas
73 x 116 cm
Private collection

91
Self-portrait
1919
Oil on canvas
100 x 64.5 cm
Museu de Arte Contemporánea da
Universidade de São Paulo

92
Head 1911/12
Limestone
63.5 x 15.2 x 21 cm
The Solomon R. Guggenheim
Museum, New York

93
Head c. 1911/12
Limestone
49.5 x 18.4 x 22.8 cm
Hirshhorn Museum and Sculpture
Garden, Smithsonian Institution, Gift
of Joseph H. Hirshhorn

94
Head 1911/12
Limestone
Height: 58 cm

Musée National d'Art Moderne,
Centre Georges Pompidou, Paris

95
Head 1911/12
Limestone
Height: 71.1 cm
Philadelphia Museum of Art. Gift of
Mrs Maurice J. Speiser in memory of
her husband

96
Head c. 1913
Limestone
Height: 61 cm
Perls Galleries, New York

97
Head 1909/14
Limestone
Height: 64 cm
Staatliche Kunsthalle Karlsruhe

98
Head 1911/12
Limestone
50 x 19.6 x 19 cm
Private collection

99
Head 1911/12
Limestone
63.5 x 12.5 x 35 cm
The Trustees of the Tate Gallery,
London

100
Caryatid 1914
Limestone
92.1 x 41.6 x 42.9 cm
The Museum of Modern Art, New
York, Mrs Simon Guggenheim Fund,
1951

101
Nude c. 1896
Pencil
58.8 x 42 cm
Museo Civico Giovanni Fattori,
Livorno

102
*Two Women and Three Studies
of Heads*
c. 1908
Ink and watercolour
48.2 x 31.7 cm
Museum of Fine Arts, Boston

103
Caryatid c. 1912/13
Pencil
39.7 x 25.7 cm
Musée des Beaux Arts de Dijon
(Donation Granville)

104
*Sheet of Studies with African
Sculpture and Caryatid*
c. 1912/13
Pencil
26.5 x 20.5 cm
Mr and Mrs James W. Alsdorf,
Chicago

105
Pink Caryatid 1913
Watercolour
54.6 x 43 cm
The Evelyn Sharp Collection

106
Pink Caryatid
1913/14
Watercolour and lead pencil
56 x 45 cm
Private collection, Milan

107
Caryatid c. 1914
Gouache on canvas and wood
140.7 x 66.7 cm
The Museum of Fine Arts, Houston,
Gift of Oveta Culp Hobby

108
Seated Nude c. 1910/11
Black chalk
42.5 x 26.4 cm
Isabella del Frata Rayburn

109
Caryatid Study
c. 1913
Ink and pencil
Private collection

110
Seated Nude 1914
Pencil and watercolour
54 x 42 cm
The Museum of Modern Art, New
York, Gift of Mrs Sadie A. May

111
Seated Nude c. 1914
Pencil and watercolour
56 x 45 cm
Private collection

112
Study of a Head
1911/12
Blue crayon
26.7 x 21 cm
Perls Galleries, New York

113
Head 1910/12
Pencil
44.5 x 27 cm
Private collection, Lugano

114
Head in Profile
c. 1912/13
Blue crayon
44 x 26.7 cm
Musée National d'Art Moderne,
Centre Georges Pompidou, Paris

115
*Portrait drawing of Beatrice
Hastings*
c. 1915
Pencil and charcoal
30.5 x 19.4 cm
The Solomon R. Guggenheim
Museum, New York

116
*Portrait drawing of Beatrice
Hastings*
c. 1915
Pencil
30.3 x 27.7 cm
Mr and Mrs James W. Alsdorf,
Chicago

117
*Seated Woman—Transatlantic
Boat*
c. 1915/16
Pencil
42 x 26 cm
Mr and Mrs James W. Alsdorf,
Chicago

118
*Portrait drawing of Blaise
Cendrars*
1918
Pencil
42.4 x 26.5 cm
Private collection, Switzerland

119
*Young Man Walking—Il
Giovane Pellegrino*
1916/17
Pencil
46.9 x 31 cm
Private collection, Switzerland

120
*Portrait drawing of Moïse
Kisling*
c. 1916
Pencil
35.3 x 25.8 cm
Mr and Mrs James W. Alsdorf,
Chicago

121
*Portrait drawing of Paul
Guillaume*
1916
Pencil
35.2 x 26.2 cm
The Museum of Modern Art, New
York, Gift of Mr and Mrs Richard
Rodgers

122
Mother and Child
1916
Pencil
36.1 x 26.5 cm
The Museum of Modern Art, New
York, The John S. Newberry Collec-
tion

123
Seated Young Man c. 1915
Pencil
42.7 x 25.9 cm
Öffentliche Kunstsammlung
Kupferstichkabinett, Basle,
K. A. Burckhardt-Koechlin-Fonds

124
Seated Man c. 1915/16
Pencil
42 x 26 cm
Musée National d'Art Moderne
Centre Georges Pompidou, Paris

125
*Portrait drawing of Jacques
Lipchitz*
c. 1917
Pencil
31.8 x 49.5 cm
Marlborough Fine Art (London) Ltd

126
Man with Hat—André Derain
c. 1918
Pencil
32.1 x 23.1 cm
Musée de Grenoble

127
*Portrait drawing of Guillaume
Apollinaire*
1915
Pencil
36.5 x 26.7 cm
Collection Mr and Mrs John
Pomerantz, New York

128
Portrait drawing of Gillet
c. 1918
Pencil
27 x 21 cm
Musée de Grenoble

129
Man with Pipe—Dilewsky
1919
Pencil
43 x 27 cm
Private collection, Zurich

130
Seated Nude c. 1917
Pencil
31.2 x 23.9 cm
Mr and Mrs James W. Alsdorf,
Chicago

131
Seated Nude 1918
Pencil
14.1 x 27.9 cm
The Museum of Modern Art, New
York

132
Seated Nude c. 1918
Pencil
42.5 x 25 cm
The Art Institute of Chicago, Given in
Memory of Tiffany Blake by Claire
Swift-Marwitz

133
Woman with Hat
1916/17
Pencil
48 x 31.5 cm
Private collection, Milan

134
Half-figure of a Young Girl
1919
Pencil
34.4 x 28 cm
Öffentliche Kunstsammlung,
Kupferstichkabinett, Basle

135
*Portrait drawing of Mario
Varvogli*
1920
Pencil
48.8 x 30.4 cm
The Museum of Modern Art, New
York, Gift of Abby Aldrich Rocke-
feller

Index of Names

Numbers in *italics* refer to pages with illustrations.

Photographic Acknowledgements

Albright-Knox Gallery, Buffalo, New York plate 76
Art Gallery of Ontario, Toronto plate 34
The Art Institute of Chicago plates 30, 45, 104, 116, 117, 120, 130, 132
The Art Museum Princeton University, Princeton plate 33
The Barnes Foundation, Merion Station, PA plate 28
Dr. Dr. Herbert Batlinger, Vaduz plate 59
Civico Museo d'Arte Contemporaneo, Milan plate 37
Collection Rignault, Musée Calvet, Avignon plate 22
Collezione Mattioli, Milan plate 6
Colorphoto Hinz, Allschwil-Basle plate 44
Courtauld Institute Galeries, London plate 56
Degonda & Siegenthaler Fotografen, Zurich plate 90
Walter Drayer, Zurich plates 71, 129
Isabella del Frate Rayburn, New York plate 108
Fujikawa Galleries, Tokyo plate 55
Galerie Beyeler, Basle plates 51, 86
Galerie Karsten Greve, Cologne plate 89
Galerie Jan Krugier, Geneva plate 14
Galerie Römer, Zurich plate 111

Galerie Rosengart, Lucerne plate 25
Galerie Schmit, Paris plate 13
Solomon R. Guggenheim Museum, New York plates 58, 82, 92, 115
Hirshhorn Museum and Sculpture Garden, Smithsonian Institution, Washington D.C. plate 93
Luiz Hossaka plates 18, 50
Indianapolis Museum of Art, Indianapolis plate 84
Alberto Flammer, Losone, Switzerland plate 42
Koninklijk Museum voor schone Kunsten Antwerp plate 57
Kunsthaus Zurich plate 43
Kunstmuseum, Berne plates 41, 66
Kunstsammlung Nordrhein-Westfalen, Düsseldorf plates 2, 4, 19
Los Angeles County Museum of Art plate 21
John C. Lutsch, Newton, MA plate 23
Marlborough Fine Art Ltd., London plate 125
The Metropolitan Museum of Art, New York plates 32, 74
Achim Moeller Fine Art, New York plate 24
Musée d'Art Moderne, Villeneuve d'Ascq plates 10, 40, 64, 77
Musées d'Art Moderne de la Ville de Paris plate 73

Musée de Grenoble plates 126. 128
Musée de l'Orangerie, Paris plates 27, 36, 83
Musée des Beaux-Arts de Dijon plate 103
Musée National d'Art Moderne, Paris plates 29, 94, 114, 124
Musée Picasso, Paris plate 75
Museo Civico Giovanni Fattori, Livorno plates 8, 101
Museu de Arte Contemporânea da Universidade de São Paulo plate 91
The Museum of Fine Arts, Boston plate 102
The Museum of Fine Arts, Houston plates 49, 107
The Museum of Modern Art, New York plates 1, 53. 63, 100, 110, 121, 122, 131, 135
The Nagoya City Art Museum, Japan plates 17, 65
Richard Nathanson, London plate 9
National Museum of Modern Art, Tokyo plate 39
Öffentliche Kunstsammlung, Basle plates 44, 65, 123, 134
Perls Galleries, New York plates 88, 96, 104, 112, 113
Mario Perotti, Milan plate 7
Philadelphia Museum of Art, Philadelphia plates 3, 95

The Phillips Collection, Washington D.C. plate 54
Pinacoteca Giovanni Fattori, Livorno plate 101
Mr. and Mrs. John Pomerantz, New York plate 127
Private collection plate 98
Private collection, Milan plates 106, 133
Private collection, Switzerland plates 113, 118, 119
Private collection, Zurich plate 48
Guiseppe Schiavinotto, Rome plate 52
The Evelyn Sharp Collection, New York plates 81, 105
Norton Simon Museum of Art, Pasadena, CA plate 78
The Sogetsu Art Museum, Tokyo plate 15
Staatliche Kunsthalle, Karlsruhe plate 97
Staatsgalerie, Stuttgart plates 47, 61
Statens Museum for Kunst, Copenhagen plate 31
The Tate Gallery, London plates 85, 99
Samir Traboulsi plate 16
Yale University Art Gallery, Bequest of Mrs Kate Lancaster Brewster plate 72